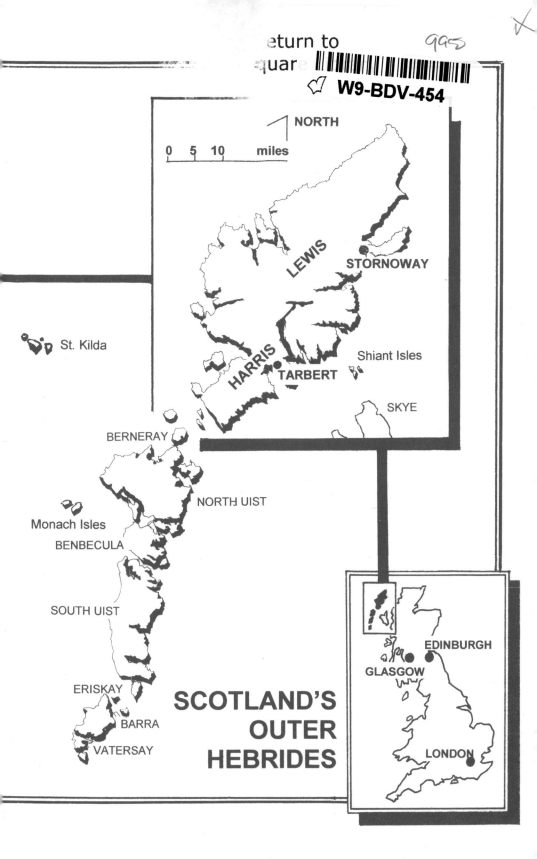

NORTH

0 5 10 miles

LEWIS

STORNOWAY

St. Kilda

HARRIS

TARBERT

Shiant Isles

SKYE

BERNERAY

NORTH UIST

Monach Isles

BENBECULA

SOUTH UIST

ERISKAY

BARRA

VATERSAY

SCOTLAND'S
OUTER
HEBRIDES

EDINBURGH

GLASGOW

LONDON

SEASONS ON HARRIS

SEASONS ON HARRIS

*A Year in Scotland's
Outer Hebrides*

Written and Illustrated by

David Yeadon

HarperCollins*Publishers*

HarperCollins books may be purchased for educational, business, or sales promotional use. For information, please write: Special Markets Department, HarperCollins Publishers, 10 East 53rd Street, New York, NY 10022.

FIRST EDITION

Designed by Nicola Ferguson

Printed on acid-free paper

Library of Congress Cataloging-in-Publication Data
Yeadon, David.
 Seasons on Harris : a year in Scotland's Outer Hebrides / written and illustrated by David Yeadon.—1st ed.
 p. cm.
 ISBN-13: 978-0-06-074181-5 (hc : alk. paper)
 ISBN-10: 0-06-074181-3 (hc : alk. paper)
 1. Harris (Scotland)—Description and travel. 2. Harris (Scotland)—Social life and customs. 3. Hebrides (Scotland)—Description and travel. 4. Lewis with Harris Island (Scotland)—Description and travel. I. Title.

DA880.H37Y43 2006
941.1'4—dc22

 2005055113

06 07 08 09 10 ❖/RRD 10 9 8 7 6 5 4 3 2 1

WORDS OF APPRECIATION

Our deepest gratitude goes to all those individuals mentioned in this book. Without exception, each one of you added immensely to our understanding—and our love—of Harris, its long, rich, and often sad history, its many challenges today, and its hopes and dreams for the future. And in addition to these newfound friends, we also thank the scores of others on the islands who took the time to talk with us, advise and guide us, offer hospitality and wise insights. Without you this book would still be a dream. With you, it has become a reality—and something Anne and I hope may help further perpetuate the compelling and unique spirit of Harris.

Our sincere thanks also go to Hugh Van Dusen, longtime friend, editor, and (when our ears are open) mentor, with deep appreciation for years of patience, advice, encouragement, and mutual enjoyment of life's bounties.

We also thank our friends who took time to visit us on Harris and let us experience the island through their sensitive eyes and minds: Robby and Celia Teichman, for their interest in and warm affection for the islands and our island friends; Michael Storey, entrepreneur-extraordinaire, who is still formulating novel ideas for encouraging the expansion of the "cottage" Harris Tweed industry; Christopher Little, literary agent supreme, who would have made it to Harris had it not been for the incessant demands of a wee gentleman known to the whole world as Harry Potter . . . And of course, Adam Nicolson, for generously giving his time and energy to share the magic of his Shiant islands and remind

us, once again, of the power and magic of these remote places—the very qualities that lured us to the Outer Hebrides in the first place.

We are also indebted to the ever-cheerful, ever-meticulous Bridget Allen, whose word processing skills transformed rough drafts into neat, crisp, and rigorously spell-checked pages.

CONTENTS

LIST OF ILLUSTRATIONS

FOREWORD

by Adam Nicolson,
author of *Seize the Fire* and *Sea Room*

One of the greatest landscape moments in the British Isles comes when you are driving from east to west over the hills of Harris in the Outer Hebrides. It is a tortuous journey, making your way between old and twisted rocks that have been filed and sanded by the glaciers into half-shaped lumps and half-gouged hollows. The hard-boiled gneiss of the land around you is about 3 billion years old, the oldest rocks in Europe. Look at any one of the pebbles that lie along the roadside and you see in its warped and creased layers, doubled over, with the folds doubled over again, a vast geological history. These are the roots of mountains that disappeared long, long before life emerged from the ocean. They have lasted so long only because they are so hard. They are the basement of life on this rough and rugged northern island.

Perhaps because of all that ancientness, it feels, particularly on the kind of bleak rainy day in which Harris specializes, as if the Ice Age ended here about a week ago. The glaciers have just retreated and the surface of the earth has been left, as W. H. Auden described his beloved, lump-strewn Icelandic tundra, "like the remains of a party no one has bothered to tidy up." Gray-faced sheep stare at you from next to black-watered pools. Peat cuttings leer around corners like soft, collapsing quarries. The sky looms as if it is an extension of the rock itself. Harris up here looks like the world before God gave any attention to it: formless and void, the meanest of landscapes, giving nothing, bitter, recalcitrant, a place that seems as if it has been ground between the twin

millstones of the sky above and the land beneath. How, you think, as the windshield wipers beat their endless rhythm across the glass in front of you, can people have ever lived here, have ever loved it, or have ever called it home?

But then, in this symbolic ten-mile journey from the east side of the island over to the west, you top the final rise and, as if by a miracle, the world changes. There, laid out far below you, still miles away but radiating its life and beauty across the intervening air, is something else. Suddenly, there is form: the huge extent of the Atlantic stretches to the horizon. The road winds its way down a valley toward it. There is an island offshore. Up to the right are the shoulders of the Harris hills. But in a sense none of that matters because what has changed, above all, is *color*. No longer the sour, tweedy dun of the acid moorland and its ribs of gneiss, but an unmatched set of the most beautiful colors in the world: the iron gray of the Atlantic transmuting into dark blue, then paler blue, then a dazzling, flickering, Bahamian turquoise which from time to time flashes pure white as a breaking wave slowly unfolds onto the white sands of the most perfect beaches in Europe. It is a vision of paradise seen from hell. There are tall dunes, scattered with marram grass, and inland of them, the sheep-nibbled lawns that, as you come closer, park the car, and walk out onto them, you find dotted with the spangle of buttercups and heartsease, milkwort and orchids, the sort of carpet that until then you might have thought existed only in the imagination of a Botticelli. It is the sort of place, as you walk these miles of empty beach, as the wind blows in off the Atlantic, where you remember again what the point is of being alive.

When you first see this transformation—and you should save and savor it like your first visit to St. Mark's in Venice or the Acropolis—it is unbelievable. In a matter of moments, you have flicked from the world of the fjords, the punishing north, to a kind of tropical heaven. It is a spectacle worth traveling halfway around the world to see, but unlike most spectacles, this one has a deep and shaping reality behind it. That polarized difference between the rocky, acid east of Harris and the sandy, limy west is a diagram of what the island itself has always been. Ever since people came here in the Stone Age, the sandy fields on the edges

of the Atlantic have been the good side. It is where most of the ancient monuments are. It is where archaeologists have found the fragile remains of the first Neolithic farms and the more substantial ruins, buried in the sand, of the Viking settlements. Over on that Atlantic side, the winter storms blow the sand up onto the peat—that mixture created a light, friable loam in which the early farmers could plant their crops. It is where the beautiful stands of barley and oats, filled with marigolds, corn cockle, and cornflowers can still be seen. It is a place of well-being and settlement.

Needless to say, it was over on that Atlantic side where, historically, most of the islanders chose to live. But now those wonderful fertile lands are virtually empty. In the great clearances of the nineteenth century, when the landlords wanted to make more money out of the good land than the people's rents could give them, the people were driven away from the shore, and from the sandy islands that lie off it, and forced onto the acid east side. Their fields and farms were replaced by sheep walks. Historically, the movement has been in precisely the opposite direction to your marvelous, revelatory morning's drive over the top of the island. Not from acid to sand, but from sand to acid, from heaven to hell.

When the people of the nineteenth century were driven to the poverty and difficulty of the east side, many went farther, on to the industrializing cities of the Scottish mainland, to Canada and New Zealand. Many of those who stayed lived a life close to starvation. You can still see the tiny, garden-scale plots of cultivated ground they somehow scraped from the rocks and peat they found there. Some of these cultivated plots are, quite literally, no bigger than the top of a kitchen table. They are life squeezed from bone. Removed from the fertile soils that had always sustained their ancestors, the men were driven to sea, to the fishing, which before the nineteenth century few of them had practiced. And there, in one sad story after another, many of the young men drowned. Sit down for a cup of tea in any one of the houses, and it isn't long before you begin to hear what that life was like, a memory still potent in the Harris islanders of today.

For this reason, Harris remains the most poignant of landscapes, a landscape at heart of cruelty and deprivation. Over on the sandy side,

there is one place in particular that embodies the sense of loss and outrage: the graveyard at Luskentyre on the Atlantic shore. It would be difficult to think of a more beautiful place to be buried. It is raised just above the huge, pale expanse of a beach that fills the hollow between hills on either side, as calmly full as if cream had been poured into a bowl and settled there. Here the Atlantic rolls in week after week, month after month, in vast, American-scale combers. The wind blows the sand from the beach over the graveyard so that even in midsummer it seems to have a light dusting of snow. This is the old burying ground and here, even after the people were cleared across to the east side, they continued to bring the bodies of their relations to reclaim some of the good land in death. Long slow processions still follow the moorland road, across the acid peatlands, down to Luskentyre's oceanside beauty. The rollers curl in off the Atlantic. The fine machair grasses poke their tips above the blown sand. The stones of the most recent graves are big, black slabs, with the names of people from the villages and islands of the east side, Rhenigadale, Scalpay, Urgha, Tarbert, Geocrab, Flodabay, carved on them, but the most touching of all these memorials are the earliest, scattered around a low hummock to one side of the cemetery. They are poverty itself, a flake or two of pink-veined gneiss, picked from the surrounding moor, neither polished nor engraved, but markers of a kind, scarcely articulate but articulate for their inarticulateness. Nowadays a thicket of roses is encroaching on this oldest part of the Luskentyre burying ground and inside that thicket the wrens jump from one thorny stem to another, landing from time to time on the little stones that record the burying places of the forgotten dead.

Who could remain unmoved by these last journeys back to goodness? It is a testament to belonging, to a remembered past, to a living grievance at the cruelties done to the grandfathers and great-grandfathers of people alive today. But it is also a mark of continuity and a persistence, a communal decision to do things in the way they have been done and perhaps should be done, whatever life or history or the demands of the rich might throw at them. Each stone is a statement of courage.

One of the most remarkable qualities of David Yeadon's book is that he has discovered this other Harris that lies beyond and within the place

usually visited by tourists. He comes, quite explicitly, as an outsider, a
Yorkshireman who is also an American, who has wandered far and wide
in his life, and led many lives within it. And as he says, he is far from
being the first outsider to have come to Harris and to have written about
it. The stream of those author-travelers has been pretty well unbroken
since Dr. Johnson decided to make his journey to the islands and moun-
tains of Scotland, a part of the world he explicitly compared to "Suma-
tra or Borneo." Even in the twenty-first century, a Scottish judge
decided that to exile a repeat-offending criminal to Leverburgh on Har-
ris would probably be a "more effective punishment" than sending him
to jail on the mainland.

In outsiders' minds, in other words, Harris has always been and
remains a foreign world. And that foreignness has usually induced in
those traveler-authors a reaction of patronizing superiority. Harris has
been seen, first, as a natural paradise in which other human beings are a
slightly unwelcome excrescence, an interference to the traveler's undi-
luted commune with the wild. There is of course a deep irony here:
much of the emptiness in Harris and its twin island of Lewis, which the
nature traveler sees as the unadorned work of the Almighty, is in fact the
product of nineteenth-century landowners who didn't like the idea of
other human beings interfering with the view.

That first reaction slides over into the second: the men and women
of the Outer Hebrides have often been regarded as if they were wild ani-
mals themselves, with their charming, simple ways, their closeness to the
soil, their dreamy visions of Celtic twilight and Celtic "otherness," all
buried under an assumption that somehow they spend their lives with
the fairies. And then there is the guilty and suddenly ferocious reaction
to that: the Hebrides are too good for the people who live there. Com-
pared with the perfections of nature, what are they but degenerate man?

This muddled mixture of admiration and contempt has been the
tone of writing about the Hebrides since visitors first started to come
there in the eighteenth century. Of course, this set of reactions and inter-
pretations have usually been more to do with the author-travelers them-
selves than with anything they actually encounter. David Yeadon's careful
attention to the details of people's lives, his natural warmth, his ability to

combine a sharply tuned eye with a tolerant and sympathetic heart, has allowed his book to stand well outside this often-repeated pattern. The flickering wit of the Hebridean frame of mind; the customary fluency and expertise in the English language that are the natural products of highly literate culture, and one whose religious practices are based firmly on the word; the deep attachment to the place itself, combined with a withering realism about its opportunities and drawbacks; a distrust of the inflated, combined with a willingness to drift off on the most romantically inflated of ideas; a warmth of welcome, which is both courteous and well-honed from being in constant use; a rage against the sort of landowners and incomers who do not bother to understand the workings of the community; combined with a readiness to go the extra mile, or five, for anyone in trouble or need: these are real human qualities in Harris, and all of them are displayed and celebrated in this book.

It is, in many ways, a depiction of life on the edge: of Europe, of the Atlantic world, of economic viability, of cultural inheritance, and of the powerful English-speaking culture province, to which Gaelic is still usually seen as a strange northern anomaly. But David Yeadon's achievement here is to show this world not as something marginal, nor as teetering on the edge of something stronger and better, but as a place central to its own existence, by definition idiosyncratic, pursuing its own way of doing things, perhaps a little quirky in its habits, not at first entirely easy to understand, but undeniably and richly itself. These are qualities becoming rare in a modern world which consistently erodes the individuality of place. Gertrude Stein's famous remark about the tedium of Oakland, California—"There is no *there* there"—can be applied to increasingly wide swathes of the world we know. Harris is different. It is, above all, a *there*, it is full of *there*. It is, in fact, a place which many of us think is one of the most wonderful *theres* there is.

SEASONS ON HARRIS

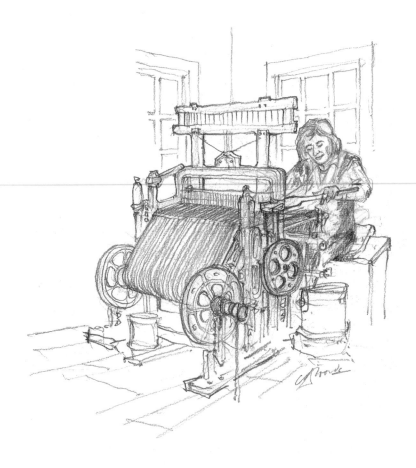

Cottage Weaver at a Hattersley Loom

PROLOGUE

Dreaming of Tweed

———————

*T*HAT DREAM CAME AGAIN. As it has done now on many occasions since my first visit to Harris a number of years ago. It's one of those floating/flying dreams I'm told possess significant—if ambiguous—interpretations. Assuming of course that you believe in such things. Which I usually don't. Much.

It goes something like this: I'm way up in the northern highlands of Scotland releasing myself like a bird from the jagged storm-gashed fangs of the Cuillin Hills on the astoundingly beautiful, legend-rich Isle of Skye. I'm floating dreamily, among high cirrus feathers toward the Outer Hebrides . . . that wild and fragmented 130-mile-long string of islands, thirty or so westward miles from the mainland—way out in the Atlantic.

Below me—far, far below—I can see the lines of whitecaps frothing across a treacherous current-laced channel known as The Minch. Here, so folktales tell, is the haunt of the dreaded Blue Men who plague unfortunate sailors in storm-racked gales, often sweeping them down to the deep, dark depths when they fail to answer complex riddles and rhymes while frantically trying to keep their frail crafts afloat. Mainlanders and incomers often smirk at such tales. The island fishermen do not.

And then, slowly through a blue sea haze, an island emerges—a looming surge of mountains to the north, broken black gneiss summits and the oldest known rocks on Earth, once Everest-sized, so they say, but now worn to somnolent stumps, wrapped in cloud tatters. Aloof and proud.

This is the island of Harris.

With just the slightest birdlike tilt, I ease my floating body down and sweep lower over a small harbor town, nestled cozily in a rocky cleft. The barren, treeless moors sweep back inland, great swathes of olive-green, bronze, and gold marsh-grass tussocks, and deep purple carpets of heather pocked with tiny acidic peat-water lakes, or lochans, frilled by explosions of golden gorse and broom. Torn and cracked strata burst through the sodden dankness of ancient peat beds, striated with close-cut lines where chocolate-soft slices have been cut in their millions by generations of island crofters for precious winter fuel.

I'm floating now over the domed heart of this strange island, clouds ponderously billowing over the long ocean horizon, and down the green sweep of sheep-sprinkled, wildflower-adorned *machair* meadowlands (a rich mix of blown sand and peaty earth) to the soaring dunes of the Atlantic coast. And then suddenly—in a masterwork of topographical trickery—appear mile after glorious mile of slow-arcing, blond-gold beaches sparkling against a Caribbean turquoise ocean with slappy wavelets easing up talcum-soft sands. Surely the last thing one expects to see in such a surly-burly landscape. And yet, here they lie, arc after golden arc, framed by bosky, grass-sheened dunes stretching southward as I move down closer to the ocean, skimming the wings of herring gulls and golden eagles, seeing my reflection flash and ripple in the slow tides.

And then comes a long, slow curl above scattered crofting homes and the weedy humps of far older dwellings with skeletal bones of stone walls, three or more feet thick—the bold remnants of island "black houses"—along with Bronze Age burial sites, and solitary standing stones whose origins are as mysterious and mythical as the place itself.

The broken, boulder-strewn spine of the island emerges again as I curl around its southern shore, but this time even more pugnacious and lunar in its lonely isolation. No more glorious beaches here—just tight rock-bound bays and tiny huddled homes set in clefts and cracks of shattered gneiss.

At first all is silence. Then comes a sound—a distant clicking, clacking sound that, as I float lower, becomes a patterned clickety-clack, clickety-clack, clickety-clack. And I swoop in a shallow loop to the source of

the sound—in a small tin lean-to shack at the end of a croft home. And, gently, my feet touch the soft grass by the shack and I stroll slowly to a rain-stained window and peer inside . . .

And there at a rust-crusted cast-iron loom sits an elderly man, perched on an angled wooden bench, his feet rhythmically pedaling the old noisy contraption. One hand guides the weaving shuttle across the hundreds of tight warp threads; the other strokes and caresses the finely patterned cloth slowly emerging on the spool, weft by tight weft. The colors of the cloth, woven in an intricate herringbone pattern, are the colors of this wild and enigmatic land—all those bronzes, burnt golds, ochres, olive greens, and deep purples of the peat moors. And I see his hands, rock-rough and thickly veined, gene-linked to generations of crofter-weavers—these weavers of the *Clo Mor*, the Great Cloth, for which this strange little island is known across the whole world. The tweed—that tough, instantly recognizable tweed of Harris. The "Cloth of Kings" is familiar to us all for its "peat-reek," its "tickle," and its enduring character. And the man's huge hand strokes his cloth with the familiarity of an old friend and his rheumy eyes twinkle and he is proud.

And I am here now with him, as the sound of the loom ceases. He sighs a long sigh and I watch his hands slowly pulling a worn oilcloth over the unfinished woven tweed, tight on its spool.

The old man stands, a little unsteadily, reaches out to a small lopsided table near the loom and picks up a local newspaper, with a prominently dramatic headline that reads:

THE END OF AN ISLAND—IS HARRIS TWEED DOOMED?

As I said, I have been here before.

Anne, my wife and best friend for over thirty years, was with me that first time and it was her enthusiasm to return for a far more extended period of residence and exploration that encouraged me to undertake this intriguing odyssey. Which surely must be the fantasy of many of us—to live simply on a remote island among warmhearted people, sampling strange and wonderful foods, and sipping, in this instance, the glo-

rious malt whiskies so beloved by the Highlanders, and the world in general for that matter.

Despite the island's long, hard history, its social deprivations, cruel fortunes, and fickle future, Harris still possesses a deep spirit of fortitude and fun that is enticing, moving, and zanily entertaining.

Let me share with you some of those earlier images and experiences. Much has changed of course, and is still changing, since that time and the future of the once great hand-woven Harris Tweed cottage industry is but one crisis being faced today by the islanders—the hardy Gaelic-speaking *Hearaich*. But not all is yet lost. In fact there is a resolute spirit here still determined to hold on to the mutual values and shared lifeways that have made the island and the islanders so unique. And, as we shall see, even the tweed itself, and the social fabric woven through so many island traditions, may well yet experience a vital revival. A fine and stirring story may still emerge here—one of those human, uplifting, rags-to-riches, determination-will-out, transformational miracles.

But all this will come much later in our tales, these woven threads of plight and possibility revealed in the spirit of the islanders and their stories and lives. For the moment let's visit the Harris Anne and I first discovered together many years ago. The Harris I wrote about then that has lured us back once again.

There's a Hebridean Gaelic saying: "When God made time, he made plenty of it," and here, on the desolate summit of Clisham, at 2,620 feet the highest point on Harris, you sense the infinitely slow passage of time. This is a fine place to know the insignificance of man and wonder if this is how the Earth may have looked at the very beginning.

The Gaelic name for this island is Na Hearadh—a derivation of the Norse words for "high land" bestowed upon this place by eighth-century Viking invaders. And it is a primeval scene here—no signs of habitation anywhere, no welcoming curls of smoke, no walls, no trees, no dainty patches of moorland flora here among the eroded stumps of archaean gneiss, breaking through the peat like old bones on an almost fleshless torso. On the wild moors of the Outer Hebrides island of Harris, I sheltered in a hollow from a sudden storm where, as they say here, "the rain

comes down horizontally" with "drops as big as bull's balls." I was crouched among the glowering bulk of the Earth's oldest mountains, formed more than 3 billion years ago, gouged and rounded in numerous ice ages, and sturdy enough to withstand many more.

And then—an abrupt soft-focus, almost sensual transformation. The storm passes on, trailing its tentacles of gray cloud like a blown tornado, whirling out over the Sound of Shiant, heading for the dagger-tipped peaks of the black Cuillins on the Isle of Skye, etched across the eastern horizon. The mist and cloud, thick and clammy as hand-knitted Scottish socks, lifts; the air is suddenly sparkling, the sun warm, and far below is a scene that would seduce the most ardent admirer of tropical isles: great arcs of creamy shell-sand beaches, fringed by high dunes, and a turquoise-green ocean gently deepening to dark blue, lazily lapping on a shoreline unmarked by footprints for mile after mile on the great empty beaches of Luskentyre, Seilibost, and Scarista.

"Aye—Harris—it's a magic place you're going to," said Hector Macleod at the Ceilidh Place pub in Ullapool, a bustling port town of tiny whitewashed cottages overlooking Loch Broom on Scotland's west coast. Hector was the elderly barman here, an enthusiastic and knowledgeable informant. "Less than three thousand people livin' on an island but some of the kindest you'll ever meet—not pushy mind . . ." He paused and then winked. "Well—they've a bit of the magic too. They're Gaelic and Celtic—so what can y'expect—they've all got the touch of magic in 'em!"

For years I've been promising myself a journey to these mysterious islands where the Scottish crofting families still weave the famous tweed in their own homes. "There's over two hundred different islands out there in the Outer Hebrides—Vikings called 'em *Havbredey*—'the islands at the edge of the Earth.' In Gaelic it's *Na h-Eileanan an Lar*," Hector continued. "And there was a time—not so very long ago too—when every one had its crofters and its own kirks. But then—well—a' might as well gi' ye a wee bit of our history. It's all bad stuff—right from the Romans invadin' in 82 AD. They tried to conquer the Pict tribes up here but couldn't and so they built Hadrian's Wall to keep 'em out of England. Then there were the Dalriad Irish—called themselves Scotti—

chargin' in around 500 AD. And then the Vikings—the Norsemen—plunderin' their way down the islands in the eighth century. And there were battles and backstabbings galore—most famous was King Malcolm's murder of Macbeth—y'know, Shakespeare's 'Scottish play.'"

"Yeah," I said. "I remember that play well. We had to memorize great chunks of the soliloquies in high school."

Hector laughed with a whisky burr, revealing enormous teeth that would have made a carthorse proud. "Aye, it was a bit bloody in those days. But in 1266 Scotland started to get things together. That's the time when all our big heroes—William Wallace, 'Black' Douglas, and Robert the Bruce—kept the English out. We hated 'em so much we even joined up with the French—the 'Auld Alliance' in the late 1400s—and got the Stuart royalty in. Y'remember Mary Stuart, Queen of Scots—the Catholic. She came over to rule in 1561 but she got into real trouble with the Presbyterian founder, John Knox, and the big lords up here and so she rushed off to England to ask her sister, Queen Elizabeth the First, for help. Not a good idea that! All she got was twenty years in jail and her head lopped off in 1587! Her son, James I, calmed things down for a while . . . by the way, are y'gettin' all this? It's a wee bit complicated!"

"Yes, Hector, I think I'm following. But it's a long time since my school history lessons—in England!"

"Aye, well, y'see—up here our history's still alive an' we don't forget so easy—especially when your English Parliament tried to get rid of all our Stuarts. Then it became a real mess and a' suppose y'could blame a lot o' it on young Bonnie Prince Charlie and his Catholic-Jacobite rebellion in 1745. Now tha's a date no Scotsman will ever forget when Charles Edward came over from France and raised a big army in the Highlands and islands to return the crown to his exiled Stuart family. It's a long, long story—there's a thousand books bin written 'bout it all . . ."

Hector paused to refill a couple of beer glasses and then continued. "But it began right enough with Charlie battlin' his way down into England—as far as Derby can y'believe! But then it all went bad and he had a terrible defeat. Battle of Culloden in 1746. Near Inverness. An' remember that name—y'll be hearin' it over and over. Charlie

escaped—y'know that story of Flora MacDonald helpin' him and that song, the Skye Boat song—an' I'm not gonna sing it t'ye but it goes—'Sail bonnie boat, like a boat on the wing, over the sea to Skye.'"

"Yeah—I know the one. It's a shame you won't sing it, though!"

Hector gave a wheezy chuckle. "Y' would'na think that if I did! Anyway, after that the English came up and tore Scotland apart. The Duke of Cumberland—'the Butcher' they called him—wiped out the whole clan system, burnt down towns and villages and made the Highlands a wasteland. Oh aye it was a bad, bad time all right—and so t'was for the next hundred years an' more. Too many people trying to live on tiny bits of poor land—all outcasts of the great lairdic feasts—then all those terrible famines—the potato famines—the collapse o' the island kelp industry—they burnt seaweed y'know to produce alkali in Napoleon's time. Valuable stuff then. And all these great 'clearances' in the 1800s when the big feudal-system lairds got together an' kicked s'many people off the land—burnt their cottages down, even smashed their precious quernstones they used for grinding their grain—and bundled them off to Canada and Australia and suchlike places—and moved the sheep in. Now I think there are only ten islands—maybe less—with any people at all. Croftin's a hard life. Always has been—but now it's dyin'."

I thanked Hector for his succinct—if depressing—summary of Scottish history and ordered drinks for both of us.

"Well—cheers t' you for that," he said, and began again. "But you know, in spite of it all, life goes on. Y'remember that old sayin': 'The happiest people are those with the fewest needs.' An' for a long while there it was best t'keep y'needs simple! But things are changin'—we've even got oil up here now—lots of that lovely North Sea stuff—and our own parliament too. Some think it's not powerful enough, though. Our famous Scottish comedian—Billy Connolly—calls it 'a wee pretendy parliament'! But the poor islands hav'na done so well. Sometimes you wonder how much bad luck th' can take. A' mean look at what happened jus' recent—'specially that Chernobyl thing—y'know the nuclear power station mess in Russia. They had to destroy the sheep on Harris 'cause of fallout. And that BCCI bank that went bust and took all the

Western Isles money with it—twenty odd million pounds. Every penny they had. And then the herring—that's pretty much finished with all those Spanish an' Japanese an' English trawlers overfishin'—an' the salmon farms, they're having problems with fallin' prices an', would y'believe—even the tweed itself—the great cloth of Harris and Lewis— that seems t'be dying out now too . . ."

A frisky three-hour ferry ride from Ullapool brought me—a little shaken by the turbulent journey and Hector's dour revelations—to Stornoway, capital of the 130-mile-long Outer Hebrides chain. This small town of 8,600 people is the hub of activity on the main island of Lewis, and the epitome of all the best and worst of island life. Fine churches, big Victorian houses, lively industries, new hotels, even a mock castle and a colorful fishing fleet mingle with bars, pool rooms, fish and chip shops, and, according to one local church newspaper, "palaces of illicit pleasures whose value to the community is highly questionable"— referring to the town's two rather modest discos.

Stornoway was obviously a place deserving leisurely investigation, but my mind was set first on island exploration as I drove off across the bleak, hairy humpiness of the moors and peat bogs looking for the tweed makers in the heart of Harris. Then—on a whim—I paused for a while to climb Clisham, and that's how I got stuck in the storm.

But as the weather cleared, I came down slowly from the wind-blasted tops and could see, far below, the thin crofting strips on the fertile *machair* land, fringing the coastal cliffs.

They say the milk of cows grazed on the *machair* in the spring and summer is scented by the abundance of its wildflowers—primroses, sea spurrey, campion, milkwort, seapink, sorrel, and centaury. Each strip, usually no more than six acres in all, had its own steep-gabled crofter's cottage set close to the narrow road, which wound around the boulders and burns. Behind each of the cottages lurked the sturdy remnants of older homes, the notorious "black houses," or *tigh dubh*. Some were mere walls of crudely shaped bedrock, four feet thick in places; others were still intact as if the family had only recently moved out. They were roofed in thick thatch made from barley stalks or marram grass, held in

place by a grid of ropes, weighted down with large rocks. Windows were tiny, set deep in the walls, and door openings were supported by lintel stones over two feet thick. Nearby were dark brown piles of peats, the *cruachs,* enough to heat a house for a whole year.

Looking at these black houses, which until recently formed the communal living space for families and their livestock, you feel pulled back in time to the prehistoric origins of island life, long before the invasions of the Norsemen from Scandinavia, long before the emergence of the Celtic clans of the MacAulays, MacRaes, and the ever-dominant MacLeods. All around the islands are remnants of ancient cultures in the form of brochs (lookout towers), Bronze Age burial mounds, stone circles and the famous standing stones of Callanish on Lewis, thought to have been a key ceremonial center for island tribes well before 2000 BC. The ponderous *tigh dubh* houses seem very much of this heritage and I experienced a strange sense of coming home again to something half remembered, deep deep down, far below the fripperies and facades of everyday "modern" life. Something that sent shivers to my toes.

Lord Seaforth, one of the islands' numerous wealthy "utopian benefactors" during the last couple of centuries, was anxious to improve "the miserable conditions under which these poor scraps of humanity live" and ordered that "at the very least a chimney should be present and a partition erected between man and beast in these dark hovels." But apparently many of the crofters were quite content to share their living space with their own livestock. And they were also content to allow the smoke to find its own way through the thatch from the open hearthstone fire in the center of the earthen floor. Once every few years, when the thatch was replaced, they would use peat soot–encrusted stalks, along with seaweed gathered from the shores, as fertilizer for their tiny mounded strips of "lazybed" vegetable and grain plots *(feannagan).*

But despite such conditions, the crofters were known for their longevity and prolific families. Dr. Samuel Johnson, accompanied on an island tour by the ever-faithful Boswell in 1773, put it down to island breakfasts. "If an epicure could remove himself by a wish," Dr. Johnson remarked, "he would surely breakfast in Scotland." I concur wholeheart-

edly. My first real Scottish breakfast came at the Scarista House Hotel overlooking the Sound of Taransay on Harris and included such traditional delights as fresh oatmeal porridge, smoked herring kippers, peat-smoked bacon, black pudding, white pudding, just-picked mushrooms and tomatoes, free-range eggs, oatcakes, bannock cakes, scones, honey, crowdie (a delicious rich cream cheese), cream, home-churned butter—everything, in fact, except the once-customary tumbler of island whisky, "to kindle the fire for the day."

"Oh, the breakfasts are still ver' fine," agreed Mary MacDonald, postmistress of Scarista village, when I later sat by her blazing peat fire drinking tea and nibbling her homemade buttery shortbread. "The world's getting smaller everywhere," she told me, her eyes sparkly, dreamy. "Things are changin' here too—we talk in Gaelic about *'an saoghal a dh'fhalbh'*—'the world we have lost'—but y'can always find a good breakfast! I'm even partial to a wee bit of warmed-up haggis myself sometimes. Very spicy." (I hadn't yet sampled this famous Scottish delight, partially because the idea of eating anything cooked in a pig's bladder seemed odd to the point of off-putting—and also because of an English comedian's description of the thing as resembling "a little castrated bagpipe"!)

I wondered about the changes she mentioned, hoping she might be a little more optimistic than Hector in Ullapool.

"Well, we're losing a lot of the young ones, that's always a big problem. But those that stay still work at the crofting and keep up the Gaelic." She paused. "I miss the old *ceilidhs* most, I think, when we used to gather at a neighbor's house to talk about local things and listen to the old tales by the *seannaicheadh*—an elder village storyteller. Now they're a bit more organized—more of a show at the pubs with poems and songs and such. Not quite the same."

I asked about the famous Harris Tweed makers of the islands. "Oh, you'll find plenty of them—more than four hundred still, I think—making it the old way in their own homes on the Hattersley looms. You can usually hear the shuttles clacking way back up the road."

Mary was right. I went looking for Marion Campbell, one of Harris's most renowned weavers, who lived in the tiny village of Plocrapool (not the easiest place to find, as all the signposts are in Gaelic!) on the

wild eastern side of the island, where the moors end dramatically in torn cliffs and little ragged coves. And I heard the urgent clatter of her loom echoing against the bare rocks long before I found her house, nestled in a hollow overlooking an islet-dotted bay. Through a dusty window of the weaving shed I saw an elderly woman with white hair working at an enormous wooden contraption.

"Aye, come in now and mind the bucket."

The bucket was on the earth floor crammed in between a full-size fishing dinghy, lobster pots, a black iron cauldron, cans of paint, and a pile of old clothes over the prow of the boat, just by a crackling peat fire that gave off a wonderful "peat-reek" aroma.

"You can always tell a real Harris Tweed," Marion told me. "There's always a bit of the peat-reek about it."

She was a small woman, sinewy and intense, and she worked her loom at an alarming pace. The shed shook as she whipped the shuttle backward and forward between the warp yarns with bobbins of blue weft. I watched the blue-green tweed cloth, precisely thirty-one inches wide, with "good straight edges and a tight weave," grow visibly in length as her feet danced across the pedals of the loom and her left hand "beat up" the weft yarns, compacting them with her thick wooden weaver's beam. Then her sharp eyes, always watching, spotted a broken warp yarn. "Och! I've been doing this for fifty-nine years and I still get broken ones!" She laughed and bounced off her bench, which was nothing more than a plank of wood wrapped in a bit of tartan cloth, to fix the errant thread. "And mind that other bucket."

I looked down and saw it brimming with bits of vegetation, the color of dead skin and about as attractive. "That's *crotal*. Lichen— scraped from the rocks. For my dyes." In the days before chemical dyes most spinners and weavers made their own from moorland plants and flowers—heather, bracken, irises, ragwort, marigolds—whatever was available.

"I'm one of the last ones doing it now," Marion told me. "By law all Harris Tweed has to be handwoven in the weaver's own home on the islands here from Scottish virgin wool, but I'm doing it the really old way—dyeing my own fleeces, carding, making my own yarn, spinning,

weaving—I even do my own 'waulking' to clean the tweed and shrink it a bit. That takes a lot of stamping about in Wellington boots!"

I pointed to a pile of tan-colored fleece and asked if it had been dyed with the lichen. Marion giggled. "Ooooh—no, no, that's the peat—the peat soot. Makes a lovely shade." I suppose I looked skeptical. "Wet your finger," she told me, so I did and she plunged it into a pot of soot by the boat. "Now rub it off." I obeyed again and—surprise—a yellow finger! Her laughing made the shed shake. "Aye, you'll be stuck with that now for a while." Eight days actually.

Later I sat by her house overlooking the Sound of Shiant as Marion spun new yarn for her bobbins. On an average day she weaves a good twenty yards of tweed. "I do all the main patterns—herringbone, bird's-eye, houndstooth, two-by-two. I like the herringbone. It always looks very smart."

On the hillside above the house I could see a crofter walking among his new lambs in the heather: out in the sound another crofter was hauling his lobster pots, or creels, as they call them here.

"You're a bit of everything as a crofter," Marion told me as her spinning wheel hummed. "You're a shepherd, a fisherman, a gardener, you collect your seaweed for fertilizer on your 'lazybed' vegetable plot, you weave, build your walls, cut and dry your peats, shear your sheep at the fank-pens, cut hay, dig ditches—a bit of everything. In the past you'd leave the croft and go to your 'shieling' shack in the summer to graze the cows and each night or each week—depending on the distance—the girls would carry the milk back to make butter cheese, and crowdie. Och—I remember that so well. Lovely times they were . . ." Then Marion's face changed and a flurry of frowns chased across her forehead: "But of course, y'had the potato famines and the clearances—terrible times—and then the crofters started fightin' back against the lairds in the late 1800s—och, well, then y'had the rebellions and the land raids especially at Pairc up in Lewis—not good times at all."

On Harris you use—and you often fight for—what's at hand. In the last century there were well-intentioned but often eccentric schemes to "improve" this lonely island suffering from signs of terminal decline. One German inventor, Gerhard Zucher, failed gloriously with an epic

explosion in July 1934, to promote "mail by rocket" as a way of speeding up the delivery of goods between the islands. The soap industry magnate, Lord Leverhulme, who purchased Lewis and Harris in the early 1900s, tried to establish a major port at Leverburgh (it flopped), to make sausages for African nations from surplus whale meat (ditto), and even built an elaborate mill to increase the efficiency of the tweed industry (likewise ditto). Lady Dunmore, whose family built the grandiose baronial Amhuinnsuidhe Castle here in 1868, was more successful in her efforts to enhance the tweed industry by organizing the cottage-based system.

The main town of Tarbert (An Tairbeart in Gaelic) was founded as a small fishing village in 1779. With a population today of around five hundred, huddled mainly in cottages on the hillside above a small quay and ferry dock, it's hardly anyone's idea of a Hebridean hot spot, although its cluster of small stores (refreshingly free of homogenized English brand-name outlets), pubs, restaurants, and churches provide an evocative community spirit. At the southern tip of the island, Rodel (Roghadal) possesses a sturdy sixteenth-century church with ornately carved tombs of the MacLeod chieftains, and there are a couple of notable guesthouses on the island offering fine and authentic regional cuisine. You might also catch glimpses of red deer, otters, seals, golden eagles, and even the occasional dolphin off the Bays. But none of these are the true appeal of this place.

So what is the lure?

Try silence, wilderness, solitude, dramatic soul-nurturing scenery, and a sense of coming home to something bold, basic, and honest—things that endure warmly in your memory.

And I remember so many moments on these islands—some sad, all revealing—seeing to the heart and core of things. I remember the shepherd, Alistair Gillies, recently returned after years of adventure in the merchant navy, only to lose a third of his ewes in this year's long, cold winter and spring. "You can't win in a place like this," he told me with Gaelic melancholy. "All you can do is pass y'r time here. Just pass time as best you can."

And I remember young Andrew and Alison Johnson's honest island

cuisine at their Scarista House hotel, where you dine on Harris crayfish, lobster, venison, salmon, or grouse (whatever is fresh that day) as the sun goes down in a blaze of scarlet and gold over the white sands of Taransay Sound. And then the two brawny Johnnys—the brothers MacLeod—on "the first good day at the peats in nine months" slicing the soft choco-laty peat with their irons into even-sized squares for drying. I talked with them at dusk as they moved rhythmically together along their fam-ily peat bank (their piece of "skinned earth"). "Another eight days like this should see enough for the year," the elder Johnny remarked, still slicing. The younger Johnny nodded, foxily eyed the whisky bottle half hidden in a nearby sack, and reached out surreptitiously with a thick-veined, peat-stained hand. "Not jus' yet," said the first Johnny. The sec-ond Johnny grunted and lifted his fifteen hundredth peat of the day.

I remember the Sunday silences too when no buses ran and every-one was "at the stones" (at church); I remember Catherine MacDonald knitting her highly praised woolen cardigans and jumpers from hand-dyed island wool; the stooping winkle-pickers of Leverburgh whose sacks of tiny shellfish leave the island by ferry for the tables of famous Paris restaurants; the first taste of fresh-boiled island langoustines; ninety-three-year-old Donald MacLeod carving sheep horns into ele-gant handles for shepherd's crooks; the sight of a single palm tree against the enormous lunar wilderness of Harris (the offshore Gulf Stream keeps the climate mild here). Then I remember Derick Murray at his tweed mill in Stornoway eyeing with pride the tweeds collected from the homes of his crofter-weavers; the strange conversations in "ganglish"— an odd mix of Gaelic and English; the lovely lilting names of tiny islets in the Sound of Harris—Sursay, Coppay, Tahay, Ensay, Pabbay; the huge Blackface rams with their triple-curl horns on the beautiful *machair* land of the Scarista golf course—an unexpected nine-hole gem of close-cropped grass and natural sand traps snuggled in the bosky dunes by the ocean and those pristine white beaches; the gritty and occasion-ally grim Calvinistic Protestantism of Lewis compared with the Catholic-Celtic levity of the Uist and Barra islanders in the southern part of the Hebridean chain.

Most of all I remember the Hebridean light—sparkling off the roil-

ing surf in the turquoise bays, crisping the edges of the ancient standing stones of Callanish on a lonely plateau overlooking Loch Roag, making all the colors vibrant with its intensity and luminosity—making the place just the way I knew it would be . . .

Pure magic.

NOW ALL THAT, ALL THOSE LONG-REMEMBERED experiences, speak of an era when crofting and fishing, while diminished, still provided a viable way of life here, and tweed weaving was a vital part of both the island economy and its proud heritage.

Today, as Anne and I quickly learned, things are rather different. Harris hangs ever more precariously on the cusp of a dying culture. Despite the islanders' determination to keep their Gaelic heritage and traditions, the strict Calvinistic underpinnings of their faith and their tiny shards of rock-rough land, their predicament is perilous. True crofting has virtually vanished now, the once teeming shoals of herring have long gone, and fishing is limited mainly to shellfish, occasional runs of cod and ling, and salmon farming. Added threats to the old ways encompass the increasingly rapid and usually lifelong out-migration of the younger generation to the job-rich mainland cities of Edinburgh, Aberdeen, Glasgow, and Inverness: the burgeoning arrival of "incomers" (also derisively labeled "white settlers"), particularly from the affluent fleshpots of London and England's southern counties, which has driven up real estate prices here far beyond local affordability, and of course—most sadly of all—the slow, ongoing decline of that once great, handwoven tweed cottage industry.

Despite a plethora of investments, some more insightful than others, by the Western Isles Council in a wide range of community and commercial projects, and recent initiatives for the creation of a huge rock quarry (defeated) and vast wind turbine "farms" on the Lewis moors (pending), the supportive pillars of the once-unique Harris lifeways are still being eaten away by the voracious termites of twenty-first-century realities.

And yet . . . and yet . . .

God is still definitely in the details here. Some say the Devil, but I'll accept Mies van der Rohe's interpretation relating to fine architecture.

Because the architecture—the whole physical spirit of Harris—still manifests itself in its infinite microscopic details.

The main inhabited part of the "island" (actually a southern "almost-island" appendage of the far larger island of Lewis, sixty miles long and up to twenty-eight miles wide) lies south of the mountainous wall of North Harris and is barely twelve miles long by six miles wide. Even as islands go in Scotland, that's small. Very small—with fewer than two thousand inhabitants (Lewis is far larger, with around 17,500, and the Outer Hebridean chain as a whole claims a total of around 25,000 islanders). But when I try to define the fascination—the seduction—of this island, it is in its multitude of "places" and experiences, each one unique and entire in itself. From the tiny black lochans in the high moors, the vast creamy swathes of the west coast beaches, the chiseled intricacy of The Bays, and the wind-racked summits of Clisham and Bleaval, to the secret fishing lochs of Amhuinnsuidhe, the tight intimacy of Tarbert town, the proud isolation of Rodel and the southern islets, and the wild glens and corries of the North Harris hills—each place resounds with its own distinct individuality and presence. Each one says to me: I am unique, intact, and proudly distinct from all other places on the island. Even each hidden, peat-bound lochan—and there are hundreds of these tiny freshwater lochs—possesses its own special aura; some are high and broad on the cusp of the watershed between The Bays and the west coast beaches; others are so hidden by crags and shadows that you barely see them at all until you reach their boggy blackwater edges.

Harris is an island that never bores. And how can it? It would take half a lifetime to truly explore the wealth and variety of sensory and aesthetic experiences here. Whatever you discover on a long, hard hike is merely prelude to the next day's discoveries and the next and the next. Deeper and deeper. Mood upon mood. Detail upon detail.

If the creator does indeed express itself in such details, here it has done so with encyclopedic subtlety and scope. There is no end to Harris. Only new beginnings. Every single day you are here.

And despite all the charges since our first visit here, all is not quite lost, as will be revealed in these tales of "an island on the cusp" of major choices and changes. Out here, on "the edge of the world," not every-

one, despite the gloom-and-doom-sayers and local media, has given up on an authentic and optimistic future for Harris. Recent events, miraculous to some—particularly with regard to the great *Clo Mor* tweed industry here—suggest that new possibilities, new initiatives and synchronicities, may still revitalize the looms and lives of the weavers and restore balance and harmony to the future of this "little island that could."

And so tweed may yet be the key, once again, to island survival . . . and what a fine, uplifting, heartwarming story that would make . . .

Postscript on the Seasons in the Outer Hebrides

The weather here, however, is not exactly what you would call by any stretch of the imagination a "heartwarming story." But if you possess an agile sense of humor, the seasons here are indeed rather amusing. Without humor and a degree of stoical tolerance, they can be irritating to the point of mild apoplexy. Rarely during our year on Harris did we find the predictability of more pliant climes, shaped and formed by larger global influences, although admittedly, with all of today's complex cause-and-effect and often contradictory warming/cooling trends, predictability even on a global scale is becoming increasingly muddled and topsy-turvy.

The islands of the Outer Hebrides hold sway over their own climatic quirks. These are the first bastions of land that surging Atlantic air masses face head-on. Muscling in mostly from the west and south, they are abruptly confronted by such wall-like impediments as the mountains of Barra and the Uists, and—more dramatically—the great bulwark of Clisham and the North Harris monoliths. While all these upsurges tend to protect the Scottish mainland from climatic excesses, anything can happen in any season here, and invariably does. The only steady, mitigating element in this chaotic confusion is the North Atlantic Drift, or Gulf Stream, which at least, and with an admirable degree of constancy, soothes the more outrageous excesses of climatic exhibitionism. Thanks to its benign benevolence and despite our latitudinal location equivalent

to the middle of Canada's Hudson Bay or Russia's northern Siberian wastes, rarely did Anne and I experience significant winter snowfalls or ice storms on the lower portions of Harris. The mountain crests, of course, were often pristinely snowcapped during the winter months, but the passes usually remained open and ice-free. What our northern latitude did guarantee, however, were long, dark days through those chilly months when a weak, liquidy sun barely rises above the horizon for a few half-light hours and then slips away again around 4:00 p.m. These were the cocooning times when domestic "nesting" became the social norm and cozy peat fires were kept well stocked throughout the days and nights.

Spring invariably slips in slowly with feathery "mizzle" (mist and drizzle) and glorious double rainbows, as lambs appear on the *machair* and moors—bright white dots of new, frisky life among a slow greening of the land. Of course, one must expect the unexpected during this season—particularly in the form of near-hurricane force winds. As a friend told us, "It's impossible for those who have never lived here to recognize the impact of our winds on the lives and moods of the *Hearaich*." And the residents long for summer. But summer seems to take forever to arrive. Sometimes it never does, at least not in terms of tan-quality heat and sear. At other times, warm, blue days float sublimely through much of July and August. And the days certainly lengthen—that's a guaranteed, and very welcome, norm. We're not quite in the "land of the everlasting sun" here as we would be farther to the north in Norway or the remote Faeroe Islands. But it's certainly close, with dawn arriving around 5:00 a.m. and sunset (barely setting) around midnight. Energy returns too (despite the incessant dawn and evening flotillas of tiny blackfly-like "midges," of which more later). You feel refreshed, invigorated, and reluctant to accept the normal rhythms of rest and sleep. You stay up into the early hours, reading, listening to fine music, or the welcome certitude of the BBC World Service and occasional Gaelic radio (*Radio nan Gaidheal*) and TV (*Telebhisean Grampian*), richly strange in their mellifluous, musical language.

Then, as the year begins to slip away and the days start their darkening decline through autumn (to the accompaniment of the hormone-

crazed cries of mating red stags on the brittle-air moors) and back into the doomy-gloom, bruised-cloud days of winter, your body once again responds to climatic realities and sleep becomes longer and deeper. Of course, inevitably, in the thin winter sun—more like a watery gruel at times—colors fade in the land with only the heather and broom providing some solace against the dunning down of summer's spectral glories.

But, within these broad rhythms of seasonal shift come all those other amusing/frustrating (depending upon your demeanor) and zany idiosyncrasies of Hebridean weather—roaring rooftile-ripping, branch-snapping gales; sudden snowfalls and hailstorms in mid-May; torrential cumulonimbus downpours in the midst of summer beach barbecues; gloriously warm and blue days deep in the fall; and strange, stickily humid afternoons in the winter half-light. And once in a rare while, we might even enjoy one of those amazing displays of the Aurora Borealis, or northern lights.

That old cliché "If you don't like the weather, wait five minutes" is all too true here. In fact, there were many days when, if we perched ourselves high enough on a North Harris peak, we could watch a whole simultaneous panoply of climatic displays, from furious thunderstorms to blue Caribbean-calm and just about every variation of mood in between. Such bizarre occurrences are described perfectly in an old Gaelic proverb: *Latha na Seachd Sian—gaoth is uisge, cuir is cathadh, tarnanaich is dealanaich is clachan meallainn* (the typical day of Seven Storms—wind and rain, snowfall and blizzard, thunder, lightning, and hailstorms).

However, when the winds shift and air masses move in from the east, rather than the Atlantic west, a more consistently benign pattern of clear skies and fresh invigorating breezes often prevails—to the relief of all the *Hearaich* folk.

As Anne and I were both born and bred in Yorkshire, England, we were all too well aware of what we used to call "porridge" weather. Our dreaded forecast in Yorkshire was invariably the "dull and mild with scattered showers" type, as that would often become the daily norm for weeks on end. That pall of clammy gray cloud, hundreds of feet thick, would move in and just sit virtually motionless and seemingly forever,

blocking out the sun and turning otherwise perfectly normal neighbors into stooped, morose, and muddy-minded strangers.

In Harris, this was a relatively rare event due to rapid fickleness of climatic eccentricities, a fickleness that also makes Harris one of the windiest places in Europe. And while this can be a little traumatic for the populace in general—and hardy shepherds in particular out alone on the high, treeless moors—such rampant energy makes wind-power enthusiasts and "venture investors" salivate at the prospect of those proposed vast wind-turbine "farms" scattered across the bleakly flat moor and peat plateau of central Lewis. They see billions of dollars' profit in such wind (and ocean-tidal) harnessing and harvesting. The locals are not yet quite so starry-eyed by such prospects—but the potential infusion of "new money" into these economically beleaguered islands is a rather tempting proposition nevertheless.

"Anything that'll make things a bit easier out here would be a godsend," one crofter told us as he mentally calculated the bonus of "rental rights" on his otherwise unused land.

"Tip end of the wedge," grumbled one particularly outspoken "Green." "There'll be no birds or wildlife—or beauty—left!"

"When wind is just about all we've got nowadays out here," said one ex-member of the West Isles Council, in a particularly dour mood, "I say—use it! Today!"

"Listen—when global warming really hits," predicted one weather-conscious outsider, "they say we might even lose the Gulf Stream—and the winds!"

Anne and I decided to celebrate the current climatic quirks of Harris and all its seasonal uncertainties and just enjoy each fickle day to the full.

THE FIRST SPRING

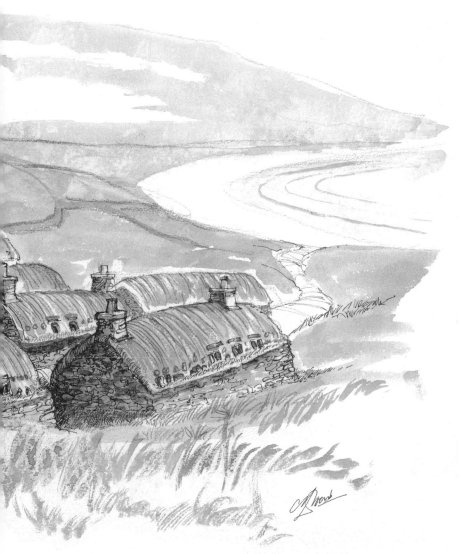

Gearrannan Blackhouse Village

1

Learning the Land

*F*IRST WE HAD TO FIND an island home. A good place to live.
I'm still not exactly sure what it was about Clisham Cot-
tage in the village of Ardhasaig on the west coast of Harris,
four miles or so north of Tarbert, that made us impulsively
pick up the phone in New York and call the MacAskill family, owners of
the place.

In front of us on my studio table we had this colorful brochure of
self-catering cottages on the island, each with a photograph and listing
of key features. The initial entry for Clisham Cottage read: "A superbly
appointed cottage in a beautiful coastal position overshadowed by dra-
matic mountains."

Appealing, of course, but so were the other fifty or so offering such
enticements as "Short drive from the cleanest beaches in Europe; a truly
secluded traditional Hebridean retreat; thatched black house–style cot-
tage in breathtaking scenery; a delightful water's edge escape . . ."

We couldn't even remember the village of Ardhasaig from our first
visit. Of course, "village" is more of a legal than aesthetic term here. On
the islands they tend to be rather straggly, croft-by-croft affairs with none
of the cozy cohesion of English equivalents.

Anyway, we called, lured by some indefinable enticement ghosting
behind the brief lines in the brochure.

"Hello, good afternoon. This is Dondy MacAskill speakin'. How may
I help ye, please?"

Lovely female voice. Mellow, young, musical, and with an enticing Scottish lilt that possessed the mellifluousness of a Robbie Burns poem coupled with the freshness of ocean breezes. Well—that's perhaps over-doing it a bit. But it was certainly a very friendly voice.

"Hello—did you say 'Dondy'?" I kind of mumbled. "I don't think I've heard that name before . . ."

There was a warm chuckle at the other end. "Well, now—it's really Donalda . . . but everyone calls me Dondy. So, how can I help ye?"

"Ah—Donalda . . . that's a new one for me too."

Anne was sitting beside me, giving me one of those "so what's hap-pening?" looks. She's much better focusing on the nub of things. I tend to get distracted by details. Left to my own devices, I'd possibly be prat-tling on for ages about the weather, or the latest world political scandals, or anything other than the original reason for the call.

"Yes?"

"Er . . . oh, I'm sorry. Listen, I was just calling about that cottage of yours—Clisham—and I wondered . . ."

With Anne prompting me by scribbling questions on the notepad by the phone, I finally managed to get a pretty comprehensive overview of what was on offer, cost, availability, and all those other vital details required for intelligent decision making.

Except I'd already made *my* decision. As soon as I heard Dondy's voice and name. Of course that's not quite the way I put it to Anne when I finally replaced the receiver. "Well," I began in a tone that I hoped sug-gested careful research and a rational approach to house selection, "I think generally it seems fine. There are three bedrooms . . ."

Anne watched me with that curiously bemused smile of hers that tells me she's way ahead of me and my ramblings.

"You like her, don't you?"

"Who?"

"This . . . person . . . on the other end of the phone."

"Donalda—well actually her name's Dondy—apparently that's what they call her. And . . . yes, well, she sounds nice . . . but that's not the point. She says the views there are fantastic—way across a loch and the Harris mountains . . . and . . ."

"And you've already decided you want it?"

"Why don't you let me finish? Dondy says her father owns a small shop right across the road and—"

"Sounds fine. Let's do it!"

"But darling, I still haven't finished—"

"It's okay," Anne said impatiently, "just book it!"

It's hopeless trying to deal with this kind of dialogue in a rational manner. My wife had already, as she invariably does, perceived the heart of the matter and made the only possible decision under the circumstances.

"Oh . . . okay. If you really think it'll be what you—"

Anne gave me that bemused smile again, along with a big hug, and went off to make a pot of tea.

And so Clisham Cottage was booked, sight unseen, but with all the intuitions intact. Well—my intuitions, at least. And all Anne's feminine intuitions about my intuitions . . . Ah, isn't marriage wonderful?

CLISHAM COTTAGE WAS PERFECT FOR US and our occasionally rather lazy dispositions. Anywhere else on the island we'd have to travel miles for staple groceries, newspapers, wine, or anything else necessary in the course of daily life. But here we had it all at the MacAskill store and gas station directly across the road, brimming with island delights as well as all those oh-so-British oddities: mushy peas, treacle sponges, Marmite and Bovril, HP Sauce, jars of Colman's delicious mint sauce for the Harris lamb we hoped to enjoy, a tempting array of British and Scottish cheeses, home-cured bacon, Branston pickle and pickled onions, kippers (smoked herring), and even tiny Christmas puddings slowly marinated in rum and brown sugar and ready to be served with golden custard and Devon clotted cream. Plus an array of all those seasonal game specialties too, such as local venison, grouse, partridge, salmon, and shellfish.

The cottage itself was perched on a bluff just below the road and contained three good-sized double bedrooms, two elegant bathrooms, and a large L-shaped living room/dining room/kitchen with a broad sweep of windows overlooking that vista we had hoped and prayed for

out across the Atlantic (with our own local salmon farm) and that dra-
matically wild wall of the North Harris hills. A brief glimpse of the land
immediately below the cottage suggested merely an overgrown slope
rolling down to the loch of ancient moors, marsh-dappled with spikey
tussocks and errant streams tumbling between outcrops of that ancient
bedrock. But as we looked closer we noticed rubble-strewn hummocks,
bulges, and indentations. And, as we walked the land we realized we were
treading on the remnants of old massive-walled black houses, overgrown
lazybeds once richly fertilized by kelp from the bay and meticulously cul-
tivated for grain, potato, and turnips, and the foundations of circular sheep
fanks—all the ancient accoutrements of the traditional crofting life here.

Immediately adjacent to the cottage was the MacAskill family home,
a large Victorian-style mansion well buffered from the strong Atlantic
winds by a dense cluster of trees. And, to add occasional gourmet
splurges to what we intended to be our simple island lifestyle, there was
the recently opened Ardhasaig House, the MacAskills' small six-room
hotel, a hundred yards or so down across the steep sheep pastures and
already the recipient of glowing gastronomic reviews in travel guides and
magazines.

Roddy MacAskill, the
seventy-one-year-old patri-
arch of the family, was a
small, stocky man with a
mischievous gleam in his
eye and a sly smile that
suggested someone who
had gained great satisfac-
tion from creating his
small empire of store, self-
catering cottages, hotel,
transport business, and rock
quarry back in the Harris
hills off the Stornoway
Road. He greeted Anne
and me with a warmth and

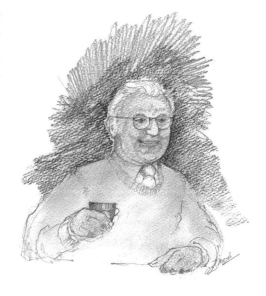

Roddy MacAskill

friendliness that we'd not expected quite so soon on an island renowned for its social reticence and occasional indifference (even antagonism) to "outsiders."

Within minutes of our arrival, we were sitting comfortably in his lounge with Joan, his wife of forty years, whose twinkling smile and warmth made us feel part of the family from the moment we entered. Of course her rapid production of a tea tray laden with her home-baked shortbread, bannock cakes, and cookies, and Roddy's insistence that "a wee dram" (how familiar that phrase became in the months ahead!) may go down well too, created a mood of benevolent bonhomie that became a permanent delight of our friendship.

The only problem on that occasion, for me at least, was the dram-drinking ritual. Had it been vodka or rum or sherry or brandy or just about any other libation of choice, everything would have been fine. But unfortunately—and inevitably—it was the time-honored tipple of *usquebaugh*—fine blended Scottish whisky—"or a wee fifteen-year-old malt, if y'd prefer . . . ," said Roddy, wafting a bottle of highly regarded Macallan in front of us.

Deep down somewhere I think I'd dreaded this moment. For reasons far too embarrassing and revealing to explain, Highland whisky was my psychological and physiological nemesis in the arena of alcoholic delights.

Well, I thought, I'm not going to spoil our first get-together with our hosts, so if I keep eating Joan's cookies, maybe they'll disguise the taste of this nefarious stuff and I'll bluff my way through without any social faux pas.

And strangely enough (with Anne, who was fully aware of my aversion, watching me nervously), it seemed to work. The stuff didn't taste as bad as I'd expected. In fact, all in all, it was rather an enticing experience.

"*Ceud mile failte*," toasted Roddy.

"And you too," we responded, having no idea what he'd just said.

"It's an old Gaelic greeting—'wishing you a hundred thousand welcomes.'"

"Ah well," Anne chuckled, "then it's definitely 'and to you too'!"

Roddy laughed. "Drink up! I've got a really special blend I'd like you to taste." Fortunately at that point in the proceedings the door opened

and in walked the rest of the family in the form of the MacAskills' three adult offspring: Katie, the cuddly, beaming-faced manager and chef-supreme at the hotel; David, the handsome, worldly-wise, off-island entrepreneur in the IT business, and—at last!—the lovely lady Dondy herself, whose mellifluous vocal lilt had lured us (me) to Clisham Cottage in the first place.

It was a most memorable evening, which—to our surprise and delight—included a splendid impromptu dinner prepared by Katie ("Well, actually," she modestly and blushingly admitted, "it's mainly left-overs from tonight's dinner for the guests . . .").

And of course it also became our first on-island indoctrination session into the ways of the *Hearaich*, the long, convoluted Harris history, and, most touching of all, the love that the multigenerational locals have for their beautiful wild island.

Roddy's pride in particular revealed itself in many ways, but most notably when he spoke the Gaelic version of what he called "our national anthem of sorts." ("I'll not be singin' this—it's na one o' my finer talents!")

The sounds of the words alone were moving in their intensity, and when he offered a rough translation—"Y'canna really translate Gaelic, y'lose too much o' the spirit"—we understood why:

I see the land where I was born
My land of heroes in my eyes
Tho 'tis hard and stony
I ne'er will turn my back upon it
From the ocean's waves
The most beautiful sight of all
The land where I was born

When he was finished, Roddy smiled a little sheepishly, cocked his head in a delightfully mischievous manner, looked away, and adjusted his tie (we realized much later during our residence here that Roddy was rarely without his tie, no matter how casual the occasion). At that moment I sensed that beneath his aw-shucks demeanor lay a family his-

tory, thick and deep as the Harris peat bogs: layer upon layer of clan loy-
alties and feuds, famines, crofter clearances, convoluted disputes over
land rights and religious principles—the birthright of so many of the
people here. He was Roddy, the generous, smiling man we were learn-
ing to like—but he was also a MacAskill, one of many generations, and
everyone who knew him also sensed this vast genealogical jigsaw puzzle
of Highland and island history and heritage.

As we were saying our farewells, Roddy chuckled: "Well—you
two've certainly chosen a fine place for your book. *House and Garden*
magazine just put the Outer Hebrides near the top of its 'Best Ten Island
Destinations in the World' list!"

We finally rolled into bed much, much later than we'd intended, and
together, propped on pillows, we watched a gloriously silver full moon
move slowly over the loch and the high black hills.

"This is just . . . perfect," murmured Anne sleepily with maybe just a
scintilla of a whisky slur. "We couldn't have wished for a better island
home . . . and family."

From what I remember, the following day was a DDD—a Decadently
Do-Nothing Day. Too many things had happened too quickly. We were
more tired—albeit pleasantly tired—than we realized. So we did what
we occasionally do in our odd little lives: we pick a day with nothing
much on the endless lists of things to do—and do nothing. Except watch
and wonder and mentally record the serendipitous ebbs and flows of
tiny events and happenings and . . . well, anything else we care to notice,
such as:

- the dawn mists moving wraithlike, snakelike, and low across the
 surface of the loch outside our living room window;
- the soft lemony flecks of new morning light touching the
 hugeness of the North Harris hills;
- that first shaft of real sunrise sun flooding across the lower flanks
 of Clisham and bathing the rock beaches far below our cottage
 in a liquid amber;
- the incessantly cheerful chuckle of the stream running down at

the side of the cottage, bouncing over boulders and swirling off under the spikey tussocks of marsh grass;

- the faintest shimmer of wavelets across the loch, suggesting a slow turning of the tide;

- a scurry of new spring lambs, hyperactive bundles of white fleece, nudging their reluctant mothers from sleep and demanding their milky nutrition from warm, dewy nipples;

- The first guttural shrieks of seagulls way down at the pier waiting for a fishing boat to come in or for the arrival of the salmon farmworkers to take the food sacks out to the fish pens in the middle of the loch;

- The scrabbling intensity of Joan's hungry hens scurrying about their enclosure, seeking early morning tidbits or a cozy place in the grass to lay their eggs of the day;

- The steady strengthening of the sunlight as it eases up the spectral range from pearly sheen to bronze to gold to lemon-silver, burning out the shadows and the mists and bathing the loch, the mountains, the bumpy stumps of old black houses, and the marshy-rocky pastures of the Ardhasaig peninsula—everything—in mellow morning warmth;

- The clouds!—so many shapes, so many moods, from tiny planktonlike "mackerel" flotillas, slow-moving stratus creatures like manta rays, and huge bubbled thunderheads to cumuli crisp-edged as breakfast bacon and cirrus like sheened flights of goose-quill pens.

You could write a whole book on just one day of such microdelights. Our long, slow DDD ended in another spectacular moon-glow night, with the faint lights of distant croft cottages on the far side of the loch flickering against a velvety black landscape. Our landscape now.

And while on the subject of books, Roddy was most enthusiastic about the idea of our *Seasons on . . .* opus. I was a little surprised by this because he had a library full of books on the Hebrides and I thought he'd possibly dismiss it as just one more diatribe by a neophyte outsider aimed primarily at the island's slowly increasing tourist trade.

"Y'know . . . y'may jus' gi' us somethin' a wee bit diff'rent . . . 'specially as y're livin' on-island for a while . . . and not jus' poppin' in an' off like so many o' the others. Journalistic types y'ken . . ."

"I hope so," I said. "That's certainly what I'll try to do. Somebody famous—I've forgotten who for the moment—once said that 'journalism is literature in a hurry.' And we're in no hurry here . . ."

"Well tha's good—and the first thing y'might want t'do is meet with our famous historian, Bill Lawson. He'll give y'a far better picture of the island than I can. I'll just gi' you the best jokes!"

Bill Lawson is intelligent, erudite, occasionally irascible, invariably outspoken, and always a man exhibiting the honesty and integrity of a truly professional researcher, particularly in the convoluted field of local genealogy.

And that was our opinion of him even before we'd met him.

Roddy had loaned us one of his many books, *Harris in History and Legend*, and we relished Bill's no-nonsense revelations of island traumas, inequities, and scandals.

According to Bill, the real trouble on Harris began when a Donald Stewart arrived as "factor" (a sort of estate manager) for the MacLeod clan, owners of Harris:

> Nothing would do for him . . . but that he would turn the whole of the *machair* [western] side of Harris into sheep-farms, and send the people away to Canada . . . In 1838 he evicted the last of the people from Seilibost. And not content with clearing the living, he had to clear the dead out as well, for he took over the graveyard that the Seilibost people had, and ploughed it up . . . But not all the crofters gave up without a fight and at one point Stewart even had to send for the army to enforce his edicts declaring: "A conspiracy for resisting the law existed in all this quarter of the West Highlands, which, if not at once checked, would lead to consequences no lover of order would care to think about . . ."

However, then Bill adds with a not-so-suppressed glee that the Hebridean clearance diaspora and the sheep-farming "revolution" failed,

and Stewart eventually lost, "for Seilibost was turned back into crofts again a hundred years later, after the First World War."

Bill also maintained a healthy skepticism about some of the "utopian benefactors" whose visionary exploits for island enhancement—aesthetic, social, and economic—often floundered on equally unsound and quixotic decision making. Lord Leverhulme, for example, owner of the vast Lever Brothers' "soap empire" (his island nickname was "The Wee Soapman"), purchased Lewis and Harris in the 1920s and tried to develop Lewis first. After failing there (primarily because of the crofters' love of their small patches of land and their reluctance to become "industrialized"), he came to Harris with his schemes for a vast fishing industry and port at a "new town" to be created around the village of Obbe, at the southern end of the island, which he, of course, renamed Leverburgh, after himself (a popular habit of benefactors in that Victorian era of rampant but often self-serving philanthropy). Unfortunately for the little lord, he apparently failed to notice that the waters off his new town were a labyrinthine chaos of rocks, shoals, and tidal islets that could quickly decimate the "majestic fleets" he envisaged harboring here.

Ironically, while the scheme floundered following the sudden death of Leverhulme, a far more realistic and modest kind of scheme many decades later for the Leverburgh *An Clachan* Cooperative survives and flourishes today. And while Bill is a little skeptical—"It was a mistake to expect a committee of amateurs, in the best sense of the word, to be able to run a wide range of businesses"—the place remains a welcome resource for locals and visitors alike, offering a well-stocked store, café, book and souvenir "loft," and an exhibition area featuring the intriguing Harris Tapestry—a series of large, colorful panels handcrafted by islanders and depicting key aspects of local history and folklore.

Bill's constant frustration with past and present schemes and dreams of island improvement is echoed by Roger Hutchinson in his recent book *The Soap Man*, which chronicles Leverhulme's activities here. He writes:

> The Highlands and Islands of Scotland have seen a greater variety of land owning thugs, philanthropists, oafs and autocrats than any compa-

rable region of the western world . . . Leverhulme's intention was to rev-
olutionize the lives and environment of Lewis' 30,000 people, together
with those of neighboring Harris . . . At the stroke of a pen he became
one of the largest private landowners in Europe with powers equivalent
to the viceroy of a small colony.

Bill writes about similar visionary high-mindedness and is particu-
larly outraged by all the controversy and confusion of the proposed (now
rejected) proposal for the Lingarabay Superquarry way down at the
southeastern tip of the island near Rodel.

> Lingreabhagh [Bill is fastidious in his use of Gaelic names] is best known
> today for the farce of the local public inquiry into the proposal. It took
> six years to reach a decision [in favor of the quarry and the local jobs it
> would create]. The government then decided to ignore the recommen-
> dation anyway. Somewhere in the process the local people were forgot-
> ten . . . and all that time the lifeblood of the community—its young
> people—drained away. The amount of money spent on the inquiry
> could have been spent on rejuvenating the economy of the south of
> Harris, but instead we have a worthless report, and nothing else to show
> for the whole sorry saga . . . And of course none of the jobs that were
> promised if the quarry was turned down have ever materialized. One
> would have thought that if the conservation bodies were so keen on
> preserving Harris they would have tried to create jobs here, and so they
> have—six part-time mink trappers!

This ongoing island project of a questionably boondoggle nature
reflects an attempt to eliminate a few mink that are said to be scurrying
around the island and possibly threatening the eggs of some of the nest-
ing birds. Results to date have been "rather ambiguous verging on total
failure," according to one of our more reliable island sources—"almost as
daft as the hedgehog hunt!" This second bizarre initiative is mainly a
project on the Uists, farther south down the Outer Hebridean chain, and
as such projects invariably do, it has set animal-loving St. Tiggywinkles and
other environmentalists, who want to trap and relocate these egg-eating

critters, against the more pragmatic "certain-death techniques of the Scottish Natural Heritage who to date claim over one hundred fifty kills."

One feels tempted to agree with Bill's outrage at such sorry sagas, particularly when the hedgehog-trapping environmentalists claim that the "ridiculous profligacy" of the Scottish Natural Heritage has so far amounted to an outrageous cull-cost ratio of over five hundred pounds (nine hundred dollars) per hedgehog!

Profligacy was indeed once again the hallmark of one of the earlier benefactors of Harris, the Earl of Dunmore, who decided that his aristocratic status was such that he needed a fine Scottish-style mansion overlooking Soay Sound on North Harris. And in 1867 the impressive Amhuinnsuidhe Castle (of which, more later) was built. In addition to satisfying the earl's overbearing ego, the structure was also intended to impress his son's highly placed fiancée. Alas, however, her rather cruel remark shortly after its completion that his extravagant creation, twenty times larger than the average crofter's black house at the time, was "not even so big as my father's hen hut," resulted in such frantic, free-spending efforts to expand the place that the earl virtually bankrupted himself and his family. And of course, as no "lady of position" would ever dream of marrying a penniless suitor, the engagement was dissolved and the castle quickly sold "at a calamitous loss."

"Roddy's right—we've got to meet this Bill Lawson," said Anne as she read his hilarious—and sad—tales of island history and life.

So, that's exactly what we did.

Throughout the warmer months, Bill and his wife, Chris, both enthusiastic naturalists, in addition to all their other interests, offer short walking tours for anyone who cares to join them. The meeting place is either at the William MacGillivray Center, a modest place of homage to one of Scotland's finest, if rather neglected, naturalists in Northton, or at the nearby notable Lawson creation, a modern white painted barnlike structure opened in July 2000, adjoining their home in the old schoolhouse here, which not only offers an intriguing exhibition of local and natural history but also houses Bill's Genealogy Research Center, an extensive and meticulously prepared repository of island genealogical data known as *Co Leis Thu?* (Who Do You Belong To?).

Here in scores of black binders are thousands of family-tree charts mostly prepared by Bill in his tiny neat handwriting (a remarkable feat for a man with such unusually large hands).

"It's so intriguing," said Bill. "We have all these people coming here, often from thousands of miles away and looking for links to their ancestors on the island. You feel as though you've given them a new perspective on who they really are . . . an anchor for their lives. Real, almost tangible roots . . . and then it all happens again when we go off to the USA and Canada—usually a couple of times a year—and visit places where the clearance immigrants built a new life for themselves in the mid-1800s. They're keener than even the locals here to find their family histories . . ."

The Lawsons quickly opened our minds and eyes to island history, family heritage, nature, humor, and just about anything else we cared to ask them.

We enjoyed their company too, right from the start—the tall, stooped Bill with his self-effacing chuckle, and the confident eyes and bright smile of Chris. Despite their local status as "incomers" (Bill from the Scottish mainland and Chris from Lewis), they both live, breathe, and adulate their adopted island of Harris, and on our first walk with them out across the vast flower-bedecked *machair* sheep pastures below the conical summit of Chaipaval, it was obvious that we had met a couple who had truly found their mutual purpose—and passion—in life.

But that didn't stop them from being direct and blatantly honest in their comments and opinions on the islanders and island life in general.

"Northton's a pretty odd place today," Bill chuckled as we set off in discovery of a series of beautiful secluded beaches overlooking the Sound of Harris. "Only forty or so houses, but since we've lived here, there's been a surge of 'incomers' to the islands buying up the old crofts at prices that are cheap for them but very inflationary for us. It's become a real eclectic mishmash here—folks moving in from America, Ireland, Canada, Germany, Sweden, Holland, even Morocco. The original village here of *Taobh Tuath* was a couple of miles away but, like all the west coast *machair*, it was cleared in the mid-1800s to make way for sheep. Typical of the lairds in those days. Just listen to their justification: 'This will ben-

efit all parties, relieving these lands of its redundant populations will improve the conditions of those who remain behind and at the same time relocate the expatriated in a sphere where there is certainty of finding productive outlets for their energies . . .' Then, when all that nonsense stopped—when the sheep economy failed—a 'new village' was rebuilt here from the earlier 1900s onwards. It was virtually a model crofting community with clearly fenced twelve-acre crofts in a line above the bay and open grazing all across Chaipaval—or to give it its correct Norse name, *Ceapabhal*—'the bow-shaped hill.' "

"So—all this was Viking territory?" asked one of the dozen or so walkers who had joined Bill and Chris at the MacGillivray Center.

And that's all Bill needed to start him off on a fascinating summation of island history. A few in the group, however, were more interested in the wealth of wildflowers already appearing in spring profusion across the honey-scented *machair*, laced in lark song.

"Oh my God, Henry, just look at these wonderful *Dactylorhiza incarnata* [apparently a rare species of marsh orchid]!" Others among them seemed ecstatic as they checked off their discoveries: bird's foot trefoil, ladies' bedstraw, centaury, meadow rue, harebells, knapweed, poppies, and clovers galore—all gloriously swaying about in the lush grasses.

Two others were avid ornithologists, bowed under the load of binoculars and cameras dangling from their necks and exuding paroxysms of delight at glimpses of arctic terns, gannets (skuas), golden eagles, oystercatchers, pied wagtails, and a host of other more obscure species that were mere litanies of names to us. Until they spotted seals off one of the rocky coastal shoals: "I'm sure that's what they are!" gushed one of them. "Or maybe otters."

"No, no, they must be seals . . . it's hard to tell, though . . . maybe porpoises . . ."

Without binoculars—which the couple seemed reluctant to share with the rest of the group—we all stared hard at the shoals but saw only the chop and slap of the tide on worn black strata.

Bill was now waxing eloquent about "the real deep history" of this bare, beach-indented sweep of *machair* that wrapped itself for miles around the base of Chaipaval like a vast emerald-green cape. He didn't

seem to have much patience with the rape, pillage, and plundering ways of the marauding Vikings of the ninth century, and as we stood among humpy lumps of turf and small exposed segments of ancient stone walls, he did a splendid job of re-creating life and lifeways here during the Bronze and Iron Ages.

"It's almost like he lived in those times—going back five thousand years!" I heard one of the group whisper to a friend as Bill pointed out the remains of clustered dwellings, shell middens, cooking hearth pits, part of a burial ground, and a heap of round "boiling stones." These, he explained, were necessary because the primitive clay cooking pots of the early inhabitants could not withstand direct heat, so stones had to be roasted in the fire and then added to the water in the pots to prepare food.

After another mile or so of slow uphill walking on the *machair*, we reached the most dramatic ancient remnant of all—the thick broken walls of *Teampall na h-Uidhe*. Located on a high point with broad vistas in all directions across this lonely, wind-smoothed landscape, and immediately adjoining the circular foundations of an Iron Age dun (fort), the *teampall*, Bill suggested, was founded in the days of the earliest Christian missionaries. "It's possible that St. Columba himself was here, but more than likely it was first built by followers of St. Maelrubha of Applecross."

Doubtless, with a more learned crowd, there would have been murmurs of recognition at this point. We, however, remained mute in mutual blissful ignorance.

"Y'mean these stones date from the second or third century AD?!" asked one of the group finally.

"Well—certainly the stones might, but these walls are what remain of a fortified chapel built by Alasdair Crotach around 1528. He was the clan chief of the MacLeods of Harris who also rebuilt St. Clement's Church at Rodel—our 'Cathedral of the Isles'—which I'm sure you've all visited . . ." (Some vague but unconvincing murmurs here from our group.)

Anne and I were moved by the power and presence of this bold ruin built upon the two-thousand-year-old foundations of one of many hermitage chapels and monasteries scattered along the ragged island coastlines of Scotland and Ireland.

Teampall na h-Uidhe

"What a faith they must have had . . . ," murmured Anne as she stroked the smooth, ancient corbel stones. Bill overheard the comment and smiled in agreement. "Oh, yes," he said, "makes us all look a little religiously . . . wimpy today, wouldn't you say?"

There was a hearty roar of laughter from behind us. We all turned to face the beaming bearded face of a thin, elderly man dressed entirely in

black. He had lagged behind for much of the walk, seemingly lost in his musings and constantly stopping to stare at the vista over Northton, Rodel, and the wild lochan-laced spine of the island.

"Sorry—sorry," he said, still chuckling. "Couldn't help but hear your last remark there, Mr. Lawson."

Bill wasn't sure whether to smile or apologize. Religious sensitivities

are thin-skinned here, although, even from his brief remark, the man's accent seemed very nonlocal.

"Charles Campbell . . . er . . . Reverend Charles Campbell."

Bill looked even more uncomfortable but gave a noncommittal "Aha . . ."

"From Melbourne, Australia. Or close by, anyway. But I suppose y'recognize an Aussie accent, Mr. Lawson. Y'must have many of us comin' to you for our family charts."

Bill's face brightened with relief, obviously pleased he hadn't offended a potential customer. "Oh yes, indeed," he smiled. "A lot. Canada was the most popular place with the lairds here to send their clansmen in the clearances . . . but Australia was not uncommon at all."

"Yes, I know. We've got a bunch of Campbells around where I have my church. And my great-grandfather left here in the late 1800s. And quite a few MacLeods too—their ancestors were pretty disgruntled about being cleared, particularly as this was once all MacLeod territory!"

"I imagine they were," said Bill. "Do you have family here now?"

"I'm not too sure . . . yet. That's where I might need your help, Mr. Lawson . . ."

"Bill," said Bill, sensing a promising "roots seeker."

"All right then—Bill. All I know of so far is that my third cousin, Hamish Taylor, lives in the Bays and has a boat there for island trips."

"Oh, yes—indeed he does," said Bill with genuine enthusiasm. "He's quite popular with visitors in the season."

"Well—I'll be meeting him. Tomorrow, I think. And then we'll see where it all goes from there."

"And are you looking to reclaim your family croft too?!" I said lightly, and then realized that I might be in danger of loosing a "legal-istic foray for lost lands"—an occasional island predicament here on Harris.

The minister laughed and his weather-lined face, bronzed to a leath-ery hide by torrid Australian summers, seemed suddenly younger and animated—"Oh, no, no—that's all past now . . . I just decided it was time I visited the home of my ancestors while I've still got . . . well, y'know . . . oh and, and also . . . this . . ."

He opened his anorak pocket and pulled out a very creased photocopy of something printed in an uneven and old-fashioned typeface. "You may be interested in this, Bill."

He handed the sheet to Bill, who studied it carefully, nodding with professional appreciation, and then passed it to Anne and me. "So typical of the time," Bill said, with a sad smile and a wispy sigh.

It turned out to be a clipping about a ship that had left Skye for Harris on the sixteenth of December, 1852, to pick up one of many cargoes of emigrants. Parts of the photocopy were blurred, but from what we could tell, it must have originally been written in log form by the captain or one of his literate officers. It read:

> Fine vistas of Harris from a distance. Background of hills of most rugged character. Soil of massive peat and compost. Upon landing we saw their black houses . . . pervaded with filth to an extent we feel reluctant to describe . . . What a coarse and rugged place with the inhabitants in a most wretched state. Getting the poor creatures on board was really very affecting and the parting scenes were most distressing . . .

The next paragraph describing the voyage was difficult to decipher except for one touching sentence:

> Few of these wretches were not sick and many died on the voyage, but their habitual reverence was not diminished and evening services were observed daily throughout the many weeks of our hard crossing . . .

We all stood quietly for a while imagining the plight of these crofter and cottar (squatter) families abruptly uprooted from their homes and cast into the unknown of the "new world."

The minister finally broke the silence. "Well—that was more than a hundred and fifty years ago and, terrible as it must have been for them, many went on to help build fine communities in Canada—and certainly in Australia."

"Yes," agreed Bill. "Chris and I often go to visit these places—mainly in Canada and the USA."

"Well," said the minister, with a broad grin, "we'll have to see if we can't get you an invitation to come and visit our little town near Melbourne."

"That would be very nice." Bill smiled. "Whereabouts are you exactly?"

"Smallish place called Hamilton, just over a hundred miles from the city."

"Ah," said Bill.

"What?!" was my amazed response. "Hamilton. I don't believe it. I've been there. Ten years ago . . . I have an aunt there. She's living in a nursing home on the edge of town. Near that wool museum of yours—that place with 'the world's largest ball of yarn.'"

"Too much!" laughed Bill. "This is becoming like one of my genealogical reunions!"

IT WAS TIME FOR A SHIFT of focus. Anne felt the same but was content to catch up with "domestics" and e-mails in our cottage. I needed the open road, huge vistas, and spontaneous serendipities—and the best place I could go to find such diversions was Lewis, Harris's "big sister" isle, land-linked over the North Harris hills. And Stornoway. Focal point of the two islands and a place I'd not seen in over twenty years.

I think Anne was delighted by the idea of having the cottage all to herself for a day and even promised to "make a surprise" for my return. Of course, like the fine wife she is, she had to remind me how much she'd miss me, et cetera, et cetera, but I could tell by her smile that she was not altogether sorry to wave me off on my mini-odyssey.

THE FIRST PART OF THE THIRTY-MILE or so drive north from Ardhasaig to Stornoway is by far the most dramatic on the conjoined islands. One moment you're skimming the flanks of West Loch Tarbert and then you're suddenly up and off and climbing the narrow, twisting road high up into the North Harris mountains. Even on a sunny day Clisham and its coterie of great monoliths seem to crowd in with their shadowy

heathered slopes and black broken summits. They're ominous but also gloriously distracting in their brooding power and their multibillion-year-old permanence. The key here, however—a very critical key if you wish for a healthy longevity—is not to be distracted. The road is little more than a paved cart track at first and barely wide enough for one vehicle, so drivers must constantly be looking out for the irregularly spaced "passing places" designed to permit a semblance of two-way traffic. Most drivers are generally generous and polite, and a combination of accurate distance gauging to determine who will pull over for whom, and lots of we're-all-in-this-together hand waving, will generally suffice to ensure safe and uneventful passage over the high watersheds. (Apparently, since our departure, this notorious road has been widened a little—but caution is still advised!)

And then, of course, there are the sheep. Thousands of them—who know nothing of civilized highway codes and gentle manners. Their greatest delights seem to include sprawling themselves leisurely on the road if the pavement is warm, making sudden suicidal chicken-run leaps from one side of the road to the other immediately in front of your car, or, in the case of overprotective ewes, standing in aggressive don't-you-dare postures in the middle of the road while their young spring lambs amble and frolic to the other side. Even woolly skeletons in the roadside ditches (watch out for these—some are deep to the point of being vertical drop-offs)—gory evidence of unfortunate confrontations between vehicles and sheep—seem not to have registered in their minds. To them, these high moors are their territory and we are the barely tolerated intruders. And in most instances they get their way as drivers shrug and meander around sunbathing flocks, barely bothering to honk their horns. Most have learned from long-past experiences that the creatures are not only dumb, arrogant, and self-destructively defensive—but also apparently rather deaf too.

As the road widens (a little) and swoops down the long slopes of Tomnaval and Liuthaid, the vista expands to include the sinuous mountain-bound expanse of Loch Seaforth. A small, elegant "castle" appears—Ardvourlie—built as a hunting lodge in 1863 by the Earl of Dunmore, owner of much of this region at the time, in traditional Scot-

tish style. Recently this was for a while an elegant hotel but now apparently has "gone private" again.

And then, abruptly, the high moors and glens fade and a vast glowering expanse of peat bogs and black-water lochans stretches out ahead for mile after mile to misty horizons. There are brief interludes of straggly crofter communities at the side of the road, but these are merely human-scaled frills on the fringe of this dark, threatening infinitude of . . . nothingness.

Even on warm, sunny days, this is an eerie emptiness, pockmarked here and there with remnants of ancient peat-cutting beds and collapsed frames of summer "shieling" shacks suggestive of traditional lifeways long abandoned to the silence and slow imploding suction of the bogs.

I'm heading for Stornoway, but a sign appears at the roadside pointing westward across the bogs to the remnants of settlements and forts and standing stones, many of which are thought to predate the great Egyptian pyramids—most notably the 4,500-year-old stone circle of Callanish.

I'd intended to revisit these places with Anne to see if they'd impress us the same as they had more than twenty years ago. But the hell with it, I thought, this day is all mine and I can go wherever I want—so why don't I just nip over and take a peep, then return some other time with Anne to investigate their mysteries more fully.

Great idea, responded my little serendipitous self. Go! So I went, easing my car off the main road and heading due west across the wild fringe of Barvas moor.

Bleak barely describes the next twelve miles. I was now alone on one of the loneliest roads in Britain. Naturalists and ornithologists of course love this place for its untrammeled wealth of flora and fauna—harder to spot here than in verdantly lush *machair* locations, but that's what makes the moor so captivating to the knowledgeable viewer able to identify all the sproutings of ling and bell heather, bog asphodel, sundew, cotton grass, bog myrtle, blue moor grass, deer's hair grass, and those spongy green masses of sphagnum moss.

I obviously respect their enthusiasm and certainly empathize with their virulent opposition to one of the most ambitious mega project

concepts to ever hit the Hebrides—that proposed creation of one of Europe's largest wind farms across these moors. The actual scale of the concept varies depending on the perspective and political savvy of the presenters, but according to the latest headlines in the *Stornoway Gazette*, there's talk of as many as six hundred four-hundred-foot-high turbines that could generate "enough sustainable energy for half the Highlands of Scotland" and ensure "considerable economic benefits" for the rather sparse coffers of Lewis.

The objectors of course decry the destruction of "a unique and beautiful wilderness," the decimation of "countless thousands of birds every year" in the huge whirling blades of the turbines, and a wide array of other traumatic factors, including "the pathetically meager royalties that the private investors proposing the scheme would donate to the island as token compensation for their capitalistic greed and topographical and aesthetic ruination."

This, I thought, as I scurried across the dark moors and bogs, is yet one more of those dramatic confrontations between traditionalists, environmentalists, and futurists. It's early days yet but already, in the strident pro and con letters to the *Gazette* and furious village meetings, I could sense the battle lines forming and the fear of yet one more unwanted invasion—invasions that for thousands of years engendered so many of the ancient remains of forts and huddled settlements in defensive locations scattered up and down the west coast of Lewis.

These remnants of threats and bombastic responses were all still intact as I meandered my way along the coastal road—the modest stone circle and standing stones of Garynahine, the Breasclete burial chamber, the restored Norse mill at Shawbost, the enormous towering bulk of the Iron Age Carloway *broch* or dun (much archaeological argument here about whether *brochs* are fortified homesteads and duns are actual forts or . . .), and the excellent renovation and museum at the Old Blackhouse Village at Gearrannan—a flourishing community in the 1950s of over twenty tweed weavers that traces its origins back more than two thousand years. And these are merely a handful of the outstanding sites here.

All these I left for later explorations with Anne and ended up, as intended, walking up the long rise from the recently opened visitor cen-

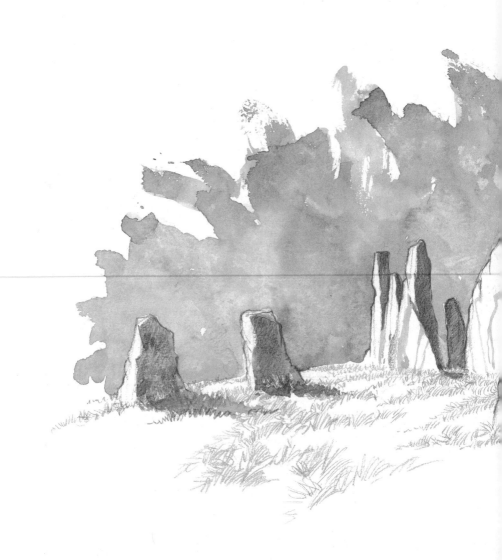

Callanish Standing Stones

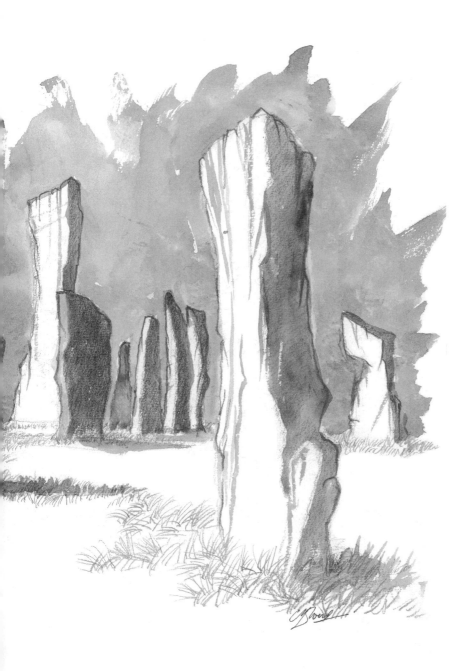

ter at Callanish to stand—alone and whipped by a vigorous Atlantic wind—at the base of the great standing stones themselves.

Nothing seemed to have changed since our last visit two decades ago. Which I suppose is what one hopes to find when faced with such splendid white stone monoliths more than four millennia old. Furious debates continue as to their origin and purpose: Were the stones actually "erratics" pushed south by glaciers or were they hauled across country by mysterious means like the huge components of Stonehenge? Was it a Druidic ceremonial center, astronomical observatory, Christian sanctuary, Neolithic trading post, "ancient saints turned to stone," focal point of invisible energy "ley lines," or a flying saucer landing site for extraterrestrial tourists? Many accept the simpler description I found in one of the Hebridean guidebooks:

> The stones at Callanish are older than those of Stonehenge and were erected sometime around 2900 BC. A worthy rival of Stonehenge, Callanish is outstanding especially in the context of the many other smaller stone circles within the area. It consists of a stone circle, a central monolith almost twenty feet high, and five radial "avenues" of standing stones.

Another commentator was fascinated by the comparative age of this remarkable creation:

> Built two centuries before the Egyptians constructed the Tomb of Tutankhaman, 600 years before Solomon began his temple in Jerusalem, 8000 years before Nebuchadnezzar's Hanging Gardens of Babylon, 1200 years before the Greek's Temple of Zeus at Olympia. And when the Chinese started to build The Great Wall these stones had been in position for fourteen centuries.

Numerous learned tomes (and many far more erratic monographs and lunatic fringe diatribes) have been written on Callanish and the archaeological wonderworld of Lewis's west coast. I will therefore leave any further academic descriptions and speculations to the "experts"

(despite their remarkable ability to disagree on just about every detail and nuance of this amazing place), and merely suggest that Callanish seems to speak to everyone who comes here in a unique and very personal way.

It helps of course to have the place to yourself, as I did on that first exploratory day, when I sat quietly sheltered from the wind by the central stone and let the magic creep in slowly. And what I sensed was not so much the ghosts of ancient generations (or any "beam me up, Scotty" sci-fi hallucinations) but rather an overpowering sense of the bold certitude—and fortitude—of the builders of these places. On subsequent visits I was equally beguiled by the certitude of some interesting (and occasionally rather odd) characters I found here, lured to the stones by their metaphysical presence and power. Neo-Druids, crystal planters, Travelers (sort of New Age gypsies), worshippers of solstices and the ancient earth goddess Brighde, practitioners of Wicca (white magic), and admirers of the winter northern lights (aurora borealis), which are particularly mystical here—all are lured to this remote and lonely place, seeking spiritual revelations and confirmations.

In the same way that I admire the intense hermitlike dedication and faith of the early Christian saints (despite the cynicism of those historians who suggest that their primary purpose was not so much the promulgation of the gospels to a Christ-less world but rather the salvation of their own souls), I sensed a similar clarity of original vision and belief here. With one difference: this was an immense *communal* creation reflecting a well-established continuum of perception and action that possibly linked ancient civilizations throughout Britain, France (Carnac in Brittany possesses an equally amazing series of creations), and many other coastal fringes of Europe. The only problem is that I, in common with most other commentators, have no real idea what that collective visionary perception once was. Obviously, the recognition of higher powers and energy potentials was the binding bond, as it has been for almost all sects, religions, and cults from time immemorial. But after that . . . what else? How were their gods—their higher powers—depicted? Was fear the driving force for communal action—fear of mortality; fear of crop failure, starvation, and social decimation; fear of

ever-present invaders with more powerful forces at their own disposal; fear of internal anarchy if the human species were not disciplined and restrained by durable power structures? Or just the oh-so-common fear and/or respect of the masses subjected to the dominance of strong clan leaders or dictators? Or . . .

IN THE CASE OF STORNOWAY (yes, I finally left Callanish, a little reluctantly, and drove back across Barvas moor to my destination of the day), you immediately perceive the visionary impact of more benign leaders in the form of affluent "social reformers" who gallantly tried to transform this modest crofting and fishing community, set around a deep, safe harbor, into something far grander, gracious, and affluent.

These utopian visions began as far back as 1599 when Stornoway was a base for the "Fife adventurers," who had been instructed by King James VI (later King James I of England—more convoluted British history here) to tame "a barbarous, uncivilized, and pagan people."

Various skirmishes and devious dealings around that time between the clans led to the ouster of the powerful MacLeods (a family of Norse origin) by the MacKenzies in 1610. Then another power shuffle during the Jacobite "rebellions" of 1719 and 1745 brought a brief occupation by Oliver Cromwell's forces, and finally, in the next century, the "gentleman visionaries" began to appear. It's a long story, but eighty-three-and-a-half-year-old Hector Campbell (he was very precise about his age, and his incandescently red face, which could have easily doubled as a traffic light, glowed with geriatric pride), who I met on a bench overlooking the harbor, seemed to have his own unique perception of the town's history from that point onward: "Well, Lord Seaforth—the MacKenzie chief had himself renamed in English fashion—built himself a fancy mansion for himself across there from the harbor. And then along comes the big 'opium king,' James Matheson, in 1844, buys up Stornoway and the whole blinkin' island, tears down Seaforth's place, and puts up—that thing—and planted all those woods too."

"That thing" is Lews Castle, one of the first features you notice as you drive into this tight-knit little town of 8,600 or so residents. It sits

on a hillside overlooking the harbor and the town, in glorious Victorian-Gothic pomposity, with turrets, towers, battlements, and elegantly carved stonework surrounded by one of the oddest sights on this storm-torn, bog-strewn, and largely desolate island: a gorgeously lush swath of woodlands stretching for a mile or so along the inlet, and way back to the Harris road. You just don't expect to see trees anywhere on Lewis. But here they are in their thousands, including an encyclopedic array of "exotic" species, and looking more like the country estate of some landed gentry family in the lush, sumptuous greenery of Sussex.

"Is it open to the public?" I asked Hector.

"Oh—aye, 'course it is. All kinds of walks and streams and nice cozy places for a bit of . . . well, y'know. It's nice to have some trees, 'specially after that ninth-century Viking raider, Magnus Barelegs, burnt down all the forest on Lewis an' left the whole flippin' moor bare as his own legs!" Hector chuckled at his own ribald imagery, revealing a battered Stonehengelike set of nicotine-stained teeth.

"The castle's closed, though—they say it's fallin' down. But there's a technical college behind it. We're proud of that. A college on Lewis. Makes us *Leodhasaich* feel a bit more important d'y'ken. Means the young kids might stay a wee bit longer . . . Anyhow so—like I was tellin' ye, Matheson moved in and started makin' changes to the town. Did some good things. Helped us out during the terrible days of the potato famines and whatnot around 1845. Brought in food and supplies for us an' got to be a baron too for 'his great exertions and munificence' an' all that. Good man gen'rally speakin', even though they said he made most of his money in the opium trade. But then again, so did Queen Victoria, I've heard . . . But when he died in comes our 'Wee Soapman,' Lord Leverhulme, in 1918 and buys up the island again and—boy—was that an eye-opener! He had all kinds of ideas and projects—plantin' great forests of willows for basket makin' all over the Lewis moors; a new iodine industry from all the seaweed we've got; peat-fired power stations can y'believe; building up the herring fleet after World War I to make Stornoway the 'fishin' capital of the world' and gettin' work for all those hundreds of 'herring girls' and dozens of kipperin' smokehouses, an' tryin' to get the crofters off the land and into canning factories here.

Lews Castle, Stornoway

Oh—an' he built that bloody great tower over there too." (Hector pointed to the west, where an impressive eighty-five-foot-high tower rose on the horizon—a memorial to the 1,159 Lewismen lost in World War I.)

"Amazin' man, really. He'd so many ideas. He even tried to revive the old whaling yard at Bunevoneadar in North Harris. Strange old place

that. Just a chimney left—and the old flensing platform where they used to cut 'em up. Leverhulme was amazed how much meat was wasted. All they used was the blubber for oil. So he invented a process for making sausages for workers on his huge plantations out in Africa."

"Africa!?"

"Yeah—can y'believe. He said, 'The African native is not an epicure, so long as it is good wholesome food—and it will also improve the possibility of mastication!' "

"And what happened?"

"His natives were more fussy than he thought. It flopped. Like so much of what he tried to do here. He ran into a lot of problems y'see when our lads—the few that were left—came back from the war and all they wanted really was just their own crofts with its own wee communion of crofters—all equal, all helping each other. They'd been promised land—'land fit for heroes'—by the government and didn'a want to work for someone else in factories and whatnot. So the poor old Soapman finally gave up and donated most of the island to the people and the Stornoway Trust in 1923 and went off down into Harris and tried to get the *Hearaich* people organized instead! And he never came back to Stornoway ever again. When he sailed across he came from Uig on Skye to Tarbert on Harris like the ferries do nowadays, not from Ullapool. Turned his back on us completely!"

"And did his ideas work in Harris?"

"Could've done—if he didn't go and die in 1925 jus' as he was tryin' to get Leverburgh goin' as a big fishin' harbor . . ."

"I remember reading about that. His board of directors stopped everything!"

"Aye that they did. In a flash!" Hector's granite-black eyes suddenly sparkled with a fierce quartzite glint. "Bunch a' tiddlypissers—no gumption, no imagination—but a' suppose y'canna blame them really. He'd spent—and lost—fortunes on our islands. Sad story really . . ."

We sat quietly for a while watching the fishing boats wallow and nudge one another against the docks as the noon tide crept into the harbor. Scores of seagulls poked and pecked the wave-worn hulls and decks for fishy scraps, and two gray seals, apparently a familiar sight in the har-

bor, frolicked in the shallows. Behind us, the tightly packed stores, restaurants, and pubs along the waterfront drew their jostling lunchtime crowds.

"So was that it for the 'utopian benefactors' here?"

Hector gave a chuckle. "Well—a' suppose so. The really big ones. But there were many others who helped make this a real proud little town . . . Y'heard of Alexander Nicolson? Fine man. Left money in his will for a school, the Nicolson Institute. Built in 1873 and—my, that place has turned out some pretty famous people . . ."

"Is it still here today?"

"Oh my—yes, indeed. Much bigger now. Jus' y'wait while around twelve-thirty. Streets'll be full of its students. Flippin' madhouse it gets for an hour or two . . . you'll see . . ."

And just as Hector had predicted, at lunchtime the kids emerge from the Nicolson and meander in snakey lines down the long hill of Frances Street, past Lloyds Bank, the County Hotel, McNeill's Bar, and groupings of turreted and towered civic buildings, proud emblems of Victorian gentility, when the little harbor town glowed with mercantile affluence. When they reach Cromwell Street they have a choice to make. Turn right to the confectionery shop, the library coffee bar, or the Golden Sea Chinese Restaurant for aromatic take-outs of chips with gravy, chips with curry sauce, chips with mushy peas, or chips with everything for 20p more. Or carry straight on down Point Street, supposedly closed to vehicles but invariably littered with parked cars, past the Criterion pub, a tiny smoky hangout of old salts and storytellers where a luxuriantly sculpted and frothed Guinness stout traditionally takes a good five salivating minutes to pour, down to the two fish 'n' chips shops, Cameron's and Paddy's. And here they emerge, gorging on limp, oil-glistening chips piled high on square polystyrene plates. Some use the little wooden forks provided free along with salt and malt vinegar (anything else, like ketchup, usually costs extra, in typical thrifty Scottish manner); others, particularly the boys, plow in with greasy fingers and huddle together, faces and eyes blank, collectively and contentedly munching like cud-chewing cattle.

Once the food is devoured, energy returns to the pubescent throng.

The girls gossip and giggle in intimate swarmings or walk four abreast, arm in arm, up and down the cobbles of Point Street, seeing themselves reflected in the store windows or in the eyes of their friends. And preening. Gently but precociously.

The boys, as boys do, mulishly chase one another, play street football, and once in a rare while insinuate themselves briefly into the girly-groups, where they whisper a few gossipy bits and pieces, or drop a few ribald remarks in baying voices, and leave the gum-chewing, jittery-fingered girls blushing and giggling with even more dizzy gusto than before.

There is a nudge-nudge, wink-wink eroticism in the hormonal force field here, albeit slightly muted and sanitized by that strict Presbyterian ethos that pervades Stornoway. Despite its claim to eight different religious denominations here—"including the Baha'is too," one lady insisted, "we even have a few o' them . . ."—it's the Calvinistic spirit of the Church of Scotland and its breakaway rebel brothers, the Free Church of Scotland and the Free Church (Continuing), that sets the tone for social mores and behavior here. But kids will be kids. Thankfully, I guess.

Eventually the streets empty again as the students move back uphill to the Nicolson, dousing their little wildfires of schizoid emotions and suppressed fantasies, at least until the evening, until the dark . . .

Which looses a far larger panoply of antics and aspirations. After the shops are closed. After the sun has set, red and furious, behind the woodlands and turreted Victorian towers of Lews Castle. After all this, the night prowlers emerge: the pub-primed philosophers (but few latte lappers—apparently this is not really a town for café cognoscenti), the disco dancers (yes indeed, the town has one—the Hebridean), the black-clad boys and the black-micro-skirt-clad girls all swirling, in little effervescences, out into the dark streets.

Late evening into early night is also the time when the fishing boats return to the harbor just across the street from the Chinese restaurant. They are brightly adorned with trims of bright yellow, red, and Caribbean blue, looking like a floating carnival, circus-gay and quaint in traditional manner.

But if you look closer, you can see that the wood and iron of the boats, the bright paint, the glass windows of the cabins, and the curved superstructure of the hulls are chipped and scarred and cracked and buckled as if by pirate skirmishes or errant shrapnel. Or more precisely, the elements—the *bleffarts* and the *gurly* seas. Thousands of days at sea are etched in their fabric. The scars and gashes gained from battling outrageous waves, storms, hurricanes, blizzards—and balancing, time and time again, on that heart-stopping cusp between survival and the sudden affluence of a rich catch, or abrupt, agonizing annihilation. A summons to the depths of the ocean with barely time to remember that old adage fishermen are taught—or certainly learn—early in their seafaring lives: *The sea will claim its own.*

Maybe they also remember the wisdom of that other popular adage:

Hunting is hell
Fishing is fickle
Put your faith in the land—it'll
Fill y' pot an' y' kittle.

And then you look at the fishermen themselves, mooring their boats to the dock with thick wet ropes wrapped around rusty capstans. And you see their faces—sweaty, still crusted with salt spray, some as barnacled and buckled as their boats, eyes averted from the people gathered in the small groups along the dock. The old salts, old men who wish they were old salts, wives hoping to scoop a bargain or two in just-docked fish, a few incomers—curious, buoyed by romantic dreams of Robert Louis Stevenson's adventures—and boys. Always boys, watching, wondering if this might be their own future and their fortune.

But the fishermen seemed to notice none of this. Their eyes, their muscles, their whole bodies are focused on the one last task of their endless odysseys out into The Minch and the Atlantic: unloading the catch.

And tonight it's a good catch, by the look of the boxes, brimming with cod and ling, being winched up from the hold and onto the dock. The seagulls go crazy, screeching and diving like eagles, fighting for scraps that fall among the rolled nets and brightly colored buoys. And so

they go, heaving up the boxes, ignoring the onlookers, the screech of the gulls and their white droppings dumped with enthusiastic regularity, the stink of diesel oil and brine and fish guts. One captain remains in his wheelhouse, stoic and steady, peering out like the ancient mariner, ghostly through the salt-smeared windows, counting his boxes, calculating the returns, wondering what the next trip might bring . . . and maybe also remembering why he went to sea here in the first place, as expressed by one anonymous bard: "Perhaps other seas have voices for other folk, but the western sea alone can speak in the Gaelic tongue and reach the Gaelic heart."

And maybe in moments of introspection, when he has cause to question the meanness and guile of the middlemen, buying his hard-won fish by the ton, not even seeing them, just counting boxes and cash and nickel-and-diming . . . maybe that was when he wanted to remind them of Sir Walter Scott's fine line from his novel *The Antiquary*: "It's no fish ye're buying; it's men's lives."

Eventually I left the clamoring harbor. The salty damp that hangs around the old battered boats had made me thirsty—a thirst that only a good tall pint or two of Scottish beer could quench. And I had two choices—one of the local pubs (actually over twenty choices here), or call the Hebridean Brewery here and see if the owner was still around. I'd heard he often worked late at his small establishment, tucked away in the industrial part of town around Rigs Road. And I'd also been told he welcomed visitors. Anytime.

Fortunately my informant was correct. Andrew Ribbens's greeting could not have been warmer. He was a stocky young man, slightly balding, with a round, friendly face and enticing grin and chuckle.

"Well, come on in! I was wondering who might be around for a taste today. I'm thirsty—how 'bout you?"

"Oh, definitely. I've been down at the harbor with the fishing boats. I can't get that salt spray taste out of my mouth."

"Soon settle that f'ye . . . ," Andy said, and immediately started to prepare for slow, leisurely samplings of his three primary creations—The Islander, a strong premium ale, deep ruby in color with a robust malt and hops flavor; the Celtic Black Ale, Guinnesslike in its caramel aftertaste

and dark porter hue, and the Clansman, a lighter concoction both in color and flavor—something you could enjoy anytime.

"Congratulations," I said, "you've got three fine brews here."

"Ah, but now there's a fourth! You've got to try our latest masterpiece: The Berserker."

"The what?!"

"Berserker. It's what the Vikings used to call their top warriors. The really wild ones. The ones with the big horned helmets and the double-edged axes—they were said to be invulnerable . . . oh, and it's seven and a half percent too—makes y'feel pretty invulnerable too—I based it on a seventeenth-century recipe . . ."

"Seven and a half percent! That's well over halfway to wine strength!"

"Yes, yes, you're right . . . now you mention it."

"Okay. Open one up. Let's try it."

It had all one would want from a fine strong ale—a creamy head, smooth, velvety texture, a fruity "nose," a deeply pungent and very hoppy flavor, and that special glow in the pit of your stomach that only something with a seven-and-a-half-percent punch can produce.

"Beautiful," I said, and smiled benignly at Brewmaster Andy.

His compact, redolent establishment, full of gleaming stainless steel fermenters and conditioning vats and complex labyrinths of piping, had been rather hard to find in this drab sector of Stornoway, and first impressions had been distinctly underwhelming. I was possibly hoping for a rather pubby tasting room with hand-carved Hebridean Brewery signs and maybe a flurry of hop plants over the door and dark beams and cozy chairs inside. Something like that. But Andy's brewery was not at all like your typical village pub. In fact, it could have doubled as a maintenance garage for local buses or a storage facility for packing crates, with its thirty-foot-high ceilings rising from the concrete floor to a steel beam roof. The sampling bar admittedly had a few colorful posters around it and a couple of beer pulls to suggest a local watering hole atmosphere, but it was obvious from the start that this was a workmanlike production shed, not a place to meet and mingle with the locals.

The tasting, however, was flowing along delightfully. To my palate, the Berserker beat them all and I told Andy this. So, fine host that he was,

he opened a second bottle and we supped away happily as he recounted the tale of his innovative venture here.

"I suppose I've always thought of m'self as a Lewis man. Even though my family lived in Kent, only a couple of hours from London, they all came originally from Stornoway. I came here first time when I was eighteen, but jobs were scarce then for a young lad—still are—so it was back to Kent for a while until the idea of a brewery first raised its ugly head a few years ago. I brought two friends of mine to sample the delights of Lewis. It was during the British Lions' tour of South Africa and, as we were all avid rugby players, much of the time was spent in pubs watching the matches. Poor excuse, I know, but that's how we passed the time. After a few sessions it became apparent that the choice of beer on the island was seriously lacking any diversity or flavor and so we wondered why nobody had started a local brewery here. A lightbulb went on in my head."

Andy paused to refill our glasses. "I'd just inherited my grandfather's croft here, which had been in our family since the 1890s, and so I thought about living permanently on the island. But first I decided I'd better attend some courses and seminars dealing with the independent brewing industry. I met Don Burgess from the Freeminer Brewery in Kent when he was one of the speakers. Since then we've become really firm friends. Don is very well respected in the independent brewing industry. He's got a wallful of awards for the beers he produces and his help has been invaluable. I even spent time at his brewery and gained a lot of practical experience.

"Finally, I was ready. I took early retirement from my job with a pharmaceutical firm, got a small bonus handshake, and came back here in 2001 to get things started. There were problems, as always, but eventually we were off and rolling and by October I produced my first batch just in time for the Royal National Mod—y'know, that huge Scottish event. Kind of an annual competition of Gaelic songs, music, dancing—that sort of thing. A year later we were gaining quite a reputation—even winning awards, and making a special brew for the Stornoway Hebridean Celtic Festival. We called it Celtic Festivale and boy—was that a hit with the local pubs!

"A lot of the small island breweries brew and bottle down in Edinburgh under contract . . . I see that as cheating and refused to do that right from the start. I wanted our products to be authentic here. Y'see, my grandfather loved this place and he brought me up to love it too. So whatever I did, I was going to do it right. And I decided if I could generate five or six jobs here for the locals—especially young ones—then I'd be happy. We lose so many youngsters every year. There's no jobs here for them so they go to the mainland—and usually stay there. So—it was a kind of mission. And my parents supported me—they even come up for the summer to lend a hand.

"There are some problems still with pubs and pub ownerships. Some resist new brews. Six Stornoway pubs in town won't even think about stocking my products. They'd rather stock rubbish American beers like Budweiser and Miller than deal with small-scale breweries like ours. But in Harris, though, we're everywhere! I've even got more sales in Skye than I have on Lewis. That's the most upsetting thing. They don't always seem to appreciate having a brewery in their own town. It can take forever to change opinions here . . . but it's always the same story with small businesses like ours, particularly in remote places like Stornoway. The big guys are always hovering around trying to nip the life out of you. But so far we're still here and proving that this kind of effort can work if you really try hard. And that's what we need on the islands. People with energy and vision willing to tough it out without government subsidies and all that 'crofter dependency' stuff. Easy money can kill initiative. It's happened so often here. People give up too soon—confidence collapses—and eventually so does the whole island economy."

"So, are you optimistic or not about the future of these islands?"

"Mmm, sometimes yes. Sometimes no. So much money has been wasted here on big fancy projects that go nowhere. We need more investment in small-scale, less airy-fairy businesses. We need to create more work for the young people. Too many are leaving and most'll never come back."

"What about the older traditional industries—fishing . . . tweed?"

"Well—fishing's not much good at the moment. We lost the big runs way back. Prawns and lobsters are still okay, though. Enough to keep

quite a few boats floating. But who knows in the long term? Sometimes those wind farm proposals, that's one of the latest mega-investment schemes here, seem to offer some serious money for our future, but—I ask you, can you imagine hundreds of those four-hundred-feet-high turbines all up and down the middle of our Lewis moors? It would change everything—all that wilderness—everything."

"So, I guess that leaves tweed."

"Ah, yes, our lovely Harris Tweed. Well, I dunno . . . everything's always on its way to somewhere else, isn't it. Everything. And no one seems to know where tweed is headed—but it looks like we're not giving up yet. Rough times, but we're still in there trying. Maybe something will come along . . . I've heard rumors . . ."

"Yeah . . . so have I. But I can't get anything definite. Maybe it's just that island stubbornness that keeps it going. Maybe it's time for all those churchgoers and ministers to pray really hard!"

"Oh, they're real good at doing that here. Embracing the mysteries an' all that. And who knows, m'be the good Lord'll listen this time . . ."

2

People of the Tweed

O
H AYE—MARION CAMPBELL—a lovely person," Roddy said
one morning shortly after our arrival. He was at his store, just
across the road from our cottage, and we were discussing the
current predicament of the island tweed industry—a constant item of
island concern. I'd described our first introduction to its nuances and
traditions when Anne and I met Marion way back on our first visit to
Harris.

"Yes, she is—we've both been looking forward to seeing her again."

There was what you might call a rather uncomfortable silence. Roddy
was fiddling around at the cash register and then slowly turned to look out
of the window at the North Harris hills bathed in soft spring sunshine.

"Ah well, now . . . ," he said quietly. "That'll be a wee bit difficult . . .
y'see, she passed on . . . quite a few years back . . . 1996 I think it was . . ."

"Oh," was all I could think to say. Marion had been one of the most
celebrated weavers on the island. She was one of the last true "tradition-
alists," still performing all the steps herself—dyeing, spinning, warp
preparation, and weaving—on her huge wooden loom, and then the
laborious process of waulking (shrinking). She seemed to be the kind of
individual who would go on forever performing these arduous and
meticulous tasks. But then I realized that when we first met her, she must
have been in her late seventies.

"Aye," said Roddy, "a fine woman. Took a bit of our island with her
when she left us. But close by her home in Plocrapool there's her cousin,

Katie Campbell. She's a good weaver. And Katie's daughter too, Katherine. They don't do their own dyes and things like that but they still use the old single-wide Hattersley looms. Make some lovely tweeds too. And her shortbread . . . that's very good if y'manage t'get y'selves invited in for a spot of tea—we call it *strupach* or *scrubag* dependin' on which island you're on." Katie's tea and delicious shortbread were indeed one of the first highlights of our visit to her home the following day. We had driven on the tortuously narrow and winding "Golden Road" (a very expensive and boondoggled feat of local engineering) to a typically tough little Bays cottage, perched on a rocky bluff overlooking a cluster of wave-gouged inlets and, way across The Minch, the towering cliffs of Skye. It's wild country here—scenes from the epic *2001: A Space Odyssey* were filmed in this lunar landscape, which doubled as the surface of Jupiter.

The sea views of the open ocean were tantalizing through Katie's small living room window, and the room itself possessed a cocooned coziness. You could imagine dark winter days by the peat fire here, with the wind howling off the moors outside and hurtling across the sound and the aroma of fresh-baked bannock cakes wafting in from the adjacent kitchen. It was a true crofter home—small, intimate, thick-walled, and full of that aura of close-knit bonds of kinfolk, and a *ceilidh* cohesion evolved through eons of communal singing, storytelling, long nights of laughter, and maybe even a spot of Highland dancing if the mood was right.

Katie was delightful—a small, gracious elderly woman haloed in a profusion of light-colored hair and eyes that sparkled with kindness and good humor. As she served us our tea by the fire, she told us about the old tweed-making process that began with a cleansing of the "dirty" (greasy) wool from Blackface and Cheviot sheep in a mixture of soap and washing soda. Then came the dyeing, traditionally in vats of home-made dye extracted from crotal (lichen scratched off the moorland rocks), peat soot, and a wide range of local plants.

"What—you just let the plants and the fleece sit in water?" asked Anne.

"Well," said Katie, " y'know what y'should do if you want to learn all about the dyeing—go see Margaret MacKay in Tarbert. Lovely lady. She's got a place called Soay Studio near the school and gives classes in tradi-

tional techniques. People come from all over the world. She's very particular about the process . . . although I don't think she uses the *maistir* anymore!" Katie gave a mysterious chuckle. "No, I doubt very much she'd be doing that!"

Anne sensed she was missing something. "*Maistir* . . . what's that?"

Katie smiled demurely and left the explanation to me.

"Oh—sorry, darlin', I thought I'd told you about . . . er . . . the pee pots . . . chamber pots. They were . . . ah . . . emptied every day into a barrel—the pee-tub—or something like that outside the house and . . . er . . . left to ferment . . . mature . . ."

"Mature! Are you serious?!"

"Well, apparently the ammonia or whatever in the urine got stronger with age and was perfect for the . . . 'fixing' of the dye in the wool . . ."

Anne gave me one of those "Well, thanks so much for sharing that with me" glances followed by a half-whispered "Okaaay . . ."

"Anyway," said Katie, obviously happy to have been excluded from that little digression, "after the dyeing and fixing came the teasing, blending, and carding processes. By that time the wool's a fluffy mass of thin fibers and ready for spinning into yarn for the warp and weft weaving threads. Nowadays the warp is prepared by the factory with six hundred ninety-eight threads, each measuring around ninety yards in length, which are delivered to the cottage of the crofter-weaver along with some forty pounds of weft yarns. These are then woven on the home loom, usually in check, two-by-three, or herringbone patterns. Sometimes we use diamond or bird's-eye—that last design looks especially smart.

"If the weaver's fast, they can do up to sixty yards—now they work in meters—a day of 'single wide'—around thirty inches wide—depending on the thickness of the threads, and who's doin' the weavin'. On Harris it was often the women—but on Lewis it was traditionally the men. But at this point the tweed's a wee bit messy. There are oils added in the blending process to make the spinning of the yarn easier and you'll get some extra dirt and machine oil on it in the weaving shed. So the last bit—the 'finishing'— is very important. You've got to scour it again in soap and soda and then 'waulk,' felt, and crop—or 'nap'—the cloth to give it a smooth feel and 'a good handle.' And then each bolt has

to be inspected by the Harris Tweed Association—they're real sticklers for any broken threads and other imperfections—and afterwards it's stamped with the 'Orb' certification mark, every yard of it, and each piece is given its own production number."

"Complicated—and all very 'official,'" said Anne.

"Well—we're very proud of that," said Katie, with a grin, as she handed round more of her shortbread. "I think we're the only cloth anywhere in the world to have an official Act of Parliament to protect it . . . d'you want to know what it says?"

"Of course."

"Well—it goes something like this: 'The production of the handwoven tweed known as Harris Tweed has been woven in the Outer Hebrides for centuries and provides the main source of work within the private sector in the region and it is vital to the economy of those islands that the integrity, distinctive character, and worldwide renown of Harris Tweed should be maintained' . . . and then it goes on to say that our tweed must be 'made from pure, virgin wool, produced in Scotland, spun, dyed, and finished in the Outer Hebrides, and handwoven by the islanders at their own homes.'"

"And all this was stamped, sealed, and signed by Parliament?" I asked.

"Absolutely. No one can take it away from us now. It's our cloth . . . no one makes it quite like us and everyone in the world has heard of it. No one can claim to make 'Harris' Tweed unless it's done right—and done here. Others have tried to sneak their cloth in with our label— 'poachers' in Italy and Canada, and even the Japanese—can y'believe they went so far as to name one of their islands Harris?!"

"From what I've heard," I said, "the islanders have always been very proud and particular about the way they make their tweed."

"Oh—my—yes! Very particular. Lady Catherine Dunmore—actually she was a countess—did a lot to get the cottage industry started here in the late 1800s, but then along came Lord Leverhulme in the 1920s with his newfangled ideas and things got a bit . . . feisty. He wanted the weavers to use machine-spun wool to save all that time they spent carding, hand spinning, and making bobbins and whatnot at home. He spent a small fortune building a special carding and spinning mill at Geocrab

just up the road here in 1922, but the machines never seemed to work properly. Anyway, the weavers believed that any kind of mechanization would remove the special reputation of home-produced Harris Tweed and so they stuck to their own old ways for quite a while after that . . ."

"When it was all hand done—y'know, the dyeing, carding, spinning, and all that—what was your favorite part of the process?" asked Anne.

"Och—the waulkin' o' the cloth . . . that was so much fun! More than the weavin' really because it was an excuse for us all to get together. Especially the young girls. They didn't get out much then. It's all gone now of course. The shrinkin' and fullin' is done at the factory today after they get the tweeds from the cottages. They say the old way dates back to Roman times—maybe earlier. I think they did it by foot then. Like they did in Ireland. But here we used a big flat board—a door would do fine—and you'd get three of the women—up to six sometimes—sittin' on each side. And then the singin' starts. Morag MacLeod on Scalpay has collected lots of the old waulkin' songs—'Orain Luaidh.' Some were hymns an' the like, depending on the people who were there—but they were all very rhythmic . . . a nice fast beat and we all pushed and pulled the dampened cloth together for hours across the board.

"There was one song I remember—a sort of hymn—that sounds a bit sort of depressin', but when you sang it in the Gaelic it really got you movin':

"I implore you
to turn back quickly
Before you're destroyed
Oh, take care for your soul

Careless people
The door is closed on them
And there is a naked sword
Behind it to watch them

Hear the thunderings of
Mount Sinai

Death threatens
asking for full penance . . ."

"Oh—very cheerful!" I said.

Katie chuckled. "Well. You've got to imagine it with a table full of women—churchgoers, God-fearin' women. They could really put a lot of energy into those words . . . but, with the younger ones, we had a bit more fun, and some of the songs were very . . . 'female,' y'know—lots of local gossip thrown in and comments about the men in the village and whatnot. A few were a little racy too, y'know . . ."

"Can you remember any of those?" I asked, and received an abrupt elbow nudge from Anne.

Katie chuckled. "Oooh, no, no, I don't think so. But there was one I used to like very much . . . it went something like . . .

"Last night I was in the shieling
Last night I was in the shieling
My time was not spent in jollity
But thinking of you my darling
Sure that high tide would not keep you
Neither flowing nor ebbing
Nor that the fair-haired one would keep you
Despite her cattle and her wealth . . ."

Katie half spoke, half sang the rhythmic verse in a soft, gentle voice. "'Course we sang in the Gaelic and much louder than that and with a lovely steady beat."

"That was beautiful," said Anne. "And you've got a good memory too."

"Ah, well." Katie smiled. "Don't forget, Gaelic's a very 'oral' language—you had to learn how to remember all your songs and hymns."

Mike Russell, in his book *A Poem of Remote Lives*, celebrates the spirit of the waulking ritual:

Of all their songs there were none more spirited than when the cloth is waulked or beaten until the fibres swell and the cloth is fully shrunk. It

may take 10 songs to make it so for here is a people who reckon effort, nay even life itself, by the length of a song: a people with a lesson for us all and who are able to transmute the dross of individual drudgery to the gold of united effort by the power of melody.

Then it was my turn for a little recitation: "I found this great little poem about the tweed and wrote it down. I don't know who composed it but it made me realize that *Clo Mor* was much more than just cloth . . . it was the spirit of the island too . . . something you could never lose . . .

"*I saw a man in Harris Tweed*
As I walked down The Strand;
I turned and followed him like a dog
The breath of hill and sea and bog
That clung about that coat of brown
And suddenly, in that London town,
I heard again the Gaelic speech,
The scrunch of keel on shingly beach;
So with buoyant step I went along
Whistling a Hebridean song,
I was a man renewed indeed
Because I smelt that Harris Tweed
As I walked down The Strand"

Somehow, for me at least, those few lines captured the whole mystique and magic of the island cloth—a warp and weft not just of spun wool but of interlocked lives, memories, traditions, and experiences, many traumatic and decimating, but shared by all crofters and weavers here, bound together in this wild, ancient, and beautiful place.

WE VISITED MARGARET MACKAY AS Katie had suggested and she had no hesitation at all in dealing with our questions about the urine-using aspect of the dyeing process.

"No, of course I don't use it! What's the point? There are so many

other ways of 'fixing' color in the wool fibers—mordant salts of aluminum, iron, copper, and zinc are fine. And some of the dye stuff like crotal—lichen—is 'substantive' anyway, and usually doesn't need a mordant to keep that lovely rich red-brown color . . . So, pee-pots and *maistir* barrels are all gone now. Thankfully!"

We liked Margaret from the moment we entered her entrancing little world of dye-plant gardens and tiny shop, set by the roadside on the edge of Tarbert. The shop was full of her subtly colored balls of wool yarn and her handcrafted cushion covers, peg bags, and collage pictures, and it was barely big enough for a couple of customers.

She was a teacher originally from southern England who moved to Harris sixteen years ago and had maintained her accent, her no-nonsense "listen to me, class" attitude, her forthright opinions on just about any subject you'd care to mention—and a beguilingly bizarre sense of Brit humor.

She needed it too. When Anne and I first saw her, crouched witch-like over a huge sooty black cauldron by her little shop, we both had an immediate attack of the giggles. Furious flames were roaring under the contraption, odd things were bubbling about inside, and tendrils of steam were whirling around her like ghostly wraiths.

"Bubble, bubble, toil and trouble," I heard myself calling out as she turned and peered through the haze.

Fortunately she smiled. "Yes, yes—but aren't I a heck of a lot better-looking than any of Macbeth's blinkin' witches!"

Margaret stepped out from the steam, wiping her forehead. "Crotal is such a nuisance. Needs so much heat to get it started right."

And so began a delightful island friendship with one of the last true experts in the traditional art of dyeing in Britain. It would take quite a few chapters to summarize all the subtleties of her dyeing processes, but what impressed us both was not so much the extent of her expertise but the deep-seated respect and affection she had for all the old traditional elements of tweed making.

"Most people have no idea of the work it took in those days to make a good tweed. I mean when you think you needed three large sacks full of stinging nettle leaves—and I mean leaves, not stalks—just to produce

enough dye for one small waistcoat—or as my American students call it, a vest. And the range of plants they used was amazing—they made a lovely deep orange from ragweed; red from the roots of lady's bedstraw; dark green from hogwort; yellow from bracken roots, and gray lichen or Stone Parmelia crotal for that deep red-brown henna shade you find in so much of the original tweed. And lots of other plants that you still see all around here—marsh marigold, and wild iris—that last one was particularly popular for deep, blue-gray color from the roots—you get a beautiful green from the leaves too, and a pale apricot from the seeds. And then there's elderberry too, bog myrtle, tormentil, brambles, meadowsweet, dock leaves and roots, ragwort, heather of course, even seaweed and willow bark, and those tall Scottish thistles before they flower—oh, and my favorite standby for a rich lemony-yellow color—peat soot! All *dathan duthchail*—true earth colors."

"Oh, I remember the peat soot," I said. "When I first visited Marion Campbell she made me stick my finger in a bucket of the stuff. Turned it yellow for a week—I looked like a chronic nicotine addict!"

"Yes—you would. These dyes really stick. You've got to be very careful when you're boiling the fleeces with some of these plants. I always use gloves, otherwise I'd be a walking rainbow! But now of course everyone's using chemical dyes—they claim they're more color-consistent and far less labor-intensive and I suppose they're right. But it's sad in a way—they don't have the subtle variations and color tones of the naturals. It's only the knitters now who really appreciate these. They're the ones who buy most of my balls of yarn—and they're very loyal. Keep coming back and back for more . . ."

"Well, I hope the islanders appreciate what you're doing to preserve their old traditions," said Anne.

"Ah well, y'never know with the *Hearaich*! I married one—Donald MacKay—fortunately he's a real 'traditionalist'—we're some of the last people on the island to still use our own peat bank for most of our fuel. People have got lazy nowadays. Coal is easy and cheap. Cutting peats in the spring—May and June—takes a lot of work y'know—backbreaking—especially for a couple of geriatrics like us! But the press certainly seems to appreciate what we're doing here—all the dyeing and whatnot.

Journalists are always coming and writing about us—*National Geographic, Elle,* BBC, lots of foreign magazines. They don't always get it right, though!"

"Why, is it a complex process?" I asked.

"No—not really. Getting the right roots and leaves in the right season can be a bit laborious, but basically you boil up the fleeces after mordanting them with salts to help the colors hold fast. The yellows can be difficult—they can fade if you don't use enough alum. And boiling times can vary. Crotal needs at least two hours depending on the condition of the lichen. Others need longer at a lower heat. But then after the dyeing comes the hard bit—the carding and the spinning into yarn. That's incredibly time-consuming—and tiring. But y'know, things happen— funny things—that make it all worthwhile. I remember once this little plump man came in—all very polite and gracious—and asked, 'Will you dye me enough wool to make a waistcoat?' He wanted a real rich crotal dye. He patted his tummy like a little Buddha. 'I need it to hold this in!' he said. So I did and sent it off to him. And then, a couple of months later Donald and I were watching TV—a debate in the London Parliament. And suddenly, there he was, asking questions of the prime minister—and he was wearing my waistcoat. And very smart he looked too. And slim!"

"Maybe I should get one of those," I said, doing a Buddha rub on my own rather prominent stomach bulge. Margaret laughed the deep, resonant laugh of someone who loved her life and her work. "Ah, well, y'could be right there! I see you in a mix of marsh marigold, iris root, elderberry . . . and maybe just a touch of heather."

"I'm glad you skipped the nettles."

"No, you're not the nettles type!"

"And the peat soot . . ."

"Well—maybe not the soot . . . but as you mention peat, you're always welcome to join Donald and me at our bank . . ."

"Where is it?"

"Just outwith town on the Rodel Road."

"You just said 'outwith.'"

"Did I?!"

"Yes—meaning 'outside,' I presume . . ."

Donald and Margaret MacKay—"At the Peats"

Margaret laughed. "Yes—but y'know, I didn't realize . . . oh boy, I've
been on this island far too long!"

And it was that laughter and her ironic humor that lured us a few
days later to watch—and even participate briefly in—the peat cutting, or
"winning," at their own peat bank a couple of miles south of Tarbert.
And mutual giggles were in full force as I valiantly tried to master the

subtle art of slicing into the thick, moist, chocolate mousse–textured peat with a traditional long-handled peat-iron (also known as a *tuskar* or *cabar lar*). The slicing itself was relatively easy, with the long, thin blade pressed down by foot like a spade, but the use of the clever little hook-like device, or flange, attached to the blade to ease the peat clear off the bank into the hands of the "lifter" eluded me. Time after time my peats would be on the verge of "breaking" (a real no-no) and Margaret would have to rescue them before they crumbled into useless fragments.

"Look—why don't I just sit and sketch the two of you," I suggested a little shamefacedly. Anne nodded enthusiastically.

"Na' there's a fine idea," said the diminutive Donald, desperate to save his bank from my neophyte destruction.

So, as the two of them worked together in a steady rhythm of cutting, lifting, carrying, and piling each peat in a semi-upright position on the drying stack, I tried to capture the graceful flow of their movements.

Apparently they'd "inherited" this bank, approximately fifty feet long, twenty feet wide, and four feet deep, from an elderly neighbor who had recently died. The top layer of "turf" had been removed to expose the rich peat, which they now cut into rectangles, about a foot wide and four inches deep and eighteen inches long. Donald told us that "a fair fit man" could manage to cut up to a thousand peats a day, but even at this rate it could take up to fifteen long, hard days to cut enough for the average house during the chill winter months. If the weather is kind, the stacked peats are dry enough in two weeks to set up as *casbhic* (little feet)—three peats "set tentwise" with a fourth across the top. After further drying they can then be built into "stacks," ready to be carried in sacks, peat barrows, or even the old-fashioned wicker basket "creels" to the roadside for transport to the *cruach* peat pile at the side of the house.

"Of course," said Donald a little morosely, "on our wee wet isle, the dryin' can be a bit of a problem, and there's nothin' worse than a winter spent tryin' to burn damp peats. They should to rights be very light—almost like polystyrene—but here . . . well, y'just never know . . ."

They both paused for a rest and a nibble of their lunchtime "pieces"—lovely thick beef sandwiches—which they shared with us.

Then I followed Margaret as she wandered away from the bank, turned, and just stood looking at it.

"Donald's doing great," I said. "He must have cut a couple of hundred peats already . . ."

Margaret didn't reply for a while and then, with a chuckle and a sigh, she said quietly, "Y'know, after a few years of this y'get to think of it as just another part of everyday life . . . until you stand back and look . . ."

"Yes," I said. "It's like a part of something ancient . . . something that's been done here for . . . countless centuries."

"Thousands of years, most likely."

We were both silenced by the thought. Then Margaret said quietly, "If you look around at the shape of the moor here you can see scores of old banks. Some are grown over now but the outlines are still obvious. And not so long ago there'd be dozens of people out here in May, before the midges came if they were lucky, helping each other—'crewing' they called it—an' eating their pieces together like one big family . . ."

I nodded. Too much here on Harris was changing. Too many of the old ways were being lost.

Margaret echoed my thoughts. "Well, I'm trying to keep something . . . with my little business . . . but sometimes . . . oh—and did you hear—I meant to tell you earlier—there was an article in the *Gazette*—Derick Murray's trying to sell his tweed mill in Stornoway . . . the one that supplies all the warp to the weavers . . ."

"That's interesting—I hadn't heard," I said, shaken by her information, "and Anne and I are going to see him next Thursday."

Margaret gave a sad shrug. "Well, maybe you should get there earlier. He may have cashed in by then!"

WE DROVE BACK TO TARBERT in a subdued mood and found the depressing article:

The future of the Harris Tweed industry has been thrown into doubt after the main mill owner has put his business up for sale . . . Managing director, Derick Murray, says he was reluctantly selling the KM Harris

Tweed Group after a lifetime in the industry . . . The group accounts for over 95% of total production of the world-renowned fabric . . . About 200 home-based island weavers are commissioned by the company.

"If there's an offer that's acceptable I will sell it," said Mr. Murray. "It will be hard to part with it, but life must go on, that's the way I look at it. I have got to move some time or other and this is, I think, the time to do it. My kids are not following me into the business and I made this decision as time went on . . ."

Derick agreed to an earlier meeting and it was not an uplifting hour. As soon as we walked through the main door and saw the dustily dismissive display of numerous once-treasured Queen's Awards for Industry on the wall at the base of the stairs, we knew something had gone terribly wrong with this focal point of the island's tweed industry. And as we climbed the stairs to his office, passing faded black-and-white photographs of tweed weavers at the looms, a sense of imminent disaster swirled around us.

Derick greeted us in his rather spartan director's office with a wan smile on his round but heavily lined face.

To give him his due, he put up a long and loquacious defense of the industry and insisted that "a buyer will definitely be found and no jobs should be lost. I'm talking to a group from Turkey next week. There've been twelve other bidders too and I've reduced the price quite significantly, so I'm quite optimistic."

Unfortunately, the look of wariness in his eyes didn't seem to reflect the optimism of his words. Finally his exasperation broke through:

"We've all tried so hard! The government and the European Union have helped us retool the industry, bring in the new double-wide looms, develop lighter blends of tweed for the designer markets. But everything seems to be against us. Even our own weavers sometimes. Some were not so keen to use these new machines. But the biggest problem is that no one's wearing jackets anymore! And . . ."—he gave a cynical chuckle—"even if they do, one Harris Tweed jacket'll last a lifetime anyway! And then there's the British pound—it's too high. Kills exports. And tariffs—especially those in the USA—they can stop trade so fast.

And too little promotion too—there's a lot of competition out there nowadays. And false labeling—we've seen far too much of that, especially in Asian products. And that's our key lifeline—our 'Orb' mark. And China—China's really turning on all fabric makers. Underpricing everyone."

We cut the meeting short. It seemed unfair to question Derick about the future at a time when, from his standpoint, there was no future. At least, not for him.

"Oh—I keep hearing rumors y'know. Companies want to use Harris Tweed for handbags, upholstery, golf bags, baseball caps . . . but nothing ever seems to come of them. We've been on a slide now for too long . . . and there's nothing worse than having all this hanging over our factory workers and our weavers. It's terrible for them."

"DERICK'S A GOOD MAN," INSISTED cheery-faced Robert Ferdinando at his Celtic Clothing store on Bayhead Street in Stornoway. "A very good man. He's given everything to that company and what's happening now is hurting him so much . . . I actually worry about him. It's almost too much for one man . . . he *is* Harris Tweed. Although he doesn't own the actual Orb label, almost all the fabric produced here comes through his two factories and his home weavers."

Despite his decidedly non-Hebridean accent and his family's ancient origins in pre-seventeenth-century Portugal, Robert has a deep affection for the islands and all the pomp and pageantry of Scottish traditional dress. Here, in his small tartan- and tweed-crammed store, he sits weaving meticulous bird's-eye fabrics on a gleaming modern double-wide loom while his wife, Kathleen, a bespoke tailor, coordinates the production upstairs of elegant silver-buttoned jackets, tartan vests, and those meticulously box-pleated kilts particularly popular with bagpipe bands.

"For a little over a thousand dollars you can walk out of here in full Highland dress," said Robert proudly. "The kind that Queen Victoria virtually invented for her own staff and the military—Argyll jacket, vest, shirt, tie, kilt, buckled belt, sealskin *sporran*-purse, hand-knitted socks complete with a wee dirk-dagger—a *sgian dubh*—stuck into the right

sock, and beautiful, sparkling-black, patent leather shoes, or *ghillie brogues.* Oh, and we can even provide the underwear—despite all the jokes, underwear is rather essential! Or y'can rent the whole outfit for a day or two and see how you feel."

For a moment—just a moment—I was tempted. Anne saw the look in my eyes and tried to convince me how cute I'd look as a traditional bagpiper.

Robert overheard her remark. "Yes, and isn't it nice to become a completely different person once in a while!"

Being somewhat of a proponent of Walt Whitman's "I contain multitudes," "multiself" concept, which encourages us to become as many different selves as we, in actuality, are, I was tempted by Robert's suggestion. And as we chatted with him we realized what a kaleidoscopic, peacock's-tail range of personas he'd become in his own reasonably young life. "Oh—I've morphed around quite a bit—a rather protean eclectic life as a musician, driving instructor, teacher, airline pilot . . . and a few other selves I'm not quite so proud about!"

"But it looks like you've settled down now . . . it says on your brochure that you've been here for twelve years."

"Yeah, that's about right. We came up from Newcastle for a vacation and never left!"

"And got yourself one of these expensive double-wide looms."

"Yes—and they are expensive. Price of a small car! That's when Derick made himself a bit unpopular too . . . trying to get weavers to invest in these things. Many considered it to be the death knell of the traditional weaver—said that the 'new' tweed didn't have that 'old tickle,' and 'famous fearsome hairiness.' Also, they often had to rebuild their loom sheds to get it inside! Bit of a difficult time . . . for everyone, 'specially as the industry declined from around two thousand workers and weavers and over seven million yards of tweed a year to less than five hundred and barely a million yards nowadays."

"So—what's the future? Will tweed just become a quaint craft hobby for a few older weavers?" I asked.

Robert gave a hearty belly laugh. "Well, no, not if Donald John MacKay has anything to say about it!"

"Who?"

"Donald John. Of Luskentyre. And his wife, Maureen. Y'mean no one's told you about Donald? He's our tweed hero! Should get a knighthood or something for everything he's trying to do to keep the weaving alive . . . ah, y'must go and see him. He'll put a smile on y'face. Obviously Derick didn't, so why don't you visit Donald instead!"

I was reluctantly leaving Robert's shop, still eyeing his kilt kits and beautiful tailored tweed jackets, when I was struck by a spontaneous urge.

"Darlin', I've decided what I'd like for my birthday present. It's time for me to do my bit for the Harris Tweed industry."

And so I walked away from the shop in a beautifully cut gray-blue and olive-green herringbone tweed jacket, which indeed possessed just a touch of the "old tickle."

Robert called out a farewell—and a blessing. "May you enjoy it, wear it, and live until you find it in shreds and tatters"—the implication being, I assumed, that as my jacket would never wear out, neither would I.

Then came Donald John MacKay.

"Aye, come in, come in—close the door. There's a nasty blast off the sound today. C'mon here and stand by mi'heater. I'll turn the radio off, otherwise I'll not be hearin' a word you're saying."

So far we hadn't said anything except a brief hello as we peeped our heads into Donald John's workshop at the side of his bungalow-home overlooking the magnificent sweep of the Luskentyre sands. At first we thought we'd stopped at the wrong place. Despite a small sign confirming that this was indeed the location of the Luskentyre Harris Tweed Company, Donald John's well-loved and well-respected business, we expected to see something a little more impressive than your standard minute metal-walled loom shed.

"Maybe there's another building at the back of the house," whispered Anne as we walked up the muddy, rock-strewn path.

There wasn't.

This was all there was to the great Donald John and Maureen MacKay empire.

"Aye, it's cozy, isn't it," said Donald John, his elfish face and mischie-

vous eyes gleaming, and his handshake, viselike in strength (hardly sur-
prising, with fingers as tough and grained as the keys on a Wild West
honky-tonk). He spoke in rapid staccato sentences, his mind apparently
whizzing along faster than his voice could keep up. "Well now, what
would you like . . . oh, some tea, would you like a cup . . . ah, no, no,
Maureen's out isn't she and I'm hopeless in the kit—Anyway, so this is
my loom and over there . . . you'll have to go in the other door if y'want
to see all my different tweeds. Is that what you . . . shame about the tea . . .
I like to have tea with visitors when . . . so where are y'from . . . are you
stayin' on island or . . . ?"

Finally his zip-zap monologue ceased and he sat grinning at us, wait-
ing for some kind of response.

We described our ongoing odyssey through the island world of the
"tweed people" and he listened, still grinning, as we explained that from
what we had learned so far, it appeared he was going to be the only one
with anything positive to say about the future of this poor beleaguered
cottage industry.

He nodded understandingly and spoke now a little more slowly.

"Well, yes, yes, it's a difficult time indeed. And poor Derick. He's in a
real bind. Been trying for years to get more trade for us all. But you
know, there's only so much one man can do . . ."

"Well, according to some, you're now that man!" I said.

Donald John gave a kind of spluttery chuckle of bashful modesty.
"Me. Is that what they're sayin' now? Well—I must admit it's not been a
bad year or two for us. Some nice orders from the Japanese and whatnot.
But it's not really what y'could call a 'revival.' No, I don't think so yet.
And if Maureen was here she'd possibly put it a lot more bluntly too!"

"Does she work with you? On this loom?" asked Anne, pointing to
one of the most well-used, fluff-flecked, greasy-looking Hattersley foot-
pedal looms we'd seen so far on the island.

This time Donald John gave a real belly laugh. "Maureen!? On this
thing? Oh no—no—you'd never see her on this. Have y'ever tried one
of these things? I should let y'have a go. It's a killer on the legs. These
foot pedals need a lot o' push to keep 'em working right. No, I don't
think my Maureen would enjoy it very much at all. But! But she's a

wonder at the computer! That's what she does and she does it very, very well. In fact, if there's any reason I'm still here after all these years, it's because of her gettin' on the Web and the e-mail and all that stuff and somehow gettin' the world to come over and visit us and—if we're lucky—place orders with us. And we've been pretty lucky. Some good orders from Norway, Taiwan, Kathmandu, Germany—and even a bunch of cowboy types in Tehachapi, California. They ordered a whole lot to make special waistcoats for themselves! Oh, and also, we got some from some of the big fashion names too—y'know, people like Donna Karan, John Galliano, Valentino, and Jimmy Choo. Not huge orders, but they like my patterns and the fact that I still work as close to tradition as y'can these days. Not the dyein' and the spinnin' and things like that of course, but the weavin' itself. I think they respect that. And I think they respect the fact that I won't—I can't—compromise. I won't mess around

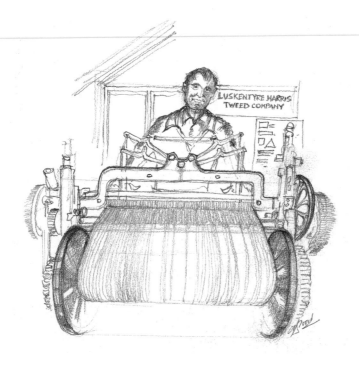

Donald John MacKay—At the Loom

mixing in these new yarns and crazy colors. That's not the Harris—that's some other kind of mix—others can do that off-island. I won't."

Donald John paused as if a little surprised by his own spirited outburst. "Y'see I was born here in Leverburgh into a weaving family, very strict principles, and very hard work. I remember m'dad used to tell me when I didn't feel like fillin' the bobbins for him: 'No bobbins—no brose and no bannock cakes!' That was a good way to remind you of principles—and I'm still proud to keep 'em . . ."

He paused again for a moment and his face became a little forlorn. "But . . . y'know what I think is saddest . . . most of all . . . I get visitors here from all over the world and I've had lots of school groups from Ireland, Italy, Norway, and other parts of Scotland and Britain, but—well, y'can hardly credit it really can ye—I've yet to see any of our own children from the local schools here come and visit and watch what we do . . . what hundreds of us used to do. Proudly . . ."

There was silence for a while and then Anne asked, "Can we watch what you do?"

Donald John's face lit up with undisguised pleasure.

"A' thought you'd never ask! I'll show you what this old thing can do, all right—she's over thirty years old and still good for another thirty. Forget y'double-wides, I'm sticking with this beauty. An' I'll tell y'another thing too. Don't be writin' off our Harris Tweed yet. Not by a long way. We've had our bad patches before and we're in a bit of a sticky mess at the moment but . . . well, if Maureen and me have anything to do about it, we'll find something to kick-start all the looms again. I promise you—it won't be long before you'll be hearing this sound again all over the island."

And with a straight back and proud shoulders, Donald John sat down at his tweed-covered bench (actually, just a plank of wood). Within seconds his old loom creaked and groaned into action. And the rhythmic, almost railroadlike clickety-clack, clickety-clack of the gears and wheels and bobbins began, and the weft yarn scuttled backward and forward between the warp threads as he worked the sturdy iron foot pedals, and his body swayed slowly from side to side with the noise of the wheels and the smell of the yarn wool and the beautiful, smooth, blue-gray her-

ringbone-patterned tweed cloth emerging on the loom, inch by magical inch . . .

And we hoped—we even began to believe—that he was right and those sounds and smells and the birthing of fresh tweed would soon become a daily part of the warp and weft of Harris life—once again . . .

3

Clisham Keel Gleanings

———————————

YOU LEARN YOUR HISTORY FAST here. You have to. The locals assume all outsiders are fully familiar with the intricacies of Highland traumas and, to one extent or another, might even possibly be responsible for them.

And one of the most notorious places for such crash courses in island historical intricacies is the Clisham Keel Bar at the MacLeod Motel just across from the ferry terminal in Tarbert.

Anne usually preferred the more refined ambience (relatively speaking, of course) of the nearby Harris Hotel, a sturdy haven of hospitality built around 1865. But from the very first day I strolled into the Keel—and come to think of it, it actually was on my very first day—I sensed that this was the kind of place in which I'd find the *Hearaich* spirit alive, well, and fully primed on generous measures of the malt washed down with frothy pints of Tennent's and McEwan's ale.

The Clisham Keel is not a pretty place by any stretch of the imagination. In fact, it has the distinctly battered, smoky, warped, and worn appearance of a pub fully accustomed to the antics of local youths, raucous rock and *ceilidh* bands, occasional beery brawls, and the bawdy brouhahas of the older "salts" who invariably occupy key positions along the small, brightly lit serving bar. Younger imbibers tend to choose the random scattering of Formica tables and the scratched and knife-slashed red Naugahyde benches around the edge of this small, but kind of cozy, watering hole.

And I shall long remember my first encounter here with the scrum of older patrons huddled in a corner by the beer pumps—a tight (in more ways than one) coterie of geriatric alcoholic alpha males. I had only planned to pop in, sample a half-pint to see what hoppy delights might await me on future occasions, sit quietly for a few minutes observing the pace and mood, and then return to our cottage to be debriefed by Anne on my discoveries. However, that's not quite what happened.

"So—what's y'tek on the Jacobean rebellion then, y'damn Sassunach . . . or m'be worse, d'y'ken."

I quickly "kenned" that the dumpy bull of a man at the bar with a red face, bright as a beer sign, was out to make an instant fool of this neophyte "incomer" (although not a "white settler," which is a definite term of derision in these parts) who had just walked through the door. But I had to smile too. Despite his bulk, his purple-veined face set in a wild tundra of cheeks and jowls, and aggressive "don't you eyeball *me*, laddie, or I'll decorate mi sporran wi' y'guts" look of ripe antagonism, the top of his balding head barely reached my shoulder and his huge walrus mustache, totally out of scale with the rest of his face, made him appear like Danny DeVito in dire dotage.

"Sorry . . . what are you talking about . . . ?"

"Culloden, y'great ignoramus. The greatest battle ever fought on Scottish soil!"

"Which—and please correct me if I'm wrong—I believe the Scottish lost. Rather badly, I think. Which led to the end of all your clans and your Bonnie Prince Charlie and—"

"Y'd not be insultin' our bonnie prince, now—the Great Pretender!"

"Pretender! I never understood that name. But I guess that's just about what he must have been . . ."

I knew I'd already pushed this mild bit of sportive repartee a little too far. And, quite frankly, I'd forgotten just about all my British history. But, as a Yorkshireman, I felt I had to do a little pretending of my own and fudge my way through this unexpected foray. After all, we lads south of the Hadrian's Wall border of Roman times had to put up with an awful lot of cattle rustling and wife stealing and daughter deflowering from

these kilted and bearded Scots, and at Culloden (odd how flickers of historical trivia return from the mysterious recesses of our memory banks), we finally kicked ass and paid the hairy tartan-clad hordes back for all their centuries of pillaging and plundering.

The little man was showing distinct signs of terminal apoplexy and I decided it was time to calm things down a bit: "Listen—can I buy you a drink?"

That stopped him cold just as he was about to rustle up a posse of locals leaning on the bar and pound me into the pavement outside for daring to malign his beloved prince.

"A dram, are y'askin'?"

"Yes. I see you're drinking the Macallan—a fine single malt. Let me buy you another one."

"No!" he said loudly, mustache quivering with bruised pride. "I will *not*, d'y'ken."

"Oh. Okay. I just thought . . ." My personality now seemed to be developing distinctly limp-shrimp characteristics.

"A stranger is a guest here in Harris. Y'must drink the first dram on me. In fact, y'look like a drinkin' man, so y'll be havin' a double . . . Dierdre, a double o' the malt f' t' man 'ere . . . and y'might as well splash one f'me too."

"Well—that's very kind of you" (limp-shrimp becoming less limp now).

He dismissed my thanks with a florid wave of his fat, horny-skinned fist, and the storm of confrontation seemed to pass as he smiled and we clinked glasses.

"*Slainte!*" he said.

"*Slainte!*" I replied in my best pretend-to-be-Scottish accent. And I thought, I can't remember the last time a stranger offered to buy me a drink in a British pub. And come to think of it, I can't remember when I've seen so many mature gentlemen so looped in a pub before. In England, pub drinking is more of a social occasion. But here on Harris, apparently, even at eight-thirty in the evening, it's a serious form of mutual decimation.

"Competitive drinking is Scotland's scourge," I'd read in a north-of-

the-border newspaper, warning of the chaos normally experienced on days like Mad Friday, just before Christmas, and the whole of the holiday season. There didn't seem to be much in the way of competition here, though. They were all winners. They were all drunk. But still talking and cheerfully confirming that old adage, "Lots of truth in a full bottle of whisky, lots of lies in an empty one."

All in all, from what I can remember, the evening ended amicably enough. My initial antagonist introduced me to all his old friends around the bar and shared with me a very long, and possibly overly intimate, story of his checkered life (hardly what you'd call an eloquent avant-garde monologue but certainly very colorfully vibrant). And I rolled home, somewhat later than I'd intended, to share with Anne the details of the evening or whatever I could remember—which, if I remember rightly, wasn't much . . .

A WEEK OR SO LATER there was yet another emotive exchange of ideas at the Keel. Most of the time things were pretty quiet here. Even boring on occasion. But I found the bar a pleasant place to while away an hour or so, catching up with my newspaper reading and generally enjoying the slow, rhythmic routines of island life.

But not on this particular occasion—which I can only liken to a "quiz," a popular evening pastime in British pubs. Only this one was a little different from most of the others I'd experienced . . .

"Like what?! Like what has Scotland done for England or for the rest of the world?!" This was a young man speaking rather pompously and aggressively—in flurries of narcissistic fury. He was tall, lean-faced, lardy-skinned, dandyishly dressed in what seemed to be a brand-new Harris Tweed jacket. He possessed one of those rather irritating "plummy" voices, reminiscent a little of Prince Charles in one of his more arrogant of moods. "Other, that is, than inventing porridge, haggis . . . what else . . . cock a' leekie soup . . . and kippers? No, not kippers. They're from Yorkshire. Whitby. Oh, and Scotch—right. Scotch whisky. And kilts—but no one wears those anymore—in fact they were never really traditional anyway. And . . . what else . . . oh, of course, bag-

pipes. And thank you so much for those. They sound like a bucket of screaming cats."

"And that's it, is it? That's all you can come up with?" This came from an elderly man with whisky-reddened cheeks, a broad brow furrowed like a freshly cut peat bed, and a huge mat of Santa Claus–white hair. He seemed to take the young man's outburst lightly, smilingly, but I sensed that traps and lures might be awaiting this strident outsider.

"Well, Scotland's only a tiny part of the world, isn't it? Can't expect too much, can you . . ."

"Weel now," the elderly gentleman said in a slow, laconic tone, thick with brogue, "how would y'feel if I told you just about every part of y'daily life has something to do with a Scotsman. Every single part. Now would that be worth a dram or two?"

That's an intriguing idea, I thought. I was sitting by the window, pretending to be reading my *Stornoway Gazette,* but actually wondering if the elderly man—so ready to wave the banner of Scottish pride in front of the sniggery face of this rather impudent young Englishman—could back up his extravagant claim.

"For example," he began, "what wa' that y'were wearin' when y'came in an' sat down 'ere?"

The Englishman was nonplused at first and then realized the old man must be referring to his raincoat. "Er . . . a raincoat. So?"

"And what's another name f'y'raincoat, d'y'think?"

There was a pause, and then, realizing that a trap was possibly being set by the crafty old Scotsman, he mumbled, "Macintosh."

"Wha'—a dinna hear ye."

"A Macintosh," said the Englishman a little louder.

"Veery gude, young man. Invented by our ver' famous Mr. Charles Macintosh of Glasgow. An' of course, I see you're wearin' a jacket of the great *Clo Mor.* Our Harris Tweed. Known the world over. An' now—how did y'get 'ere t'day?"

"What—here, to this pub?"

"Aye, of course. Where else?"

"By car."

"And what makes y'car move d'y'think?"

"The engine."

"Aye, well, there're plenty of engine parts made by Scottish inventors, but what helps your wee car move along the ground?"

"Wheels. I suppose you'll tell me Scotland invented the wheel too . . ."

Silence—but an ominous scowl on the old man's face.

"Okay—tires."

"Now tha's right. Now y'thinkin'! An' who, may I ask, invented your tires—the inflated ones?"

"I have no idea at all—and I'm honestly not sure I really care," replied the Englishman, maintaining his quixotically arrogant stance.

"Ah—weel. That would be our dear Mr. Dunlop now, wouldn't it? Another fine Scottish gentleman."

No comment here from the Englishman, but one could sense a distinct deflation of bloated bombast.

"An' what did y'car drive on t'get 'ere t'day?"

"Roads?"

"Weel, yes, that's true—roads. But what were the roads covered with?"

"Tar."

"Weel, actually, the proper name is macadam—as in Mr. John MacAdam—and before w'had petrol motors, what kind of engines did we use?"

"Oh, I don't know," said the Englishman with increasing frustration. "Steam?"

"Veery gude, indeed. Y're doin' well, young man. An' d'y'remember who invented the steam engine by any chance?"

"Er . . . Watt. James Watt."

"From . . . ?"

"Scotland, I suppose."

"Naturally. From Greenock, actually. Near Glasgow."

"Fine. I get your point. But that's just a few things."

"A few!? Is that what y'think now? Well—may y'should remember a lot of other things too, like the telephone invented by our Alexander Graham Bell, and then the television by our clever Mr. Baird, an' the bicycle, an' penicillin, an' the Bank of England—now that's a surprise

f'ye, isn't it—but that was started by our Mr. William Patterson of Dumfries."

"Yes—however . . . ," said the Englishman, showing signs of a fragile psyche fraught with fractures. But the old man was on a roll.

"And that fine sandwich y're eatin' . . . what's in it?"

"Beef."

"An' what kind o' beef would you be thinkin' that might be?"

"No idea."

"More likely, it'll be our famous Aberdeen Angus. And if it's not, it should be. And if you had marmalade with y'breakfast, that's Mrs. Keiller's creation from Dundee—isn't it?"

There was no response at all now from the Englishman, so the old man continued: "And I won't bore you with all our great writers and poets like Robbie Burns, Sir Walter Scott, and Robert Louis Stevenson because I'm sure y'know all 'bout them. But the greatest book of all— we can claim that, too. And what d'y'think that might be, young man?"

"Oh, I don't know. The Bible, I suppose."

"And you suppose correctly! My, what a fine brain y'have. Y'could almost be a contender for a Scotsman . . . and who was it that made sure the Bible was translated into a language w' could all understand?"

"I forget."

"No, c'mon now. Think a wee bit. King . . . ?"

"King . . . James."

"Yes! Well done. And which one of the Jameses d'y'think it was?"

"Eh . . . the Fifth . . . no—the Sixth."

"Ah, that's right. My—y'should be in one o' those millionaire quizzes. And where d'y'think the good king was from?"

A long, reluctant silence followed.

"C'mon now. Y've got most of y'other answers right so far."

"Okay. Scotland."

"Well—now there's a fine young man! That wasn't too difficult at all, was it? And of course, there's a lot more, y'know—a lot more, to be sure. Many other inventors we have. Great engineers and builders. In fact, if y'study y'history carefully, y'll see that the British Empire—y'know, all those great sweeps of red that once covered the world maps in school

classrooms—well, who d'y'think really controlled all that? Y'know— managed it, made it work . . . made it very, very profitable . . . who d'y'- think that might have been, a' wonder? Who?"

The young Englishman couldn't help but be amused by his own folly at being trapped into such a dialogue and he smiled but said nothing.

"Aye, weel, y'll know all these people I'm talkin' about—all these clever Scots—we had so many. And now I'm chust thinkin'—didn'a we have some wee kind o' drinkin' bet on all this? I've forgotten now . . . ," said the elderly gentleman, with a beguiling grin.

The Englishman laughed. "No, we did not, but what would you like anyway?"

"Och, a wee dram would be chust fine. An' ver' gude o' ye t'ask, lad- die!"

"Fine," said the Englishman gracefully, and rose to go to the bar.

"I'll have Talisker—if y'd be so kind" (a very fine and expensive sin- gle malt whisky made on Skye).

"Okay. Talisker it is, then."

"An' while y're at it, might as well make it a double. All this talkin' makes y'so thirsty, d'y'ken."

His beaten opponent smiled, "Oh, yes, I do indeed ken."

I heard a male voice whisper to someone at at an adjoining table. The lines had a familiar ring—something from a Jack Nicholson movie, I think: "Smart-ass! And if he's so fuckin' smart, how come he's so fuckin' dead. Dead by Donnie!"

"And what a blush on his face!" murmured another with dismissive flippancy. "Brighter'n a baboon's bum!"

I was about to leave the Keel after that diverting little incident, but saw someone signaling to me from the bar. It was Angus MacLeod, who, with his father, runs this lucrative little complex of pub, restaurant, hotel, and self-catering cottages. Angus was a handsome, young, sparkle-eyed individual with a great sense of humor and a welter of island tales, although, to give him his due, he always claims his father tells them much better than he does.

"So—did y'see old Donnie up to his tricks?"

"Is that who it is . . . he's a sly old so-and-so."

"Och—y've no idea. Gets 'em every time. Hardly ever needs t'buy a drink hiself. Sometimes it's sad to watch 'em gettin' snared. But they all usually end up laughin' and drinkin' the night away with 'im. He's harmless—but he knows how to get the hook into 'em."

Angus and I had chatted on many occasions. Anne particularly enjoyed his company. He seemed to have little of the island "angst" that we detected in many of the older residents. He'd lived an active and varied life, even spending some time in Manhattan—and having a wild old time there too. "Can you imagine that?" he once told us. "Coming all the way back to Tarbert from a magnificent place like Manhattan. But I missed the people . . . the spirit of the people here and the family closeness. Most of my friends still live on-island and those who've left don't have a quarter of the fun that we have. We've got the boats, the fishing, surfing, singing, drinking, climbing, football—you name it. And even the winters—people laugh at me for spending the winters here because we close down much of the place, but I look forward to it. Best thing is, what happens is the closeness, the hard core of the community—we're all still here and we take it deeper and we have an even better time! And there's always stuff going on. I've done quite a bit of acting. BBC. I got involved in that crazy *Castaway* project on Taransay." (*Castaway* was one of the first *Survivor*-type reality TV shows, of which there are many tales on-island here, particularly those told by Bill Lawson.) "And I got a part when they made the film of Finlay J. Macdonald's book *Crowdie and Cream*, and I got a couple of lines in that film *The Rocket Post*. Do you remember that story?"

I did, but Anne didn't and she asked him to tell us about it. So Angus recounted how a German inventor, Gerhard Zucher, in 1936, tried to persuade the British government that mail and medicines and the like could be easily and cheaply delivered to remote islands by rocket. He claimed that such a device would survive any kind of wind and weather and he set up a demonstration on the nearby islet of Scarp, but unfortunately the rocket and all its contents of letters and supplies blew up. Twice.

"Poor guy," said Angus. "He never seemed to get much luck. He went on to develop rockets for the Germans which did some damage

to London during the Second World War, but for some reason, Hitler didn't like him and had him 'liquidated.' It could have been a great film. From the bits I saw, it *was* a great film. Cost over ten million pounds to make. Originally there was going to be a real heavy-hitter cast—Albert Finney and Sean Connery. But something went wrong—in fact, everything went wrong and somehow the money vanished, and even the incomplete film itself vanished. It's been found again recently, and there's even talk of releasing it, but I've heard that my lines were cut so I guess I'm never going to be famous as a film star. I'll just be stuck here with my dad, lookin' after all our locals an' watchin' the tourists come in—and get fleeced by Donnie."

"Well—they certainly seem to like this place. By the way, how did it get its name?"

"Oh," said Angus, with a grin, "that's quite a story. *The Clisham* was a tough little cargo boat owned by my great-grandfather. Used to run coal and salt. Originally it was owned by some Dutch gin runners—a 'gin cutter' is what they used to call it at the turn of the century. And once it was runnin' booze and tobacco and perfume off the coast of Ireland and the coast guard grabbed 'em and impounded the boat in 1901. They imprisoned the crew and were selling off the boat cheaply so my grandfather bought it and he used it sometimes to run all the way to Poland for coal. Eventually it got beached and was pretty much destroyed in a storm. All that remained was the keel—the iron keel—which we still have just across the road. So we named this place after the boat and my grandfather."

"And have you seen many changes since you got back from New York?" asked Anne.

"Oh yes, maybe too many. Tweed is one of the saddest things. I don't think it'll ever die, but it just doesn't seem to be a modern kind of fabric at the moment. Maybe if y'mix it with cashmere an' things . . . problem is, it's too strong and heavy. It lasts forever! Y'buy one jacket an' that's it for the rest of y'life . . . but . . . I hear there are some new things happening. It may have a comeback . . . again. But tourism, I suppose, is definitely the key to our future. The challenge is balancing what brings people here—the remoteness and the solitude and the wild beauty of

the place—with the increasing number of people who may want to visit. I tell them it's not for everybody. It's magnificent, but you have to be able to handle all those days of rain and wind—and midges! Not everybody can see its beauty in the wind and rain . . . but we don't want a Spanish tourist–type market. We need what we have. We possibly also need another Lord Leverhulme to come and get us organized again. There's always lots of meetings going on and lots of new projects thrown about—most of which we *Hearaich* seem to oppose. But I don't think we do it just to be difficult. I think we all know that this island, despite how strong it looks, is still fragile, and keeping a balance here between the wildness and all these wonderful new schemes and dreams of the 'white settlers' and others is our biggest challenge."

"Well, Anne and I certainly sense an awful lot of pride here on this island."

"Oh aye, there's plenty of pride about," said Angus, laughing, "and with people like Donnie around braggin' as to how we Scots invented everything an' run the whole blinkin' world, that pride'll never die!"

We toasted Scottish pride.

Then Angus, still laughing, said, "Listen, have y'heard this one. Could apply to quite a few of our regulars here." He gestured toward the huddle of dram-and-chaser geriatrics at the bar. "This old guy comes into his local and spots a fine young thing at the bar. 'Oooh, that one's for me,' he thinks, but a long day's drinkin' has not done much for his mental agility, as he leans over and slurs out, "Scuse m'miss . . . but plis would y'be tellin' me now—do I come here often?' "

Angus was right. That could just as well have happened—and possibly has—at the dear old Clisham Keel.

4

A Day with the Lobstermen

———————————◆———————————

L OOKS LIKE A NICE CALM DAY," I said in morning-buoyant
mood. Very early morning, actually. Quicksilver-light time.
Around 6:00 A.M. The traditional Hebridean time to go prawn
fishing or lobstering. And The Minch did indeed seem calm, blue and
sparkling despite gauzy frills of dawn mist around the rocky inlets, and I
was looking forward to my first day out on a fishing boat with three
experienced reapers of the deep.

My jaunty comment elicited no response other than a whispery
grunt from Angus Campbell, the tall, forty-two-year-old owner of *Har-
mony*, his fishing boat, a foxy kind of grin from his leaner brother, John,
and a wee chuckle from Duncan, their apprentice and third cousin
removed on their mother's side. (Or something like that. Everyone seems
to be related to everyone else on Harris.)

"Did y'have y'breakfast already?" asked Angus in what I assumed was
a kindly expression of concern for my gustatory well-being.

"Actually, no. Just coffee," I said. "But I brought sandwiches."

"Best keep those for the time bein'. Until y'get . . . adjusted," said
Angus, his large chin wagging ominously.

"Adjusted—to what?!" I asked with neophyte nonchalance.

"To the sea, man . . . to the sea."

I stared again eastward across the twenty-mile-wide Minch toward
Skye. Had I missed some key indicator of trepidatious conditions out there?
A spiraling water spout? A surging tsunami? A boat-sucking whirlpool?

"Looks smooth enough from here," I said complacently.

"It's not here I'm talkin' about. It's there. Out there five miles. Can y'see those whitetops?"

I stared again. Yes, I could see something but I assumed it was just lines of sun-glitter striations across the water. Signs, I assumed, of a benevolent calm.

"I thought it was just reflected sunshine."

"Ah, did y'now?" said Angus, now with the same foxy smile as his brother. "Well—we'll just have to wait and see, won't we?"

I had a feeling I was being made the butt of some undisclosed joke, so I changed the subject. After all, I was a guest on their boat and maybe a not particularly welcome one at that. It had been Angus's wife, Christina, a sprightly individual with a generous spirit, who had suggested the idea and nudged Angus into acceptance. Reluctant or otherwise, I wasn't sure. This is what he and his crew did for a living every day, and maybe the idea of having some curious outsider getting in the way of hauling up his fleets of creels—hundreds of creels—didn't seem as enticing to them as it was to me.

"So, what are the plans for today? Prawning? Lobstering? Or what?" I asked.

Angus grinned benignly. "No, no lobstering today. To do that we'd have to be on the west side of Harris, going out into the Atlantic from the other pier in Tarbert. Seabed's rocky there and lobsters like rocky hiding places. We're on the east side today."

"So that means prawns?"

"Prawns it is—they like the sandy, muddy bottoms. Though maybe not so many today. The creels have been out too long and the bait will be eaten up by now. We couldn'a get out for the last five days. Weather was too bad."

"So if the bait's gone, the prawns won't come to the creels?"

"Right."

"But what about all the prawns that ate the bait in the first place? Won't they still be in the creels?"

"Unlikely."

"But I thought they were designed so that once the prawns got in, they couldn't get out again."

Another smile, a little patronizing this time. "Well—y'd be right if it were lobsters. They're too big to get out. But the prawns—actually they're langoustines—like small lobsters, claws and all. They're small and they're pretty canny. They can get back out easy 'nough and we end up with hermit crabs, starfish, and whelks. Nothing we can sell."

Something seemed a bit wrong about all this. Why design creels that can't keep their catch? Especially when bad weather is a regular state of affairs in these parts and boats can't always go out to collect their catch on a preplanned basis? I put the question to Angus but all I got was a shrug of acceptance, as if to say "That's the way things are and that's the way they have been from time immemorial." It was the kind of answer you get to a lot of questions—perfectly logical questions—on Harris. You accept it after a while and either stop asking questions or wait until you find someone with a broader purview. So, I stopped asking questions, settled myself into a sunny corner of the boat near the small cabin, and watched as the three of them went through the preparations for our journey out into The Minch.

Which, as Angus had hinted, was not calm at all.

In fact, as soon as we chugged out of the narrow rock-bound harbor, the change came. The docile demeanor of our forty-foot-long boat was quickly lost as a vigorous swell sent her lolling and rolling into five-foot waves, white-crested and erratically rhythmed.

"That's The Minch f'ye," growled Angus from the wheelhouse, carefully studying half a dozen electronic devices that gave him depth analyses, warnings of pernicious subaquatic rock ridges, weather forecasts, fish-shoal indicators, our GPS position down to a few yards, and even the precise location of his precious fleets of creels, miles farther out in the now truculent waters.

I kept my eyes focused on the horizon. On previous boat adventures in various parts of the world I found that I am by no means a natural-born sailor. Green-gilled nausea rapidly surges in, wavelike and stomach-churning, unless I have the horizon in view and blasts of ocean air that I can suck in deeply like cans of cold soda to settle my tumultuous intestines.

"Y'okay?" asked Angus.

"Me? Oh, I'm fine . . . thanks. Fine."

All three of them smiled together, like members of a club amused at the behavior of some errant outsider.

"When we get to the first fleet, we'll have some tea," said John. "Tea always helps."

"Helps what?"

"Well . . . y'know," he replied, grinning wider now. "If y'feelin' a bit . . . y'know . . ."

"Oh, don't worry about me. I'm fine," I tried again. "But a cup of tea would be nice."

"It'll ward off the Blue Men," said John mysteriously.

Angus Campbell's **Harmony**

"Oh, right—the Blue Men. I've heard all about them."

"Ah, y' know the story? I thought m'be y'hadn'a heard."

"Well—it's only an old folktale. Nothing to be fretting about, is it?"

"Oh, no. Many did, mind ye. In the past. When boats were smaller, an' all that. But not so much now. Things are much better, y'ken. Much better now . . . usually."

"How d'y' mean—'usually'?"

"Well, it's still best to keep y'wits 'bout ye," said John, smiling that mysterious smile again.

And, as if to emphasize his point, a sudden double-punch of waves moving in different directions caught us all by surprise. Angus gripped the wheelhouse door frame, John grabbed the anchor chain, Duncan slid a ways before hitting the rail, and I missed my handhold and ended up sprawled on the wet deck awash in wave spume, until I grabbed a leg of the sorting table and held fast.

"Hang on!" shouted John. As if I had plans to do anything else.

Slowly the boat righted itself and the surge diminished, and the now familiar bounce 'n' buck rhythm returned.

"Y'okay?" asked Duncan. Even he looked a little perturbed by his hasty skid across the deck, and I must admit I felt comforted by that look. They were all obviously experienced sailors, but they also knew, far better than me, that the sea is a pernicious companion whose friendship and felicitude can never be assumed.

"Fine," I lied again. This was my fifth "fine" in less than five minutes and I'd lied every time.

"Gotta watch out fer those wee sneaky little bastards." John was now only half smiling.

"Och—it's just the Blue Men playin' a bit wi' ye!" shouted Angus over the roar of the engine.

"Okay! Enough about these blasted Blue Men. Isn't it time for tea?"

And so it was, and we sat bobbing about like corn in a popper close to the orange buoys marking the first fleet of creels, slurping on Angus's strong, sweet tea. But the image of those demons of the deep waiting to lure us to a watery demise persisted and I kept my eyes fixed on the horizon, watching out for more of those pernicious waves.

When it came to the laboriously rhythmic process of hauling up the creels, I, of course, offered to lend a hand. And I assumed that such benevolence on my part would be met with good-natured gratitude and the promise of "extra rations" or something equally enticing for my endeavors.

"Oh—no, no, y're good jus' where y'are," said Angus, maybe a little too hastily.

"Yeah, stay there and you'll need to hang on tight," agreed John, obviously a reflection on my prior inability to stand upright when broadsided by errant surf.

Duncan just smiled. A trifle empathetically, I sensed, maybe because of his own lowly third-rung status as an "apprentice."

Now, I suppose I could indulge in a little artistic license and claim that eventually, as the grueling haul continued, they gradually turned to this big strapping individual (me) lolling by the rail and begged for the use of his muscular prowess. But truth must out and that didn't happen. They were the very picture of perfect teamwork, with Angus operating the noisy, diesel-powered hauling winch, which lifted the heavy metal and nylon-net creels over five hundred feet from the depths of The Minch.

Each "fleet" line contained a hundred creels, and up they came every ten seconds or so. Angus quickly removed the lead weights that had kept each creel firmly on the prawn-littered Minch mud; John flipped open the flap of the creel, poured its contents onto the sorting table that stood waist high on middeck, and tossed back into the waves the "junk" of small "brown" crabs, whelks, hermit crabs, and starfish (much to the frenzied delight of a host of gulls and gannets following in our wake). He threw, with remarkable accuracy, the larger "velvet" crabs (apparently very popular with the Japanese market), small octopus, and the footlong, sharklike dogfish—ideal as bait for velvet crabs—into separate buckets by the wheelhouse, and in a rare break of silence, he shouted to me, "Y'like octopus and suchlike?"

"Sure," I said. "Definitely."

"Okay, well this one's for you, then." He grinned, holding up a particularly large and gelatinous-looking specimen.

Then came the key task—Duncan's sorting of the langoustines, with their long flailing, lobsterlike claws—into three separate boxes, each box for a different size of langoustine and each slotted neatly, claws upward, into a grid of "tubes" within every box.

And so it went—a robotic regimen of creel hauling, opening, emptying out, throwing back, and meticulous size selection of the scores of scarlet and white, knobble-shelled creatures. I'd been told that as soon as we docked at the end of the day, these would be whisked away in a special refrigerated truck bound for Stornoway airport, and within a few hours, they'd be the specialty of the day at the dining tables of elegant tourist-resort restaurants and hotels in Spain.

The three of them worked silently and without pause until the first fleet of creels had been emptied and stacked in a rapidly growing pile at the rear of the boat.

"Fantastic," I gushed. "Looks like a great catch."

Certainly Duncan had managed to fill quite a few of his boxes and had never for a moment slowed in the rapidity and accuracy of his selection.

"S'terrible!" grunted Angus.

"No, s'not good at all," agreed John.

Duncan just smiled as usual and shrugged.

"Normally," Angus began to explain, "on a good run, we get anything up to twenty or thirty in a creel. Today we're less'n three or four. Like a' said—they've been down there too long because of the lousy weather. So the cheeky little buggers ate up all the salt herring bait and left."

"So why hasn't someone designed a creel especially for langoustines," I asked without thinking, "y'know, something with a narrower—maybe a more confusing—'entrance' or whatever y'call it."

There was a sort of hesitant pause until Angus stated the obvious: "Well, y'can get 'em if y'just a prawn man, but we do lobsters too and at a cost of twenty pounds plus a creel and twenty fleets—that's two thousand creels total—well, you work it out. We'd have to have double the investment—two lots of forty thousand pounds! Far too much outlay for a three-man boat. Even now, what with the oil, replacement creels,

ropes, tackle, and God knows what else—and all those damned taxes on top of everything—it's amazing we keep goin' even during the good months!"

"Ah," I said.

More silence.

"Well, okay, but—listen," I started up again. "So couldn't you just clip on a kind of extra escape-prevention net over the main entrance when you're prawning and then remove it when you're on the other side of the island going after lobsters?"

Brilliant idea, I thought. But for some reason it didn't seem to impress Angus and John, and before we had a chance to continue the discussion, along came another one of those mini *Perfect Storm* waves that caught us all unawares and flung us about the deck like flotsam.

"Jeez!" shouted John.

"Whoa!" agreed Angus.

"Shoot!" came a third exclamation. From me actually. Not only had I collided scrotally with a particular hard and rigid bit of deck furniture but my bucket of precious octopi had just been flipped over and the delicious little darlings were off spinning overboard in furious spumes of spray. "There goes my dinner!"

"Okay," shouted Angus. "Two more fleets and then lunch. Got some of MacLeod's sausage—goes great with slabs of cheese . . ."

And so off we went, farther out into The Minch, to continue the haul, dump, and sort process all over again while the gulls screeched around our heads and gannets dive-bombed the ocean voraciously for throwbacks in vertical, wings-folded formation. And when they tired of being bird-torpedoes, they started attacking the gulls, making them drop their pickings, which the gannets then snatched up just before they hit the water. The gulls were understandably annoyed by such incursions but were no match for these huge seabirds with their stiletto wings, piercing black eyes, and facial markings that made them look just like the angry, take-no-prisoners predators they were. The gulls screeched and wheeled and some managed to fly off with tidbits of lunch, but the gannets invariably won the game and perched themselves on the rolling swell, complacently digesting their ill-gotten gains.

Our own lunch came after another couple of hours of rhythmic hauling and sorting. Angus decided that he'd need to unload the empty creels that had been accumulating in their hundreds at the rear of the boat. So we headed out of The Minch swells and into a calm, cliff-bound cove where he kept a storage area on the quay.

Angus was right. MacLeod's sausage was indeed delicious after all those salt-spray soakings. It came in the form of thick, square slabs that turned brown and crisp in the frying pan on Angus's small two-burner propane stove in the wheelhouse. A square of succulent cheddar cheese, a little mustard, and a spread of spicy Branston pickle on whole wheat buns and we were off, wolfing the "pieces" down along with more scalding-hot tea and, later on, fat wedges of Christina's home-baked banana and raisin cake.

After a sprawling period of recuperation on the deck of *Harmony*, bathed in a warm sun away from the ocean breezes, the men decided it was time to unload the empty creels.

I, of course, offered to help again but realized that they were used to working to a strict, well-honed rhythm that would only be disrupted by an outsider, no matter how well meaning. So, leaving them to their labors, I wandered off up the cliffside and onto a broad sheep-dotted pasture. Wildflowers were scattered everywhere across the bright green grasses—daisies, sandworts, clover, lady's bedstraw, buttercups, primroses, and tiny, delicately colored "frog orchids."

At the far side of the meadow a couple of croft cottages snuggled against a high bastion of exposed gneiss strata. Laundry was flapping in a gentle sea breeze and the faint aroma of something baking wafted across the grass. I followed the aroma toward the cottages until an elderly woman with tightly bunned hair and wearing a white kitchen apron emerged and stood staring at me as I loomed closer. Then she gave a quick laugh—a laugh of recognition. "Ah, I know you . . . I've seen y'face before."

I smiled (I was also salivating from the delicious smells now pouring from her open front door). "Oh, no, I don't think so."

"Oh, yes . . . I'm sure . . . Ah! I know. You were in the *Gazette* last week . . . or the week before. You're that writer chappie."

Now it was my turn to laugh. She was right. A young journalist, Iain MacSween, from the *Stornoway Gazette* had spontaneously interviewed me while I was interviewing him about island affairs. And—voilà—a week later, there I was, splashed on the front page (in color, no less) prattling on about our traveling life, with a photograph taken in their office of me sprawled on a chair, tea mug in hand, Harris Tweed jacket rampant, and looking for all the world like some rambunctious bearded laird down on the island for a few days to bag a stag or two on the castle estate.

"You've got a good memory," I mumbled, feeling rather bashful.

"Och—a face like 'at y'dinna forget s'fast, d'y'ken!"

"Ah," I said, not sure exactly how to interpret that remark.

"An' wh'y'doin' in these parts. Are y'hikin' about a bit?"

"Oh no—no. I'm just up from the quay. I'm on Angus Campbell's boat. They're unloadin' some creels . . . we've been out in The Minch."

"Oooh—bit rough today, I'm thinking. Well—listen—d'y'have time for a wee spot o' tea?"

I rarely refuse such spontaneous invitations (islanders tend to be offended if you do), but I knew that Angus would be anxious to get back out to complete the hauling. There were still four more fleets to "service" and I had no intention of delaying them.

"Ah—I'd love to but . . . well, y'know fishermen. Always wanting to be back out there . . ."

"Well, how many are y'then?"

"There's four of us—three fishermen and this novice!"

"Och, well y'just wait here a minute and let me see what I can find for y'all . . ."

A few minutes later I was back at the boat bearing a foil-wrapped parcel for my friends.

"Jeez!" laughed John, as I opened it to reveal an enormous square of just-baked fruitcake, still steaming from the oven and cut neatly into portions by the generous lady up at the croft. "Y'jus' wander off and return with wonders like this! Y'must be our token of good fortune!" (This latter said while spewing crumbs from a mouthful of soft, warm cake.)

"Ah," added Angus, "so m'be y'll be our token when we get back out there and try to haul up a better catch than this morning's . . ." (more flying crumbs).

Duncan, as usual, just smiled. But his silence at least enabled him to wolf down a second square of cake long before any of us had finished our first.

I wish I could have indeed lived up to my status as a potential "token," but—no artistic license allowed once again—the afternoon's haul turned out to be even more meager. However, despite that, we still managed to hand over twelve boxes of langoustines to the refrigerator-van man and then we all sat together on the quay at the end of the day sipping drams from a bottle of Glenfiddich I'd brought as a thank-you gift.

Angus finally became a little more talkative as the whisky washed away some of the disappointments of the day and told me about a "pet project" he was currently completing.

"I think it'll work out—I hope so 'cos it's costin' enough. Y'see I've designed this boat—a high-speed beauty—and I want to take people out on day trips to the island of St. Kilda."

"St. Kilda! I've been told that's a nine-, ten-hour trip. One way. Fifty miles or so . . ."

"Tha's right. It is—or was. Until now. But a' think I'll be able to do it in a couple of hours if it all works out right. An' a' know I'll find people who'll want to do that—they're always askin' how to get out there. It's a place that fascinates visitors. Fascinates me too when we go lobsterin' out there. There's nowhere like it . . ."

"I know. I've read a lot about it. Strange stories about the small community that once lived there. So—when do we leave!?"

"Och, soon—soon. It's not quite ready yet . . ." Angus laughed. It was good to see him laughing again after his hard, and disappointing, day of hauling.

"Well, sign me up. I want to be one of the first to go with you."

"Okay—consider yourself signed up!" and he spontaneously raised his glass in a toast. "An here's a wee bit o' Robbie Burns f'ye:

"Fortune! If thou'll but gie me still
Hale breeks, a scone, and a whisky-gill,
An' rowth o'rhyme to rave at will,
Tak' a' the rest."

I couldn't quite understand all the broguish subtleties, but it seemed to possess the celebrate-what-you-have *Rubaiyat* spirit of "a glass of wine, a loaf of bread—and thou."

There was a silence—a most companiable silence—and I rummaged through my brain for a toast-worthy response. "Ah—I've got it—I think it's a translation from the Gaelic. Roddy MacAskill once said it to Anne and me and it kind of sums up my thanks to you all for letting me be a shipmate—if unfortunately not a token of good fortune—for today. It goes something like:

"Would it not be the beautiful thing now
If you were coming instead of going . . ."

We all raised our glasses, chinked them together, and downed that silky single malt nectar. High overhead a golden eagle circled on the spirals while the setting sun burnished our faces.

It had been a very good day—at least for me. And the prospect of another day with Angus on his St. Kilda project seemed even more enticing . . .

5

Cooking with Katie

OMPILERS OF TRAVEL GUIDEBOOKS and "best hotels and restaurants" publications, complete with all those stars, rosettes, and purple-prosed accolades, have not had a particularly easy job when gathering tempting "must go" material on Harris. All, naturally, have celebrated the island's long and fascinating history, its enduring Gaelic heritage, strict Presbyterian mores, and, of course, the dazzling array of earthscapes—from majestic mountains to wild, lunarlike wastes and those eye-candy arcs of gleaming golden sands along the west coast. But when it comes to the more pragmatic elements of accommodations and eateries, enthusiastic verbosity occasionally falters and certainly diminishes. For the simple reason that, despite the island's increasing reliance on tourism, the options still remain rather modest here. To whit: three smallish hotels (Harris, Rodel, and MacLeod), four guesthouses (with a total of fourteen rooms), and twenty-three or so bed-and-breakfasts (fewer than forty rooms). For those looking for extended stays, there are admittedly around fifty "self-catering" cottages, plus a couple of hostels and scattered camping grounds, but no single serious independent restaurant outside the hotels and guesthouses.

When we first visited Harris almost twenty years ago, the scene was even more frugal and the only place that seemed to generate any attention and accolades was Alison and Andrew Johnson's Scarista House. I believe, in those days, they offered only three rooms, and although it was

a little expensive, I remember Anne and I managed to scrabble together sufficient splurge funds for a two-night stay. At that time Alison was still writing her intriguing book describing how she and Andrew, virtually by themselves, had taken this run-down old minister's "manse," set high on the moor overlooking the magnificent sweep of Scarista Bay halfway down the west coast, and transformed it from a "chicken shit–filled wreck" into one of the most celebrated guesthouses in the Western Isles.

Alison's popular book *A House by the Shore* put not only Scarista House but Harris itself on the hidden-gem-hunters' shortlists. "I was very surprised at first by all the attention," Alison told us later with beguiling modesty. "It was a pretty ordinary story of how two neophytes like us with no knowledge of building construction or hotel management almost bankrupted and bludgeoned ourselves into oblivion."

When Anne and I first stayed there, work was still in progress, but all we remember were cozy, comfortable bedrooms, glasses of sherry in the evening by the peat fire in the library, and superb multicourse dinners concocted by Alison from the best and freshest of island produce and served in an intimate, candlelit dining room overlooking the bay and hazy Taransay Island. Her soups, including a classic *cullen skink* (a silky melding of smoked haddock, onions, potato, and cream), and her entrée of lobsters in a cognac, lemon, and tarragon sauce, were five-star marvels. And indeed, in subsequent years, Scarista House received a welter of awards from just about every guidebook and travel magazine around.

Eventually the weary couple moved on to other adventures in Harris, but today the current owners, Tim and Patricia Martin, have kept the standards high and even added a couple of additional rooms and self-catering cottages. One would have thought that Scarista House might have spawned a host of eager imitators ready to capitalize on Harris's increasing popularity. But strangely, with the exception of the elite "hunting party" accommodations and gourmet fare at Amhuinnsuidhe Castle on the road to Huishnish, there are still only two other similar guesthouses: Leachin House, on the outskirts of Tarbert, which has attracted a loyal following, and the MacAskill family's Ardhasaig House, just down the hill below our cottage, which has in three short years become a focus for Katie MacAskill's remarkable culinary triumphs.

Guidebooks gush and stars galore adorn hotel and restaurant reviews
that celebrate this "white-painted hundred-year-old croft with a beauti-
ful situation at the head of a sea loch on the western side of the island."
One reviewer ecstatically recalled: "a superb dinner comprised of carrot
and red onion soup with ginger and garlic; Parma ham and fruits; local

Amhuinnsuidhe Castle

trout with lemon and almond butter; Cloutie dumpling with crème Anglaise and coulis." The reviewer was also enamored of "excellent breakfasts with abundant choices including porridge, venison sausages, sauted lamb's kidneys, black and white pudding and oat cakes."

Diminutive Katie, thirty-five years old, and Roddy and Joan's second-

youngest daughter, blushes a little at all the attention but told me that "it's what I've always wanted to do. I also wanted to live here on-island and not go to the mainland like so many of our youngsters have to do nowadays. I had to leave for a while to get my diploma at the Edinburgh Food and Wine Institute and then learn the ropes in a large turnover kitchen. I chose the Glasgow Hilton and worked with James Murphy, the executive chef. And then I worked with Andrew Fairlie before he became one of Scotland's most famous chefs. And I mean worked! You really have to focus in places like that and be very organized. When you're serving over two hundred dinners a night you've got to produce or you very quickly end up 'in the weeds'! Here in my little guesthouse the numbers are obviously far less—one seating for twenty is about our maximum—but then, there's only me and sometimes two staff for prep and serving, so I'm running the whole show from the little 'amusées' I always serve before the four-course dinner, to the petits fours with the coffee after dessert. Oh, and I help Dad and Mum with the shop too!"

And indeed she does. Many times in the early-afternoon gap between serving breakfast and prepping dinner, I chatted with her at the shop across the road from our cottage while trying to find inspiration for one of my own "improv" dinners for Anne and me.

"You love cooking, don't you?" she once said.

"I guess I always have," I admitted. "Ever since my mother and father—they ran a shop too, you know, in Yorkshire—let me fend for myself when it came to meals during the day. I think I was the first person ever to cook rice in our house. And when I started carting in bottles of oyster sauce, Indian mango pickle, Thai curry pastes, and all kinds of other exotic stuff, my mother thought I'd gone a bit bonkers, but she always kept popping into the kitchen from the shop for a taste and a nibble."

Katie smiled. "That's a great way to get started. Just experimenting and tasting . . ."

"It was the only way to keep myself interested. If I knew exactly what a dish would taste like because of a recipe or the fact I'd done it a dozen times before—I'd lose patience. I needed to surprise myself—just like going into a restaurant and not knowing exactly what you'll be served. I loved that anticipation. I loved to learn new ways of blending

flavors—inventing entirely new dishes. Fusion cooking, I guess, although fusion's got a bad name nowadays. Too many chefs using too many ingredients all at once. I still believe in keeping things relatively simple—clean, clear flavors—but also a little unpredictable. I love it when someone says, "Wow! That's a great sauce! What's in it?" My only problem is I don't usually keep notes, so I have a helluva job trying to tell them."

Katie smiled, nodded, and then said exactly what I'd been hoping for: "Well, maybe you'd like to pop down to my kitchen one night when I'm doing din—"

I didn't hesitate for a second. "How about tonight?"

Katie laughed and her pretty dimpled face turned pink. "I . . . all right, then . . . tonight. I've got about ten in and it won't be too crazy . . . no, tonight's just fine."

So, at 6:00 P.M., there I was, strolling down the field from our cottage to the guesthouse. ("Actually it's a small hotel now," Katie told me. "We've just added a sixth room, so I've been upgraded!")

Her "small hotel" is immaculate. Roddy supervised its extensive renovation and expansion from a dilapidated crofter's cottage to the little gem of today, complete with cozy lounge and bar overlooking Loch Bunavoneadar and the North Harris hills, and an outdoor patio for summer evening gatherings if the midges aren't biting.

Katie's kitchen is something out of a "how to design a perfect restaurant" handbook. It is spacious, well lit, airy, and abundantly equipped with stainless steel ovens, warmers, prep counters, serving counter, and huge sinks at either end of a stove with eight high-velocity gas burners. This is a truly serious hotbed of culinary creativity, and Katie is a truly serious chef. Fortunately, her approach is tempered by disarming smiles, occasional fits of giggles, and an inbred intuition on pacing and mood—all vital ingredients of a good kitchen. She is constantly asking Catriona, her assistant and server, about her guests: "Are they enjoying it?" "Are they happy?" "Do they need a bit of a break?" "Are they still hungry—should I do a few extra veggies?"

This is a place where the guests, and not the kitchen regimens and protocols, definitely come first. She tries to discover their likes and dis-

likes and designs the nightly menu accordingly, along with a few gastro-
nomic surprise "gifts," such as hors d'oeuvres or homemade petits fours
that may reflect items guests had previously complimented during their
stays. And she is the recipient of many compliments. You can hear the
"oohs" and "ahs" as dishes sally forth from the kitchen into the adjoin-
ing intimate dining room. Little comes back. Most plates are scoured
clean, which in itself is one of the best compliments a chef can receive.

Occasionally, at the end of the meal, a guest will ask to speak to Katie
personally in the kitchen. The evening I was there an elderly gentleman
smartly dressed in tweed jacket and striped silk tie and speaking in a slow
American drawl entered and stood, eyes sparkling with delight, by the
serving counter.

"Miss Katie," he began, with a beguiling smile, "I'd just like to say that
this is the first time my wife and I have ever visited your restaurant. And
although we've been coming to the Highlands for many years and dined
just about everywhere worth dining, this has been—without any shadow
of a doubt—one of the finest meals we have ever had. By far, young lady,
by far. From your first little crostini with the pâté we knew it was going
to be real special. And real special it was. We ate everything—every drop
of sauce—everything. And we just wanted to say thank you—truly thank
you—for an experience we shall never forget."

Katie, standing demurely by the stove with her little chef's hat on and
crisp whites, blushed (Katie blushes quite a lot), grinned, and said how
pleased she was that everything had gone so well. I sensed she was not
unused to such praise, but she accepted the man's thanks with beguil-
ingly modest grace.

"You'll go far, Miss Katie," the American guest said as he turned to
go. "We'll be hearing a lot about you and your cooking—of that I'm real
sure."

And then he was gone, leaving Katie still blushing as she quickly
turned her back and busied herself at the sink. Catriona said, "Oh,
Katie—wasn't that so nice of him?"

"Och! It was only a regular dinner," she said softly, but then she
turned and I knew that compliments of that kind touched her and made
her work here richly rewarding.

And what did her "regular dinner" of that evening consist of? Well, when I arrived three dishes were already slowly maturing on the stove. Two were soups—a carrot and parsnip blend and a cream of fennel—and a wild mushroom medley risotto.

"Help yourself to a spoon and test," Katie said. "I'm still open to suggestions."

In the case of the two soups I could think of nothing that would enhance the silky-creamed purity of their texture and flavor. They tasted just as the menu described them—no tricks, gimmicks, or muddied mélange of ingredients. The distinctiveness of the selected vegetable flavor was the whole point of these creations.

As for the risotto, it was still at the very al dente stage but the flavors of the four different types of mushrooms Katie had used were permeating wonderfully. "Maybe it just needs some more . . ."

". . . stock," said Katie, and poured in a couple of cups of her made-fresh-daily chicken stock. "And wine . . . ," and in went a generous swirl of an elegant New Zealand chardonnay. "Anything else?"

"Well, it's got a way to go yet . . . ," I said hesitantly. Cooks may invite suggestions but not necessarily always welcome them, so I was a little cautious in my comments. "But I remember in southern Italy some of the mammas would add a handful of grated parmesan during the cooking. Some sprinkled it on just before serving."

Katie laughed and lifted a cloth partially covering a chopping board to reveal a heaping mound of freshly grated parmesan. "I do both," she said. "Some goes in while it's still cooking, and some at the end as a garnish!"

The guests were assembling in the dining room and Catriona hurried to prepare the little plates of golden oven-baked crostini piled high with homemade game pâté and each topped with a single red currant. I got to test one—actually four—and off they went along with iced water in glass jugs filled with slices of orange, lemon, lime, and strawberry. (A real Martha Stewart touch—why hadn't I ever thought of that?)

Five minutes later the soups went out, garnished with hot toasted almonds and accompanied by baskets of dainty puffballs of kitchen-baked bread scattered with blackened sesame seeds. Then Katie began to

finalize her "dressed salad leaves with scallops, monkfish, and chili jam." Her dressing couldn't have been simpler—virgin olive oil, fresh-squeezed lemon juice, and pepper, hand tossed with the multicolored leaves.

"I wondered about shaving a few wee slices of cucumber in the salad . . . ," Katie mused.

"Oh, I wouldn't if I were you," I said before I knew I'd said anything.

"Oh—and why is that now?"

"Well—you remember what the great Dr. Samuel Johnson wrote about cucumbers . . . ?"

"No, I don't . . ."

" 'A cucumber should be well sliced, and dressed with pepper and vinegar—and then thrown out as good for nothing.' "

"Well, now," said Katie. "And isn't he the one who also said oatmeal was only fit for pigs and Scottish peasants?"

"I don't think he put it quite so rudely . . ."

"Well, I'm sure it wasn't far off. He didn't like us at all!"

I couldn't really argue with that except to say, "Well—he was much more complimentary when he traveled here with his Scottish companion, Boswell."

"Poof!" scoffed Katie.

I wished I'd never brought up the subject of that irascible old tyrant.

Next came the sea scallops and monkfish doused with a little chili jam—seared golden on one side in olive oil and French *Celle sur Belle* butter, then poached more slowly on the other side, the whole task taking less than two minutes. Katie offered me a spare scallop. The combination of golden-crusted topside with the chili jam on the softer side tantalized my palate—until it suddenly dissolved in a gush of gorgeous seafood with a texture almost like that of a cream custard.

Katie smiled at my delight. "All my scallops are hand dived. A guy down in Strond scubas down for them every week—sometimes twice a week in the height of summer. It's a tricky business, though. One diver recently had a bad attack of the bends. Came up too fast or something. They say it almost killed him. Couldn't go down again for weeks."

I was still absorbing the scallop "custard," so an empathetic nod was all I could manage.

"Okay—entrée time. Three different choices. We've got about twenty minutes."

And what a twenty minutes that turned out to be. Katie and Catriona worked together like automatons. I offered to help but was told that my role remained that of tester, which was just fine by me because first came her sauce for the initial entrée—halibut. This was a mix of melted sautéed leek strips flambéed in white vermouth, rapidly reduced, and then melded with fresh lemon juice, double cream, and seasoning and poured around a gently poached fillet of snow-white halibut garnished with spoonfuls of "caviar" made from Scottish herring roe.

Then came a bronze-skinned guinea fowl baked for twenty minutes or so in her huge, blazing-hot oven and served on beds of sliced fennel

Katie MacAskill at the Stove

and peaches in a rapidly reduced sauce of flamed tawny port, chicken stock, and fresh red currants.

Finally there were the filet mignon steaks, two inches thick, flash-sautéed then oven-finished to medium rare and served with one of the most decadent sauces I've ever tasted. Try this sometime—the steak sauté pan is deglazed with chicken stock followed by double cream, a generous chunk of Stilton cheese crumbled into the pan, a handful of chives, parsley, tarragon, and seasoning (including that final magic mix of a little lemon juice and a little sugar)—all reduced over high heat to a golden-hued nectar and poured over the succulent steaks.

All the entrées were accompanied by side platters of vegetables, which included that wild mushroom risotto (pure succulent perfection), baked asparagus spears wrapped in prosciutto, tiny purple Peruvian potatoes, miniature white turnips and carrots, and daintily green baby squash. A dazzling display but hardly a dinner for squeamish dieters, although Katie insisted that she catered for all preferences.

The plates were returned to the kitchen wiped clean. Not a morsel had been left by any of the ten dinner guests.

"Well, I guess if the plates are so clean that means they've still got room for dessert." Katie grinned, putting the finishing touches on her molds of cold creamed-rice mousse topped with a caramelized crunchy sugar cap, each one carefully browned by Catriona with a tiny kitchen blowtorch and set floating in a rich, dark red lake of poached plums and Madeira sauce.

"And now the petits fours . . . ," said Katie, dipping tiny wild strawberries into a warm chocolate glaze and presenting them with her just-baked star-shaped shortbread crisps to accompany the coffee.

Half an hour later the diners had left for liqueurs in the lounge and Catriona was completing the washing up. Katie and I sat together on the patio outside the kitchen door, watching the moon creep up from behind Clisham to cast a silver shimmer across the loch and "ghost shadows" among the trees surrounding the guesthouse lawn.

"So—wha'd'you think, David?" she asked. "Was that fun or what?!"

"And you pulled all that together since six o'clock?!" I asked. It was barely nine-thirty.

"Six-thirty . . . I think," replied Katie.

"Amazing—and almost everything you created came from the islands?"

"Pretty much. The miniature vegetables and asparagus are from the mainland, but I try to use as much local produce as I can. I like to know who's supplying my beef and lamb and game. That's what I'm doing tomorrow night—a salmon and game dinner. The salmon is wild—not from the fish farm—and the game is from the Amhuinnsuidhe Castle—plenty of good venison . . ."

"I don't think I can think about food anymore tonight," I said wearily.

"Och, you're fine. Surely y'can manage a wee dram."

Once again the Scottish solution to everything—"a wee dram"! In Yorkshire it's a cup of tea, but when in the islands . . .

"You know what would be fun," I mused as we sat sipping together. "You remember we've got some friends coming up to stay with us for a few days next month?"

"Yes, Dondy told me you're expecting company."

"Well, I'm wondering if we could commission a real traditional Harris dinner from you. I mean I know they'd love the kind of dishes you produced tonight, but I'm thinking of something that captures the 'old times'—the black-house days . . ."

"Like what?"

"Well . . . you know—things like *cullen skink* soup, fresh cockles steamed with seaweed, salt herring, or herring in oatmeal with Kerr's pink potatoes, maybe some game—venison or hare or pheasant—aged to get that rich gamey flavor and—"

"Anything else?"

"Well, maybe a haggis flamed in whisky, and then sweets—something with crowdie and cream and homemade jam—maybe oatcakes or Scotch pancakes or bannock cakes and, of course, your Clootie dumpling—full of all those sultanas and raisins and black—"

Katie started to giggle. "You're not asking for much now, are you . . ."

"Well, it doesn't have to be all of those. Just a selection to make them realize that, despite all the hard conditions and subsistence lifeways of the

islanders, people ate pretty well here just using whatever was at hand . . . you know, real honest and simple—and very tasty food."

Katie sat for a while, smiling. Then she said, "Well, it's certainly something to think about."

"Yes—that's right. Just think about it—it's only an idea."

"Anything else—sir?"

"No—no, that's fine—oh! Except I'd like you and Dondy to come up to the cottage for dinner one night—if you ever get a night off—I'm not going to compete with your masterpieces but—well, I've got a few tricks up my culinary sleeve too."

"Oh, and what kind of tricks might they be now?"

"Ah, that," I said, suddenly wondering if my offer was really a good idea in the light of my rather spontaneous, ad hoc approach to cooking, "is something you'll just have to wait and find out . . . isn't it?"

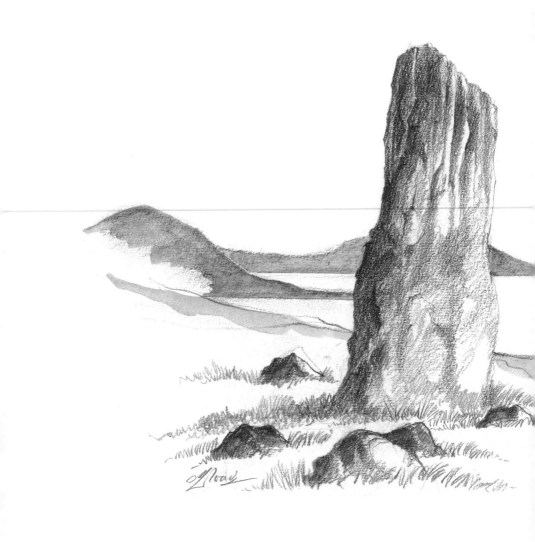

SUMMER

MacLeod Stone, Scarista

6

Scenes of Summer

<hr />

ESPITE THE INCLEMENT WEATHER (a polite euphemism for "distinctly lousy" in the case of Harris in 2004) and those devilish clouds of minuscule, maddening midges, the surge of summer events rolled on unabated in the Outer Hebrides. A spate of agricultural shows, galas, Highland games, and mod musical competitions filled the weeks around the grand summer climax: the hugely popular Hebridean Celtic Festival in mid-July at Stornoway.

Anne and I unfortunately were off-island for much of the time, not so much to avoid the rain showers and persistent biters but because of the sudden loss of Cynthia, my mother's younger sister.

The ensuing weeks were a marked contrast to the slow-paced hours and days spent on Harris. We traveled the four hundred or so miles south to green, sun-soaked Yorkshire, where the funeral was arranged, endless forms were signed or witnessed, probate lawyers were dealt with, and a house was cleared and readied for sale. Fortunately, it was a small house, snuggled away in an idyllic Constable-type spot—a cozy village overlooking the Vale of York and the great upland plateau of the North Yorkshire Moors to the east. Bishop Monkton possessed all the seductive characteristics of pure English rurality: a chuckling, duck-dotted stream winding its way alongside a narrow main street lined with quaint cottages and rose-bedecked gardens, and two village pubs, intimate and oak beamed, full of the kind of central-casting regulars that constitute the backbone of British sitcoms and soaps.

But without Cynthia, the village seemed a little forlorn. "Let's just get the house ready," Anne said, "and then it's back to our island."

Every once in a while, for diversion and delight, we'd call our *Hear-aich* friends to hear how the summer was progressing. "S'better this year than last," Roddy told us. "Katie's guesthouse is full of tourists and her cooking is getting real popular. She's just got an award for the second-best new hotel in Scotland, and second-best hotel breakfast in Scotland. So, wha'd'd'ya think about that?! Not bad, eh? She's got quite a reputation now and it's only her third year . . ."

"Wonderful! Send her all our congratulations . . . couldn't happen to a nicer person . . . oh and tell her when we get back I'd like to spend some more time in the kitchen with her—see what new magic she's concocted," I said.

"Well, you better ask 'er y'self . . . last time she had dinner with you and Anne at the cottage, she said she'd feel nervous if y'ever started peepin' over 'er shoulder again."

"Oh, really—was my cooking that bad?!"

"Oh no, no—not that at all. It's just that she didn't even recognize half the stuff you used . . . she thinks maybe her dishes are too simple f'ye."

"Just tell her, Roddy, that if that one dinner we all had together at her guesthouse was anything to go by, I've got an awful lot to learn from her."

Another friend, a crofter, insisted on giving us a full—far too full—account of the delights at the many agricultural shows, galas, and games, with their whirlygig mix of clay pigeon shooting, falconry displays, llama rides, crafts, flower and baking competitions, greasy pole battles, caber tossing, and hammer throwing, in addition to all the scores of livestock judgings that seem to award cups, medals, and rosettes to just about every crofter-farmer on the island.

"Ah—but y'missed the best of all," said Jack MacLeod, one of our younger friends and an avid Celtic music fan. "This year's Hebridean Celtic Festival. Fantastic! The ninth one we've had and the best by far—three nights on the castle grounds at Stornoway. A real madhouse . . . over twelve thousand people and wow! This was really good stuff! The

whole place went wild—even outside the marquee, in the rain, there were hundreds of us just dancin' an' singin'—people from all over the world—loads of foreigners! I'll tell ye, Dave—you two really should 'a been 'ere . . ."

I explained the reason for our absence and he was appropriately empathetic, but I knew he was right. "We should 'a been 'ere." With a good dollop of Irish blood in me, and a checkered past of singing English/Irish folk songs with my sister long ago, I truly would have liked to experience that *Gaidhealtacht* spirit of ancient Celtic music and heritage.

"Not to worry—we'll go next year," said Anne.

"Okay," I said, wanting to believe her.

But all was not lost.

When we finally did return, toward the tail end of summer, the islands were slipping back into their more introspective and introverted personas. Most of the tourists had departed, leaving a generous fiscal largesse behind them despite the somewhat mizzle- and midge-plagued season. All the big flash-bang-and-dazzle events of those warm weeks were now replaced by far more modest but authentic "entertainments" for the locals.

Stornoway, of course, tended to be the focal point of such activities, and Anne and I loved those afternoon drives up over the surly monoliths of North Harris and out across the Southern Lochs, the infinitudes of the central peat bog plateau, and into the bustling intimacy of that little town.

The harbor, as always, bristled with the masts and sea-stained gear of the fishing boats. The shopping streets were still abuzz with scores of students from the Nicolson Institute hovering around their favorite fish 'n' chip haunts, swigging on that rust-colored and uniquely Scottish soda, Irn-Bru, and nibbling on deep-fried delights. McNeill's, the Crown, The County, Criterion, and all the other twenty or so pubs and hotel bars here had their coteries of regulars, telling the same tall tales and sipping their whiskies and pints of Tennent's in a haze of early-evening bonhomie.

Nothing had really changed since the spring except for the impressive new arts center and theater on South Beach now nearing comple-

tion. We wished the same could be claimed for poor old Lews Castle, peering elegantly but emptily over the town from its lush woodland grounds across the harbor. The place was still closed up and awaiting yet one more "feasibility study" to justify funds for its long-postponed restoration—funds in addition to the hundred thousand pounds it apparently took each year just to keep the place empty and unused.

Fortunately, the woods themselves were open for languid strolls on that still-warm afternoon, as we whiled away the time before two evening events that had lured us here from the home comforts of Clisham Cottage.

After the barren, wind-scarred plains and mountains of the island, it felt so beguiling and strange to be walking through these meticulously nurtured and dense flurries of trees and bushes, including many exotic species originally planted well over a century ago. In contrast to the uncluttered openness of the moors, here we vanished into a flurried half-dark—an edgy mosaic of spidery shadows and filtered sunlight—interspersed with eerie, echoing bird calls and slithery rustlings in the dense undergrowth. Out over the harbor we could hear gulls screeching with their typically aggressive hysteria as we walked silently on cushiony moss paths veined with roots and tangled vines. A little slice of clammy labyrinthine jungle, moist and mysterious, and yet so close to the tingling small-town tumult across the water.

Following our long stroll up to Gallows Hill, with its broad vistas across the town and the dark, treeless infinities to the west, it was with some relief that we ended at the park's Woodland Center—an airy café and interpretation room. We mentioned our curiosity about the fate of the castle to Kevin Brown, the young park ranger here, originally from Yorkshire. His reaction, like that of so many other incomers, was incredulity tinged with a shruggish humor.

"Well, officially it's a listed building, so they have to preserve it no matter what the cost. The basic problem here is the fact that Lord Leverhulme loved to entertain and he decided to enlarge the ballroom by knocking down a few walls. Unfortunately, some were structural walls—he'd been told this, but the good lord had a bad habit of not always listening to his advisors—so, the place sort of got all bent and buckled and

never recovered." Then, when he realized that the three of us all came from the same part of England, Kevin waxed philosophical: "Y'know, y'keep assumin' y've got a handle on island life here and island thinking—but then something happens and you realize you've got to constantly reevaluate things. I remember when I first came here, I wore a Harris Tweed jacket—y'know, to show respect. And suddenly I realized that I was the only one wearing tweed—it was all Gore-Tex and Kagool and jogging clobber. The islanders hardly ever wore the stuff!" He laughed and then became serious. "I've been here fifteen years, but my perceptions always keep changing—always getting deeper. It's endless, in a beguiling kind of way. Particularly Harris—'an old soul' of an island. I love that place. I live in Stornoway at the moment, close to my job here, but to me these islands are all about Harris, particularly the mountains of North Harris."

"That's our favorite part," said Anne.

"It's fantastic, isn't it—the Lost Glen, the track over to Tarbert from Rhenigidale, those amazing sands out at Scarista, and Seilibost, and Luskentyre—so much on such a small island . . ."

We wondered, after our walk in the woods, about an early-evening dinner picnic by the harbor, or if we felt flush, a gourmet meal at Digby Chick, one of Stornoway's most creative small restaurants—before moving on for the evening's "entertainments."

While "entertainment" is perhaps an inappropriate term, before leaving for Yorkshire we had attended a truly inspiring revival kind of event at a local church hall here just up from McNeill's pub. It was advertised on local store-window flyers as an "Ecumenical Praise Night."

"All the churches in town have been invited," a young man at the door told us. "Well, except the Baha'is. They don't recognize Jesus Christ as the Lord, y'see."

We suddenly became rather skeptical of the evening's intent. Such a remark reminded us of the prime dilemma impacting "organized" Christian religions in general—heaven is only an option for members of the faith, and everyone else, over 80 percent of the world's population, no matter how good and loving and contributory their lives, apparently seem destined for eternal damnation. In addition, of course, there are

certain ultrastrict Christian sects, most notably in Scotland, convinced that only membership (very limited in numbers too) in their specific schism of the church will ensure opportunities for celestial eternity. It appeared to us that such attitudes were not only needlessly divisive but also contradicted the very foundations of a Christianity advocating godly love, forgiveness, and universal harmony.

We almost turned around and walked away. But in the end, curiosity won out and we joined over a hundred and fifty bright-eyed, enthusiastic adults and youngsters in an hour or so of rousing anthem songs delivered by a local folk-rock band. Arms were raised together, hands outstretched and waved in unison to the driving rhythms. Moving personal testimonies of reformation from sinful Stornoway living to soul-nurturing salvation were given by some of the young attendees. Tears rolled, laughter boomed, and the scene throbbed with true spiritual intensity.

"We're all looking for God!" cried out one young girl, to thunderous applause.

"We should enjoy Him in ourselves every single day!" shouted the lead guitarist as he improvised that one simple line into a Keith Richards–inspired riff and had the whole audience up and dancing in the aisles. It was an impressive spectacle and so very different from the somber church services we'd attended in Harris. It was just a shame they hadn't invited the Baha'is. I'm sure they would have enjoyed it just as much as everybody else.

There was still a while to go before the evening's entertainments—a couple of tempters I'd lined up for us involving live theater, and a bagpipe recital at the An Lanntair Arts Centre.

I suggested to Anne a spell in the library, a place I'd come to love for the enthusiasm and expertise of its staff. One man in particular, David Fowler, had helped me delve into the intricacies of island history and heritage on many occasions and invariably greeted my visits with a "Now, d'y'remember that thing y'were askin' about last week? Well, a' think a' may have found . . ." That man was indispensable as a reliable source. (Or, of course, as a recipient of blame and grave retribution if any information in this book turns out to be inaccurate! Authors always need a scapegoat . . .)

Anne suggested the museum instead. So, up the long slope of Francis Street we trundled to a stately stone edifice, built as part of the beloved Nicolson Institute in 1898. Today it is truly one of the best-designed and most informative small museums we've ever visited anywhere in Britain. Somehow, in two modestly sized rooms, they have managed to create a succinct summary of the whole history of Lewis and Harris from 7000 BC to present times. And despite the amazing amount of information and the remarkable variety of items on display—including a re-creation of part of a crofter's black house complete with central peat fire, the ubiquitous dangling pot on a chain, and huge sideboard with its modest display of chipped crockery—the place never palls. It provides information with imagination, which is more than can be said for some of the far larger British museums that often leave us bedraggled and befuddled.

There was just time for a light dinner before the evening's activities. I suggested the Indian Balti House, overlooking the impressive new octagonal ferry terminal built as a replica-tribute to the old fish market. This was once the nexus of the town during the golden days of the endless fish shoals in The Minch and Atlantic, with hundreds of gut-salt-and-pack "herring girls," the lines of "kipper houses" on Kipper Road near the docks (where the split herrings were smoked overnight to "a rich hammy flavor" before being packed in wooden boxes and sent by boat and train to the great Billingsgate fish market in London), and the grand Victorian mansions of the town's merchants all along Matheson Road. Anne, as I thought she would, pressed for the new Digby Chick restaurant, with its baked mussels in a sage and onion crust, but located incongruously among the fish 'n' chip and pizza places on Point Street, it's the haunt of the town's rowdiest youths.

We finally compromised with platters of sizzling roast duck, Singapore noodles, General Tsao's chicken, mushrooms in oyster sauce, and a mountain of prawn crackers at the Golden Ocean Chinese Restaurant.

"Shame about Digby Chick . . . ," said Anne gloomily, but apparently not gloomy enough to dampen her appetite.

"But we don't have that much time and you can't rush that kind of place. It's too romantic . . ."

In hindsight it would have been better if we'd just enjoyed that leisurely romantic dinner at Digby Chick and forgotten the rest of the evening. Because that's what we tried to do on the drive back to Harris: forget everything that occurred after the last delicious slice of roast duck was devoured. By Anne, of course.

It was not so easy. Memories of that series of five one-act plays at the Town Hall Theater will be hard to eradicate. In fact, we only managed three. Actually two and a bit. The first was, I guess, intended as some kind of intellectually challenging meditation on fire. At least, we think that's what it was. There was certainly an awful lot of rhetoric about fire and burning witches and incendiary biblical characters and holocausts—all delivered in chanting and unison dancing by six zombie-faced, black-clad youngsters. To be honest, the youngsters were the best part—they had learned their movements well. Unfortunately, we could hardly make out their words due to a drummer at the side of the stage whose spirited accompaniment was distinctly overspirited (in more ways than one). And then there was this extremely anxious prompter who mistook the cast's subtle silences and pauses for forgetfulness and ended up delivering two-thirds of the entire script herself, much to the frustration and embarrassment of the hardworking young actors.

The second playlet was a comedy piece with potential. Set on the deck of a cruise ship, it involved two middle-aged ladies, both trying, in the course of some clever wordplay, role reversal, and maintenance of polite facades, to escape from each other. The only problem, once again, was the prompter's dominance, but this time not as a result of anxiety but simply because the two actors, who actually seemed to be enjoying themselves immensely, had obviously not been able to learn their lines in time for the performance.

The interval came not a moment too soon and we could see the small audience of fifty or so locals unwrap themselves out of their nervous tangles and rush off for instant liquid relief.

"Y'see, darlin'," I whispered to Anne, "this is why I can't go to theaters. I should have known it was a lousy idea. I'm a jangling wreck, dreading the next botched cue and prompter's prompt."

Anne smiled understandingly. It was an enduring bone of con-

tention, my dread of live theater. I'd tried to explain that ever since my ill-fated efforts at amateur dramatics as a youth in Yorkshire, I've not been able to sit through a performance, even by fully fledged professionals on national stages, without fearing a recurrence of the traumas that once beset our game little troupe at the Oulton-cum-Woodlesford Amateur Dramatic and Operatic Society. It was there backstage that I saw grown men weep at the fear of "freeze-up"; women ashen-faced and almost fainting before their cues to enter stage left (especially if they were on the right—actually wrong—side of the stage); directors biting fingernails down to knuckles trying to patch up subpar performances ("No, darling—y'see, you were supposed to be laughing at that point, not screaming with terror . . ."), and audiences wiggling like worms on sharp hooks when lines were flubbed or whole pages of dialogue skipped as some panic-driven character rushed prematurely into the comforting shadows of the wings.

And so it was on this night. I knew I shouldn't have come. And as the whole prompting thing began again with the third offering, I could only nudge Anne and whisper, "I'll see you outside."

But outside was no better.

The second performance of our evening of local culture and creative uplift was supposed to be a solo bagpipe recital held directly above the town hall in the arts center. Now, I'm not sure I've ever listened at any great length to a solo bagpipe player. I'm much more used to seeing them en masse in gloriously bedecked bands complete with tartan kilts and sporrans and white socks and perky little hats and backed by drummers. Lots of drummers. So that the occasional missed or cracked note would not be noticed in the martial-marching beat. But a solo bagpipe is different. Very different. You tend to notice every note, and as I stood in the street below an open window in the recital room, I was indeed all too painfully aware of each and every single cracked, missed, off-key, off-beat, and off-the-map note, along with a few extraneous squeaks, growls, and whispery susurrus sounds thrown in for good measure. Anne then joined me. Obviously the third playlet had not done the trick and she was ready for the next exciting escapade of the evening.

"So—where's this bagpipe concert?" she asked.

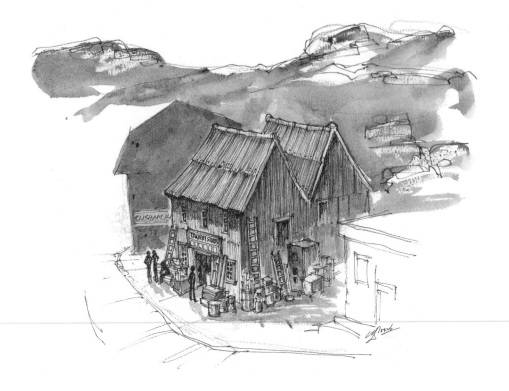

Tarbert Stores, Tarbert

All I did was point upward at the open window. Anne stood stock-still for quite a while, listening intently. And then, in a small plaintive voice, she inquired: "So what now?"

"Well," I said, "there's a couple of fishing boats over by the harbor and they look like they've just docked . . . Why don't we go and see if we can buy ourselves a pound or two of those beautiful prawns they keep bringing in?"

So that's what we did. The fishermen had just finished unloading their boxes of large langoustines and must have taken pity on our somewhat stress-striated faces. (It had not been an easy night.)

"Aye, why don'ya gi'em some from y'sack there, Donald," said one of the fishermen. And Donald, God bless his cheerful, smiling face, needed

no further prompting as he filled a small supermarket bag for us with those delectable little morsels. "Bit of a racket goin' on over there, eh?" he asked, pointing toward the arts center.

"Oh, yes, y'could say that," said Anne.

And very faintly, on the night breeze, we could just hear that bagpipe still wailing plaintively—and even more discordantly.

Our secluded cottage back in Harris suddenly seemed like a very pleasant prospect.

Man Sitting . . .

H E WAS SITTING ON HIS front porch when I was on my way out to Scalpay Island. I was enjoying one of my "randoming" drives around Harris and found myself heading on the switchback road east from Tarbert to this little appendage, once the center of a prosperous fishing fleet when the herring were running eons ago. Today the vast shoals are long gone, but Scalpay still possesses a more demure and prosperous aura than Harris and is now linked by an impressive modern bridge opened by Britain's prime minister, Tony Blair, in 1998 (an occasion remembered more for the horrendous onslaught of midges that day rather than his flamboyantly political rhetoric). Some of the Scalpay residents welcome it; others prefer the old days when they were linked to Harris by an infrequent ferry and enjoyed their prosperous isolation.

He was still sitting on his porch when I returned an hour or so later: an elderly man, puffing on his pipe and staring out across The Minch to the soaring cliffs of Skye, twenty miles or so to the east.

I pulled the car over to the side of the road and just watched him. And I thought over all the events, all the changes and traumas he must have witnessed in his lifetime here. Not quite old enough to know the famines and the clearances firsthand, but certainly wise enough to sense their impact on the land and the people who loved the land and their crofts, and their lazybeds, and their tiny crops of hay, oats, and "taties and neeps" (potatos and turnips). Doubtless there had once been great anger

at the indifference of absentee lairds, the greedy factors and tacksmen demanding ever-increasing rents for their "six acres and a black house"—the stumpy stone remnants of which melded with the earth like the bones of some ancient creature, long dead. Anger too at the wasted utopian dreams and schemes of the visionary—and very wealthy—incomers, The Dunmores, Mathesons, and Leverhulmes, whose "improvement projects" for fisheries, forests, new ports, and tweed weaving, are now mere skeletal remnants. Rust-bound piers at Leverburgh, a collapsing "castle" in Stornoway, forests that never grew beyond mere saplings, and of course, the erratic history of the great Harris Tweed itself.

And sorrow. He must have known the sorrow of the endless immigrations to the New World—the final decimation of tight-knit clans and kinfolk, and that terrible loss of two hundred and forty island boys on HMS *Iolaire*, returning from years away in the bloody First World War trenches of Europe and drowned as the ship struck the Beasts of Holm rocks, just outside Stornoway harbor on New Year's Eve in 1919.

The *Stornoway Gazette* gave a horrific description of the catastrophe:

On the deck of the Iolaire men met with schoolmates whom they had not seen since together they rushed to the Colours, four and a half years ago. The older men were glad to meet with relatives whom they had left behind as pupils in the village school, now striplings in naval uniform.

Two hours' steaming from Stornoway, the New Year was welcomed in, in time-honored fashion. All were in high spirits.

As the light on Arnish point drew near, many began getting their kit together, expecting in a very short time to be safely moored at the well-known wharf.

Suddenly there was a crash, and the ship heeled over to starboard. When she listed, huge waves came breaking over her, and 50 or 60 men jumped into the sea. All of them perished.

It was impossible in the pitch blackness to see the land, which, as it transpired, was less than 20 yards distant. When rocket lights were fired, the landscape was lit up, and it was found that the stern of the vessel was only half a dozen yards from a ledge of rocks connecting with the shore.

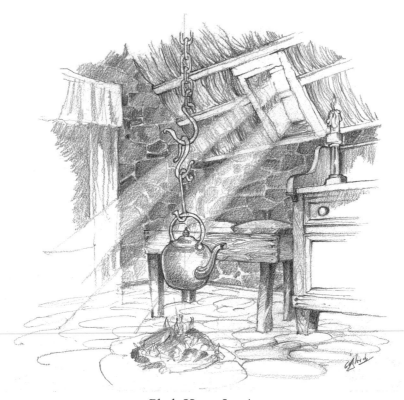

Black House Interior

There was a tremendous rush of water between the stern and the rocks, but many men were tempted to try to reach the shore there, and scores of them were drowned or killed by being dashed on the rocks.

That kind of event you never forget. And maybe you never forgive or understand. For yes, Calvinistically speaking, "The Lord is a vengeful Lord," but surely not to his believers who have already suffered so much and are buoyed only by an enduring faith in the mercies and ultimate bounties of a "just" God.

Finally, I stopped watching him from the car and strolled across the road. I think I may have made some rather flippant comment like, "Well, you certainly look very comfortable."

The old man smiled and nodded. Knowingly. "Ah weel, tha's m'be the secret of it all now, d'y'ken."

"The secret of what?"

"Of being alive . . ."

"Oh—right. Yes. Definitely."

"Y'know, being comfortable—and conscious."

"Right, conscious. Very important."

"Like being . . . well, like being the eyes of the Creator sort a' thing."

Now, that was a new concept. For me at least. Or maybe just an old idea expressed in a new way. And I couldn't think of anything to say for a moment. It was almost as if he'd been sitting waiting for someone to come along to continue a dialogue that had been going on in his head long before my arrival.

"D'y'mind m'meanin'?"

"Yes . . . I guess so. The eyes of the Creator. A nice way of putting it."

"Well, don't y'think that's what we all are? Givin' the Creator a bit of a boost by seein' and enjoyin' all the things He's created?" Then he chuckled—"'Course I'm talkin' at ye with m'old Gaelic mind now—an' m'Gaelic eyes. Very diff'rent from today. Even though us pensioners still use the old tongue every day, it's not like it was. Y'get to feel a wee bit 'historic' at times, y'ken? 'Specially with all the incomers 'n' such. Too much stuff written down now too . . . nothing much remembered anymore . . . like in times past when y'memorized most everythin' almost like music. Everythin' seemed to have a song in it . . . jus' in the way the words were said. The lovely sounds . . . and all those different meanings. One word could have so many meanings dependin' on how it was said— or sung—och, it's a fine, beautiful language."

"And is it really dying out? I keep hearing so many different opinions."

"Well, I don' know about numbers and the like. They tell me there're schools now all over in the big cities that use it all the time and that y'need it to get a good government job. I hear all that but I'm wonderin' that it won't be the old way . . . the sounds . . . the rhythms . . . the real power of love and livin' . . . livin' hard, livin' like gardeners—gardeners of our own lives—the way all those old bards and poets and blind harpists and travelin' storytellers would tell it. Y'could once make a good livin' y'know just wanderin' from *ceilidh* to *ceilidh*. Some could stretch out one

of those Gaelic 'long-songs' on f'more 'n' a week of nights—and all us sittin' round the pit fire in the black-house floor and the smoke driftin' up into the thatch where haunches of lamb and split-fish were hung from the rafters and smoke cured, and the warmth of the cows comin' through from the byre in the next room—an' those lovely smells of salt herring roastin' in oatmeal ... och, soo ... soo ver' gude! An' no midges or mossies—the peat-reek kept all those creatures well away ... oh—and the cattle piss an' all, that outsiders said was so unhealthy. Well—it turns out that the ammonia fumes and whatnot kept down diseases—TB 'specially. We had the lowest outbreaks of anywhere in Britain!"

Another pause. Not uncomfortable. But maybe with just a touch of melancholy as the old man let his memories flow on and I sat quietly. Waiting.

"Y'see," he began again thoughtfully, "in the past it was the young ones that we needed t'keep the life in the language ... just like a blacksmith-poet of ours, I've forgotten his name, us'ta sing:

"I am drowned in the 'old' man's sea,
In sharp cold clear and winter coldness,
the glorious 'new' man come to the teampall
and he sets my feet a-dancing.
It is the 'old' man who made me gloomy,
the 'new' man is my blazing lantern."

It was ironic that we were having this sudden impromptu conversation about Gaelic because earlier on that day I'd visited Morag MacLeod on Scalpay. This delightful, soft-spoken, silver-haired lady, full of grace and sensitivity, is one of Scotland's leading experts in the use, preservation, and expansion of the Gaelic language. She is particularly noted for her collections of the martial-rhythmed Hebridean "waulking songs" that once accompanied all those odd tweed-shrinking rituals. But even she, for all her years of efforts and her many publications, seemed as concerned as my elderly companion on his front porch about the future of the Gaelic language and the lack of "new" men to ensure its artistic—as opposed to merely academic—continuity.

"Well—y'ask me a direct question about what will happen but—lucky for me—Gaelic has no real words for 'yes' or 'no,' so I can kind of dodge the answer a bit!" Morag chuckled, but her eyes were sad. "But it's obvious, the real challenge is the loss of our young people. Once they leave the island they stay away. There's always talk 'bout ways of keepin' 'em here but it doesn't seem to be helpin' very much . . . and I wish I could honestly say that wasn't so."

I could sense a distinct lack of "new men" and "blazing lanterns" in her response.

Then it was back to my friend on the porch.

"Now, would y'fancy a wee cup a' tea, laddie?"

And how could a wee laddie like me of sixty-two years of age resist?

And so we sat sipping his strong brew, for how long I'm not sure. Chatting occasionally, sometimes just watching eagles and feeling the soft, sea-scented breezes on our faces. Then he rose abruptly and vanished into the house.

I wondered if I'd outstayed my welcome.

After a couple of minutes he returned with a book. "This is one of my favorites—Fiona MacDonald's *Island Voices*. Would y'mind if I read you something? Might give you a better idea about all us strange island folk."

"I'd like that," I said.

He shuffled through the pages, looking for the right passage. Then he sighed softly and began reading:

"A Celtic mind has a childlike trust in a bountiful God. When you're an island person and you're hemmed in by nothing but an imaginary line called the horizon, you are utterly dependent on the bounty of God's Creation. A Hebridean could live on his own in the middle of nowhere—we are a solitary people. You are at peace in your own mind. You are in tune with creation, the spring tide, the moon the sun and the stars and all the wonders and mysteries of this amazing universe."

When I finally left, there he still sat, smoking his cracked walnut pipe, staring with fading eyes over the cliffs and bays and out across The

Minch to the huge, hazy crags of Skye. And he smiled with a frownless face—a sort of Siddhartha smile—as if somehow everything that he'd experienced in his life all made perfect sense in the Creator's grand scheme of things.

DONALD MACDONALD, RENOWNED ISLAND GAELIC songwriter and singer, was, like Morag MacLeod, wary of the future. He and his wife lived in a large house (by island standards) that doubled as a bed-and-breakfast and was set on a bluff in the tiny community of Horgabost, overlooking the vast shell-sand expanses of Scarista, Seilibost, and Luskentyre. Donald John MacKaye, during one of our many conversations on the state of the tweed industry, had suggested I meet him. "He's what you might call a local icon—holding on to the Gaelic heritage for all of us. Remindin' us of how things used to be . . ."

Donald, an elderly and extremely modest man, was reluctant to accept such accolades. "Oh—it's my late brother who was the one. He wrote most of the songs—fifty or more. Beautiful words. I could never compose the poetry like he could. I could sing them at *ceilidhs* and suchlike but composin' came hard f'me. My daughters have written them all down, though. Before that we jus' remembered 'em in the old 'oral tradition' way—y'know, what we call 'folk memory.' One is teachin' Gaelic on Barra now and the other is doin' Gaelic at Glasgow University. But y'see the problem today is that if you're not speakin' Gaelic in the home, it's not so good. Here we spoke Gaelic all the time with our three daughters. Without the home it can die away so quickly. The problem is so many of the old Gaelic words and expressions have been forgotten—you can't find 'em even in dictionaries. Also different places use different words. Lewis Gaelic is not so good because they're terrible for mixing Gaelic and English together—y'know—that 'ganglish' way of speakin' y'hear so much up there. Barra Gaelic is perhaps the most pure. They didn't stop teachin' it in schools like we did. Here they said it was old-fashioned . . . didn't have any use off-island . . . that kind of nonsense—"

"Ah, but now there's changes . . . ," interrupted Donald's wife, prepar-

ing the traditional *strupach* tray of tea and shortbread as we sat in their cozy kitchen.

"Yes—yes, y're right there. Now things are changing—there's a new Gaelic Language Act goin' through the Scottish Parliament to increase its official usage. An' they've started teaching it again . . . and collecting all sorts of stuff from the old Gaelic . . . maybe teachin' people not only a different way of talkin' but also a different way of seein' and thinkin' . . . who knows—m'be even a different, a better, way of livin' . . . An' even Prince Charles is helpin' us y'know. He was up on Skye just recent . . . I saw it in the paper . . ." Donald searched through a small pile of newspapers and magazines on a stool by the table. "Ah—here it is . . . he said he uses Gaelic now for part of his official Web site an' he made this speech:

"If Gaelic dies in Scotland, it dies in the world. The Scottish identity as a whole is immeasurably enriched by its Gaelic dimension . . . the beauty of Gaelic music and song is inescapable. But without the living language, it risks becoming an empty shell. However if the appropriate climate exists, then great results can be achieved. And if Gaelic flourishes here it sends out a message of inspiration and optimism to the world."

"Good for Charles! A true Highland loyalist. Listen, do you think you could sing me one of your songs?" I asked, hoping I wasn't stretching hospitality too far.

Donald paused, looking a little uncertain.

"Ah' g'on," said his wife, with a warm grin. "Y' love to do that . . ."

So, as the tea was poured and the shortbread rapidly devoured (mainly by me), Donald sang two of his songs in a deep, mellow voice and the rich sounds of that ancient language, throbbing with layers of meaning well beyond my comprehension, filled the kitchen. And this was no gloomy "old" man singing. Maybe this was the "new man of the blazing lantern" in that poem told to me by the quiet gentleman on the porch.

Sunday Silences

*T*HE SILENCE OF ISLAND SUNDAYS is both comforting and disturbing. Comfort comes from the virtual absence of traffic on the narrow, twisting lanes and the almost obligatory strict Presbyterian Church Sunday observances that preclude the most innocent of recreational activities and even the purchase—indeed, the reading in more orthodox households—of newspapers. Normally we would find such restrictions irritating to the point of open rebellion, but for some odd reason, on Harris it feels right. Time is given over to quieter, more considered meditations on life, family, and the welcome absence of any real choice of activities. On Sundays you go to church, celebrate familial intimacy at home, usually eat a little more simply than during the week, drink in moderation, if at all, restrain excessive mirth, and go to bed early.

To say Sundays are silent here would be like saying winter nights are dark. But the silence is not like the darkness of night, which comes in gradually as lights are dimmed, TVs turned off, and pillows plumped for rest and slumber. Here it is a sudden, self-imposed silence. As Derek Cooper in his book *Hebridean Connection* suggests: "Many people here observe Sundays with almost Jewish fervor, denying themselves the pleasure of a cooked meal or any activity not directly motivated by worship of the Lord." A regimen of strictly regulated behavior is imposed from midnight on Saturday in many homes, time-honored for generations and bound by deep fears of fire and brimstone and terrible retribu-

tions and eternal scorchings in the furious fires of damnation. Of course, few would express it quite so dramatically, except perhaps the ministers of the local churches, whose words are still regarded by many of the older residents as virtually the issuances of the Creator himself. (A few are less complimentary, with one elderly gentlemen "of no particular religious affiliation whatsoever" suggesting to me that some island ministers were "like leeches on the human soul sucking out the music, the song, the sweetness, and all the abundant joy to be had in this one wonderful life we've all been given!")

Even the normally hysterical screeches of seagulls are silent on Sundays. Maybe it's the lack of any action on the fishing boats, the paucity of enticing tidbits and freebies from the fleet, the absence of people, cars, and open garbage cans at the backs of stores, now all shut tight as clamshells.

Joseph Pennell, a visitor to Tarbert in 1887, recorded this dispirited scene:

> The Islanders are as melancholy as the wilderness in which they live. The stranger never gets used to their perpetual silence ... to them religion is a tragedy. Nowhere was the great conflict in the Church of Scotland fought with such intensity, such passion ... but we met people coming home over the hills, and still they walked each alone, and all in unbroken silence ...

The only activity was indeed the flurried arrival and departure of congregations at the churches. Straight from home and straight back with barely a chance for an exchange of pleasantries or a little gossip about last night's dance or whatever other devilish diversions had been selected on that particular occasion. All the "And did you see"s and "Can you believe"s would have to wait until Monday. Even the Sunday dinner had often been cooked the night before in many homes. Any noise or levity, certainly out on the streets, was frowned upon. And of course there were no Sunday papers because ferries from the mainland didn't run on Sundays due to the determination and the pride of most Harris residents—and much to the frustration of the ferry companies. So the

Sunday papers, and the tourists, didn't arrive until Monday. And there were no pubs open, no meals at the hostelries except for residents, and no buses. Even—so someone told me—the swings in the playgrounds were once padlocked, although I didn't believe Tarbert had many of those, so that was possibly a Stornoway joke. Not that you'd laugh at it. Because, on Sundays, you didn't laugh.

"An' also . . . ," Roddy had told us on one of our Friday get-togethers, "y'didn'a take the fire ashes out, or use a knife, or shave . . . oh, an' for some strange reason you could only peel potatoes if they were already boiled—not raw. An y'couldn'a read—except, o' course, the Bible . . ."

You were meant, in a word, to reflect. Seriously. Sententiously. And surrounded by this barren, wind-blasted, rain-ripped landscape, devoid of all distractions, empty and ragged at all its edges, uninviting in places even for brief walks because of its pernicious bogs and ankle-snapping heather roots—inward reflection and religious meditation came far more naturally here than in the fleshpots and shopping malls and tantalizing seductions of the heathen mainland.

Drinking, however, in pubs or hotels on Sundays has recently been a cause célèbre, particularly in Stornoway, where chinks in the Sabbath armor have been appearing. And there has indeed been some secularizing of other once-rigid rules, much to the dismay and disgust of letter writers to the local paper:

I wish to express concern regarding what's happening to our islands on the Sabbath day . . . The spiritual awareness of our islands has gone into sudden decline . . . Remember—it only takes a millisecond to go from this world into the next; it's a somber thought, but joyful for those who trust in the Lord . . .

And another:

And now they want Sabbath ferries! The Sabbath is a blessing given to his creatures by a loving creator for our spiritual and physical good. It is my fear that if we continue to reject this blessing the loss of other blessings will certainly follow.

An even sterner correspondent wrote:

> The sailing of ferries anywhere on the Lord's day is an offense to the law
> of God . . . If only people would appreciate that the Christian Sabbath is
> a bulwark against keeping our lives from being completely secularized . . .
> The wise man looks upward and bows the knee to God in Christ . . .
> realizing that there is a date with death and a judge to face.

But just once in a wee while, someone with a more pragmatic take
on the matter gets to make his case:

> Let them sell the Sunday papers, let the airport bar open on Sunday. It's
> not the end of the world. Do Edinburgh Christians not buy Sunday
> papers? If you don't want to buy them in Stornoway there's a simple
> solution: Don't!

It took Anne and me a long while to get used to these strange "Sun-
day Silences." We even tried attending the church services with a kind
of "if you can't beat 'em . . ." acceptance of local mores, but a combina-
tion of Gaelic-laced presentations, dirgey and instrument-less hymn
singing, odd protocols of sitting and standing (we invariably found our-
selves doing the opposite of whatever the rest of the congregation did),
and the harshly strident reminders of individual retribution and eternal
damnation made the exercise feel foreign—even a little frightening. So,
doubtless risking the welfare of our eternal souls, and much to the dis-
appointment of some of our local friends, we eventually gave up on the
services and found our own way to celebrate the silences of our many
Sundays.

We knew that farther down the Outer Hebridean island chain, par-
ticularly in the last major inhabited island of Barra, the Catholic Church
still held sway and things were significantly different. Pubs and restau-
rants were open, even some shops, cars buzzed around, ferries ran to and
from the mainland, people laughed and frolicked and romped about
with children and, I'm sure, had a gay old time on the unpadlocked
swings and roundabouts in the local parks.

"Ah, weel, tha's Catholicism f'ye, d'y'ken," one elderly gentleman told me at the Harris Hotel bar one evening. "They've got a real kooshy setup down there."

"Kooshy? That's an interesting word."

"Aye, well, tha's what 'tis. If y're Catholic y'can go about an' do all manner o' sins—fornication, intoxication, adultery—who knows, m'be a bit o' mayhem, too! An' then it's all this 'Forgive me, Father, for I have sinned' an' off they go, mumble a few Hail Marys, an' it's all written off, so to speak. Forgotten. Clean slate, y'ken. Free to go off an' do it all over again . . ."

"Well, I think they have to have the intention, when they go to confession, of not committing the same sins again . . ."

"Says who?"

"Well . . . ," I faltered, "that's what I've heard . . ."

"Bollocks! An' double bollocks!"

"Yes . . . well. I see your point . . ." I was floundering now.

"T'my mind it's jus' no fair. No right, y'ken."

"What—you mean we should just let all our sins pile up and then—"

"Tha's exactly right. Let 'em pile up an' up. An' those wi' the biggest pile go down an' those wi' the littlest piles get their just rewards . . ."

"In heaven?"

"Tha's chust right. In heaven. Where else, f'God's sake."

"Yes. Well—yes—where else indeed . . ."

I was curious to get his reaction to the ideas of divine forgiveness, love conquering all, and the fact that the New Testament I'd read makes little, if any, reference to hell. There seems to be an assumption that, as we're such a pathetic lot of "born into sin" sinners and that we've already been forgiven anyway by Christ's self-sacrifice, we'll all more than likely nudge our way into the heavenly hordes without getting crisped in the eternal fires.

But I didn't ask him. I had a feeling I wouldn't like the answers and I was tired—very tired actually—of the infinite schisms, not only of Christianity but of all so-called religions.

It was time for a change of perspective and place—a place supposedly

awash in Catholic benevolence, tolerance, and forgiveness. A place like Barra maybe . . .

"Fancy a trip down through the Uists to Barra?" I asked Anne at the tail end of a particularly somnolent Sunday.

"Wonderful!" she said. (I do enjoy her sudden spontaneities.) And so—we set off to Barra to see how other islanders lived . . .

Barra and Back

———————————

*E*VEN THE MOST CURSORY GLANCE at a map shows the Outer
Hebrides as a wiggle-tailed, fishlike (one outsider suggested "an
overanxious sperm in hot pursuit of an elusive egg") archipel-
ago, with the broad expanse of Lewis as the head, Harris as a kind of
neck, North and South Uist and Benbecula as its spine, and tiny Barra as
its tail—slightly, and appropriately, off kilter.

Which of course is one of the reasons we responded to a serendip-
itous urge to leave Harris for a few days and see if all the rumors about
that rambunctious little Catholic isle way down at the bottom of the
Hebridean chain had any validity. Rumors, as we've often discovered in
our wanderings, have a habit of galvanizing into reputations, and
reputations into distinctly biased and self-fulfilling realities. And
the rumors about Barra were indeed rife on Harris: "Och, they're
soo diff'rent from us up here—'s MacNeil territory, d'y'ken.
S'wha'd'ya expect?" (with a sly wink, the significance of which eluded
us completely at the time); "'S'more Ireland than Scotland—and
not the best of the Irish either . . ."; "Oh, it's a wild, barren, boggy
place"; "Now what kinda place would put an airport runway on a tidal
beach, ah ask?"; "Well, y'should read Compton Mackenzie's *Whisky
Galore*—he lived there, so he knew about all their drinkin' an' their
blasphemies . . ."

The first time I remember reading anything about Barra was in one
of Isabella Bird's magnificent nineteenth-century travel odysseys,

Unbeaten Tracks in Japan. Her reference was regally dismissive (as indeed were many of her commentaries on life in foreign climes), as she stated that the thatched village dwellings of northern Japan were "as black and vermin-filled as the insides of a Barra black house."

So, in the hope of negating such images we took the ferry from Leverburgh one blue morning to Berneray and began the long drive south through the Uists. Fortunately, on the boat we met a young woman returning to her home on Barra and she began to set the rumor record straight: "Och, so much nonsense y'hear 'bout Barra. But I think people up north have a bit of a bleak outlook on life anyhow, y'know. They canna help it. It's that Church of Scotland thing—doom, gloom, and damnation for the majority. God—it gets a bit much at times! And most o' them have never even been to Barra. We call it 'The Garden of the Hebrides'—and it is that, y'know. Over a thousand different types of wildflowers we have on a tiny place barely ten miles around and over a hundred and fifty different kinds of birds, seals, dolphins, and whales. It's like the Hebrides in miniature—heather-covered hills, beautiful white beaches, little rocky coves which you normally have all to yoursel', big, high cliffs—oh, and that lovely, lovely castle of the MacNeils—Kisimul—the tower dates back to 1120, y'know—floatin' off all by itself in the middle of the bay at Castlebay. That's our main town—well, it's our only town, actually—and there's only a couple hundred of us there out of tourist season. We still have around fourteen hundred people altogether on the island and everybody knows everybody . . . oh, and if you climb up Heaval, it's only around twelve hundred feet high, but at the peak y'feel you're on top of the whole world . . . y'can see . . . forever!"

We didn't want to stop her. It was refreshing to feel the silly rumors and bad-mouthings about Barra being washed away in her gush of eager-eyed enthusiasm.

"Oh—and we're the last inhabited bit of land before America," she added. "In fact, the pub in the Isle of Barra Hotel—modern place on the west side where we once hid the Shah of Iran's family when there was all that trouble with Khomeini in the seventies—y'remember that? Well, that's where y'can sip 'the last dram before America.' Nice place. Fantas-

tic sea views . . . honestly, my wee island's jus' 'bout as good as it gets . . . anywhere!"

The hourlong ferry ride was a sinuous wiggle between the islets and shoals of the Sound of Harris. I wondered why on earth Lord Lever-hulme ever thought of trying to make Leverburgh into one of the main ports in western Scotland. This gauntlet of ragged rocks could hardly suggest a safe haven for large vessels. Even Andrew Johnson, who takes tourists out to see the seal colonies among this labyrinth of islets in his small sailing boat, admits after years of experience that he still finds the place "a little treacherous." He particularly dreads the sudden smother-ings of sea mist "that can emerge out of perfectly normal days and turn the sound into a thick soup in a matter of minutes."

Fortunately ours was a soupless journey, although it was fascinating to see how wide a berth the captain gave some of the shoals. Way off to the east, on the far side of The Minch, the towering cliffs of Skye were bathed in early-morning sunshine and behind them rose the frost-shattered peaks of the Cuillin Hills, purple hazed against a dome of cloudless blue. There was something majestic and proud in their massive jagged profiles, but, as always in the Hebrides, beauty rarely comes with-out its inner layers of Gaelic melancholia—a mood captured to perfec-tion in the strong, sinewed Scottish poems of Sorley MacLean and Louis MacNeice.

"Captain's a canny one," commented a fellow passenger, crouched by the rails in a stiff breeze, apparently intrigued by our serpentine wake.

"That's fine with me," was all I could think to say before going off to the ship's store to buy a detailed map of this southern section of the Outer Hebrides.

And if ever a map was worthy of an art gallery hanging, this was the one. It was hard to tell land from lochans in the intricate lacework of abstract shapes. Even Finland's beloved Lakeland region has nothing on the detailed meldings and scribbly patterns of islands, lochans, pools, and puddles here. Thousands upon thousands of them pockmarked the land from Lochmaddy at the northern tip of North Uist, through Benbecula and South Uist, to the new bridge across to Eriskay (a small island described by one writer as "a lumpy huddle of grass and heather, croft

and beaches" and a haven of escape for Bonnie Prince Charlie after his disastrous campaign to restore the Stuart monarchy) and the second ferry crossing point to Barra itself.

In the days, not too long ago, when movement across this strange, boggy waterland topography was a hazardous process along pernicious paths and across fickle tidal fords, the old Gaelic blessing to travelers of *Faothail mhath dhuibh* (May you find a good ford) characterized the tenuous spirit of life on the Uists. Despite the presence on the eastern side of significant upland terrain, most of the land here is pool-table flat, treeless, and blasted by ferocious Atlantic winds. And the farther westward you look, across the vast sweeps of green *machair*, the more you sense the eerie infinitudes of the terrain.

Crofter cottages were dotted about in irregular fashion, but despite evidence of grassland fertility characterized by the presence of cattle (a relatively rare sight in Harris and Lewis) as well as sheep, Anne and I sensed a distinct loneliness here. This became even more evident when we left the security of the single main road down the island's spine and meandered off along narrow backroads and rough tracks deeper and deeper into this flat dreamscape. The loopy edges of the lochans merged one into the next; round patches of *machair* nestled together like green pancakes in the shallows; sheep hopped from one to another like agile rabbits. Eventually a slight rise in the land of low dunes signaled the final western merger of *machair* and ocean. We stopped the car by the side of a gravelly track, strolled through the dunes, and walked out onto vast, slowly curving strands of almost pure white sand, fine as baby powder, and utterly unoccupied for mile after mile in both directions.

"There's enough seaside frontage here for the whole population of Scotland!" I remember exclaiming at one point as we sat in a sand hollow, staring southward from Ardivachar Point on South Uist down twenty-five or more miles of virtually unbroken beach. With not a soul to be seen anywhere.

"Yes—but those gales here. They'd blow them all back to the mainland!" said Anne, which at the time seemed an amusing retort. However, a while later, in unexpectedly ferocious hurricane-force winter storms, we learned that a whole family of five in a car had been literally lifted off

the road in a gale-created tidal surge and drowned while trying to cross the two-mile causeway linking Benbecula with North Uist.

But such tragedies, past and present, have obviously not discouraged settlement along these shores. The rich *machair* was just too tempting for ancient Neolithic (up to 2000 BC), Bronze Age (to 300 BC), and Iron Age (300 BC to AD 200) settlers—a heritage of over five thousand years—whose bold remnant structures and standing stones still litter the island chain today. Then came the marauding Vikings in the eighth century, and subsequent generations of crofter-farmers who maintained a subsistence way of life here for centuries. The population increased rapidly, as in Harris, during the peak of the kelp industry in the early 1800s, and in the lucrative herring era. But then, crisis and calamity came just as it did to so much of Scotland, particularly the island communities. It's the same story over and over. The overcrowding of the crofter populations, the terrible potato famines of the 1850s, the decline of kelp and fishing, and the frantic maneuvers of the clan chiefs to introduce widespread sheep farming by "clearing" the crofters off the land and shipping them off to Canada or Australia. All led to a decimation of the "old ways," the destruction of the small crofts, and the creation of a *machair* plain inhabited only by sheep and cattle.

Today, although the crofters are back following dramatic reforms and tenancy laws after the passing of the 1886 Crofter Act and subsequent "social enhancements," their numbers are few compared to the old days. And while prosperity is evident in the well-kept pastures, the neat fencing, and the newly whitewashed homes, the vast green *machair* still possesses an empty aura punctuated by the grass-smothered humps and bumps of long-abandoned black houses. Yet one more place of whispered tragedies and cruel evictions.

"We had to do it," claim descendants of the clearance-era lairds. "There were just too many people on too little land and they were starving and the industries were dying—and we were going bankrupt too! So—we tried to help our crofters get a fresh start somewhere else."

The crofters, of course, tell a far different story. And even today in bars and community halls all around the Hebrides, you can still sense their anger and resentment and their "never again!" spirit.

We got a smattering of it when we stopped briefly at the Politician pub in Eriskay to see what more we could learn about the famous story that made Compton Mackenzie's book *Whisky Galore* an international best-seller and movie and put these remote islands well and truly on the tourist map.

"Y'wanna hear the story, d'ye?" An elderly, stooped man approached us as we were studying the old sepia-tinged photographs on the walls of the modern-looking pub, whose windows faced out across the Sound of Barra and the wide Atlantic. He gave a sort of lopsided leering sneer when he noticed we were reading the "official" history of the event framed beside the photos, and stood close enough to drench us in pungent whisky fumes.

"Aw, f'get a'that. Ah'll tell'e wha' really 'appened."

"Why—were you there?" I asked. The event took place in February 1941, so as I guessed he was well into his seventies (but looking more like a hundred with his wrinkled, line-etched face), I assumed he might well have been a participant in this hilarious episode.

He gave a kind of "What kind of daft question is that?—Of course I was" grimace and proceeded to describe how the twelve-thousand-ton cargo ship *Politician* had been grounded by an errant navigator "on the last bit o' rock between here and America" at the eastern end of the Sound of Eriskay and was quickly found to contain over twenty-four thousand cases of whisky ultimately bound for New York.

"This wa' the war time when whisky—we called it the *cratur*—was a wee bit rare in these parts so y'can imagine what a lovely surprise this was for us all. And quick work we made of that liquor too—dropped those boxes off fast as lightnin' and hid 'em in places like y'wouldn'a believe."

"But it says here that the customs men were able to requisition most of the cases and very few were stolen . . . ," I said, pointing to the "official" story on the wall.

"Rubbish!" the old man responded with remarkable vigor, dousing us once again in a noxious smog of whisky fumes. "Tha's wha' they had t'say, weren't it?! But even today y'still find people sellin' them ol' bottles fer enough cash t'fill this bar with the *cratur* fer a year or more. Oh,

no—w'got a nice lot o' the stuff off long before the customs got 'emselves up 'ere."

"And it says that many of those that were caught got prison sentences . . ."

I waited for another blast of fumes but he decided to sulk instead at my tactless interruption.

"Och—believe wha' the hell y'wanna believe."

He moved away. I wondered if I'd been a little rude and Anne was nudging me with a kind of "do something" urgency, so I followed him to the bar and offered him a drink. "Och, weel—I'll jus' have a large one then, seein' as y'askin'," he replied, and I felt I'd been caught once again in a little local trap for gullible outsiders. But I bought a round for all of us, including the barman, and the old man started up again.

"Y'see, what they don't really tell you in all this official history is what else was on board that poor ship. Y'won't believe—there were boxes of cigarettes—real expensive ones—an' silk dresses, an' fur coats, an' perfume, an' fancy shoes an' all kinds o' cases—travelin' cases like y'take fer a holiday. An' can y'guess who all this stuff was for?"

"No idea," said Anne. "Doesn't sound like normal cargo . . ."

"No—and 'twasn't!" The old man leaned closer (more fiery fumes) and half whispered, "'Twas for the Royal Family, King George and the Queen Mum and all of 'em—their stuff—bein' sent over to Jamaica or Bermuda or some such island paradise to make them all cushy-like there if we lost the war with Germany . . . so . . . wha'd'ye think about all that then?!"

This was new information and we digested it with bemused skepticism, but at the same time we toasted our aged informant to prevent further misunderstandings.

I thought it best to return to the subject of Compton Mackenzie and his book.

"Ah, well—that Mackenzie man was a fine man, all right. Maybe he played 'round with the truth a wee bit, y'ken, with his book—he did another one too, y'know, about the rocket range up there in South Uist—*Rockets Galore*, he called it. Didn't seem to catch on, though, like *Whisky*. But what did catch on was the man himself and his Scottish nationalism . . ."

"I thought he was English . . . ," I said, and wished I hadn't.

"English?!" The old man made it sound like some kind of terminal disease. "Well, if 'e wa', 'e wa' a much better Scotsman than any Englishman I've ever met!"

"Okay," I said, once again subdued into silence.

". . . An' he did a lot more for the people here—us crofters who'd been treated so bad for centuries—and the fishermen of the isles too—with his Sea League and all his speeches about illegal trawlin' by the damn Spanish an' those Ruskies an' the Japs . . . he really tried to stop a' that. An' he lived down there on the beach where the planes land on Barra. He was there 'til 1945 an'—och, y'should have seen the fuss they made when he died in 1972 an' they brought him back for burial at Eoligarry. All the islanders wa' there. That was a fine, fine day for a ver' fine man . . . a *Scottish* man!"

We thanked our informant for his time and slowly crept out of the bar, passing a "genuine" bottle of Politician whisky proudly encased in a cabinet by the door, and leaving him to his musings.

We'd left with a similar humility too a while earlier in the day after one of the finest lunches we'd enjoyed anywhere in the Hebrides. The place was called the Orasay Inn—a true gastronomic oasis set way out in the lochan-laced landscape of South Uist. If it had not been for a friend insisting that we sample the fare here, we never would have noticed the small sign at the side of the main road near Ardmore pointing the way across a bleak, gale-whipped landscape to this intimate hotel and restaurant, where Isabel and Alan Graham proudly showed us just how good local Hebridean fare can be when prepared with imagination and flair.

All the raw materials of the isles were there on the menu: venison, lamb, duck, salmon, fresh fish, crabs, hand-dived scallops, cockles, mussels, locally smoked "flaky" salmon, Hebridean fish soup—even crème brûlée and "milky seaweed pudding" for truly discerning gastronomes. We dined like royalty.

There were hotel rooms too, all with spectacular views across the lochans and moors. It was tempting . . . but we had a second prebooked ferry to catch to Barra, so, in a gastronomic glow, we moved on.

We could see Barra quite clearly across the sound as the boat eased

its southward way from Eriskay and we stood at the rail, sea breezes toss-
ing our hair, remembering an evocative description of the island's spirit
by Alastair Scott in his delicious book of Scottish journeys, *Native
Stranger*: "It was another Sabbath. The good people of Barra had attended
mass. There was to be a football match that afternoon. The bars were
open (though you couldn't buy a condom for love nor money). A gen-
eral levity rubbed shoulders with humor . . . Even the ferry sailed." (The
author was obviously well aware of the difference between Harris and
Barra Sabbaths.) The idea of Sabbath ferry sailings and pub openings on
Harris is, of course, taboo territory, as the Calvinistic islanders fight to
keep their Sunday traditions sacrosanct. So Barra's rather lax Catholic
attitude toward such matters is regarded by the *Hearaich* as sacrilegious
and "papist" in the extreme. Hence, the bad press up north and exagger-
ated rumors of the flagrant Sodom and Gomorrah antics of the natives
down here.

As we were arriving midweek, we had no chance to witness the ter-
rible sins of "Barra Sundays." We do remember, however, the smiles and
waves of the locals as soon as we drove off the ferry, up the slipway, and
onto the main—the only—circular road around the island. Everyone
seemed pleased to see us. Admittedly, we were grinning like tourists as
we realized, within minutes of our arrival, just how serene this "small is
beautiful" place appeared to be. And our grins turned to guffaws as a
small twenty-seater turboprop plane skimmed low enough over our
heads for us to feel the backdraft and landed, gently as a descending
swan, on the golden sands of Cockle Strand Airport just ahead.

A sign at the roadside warned: KEEP OFF THE BEACH WHEN
THE WINDSOCK IS FLYING. It didn't, however, mention anything
about keeping your head down when the plane is actually landing.

We decided we'd stop for a coffee at the airport. It was a clean, well-
organized little facility and the sunlight-filled cafeteria even claimed to
offer "home-cooked island specialties." I was hoping for a "light snack"
of fresh-steamed cockles with drawn butter or maybe a bowl of *cullen
skink* soup, but all the cheerful lady behind the counter could offer was
a rather wrinkled meat pie. ("So sorry—the passengers who are chust
leavin' 'ave eaten all the specials.") Unfortunately, it was also one of those

Scottish pies, a rather sad, deflated four-inch-diameter concoction of pale leathery pastry filled with an innocuous mix of minced meat— so very different from the crisp, bronze "cold pastry" pork pies of England oozing with jellied stock and richly spiced chopped meat. Anne wouldn't touch it and I gave up after a couple of bites. Not a promising introduction to the gastronomic bounties of Barra, I thought.

A uniformed gentleman standing nearby chuckled, "Bet y're from England—and y're wondering whatever happened to real pork pies up here!"

I laughed too.—"Yes—absolutely. I just can't seem to develop a taste for . . . these things . . ."

He nodded empathetically. "Don't worry. When y'get down to Castlebay, y'll be in for some fine dining!"

He was obviously an airport employee, so I asked how many flights he expected at the airport that day.

"Oh—just the one. From Glasgow."

"One?! Y'mean—you have all this airport and all these staff people I see wandering about for one flight a day?!"

He laughed again, not in the least bit offended by the implication that this might be some kind of ridiculous bureaucratic boondoggle. In fact, he seemed delighted to have someone to talk to. And—could he talk! For the next fifteen minutes we listened to the most remarkable stream-of-consciousness monologue that encompassed the fickleness of the local weather; the current health of his wife and kids (five in all); the foibles of the British Labor government and the "craftiness" of the prime minister, Tony Blair; the eccentricities of the local Catholic church ("it's like they're all nervously whistling past their own graves!"); his resentment at only being a part-time employee of this nothing-much-happening airport, and his radically revised philosophy on life following a recent traumatic operation, which he insisted on describing in glorious technicolor detail.

We were worn out by his diatribe, although I was enticed by one Scottish quotation he gave as the key to his "new" life following his operation: "Nae man can tether time nor tide." He then went on to explain in more extravagant detail how he interpreted this Robbie

Burns aphorism to mean that you've got to make the most of each and every day because you never know what fate may have in store for you next. And as if to clinch his own "reborn" attitude toward life, he quoted the great bard once again:

> *"Heaven can boil the pot*
> *Tho' the deil piss in the fire."*

"Well, we'll certainly remember that," I said as we hurried for the exit.

We drove on toward the end of the narrow peninsula north of the airport, passing Compton Mackenzie's old home, and ended up in a windswept cemetery where the rambunctious writer is buried. The sheep-shorn grasses rose uphill to bulky stone remnants of an ancient church, *Cille-bharra*, thought to be a twelfth-century structure built on

Kisimul Castle—Castlebay, Barra

the site of a seventh-century church dedicated to St. Barr. The island's mysterious patron saint, a loyal follower of St. Columba and also known as St. Finbarr or Barrfinn, is thought to have settled here from Ireland, bringing a staunch Catholic faith with him. Although he almost didn't. According to local legend a missionary sent to prepare for his arrival was roasted alive and eaten by the Barra residents! This is, therefore, one of the most important religious complexes in the western isles—burial place of the island chiefs, the MacNeils, and once a monastic community with a famously unique gravestone boasting a Celtic cross on one side and an inscription in Norse runes on the reverse, which, historians claim, is ample evidence to suggest the conversion of Norse raiders and settlers to Catholic Christianity in the eleventh century. Their presence here was certainly a dominant factor from the eighth century, and the melodic names of the tiny islands off Barra reflect the ancient Viking tongue—Orosay, Gighay, Flodday, Vatersay, Mingulay, and many others. As do the place names of the tiny communities scattered around the island—Brevig, Skallary, Earsary, Boinabodach, Borve, and Tangusdale.

The sun was out and it was warm. So, as Anne wandered among the gravestones and over the marram grass–topped dunes to the beautiful mile-long beach of Traigh Eais, I sat with my back against a rock and tried to capture the power of these ancient ruins on my sketchpad—particularly the huge double-arched doorway that once led into the interior of the twelfth-century church. Birds chirped all around; buttercups and daisies that had somehow survived the constant onslaught of avaricious sheep danced in the late-afternoon breezes. And a great peace came over me. One of those frisson moments when everything in life seems to be just the way it should be. And I laughed quietly, remembering the Burns life-affirming aphorisms offered by the man at the airport. They pretty much said it all.

"You're daydreaming!" Anne chuckled, her cheeks flushed by the strong ocean winds blowing on the other side of the dunes.

"I guess . . . ," I said, wondering why I hadn't completed my sketch. "I just feel . . . ridiculously happy . . ."

"Must be the spirit of little Barra sneaking in . . . ," said Anne, and

snuggled down beside me. We sat quietly together, our backs against the warm rock, listening to the birds and watching the flowers dance their summer dances.

A while later we drove southward down toward Castlebay, passing remnants of ancient Iron Age duns (forts) and standing stones—now a familiar sight across the wild Hebridean landscape.

"I think we just passed a golf course!" Anne giggled.

"A golf course?! In this wild terrain?"

"Go back . . . let's see . . ."

So, obedient as ever, I drove back a mile or so and saw, way on a high promontory, the familiar golf course flags. And as we drove closer we realized that each of the greens had a neat little fence around it. We parked by an empty green-fee shed. Obviously, as on the similar nine-hole course on Harris, they use the honor payment system here.

We saw a young couple dragging their golf club bags up the steep hillside toward the shed.

"You look a bit weary!" I called out to them.

They both smiled. "We should be. It's our third round here today!"

"How many holes on the course?"

"Only nine—but with crazy topography like this—all these rocks and cliffs and near vertical fairways—it's a par sixty-eight. You should see the bunker on the fourth hole. World's largest, so they say . . ."

"And those fenced-off greens—they're pretty unusual . . ."

"Well—they need them. Cows get everywhere. They even had to electrify them."

"They don't have those on Harris."

The woman laughed. "Well, they don't need them. They only have sheep there. But believe it or not, even though it looks pretty mild, Harris is a harder course than this one—more subtle and devious."

Neither Anne nor I were golfers, so we just nodded and accepted their verdict. They seemed to be confidently knowledgeable about the refinements of the game.

"Well—this certainly seems a very challenging place to put a course," I finally said.

"Y'shoulda been 'ere yesterday," the man said, with what can only be

described as a goofy golf addict grin. "Pouring down and winds that would send y'flyin' on those top greens." He pointed to the rocky summit of the promontory, a couple of hundred feet higher than where we stood.

"Y'mean the course goes up there? Right over the top . . . ?"

"Oh—way over. It's a real bugger in places. We only managed a couple of rounds."

"In the storm?"

"Right—in the storm."

"You must be very keen . . . on all this," said Anne, with a kind of why-would-you-bother grin.

They both laughed. "Oh, yes, you could say that," said the woman. "You two obviously don't play golf."

"No," I said.

"Well, we like miniature golf, though . . . a bit . . . don't we?" Anne suggested hesitantly.

There was a rather uncomfortable silence. The yawning gap between golfers and nongolfers was fully manifest as we all stood shuffling our feet by the shack.

"Well," said the man finally, "enjoy your day . . ."

"So, where are you going now?" I asked as they turned away together.

The woman chuckled. "Oh—back for one more round."

"Can't keep a good golfer down, y'know," said the man.

And off they went, dragging their hefty golf bags again, still looking rather stooped and weary.

"I guess I'll never get it," I said quietly to Anne.

"Ditto," she said as we strolled back to our car. "But miniature golf can be a bit of a laugh . . ."

But we certainly "got" Castlebay. As soon as we entered this somewhat straggly community scattered around its cliff-bound bay at the southern tip of the island (the rugged cliffs of Muldoanich here tower over five hundred feet above the ocean), we sensed a lighter spirit of life here. Quite different from the restrained—even rather stern—modesty of Tarbert. Notices in the shop windows suggested a turbulent social life

of *ceilidhs*, fairs, community dinners, visiting lecturers, pub and hotel "special evenings," and a welter of New Age enticements, including massage, meditation, yoga, tai chi, and a few other odd practices we couldn't quite understand.

There were tourists around too. We'd missed the peak of the season, fortunately, but there were enough backpackers, snuggling teenage lovers, and café-filling families to give this small community a distinct zing of incomer eclecticism. There was even a gaily painted hostel set on a bluff overlooking the harbor that exuded all the "make love, not war" spirit of the sixties—including drawling Bob Dylan songs wafting out across the road (definitely not a Stepford Tourist venue here). "Hey, Mr. Tambourine Man" never sounded so good.

"Great time-warp territory," I chuckled.

"And time to find our B and B," said Anne in her "let's get organized now" voice.

And there it was, a short distance from the proudly gabled Victorian facade of the 1890 Castlebay Hotel, which was set high on a bluff alongside the more mundane-looking but, as we later discovered, maniacally popular Castlebay Bar. We'd booked in advance and were greeted with unabashed enthusiasm by the young couple who ran a cottage-like cocoon of cozy hospitality. Even though the place was full, we were treated as if we were their only guests, and they stood together, beaming brightly, as we admired our chintzy bedroom with windows overlooking the bay and the bulky ramparts of Kisimul Castle.

"You'll be able to get a boatman to take you out there, if you like," said our smiling hostess. "He'll tell you some juicy tales about the Mac-Neils of Barra—some of them were real pirates, y'know. One of them— Ruari the Turbulent—even tried to capture one of Queen Elizabeth the First's treasure ships. And they say when the castle was first built in the eleventh century, they had a herald with a trumpet up there in that tower and when the clan chief had finished his dinner each night, the herald would blow his horn and shout out across the town, 'The MacNeil has dined. All other princes of the earth may now eat!'"

Many more enticing stories flowed out from our hostess (her husband, who must have heard them a thousand times, left politely and

apologetically "to fix a tap washer") until eventually we were left alone to prepare for dinner at the adjoining hotel.

And what a fine meal that turned out to be. Despite the abundance of game, fish, and fresh seafood all around the Hebrides, it's often frustratingly difficult to find authentic regional dishes and local ingredients here. But not at the Castlebay Hotel, where the menu ran the gamut from venison, grouse, Barra lamb, and haggis to a welter of seafood delights including fresh cockles, mussels, scallops, crabs, langoustines, herring in mustard sauce, herring in oatmeal (true traditional fare and a staple dish of the old crofters), and razorfish. We stuck with the seafood and fish and ended up with a vast sampler platter of just about every type of creature caught that day. I was particularly enamored with the razor-fish—a strange elongated entity with a lobster flavor and a texture like tender scungilli. Anne seemed a little discouraged by its odd appearance and stuck to more familiar delights.

After leisurely coffees and a quiet digestive period in the large armchairs of the lounge overlooking the bay and the still-bright evening light, we wandered out for a walk. Those long Hebridean summer days seemed to inject fresh energy, and going to bed felt like such a ridiculous waste of playtime. So we played—next door at the Castlebay Bar along with what felt like the whole population of the island. And I would truly like to amuse readers with wonderful folktales gleaned from the old salts here, but for some odd reason, my mind draws a blank when I try to recall whatever occurred over the next few hours. I remember it was noisy. And there was occasional feisty music from a live *ceilidh* band. And laughter—there was a lot of laughter. And drinks. Well, yes, I do admit to maybe a slight overconsumption of traditional Scotch and beer chasers with a bunch of locals who kept insisting that I (Anne had wisely distanced herself from the fray) was "na keepin' up, laddie" and implying that we English were no match for the wash-it-down-and-have-another spirit of the islanders. I guess I must have regarded this as some kind of challenge and so, merely in an effort, you understand, to show what we Yorkshiremen are truly made of, I may have overestimated my ability to keep up. But of course, I didn't know that at the time.

The following morning, I certainly did. And I sat morosely at the

breakfast table, woozy-eyed and fuzzy-minded, nibbling like a nervous mouse on cold, dry toast while Anne gleefully downed the full repast of bacon, haggis, black pudding, sausage, eggs, beans, tomatoes, and fried bread. Now, normally my wife avoids such gargantuan platters and eats a far healthier fare of oatmeal, fruit juice, and fresh-baked scones or little pancake-like bannock cakes. But for some reason, on that particular morning, she chose my kind of breakfast as—I suspect—a none-too-subtle rebuke of my antics of the previous night.

"I think I'll go up to the room now," I half whispered (a full-volume voice echoed around my head like a thumping bass drum).

"Oh, no, darling," my darling replied, determined to get her message across. "Just wait a few more minutes. I've almost finished," as she proceeded to devour every item on her plate and my stomach roiled in silent protest.

Fortunately, the fresh sea air outside our little B&B removed much of the porridgey mush floating around my skull and, although I decided to abandon plans for a choppy boat ride out to the castle, we managed to enjoy a slow (geriatric-paced, actually) stroll around the town.

And what an odd, enticing place it turned out to be—dotted with bizarre characters and bathed in a spirit of benevolent bounty that made us wonder if we should add Barra to our list of must-revisit locales.

First we saw one elderly lady with a thick walking stick, dressed in wrinkled sporting trousers, rubber boots, heavy knitted sweater, and a huge paisley scarf wrapped many times around her head. She carried a plastic pail and kind of shuffled along in a hunched manner trailed by a large black dog. She took a rough path down to the shallows near the harbor and, balanced somewhat precariously on the rocks, started to pick things off the tide-etched strata.

Anne was a little concerned and asked a passerby if he thought the old lady was safe. The man laughed. "Och, don't y'worry 'bout old Sarah. She's always down there lookin' f' her winkles an' cockles. She'll be back up soon an' go to the café and try t'sell 'em. Even if she doesn't, she always gets a free cup o' tea. Everyone loves 'er . . . she's had a tough life but she keeps on goin'. Inspirin' to all o' us—tha's what she is!"

And "inspiring," I guess, is one word to describe the gentleman we

met at the far edge of town. His tiny cottage, gaily painted in cream with red trim, was the epitome of the "doll's house" style, and his garden was a mini-wonderworld of flower varieties, neatly trimmed bushes, garden gnomes, and meticulously pebbled pathways. We had been accustomed to typical Hebridean homes that possessed what might be called a kind of "crofter-chaos" appearance. Not exactly untidy, but usually reflective of a wide range of "projects in progress."

The owner of this almost-fairy-tale creation was putting away his collection of gardening implements into a tiny, brightly painted shed and we stopped to congratulate him.

"We don't see many places as neat and colorful as this," I called out.

He gave a warm smile of acknowledgment and came over to where we stood by his brightly painted fence. And as soon as he opened his mouth, it was obvious that he was no islander.

"Let me guess," said Anne. "That's not exactly a Yorkshire accent . . . so I'll try . . . Lancashire."

"Spot on, luv," he laughed. "Manchester born and bred and proud of it."

"So what are you doing here?" I asked.

He grinned. "My—it's been so long now, 'most on twenty years— I've almost forgotten why I first came up. But when I did, I decided I could do awright 'ere. People're friendly. Property were cheap then an' I had a small pension. An' I just sort of got . . . involved . . . with this place. Doin' it up like. Makin' it look nice."

"Well, you've certainly done that," said Anne, with a wide smile. "Quite an example you've set."

"Oh, well—y'know, they tease me a bit about that. But it's what I love to do . . . so . . . y'know, it's as they say: 'If y'do what y'love, it'll love ye back.'"

I'd never heard that particular aphorism before, but it certainly seemed to apply to this man's work. The place glowed with . . . well, love, I suppose. It made you happy just to look at it—and him, too (despite the fact he was a Lancastrian, once dire enemies of us Yorkshirefolk).

After that the day became a collage of serendipitous meetings and conversations, and we shall never forget our final experience. We'd sat

with one elderly gentleman—a sturdy little troll of a person—down by one of the harbor cafés. We only intended to join him briefly for a coffee. But Andy MacLean turned out to be one of those splendid human repositories of historical fact (and maybe a little colorful fiction too) who insisted on clarifying our somewhat jumbled understanding of Barra's heritage.

"It was awful hard to be a Catholic in this place," he told us after a little idle chitchat, his rheumy eyes brightening with pride and his mop of silver-white hair shaking with emotion. "Back in the seventeenth century those bloody Presbyterians persecuted us Catholics all over Scotland. And it was ver' bad here—even our MacNeil chiefs gave in an' turned Protestant and brought in the Church of Scotland ministers to punish us and tax us and even evict us and send us off on those immigrant ships in the mid-1800s. Quite a time that was . . . there were riots by the crofters an' it got so bad that there were government warships runnin' up an' down The Minch."

Andy spoke with such intensity that we felt as if these traumatic events had occurred just recently rather than a century and a half ago. It was obvious that more coffees would be needed. "No, no!" said Andy. "Let me get 'em." He leaned across the table and half whispered with a mischievous gleam in his eye and a lopsided smile revealing a Callanish-like line of broken teeth, "Mairi usually gi'es a second cup fer free." Mairi was apparently the owner of the place and she did indeed show such generosity—in a way that's quite customary in America but rather rare in thrifty-spirited Scotland.

"Anyway . . . what was I . . . oh—the warships. Quite a time that was, what with all the people leavin' an' even talk of makin' tiny Barra into a prison colony! Can y'believe that?! Our beautiful island bein' turned into another Botany Bay. But it didn't happen and those that were left got some new land rights—an' all that time they stayed Catholic. Hardly a one converted over. For sixteen centuries we kept the faith. An' there's our lovely church to prove it." Andy pointed to a large gray stone church with a prominent crenellated tower on a rocky bluff overlooking the town—"Our Lady, Star of the Sea . . . now that's determination f'ye, don' y'think . . ."

Anne smiled and nodded.

"And maybe a little luck," I added. "Apparently the government warships never landed."

Andy laughed and pushed back his mop of hair, which now hung so low over his eyes he looked like a shaggy sheepdog.

"Aye, well, there's some truth in that. The MacNeils were known for their luck! Y'know the story of Ruari the Turbulent's takin' o' one o' Queen Elizabeth's ships, d'ye?"

We both nodded. We'd heard this famous story from our hostess and a couple of others already.

"Well—they tricked 'im off the island and sent him to Edinburgh fer punishment, but he told King James that he'd done it as a gesture against Queen Elizabeth the First—'the woman who murdered Your Majesty's mother, Mary Queen of Scots'—and so he escaped a hangin'! And also—when Bonnie Prince Charlie came to Eriskay after the rebellion to take the throne back for his father, the MacNeils were a canny lot an' didn't show much support, an' even though the clan chief was arrested and put in one of those terrible prison ships in London, he was never properly prosecuted. So that's two escapes. Pretty clever bunch, eh?"

"Flora MacDonald in South Uist wasn't quite so lucky, though, was she?" I said, trying to remember my island history. "I know she tried to help the prince escape after Culloden—dressed him up as a servant girl, or something . . . but wasn't she caught later on and imprisoned?"

Andy laughed. "Well, no—actually not. She told such a good story to the judges in London that they let her off. Then she went to America for a while but came back and met Dr. Johnson and Mr. Boswell on that famous trip o' theirs. An' one o' them, I think it was the Boswell fella, said she was 'a little lady of most genteel appearance, mighty soft and well-bred . . . ,' an' 'e said that she will be remembered forever and 'if courage and fidelity be virtues, mentioned with honor.' So she turned out to be as canny and as lucky as the MacNeils!"

Again we had the sense that history to Andy was alive and almost tactile. These were not just legends to him. They were rather a source of pride and island identity that for him remain right up to today.

"But you had good times here too," I suggested. "Y'know, after the

Napier Commission—much better conditions for the crofters. And the kelp and the herring and cod fishing in the last century—they were pretty lucrative."

"Ah, yes yes—an' all those lovely herring girls . . . scores of 'em at the curing stations on shore . . . beautiful creatures . . ."

Andy's eyes seemed to water a little as he recalled memories of an obviously private nature.

"Yes—but weren't they always on the move . . . following the fleets to the English ports?" asked Anne.

"True, true, some were but . . . they always came back, y'know," said Andy, "always came back."

We didn't want to disturb his reveries, so we sat quietly watching the gulls wheel over the harbor and looking out for seals, which we'd been told occasionally frolicked around the rocky shallows here.

And then he was off again. "An' y'know, at one time in the late 1800s, our little harbor here held more fishing fleet boats than Stornoway! Sometimes more'n four hundred boats."

"And didn't old Compton Mackenzie help keep the industry going with his Sea League?" I asked, hoping I'd got my history right.

"My, my, you've been doin' a wee bit o' readin'!" chuckled Andy. "Tha's good—ver' good. Most visitors 'ere know nothin' 'bout us. They come fer a few days o' scenery an' eatin' an' drinkin' an' then they're off again. But y'right, Mackenzie did 'is best to stop the foreigners—the Spanish were the worst and the English—from overfishin' The Minch. But even he couldn't stop that stupid use of the big nets and the dredgin' which wiped out the spawnin' beds and killed off the whole damn thing . . . so bloody stupid!"

He sat quietly again. This was a sad tale of greed, shortsightedness, and the insidious political clout of big trawling companies and we'd heard it many times before throughout the Hebrides.

"Tha's the whole history of these islands—stupidity, cruelty, and no power for the wee folk—we had so little power . . . y'should listen to some of our Gaelic long songs and stories. They tell y'all about it—an' they tell it in a way that's so much richer than English, so many levels o' meanin' in the words and the way they're said. Coddy MacPhearson up

at North Bay—he helped us keep them, and Angus MacMillan on Ben-becula, and Angus MacLellan, a great storyteller, an' books like Colm O' Lochlainn's *Deoch-slainte nan Gillean.* But I don't suppose y'understand the Gaelic s'much."

"No," I admitted, "we've listened to many of the songs but it's a complex language . . . although y'know, we keep hearing about efforts to keep Gaelic alive. Our friend Dondy MacAskill—she's one of the teachers at the Tarbert School on Harris—she and others have worked with the students on Gaelic projects. In fact they've won all kinds of awards."

"Right," said Anne, "and just last week we went to a presentation they made of a little book they've produced on life in Tarbert. All in Gaelic. A beautiful publication which won another big prize."

"Aye," murmured Andy, "I heard about that. But y'know, it'll be a struggle. What with the young folks leavin' because there's no jobs an' forgetting it all so fast, y'know."

Of course there were many throughout history—even notable Scottish writers like George Buchanan in the sixteenth century—who are remembered by Gaelic speakers with scorn for their snide dismissal of the language. "I can perceive," Buchanan wrote, "without regret the gradual extinction of the ancient Scottish language, and cheerfully allow its harsh sounds to die away and give place to the softer and more harmonious tones of Latin." (Latin!?)

A suitable refutation, however, can be found in the wonderful "Ode to Gaelic" words of Duncan MacIntyre in the eighteenth century:

Tis the speech used in the Garden—
Adam left it to mankind

I quoted that to Andy and he roared with laughter.

"Na' tha's ver' good. I'd not heard that! But poor ol' Gaelic seems to get blamed f'so much—there was a fella here couple o' weeks ago. Studying the language an' all. And I remember he told me that almost anywhere in the world he's found a language dying, those from outside will always say the people are lazy, rude, and too much into the alcohol!"

I laughed but also remembered blurry events of the previous night at the Castlebay Bar and decided not to touch that rhetorical firecracker.

"Well," said Anne, "maybe it's time . . ."

"Yes, right," I agreed. We'd just had three cups of Mairi's strong coffee and the caffeine surge was making us restless for the road again. There was a long journey ahead for us all the way back to Harris.

"Well . . . I'm ver' glad y'both sat down wi' me and listened to all this idle chatter o' mine."

"No, no—it's been fascinating," I said truthfully. "You've helped us understand a lot more about this little island." Anne nodded in enthusiastic agreement.

And then, as a parting gift of sorts, Andy spoke a few lines of gentle, lyrical Gaelic.

"And that means . . . ?" asked Anne.

"Well, roughly translated, and it is rough because Gaelic never translates so well, y'know, it says:

"May the hills lie low,
May the hollows fill up
And make thy way
Easy and light."

"Thanks, Andy," I said, trying to think of a suitable response. "Oh . . . and I have one for you . . . if I can get it right . . . goes something like . . .

"Plenty herring, plenty meal,
Plenty peat to fill your creel
And plenty bonny bairns as weel . . ."

Andy's white mop of hair shook vigorously as he chuckled. "Tha's good . . . tha's ver' good. I thank you . . . although mi' bairnin' days are long gone—and the brood I have are not so wee these days!"

"Ah well," I said, "just keep remembering those lovely herring girls."

"Och, I'll have n'problem with that . . . I married one of 'em! A lass from Vatersay," Andy said, with a wide grin, and pointed southward

beyond the castle floating in the middle of the bay to the misty outline of yet one more island—the last inhabited place on the 130-mile-long Outer Hebrides chain. "Have y'bin out there yet?"

"To Vatersay—no," I said. "But we plan to before we leave. If the mist eases up a bit . . ."

"Och—mist or no mist—take a wee trip over. There's a causeway now. Y'don't need a ferry anymore. I think you'll find the place . . . ver' interestin' . . ."

And he was right.

Vatersay is indeed interesting—and intriguingly beautiful—even in capricious morning mists. In fact, the mists added to the magic here as we crossed the narrow causeway. They eddied in ghostly filigrees around the base of bosky, four-hundred-foot-high hills cloaked in heather and brittle grasses and dotted with ancient duns and chapels. Sheep grazed contentedly on the lower, bright green *machair* where the Siamese twin–shaped island—barely three miles long and a mile wide—is almost divided by an isthmus of two gently curved bays, each graced by more of those brilliantly cream-colored Hebridean beaches.

We could see a few scattered cottages on the *machair* fringes, but today Vatersay can only claim ninety or so residents. Once there were hundreds here but, typical of all the Hebridean islands' sad history, they were subjected to the cruel "clearances" of the late 1800s by the owner of the island (and much of Barra and South Uist too), Lady Gordon Cathcart.

In later years many crofts and cottars returned and, with growing power and outrage, threatened to retake possession of their lands by force. Using an old Scottish law, many hastily erected wooden shelters "roofed and with a hearthstone fire and built between sunrise and sunset of the same day." This was usually enough to confirm "possession" and, although Lady Cathcart attempted to have the "Vatersay Raiders" removed and imprisoned, such was the outcry of the islanders that most were given early release and eventually achieved a government buyout of the land. Landowners throughout the islands trembled at the implications of such a "socialistic" solution, but a flourishing island community was reestablished here and became famous for its annual "cattle swim" event in which island animals were made to flounder across Vatersay

Sound to the ferryboat dock at Barra for transport to mainland markets.

Such colorful traditions gave the island a gloss of "romantic" crofter-lifeways. But—in typical Hebridean fashion—there were other hard times and misfortunes in island history and tales here. Not least on September 28, 1853, when 333 of 385 emigrants bound for America as "redemptioners" (indentured workers) were drowned as their ship, *Annie Jane*, ran aground in a violent storm and was torn apart on the vicious west coast reefs here.

Anne and I walked up to the ponderous granite monument to this terrible event, similar in the scale of its death toll and island impact to the wreck of the *Iolaire* on the Beasts of Holm rocks near Stornoway harbor in 1919.

The mists were lifting now. Shafts of sunlight dappled the hills and beaches. The land glowed green and lush. And once again we were moved to silence by the beauty of such solitudinous scenery. But also by that hard sadness of history—those old stories of doom and disaster that cast bittersweet shrouds over all these idyllic isles.

We stood by the rail on the ferry back to Eriskay, watching Barra recede into the sea haze. It had taken on a wild and barren look, with clouds massed ominously over the rocky summit of Heaval. But we knew differently—despite the sadness we experienced on Vatersay, we had found its softer heart, its Catholic levity, and its generous spirit.

"Add Barra to the list . . . ," said Anne.

"Of?"

"Of 'must-returns'!"

10

The Funeral

———————

Roddy and I were well into our third glass of Johnnie Walker Blue. Actually, that's not quite correct. Roddy was on his third and I was sliding hesitantly into my second—more as a matter of respect than restraint. Johnnie Walker Blue, at around $250 a bottle (including of course an elaborate presentation box decorated coffinlike inside with blue satin) is not a whisky one normally imbibes on a regular basis. It's a classic of its kind. Blended, it's true, not a single malt, but regarded by the cognoscenti as one of the finest produced in Scotland.

"Come on, Dave, you're laggin', man," chuckled Roddy, his pink flushed cheeks and nose gleaming and his mischievous leprechaun grin wider than ever.

"No—not lagging. Merely leisurely sipping, as one should with such a superlative concoction. How can I ever return to the lesser brands when I have enjoyed such splendid nectar?"

"Weeel . . . ," said Roddy, "so long as you're drinking in this house, there'll never be a need to. No compromises allowed here."

"I'll drink to that. No compromises!"

Joan giggled. The heat from the peat fire had turned her face rosy. Dondy, sitting beside me on the old leather sofa, feet curled under herself pixie-style, smiled her usual demure smile. She had resisted, as usual, all of Roddy's invitations to join us in the delights of whisky sampling. She exuded that air of placid self-containment and I often wondered

what she would be like if she ever lost her temper. I'd been told she could be a firebrand—an alter-ego contradiction—but I'd never seen her in any other mood than pleasantly mellow and benignly smiling.

"Well, as I'm getting up I might as well fill y'glass, David," said Roddy. I didn't resist. There was no point. It would be filled anyway.

But it wasn't . . .

The phone rang, interrupting our pleasantly meandering conversation. Roddy rose, not exactly unsteadily, but certainly slowly and deliberately. His evening drams were never wee ones, unlike the ridiculously meager shots poured in the local pubs. These are said to be precisely measured as one-sixth of a gill, but as few people had any idea what a gill was, the expression was pretty meaningless. All I knew was that if you whirled one of these official pub drams around your glass, it was so wee as to disappear completely for a moment before slowly "legging" back down into the bottom of the glass.

Roddy vanished into the kitchen to answer the phone and Dondy and I resumed our ongoing chat about the building of her new home across the road. It was on a superb high site overlooking the MacAskill compound of large family home, our cottage, storeroom, petrol station, shop, Katie's guesthouse farther down the hill, and the huge MacAskill contracting offices, plant machinery garage, and storage yard—not to mention his large rock quarry up the road in the North Harris hills. For reasons far too legally convoluted for me to grasp, there had been delays and all that was in place after four months was a rough foundation for her house.

"It'll be done, it'll be done." Dondy smiled placidly. "There's no rush . . . I'm trying to get a grant to drill for 'thermal heating'—using natural hot water in the rocks hundreds of feet down. It's a new idea for energy conservation."

Roddy returned. His face had changed. The warm glow had gone from his cheeks. He looked stooped, tired, and ashen. He flopped down in the chair by the fire and gave a deep sigh. "She's gone," he said quietly.

Joan and Dondy looked at him, understood, and nodded.

"Ah, well," said Joan slowly. "That was to be expected now. We knew it wouldn't be long, didn't we?"

Dondy bowed her head and then said, "Peggy Ann was a lovely person. I'll really miss her."

There were no tears. At least, no outward tears. Just looks of resigned acceptance. Then Joan turned to me and explained that Peggy Ann Stewart, a ninety-five-year-old friend of the family, had been living in a small nursing home at Leverburgh for many years. She had been well loved in the community and renowned for her stories and remarkable energy—an energy that was said to have "kept most of the others in the home alive!"

I nodded and also sensed a little wave of sorrow sweep over me. Not because I knew Peggy Ann personally but precisely because I *didn't* know her although she had been high on my list of people to meet. Her name had come up many times in conversations with others, each one insisting that I must visit her at the nursing home and listen to her tales and her memories of island life. "She'll take you right back to the crofting times," one person had told me. "You'll be right there with her in the black house, eating her crowdie and cream and salt herrings and boiled potatoes and weaving the tweeds . . ."

I'd finally planned to visit her the following week, but it was too late now. I'd left it too long. Maybe I believed others who'd insisted, "She's got another ten years at least left in her still!"

Roddy tried to think of something to cheer us all up: "Weel," he said finally, with a chuckle, "at least Historic Scotland will be happy!"

Joan and Dondy smiled. Was this some in-family joke? "No—you wouldn't know about this, David, but Historic Scotland, which owns Rodel Church—you know—'The Cathedral of the Isles . . .'"

"Oh, yes—I know the place well. I made a couple of sketches down there."

"Is that a fact? Well, y'see—it's a story everyone on Harris knows—Peggy Ann's family, the Stewarts, have a family plot down there and there's been a space waitin' for her since she was born. It's the last official plot in the cemetery and they had to keep it open 'specially for her. They weren't happy about it. They've been waitin' for years. Peggy Ann used to joke about it. 'Well—they're just going to have to wait a wee bit longer,' she'd say. 'I've no plans at all to leave just yet.'"

We all laughed but then the silence returned. Peggy Ann's passing represented something more than just another sad burial. She was one of the last of the old true crofting generation and a touchstone of the ancient traditional ways of the island. It was not just a person dying. It was the ending of an era.

The peat fire glowed. The three clocks in the lounge ticked almost in time. Everything went quiet for a while. Even Chico, the MacAskills' normally hyperactive Scottish terrier, lay quietly on the hearth rug watching us nervously. He was apparently unused to long silences in this house.

"You know, it's really strange," I said finally. "I'd planned to go down to Leverburgh next week to see Peggy Ann and to hear some of her stories . . ."

Roddy smiled and nodded. "Aye . . . she had plenty of those. That she did, indeed." Then he stood up again, took a deep breath, and walked back into the kitchen, telling us he had "best get on with the phone calls now."

Joan explained that as Peggy Ann's executor, Roddy had the job of organizing everything—making countless sad calls, arranging the funeral service, the wake, the burial. "So much to do," she said quietly. "But well . . . you know all about that now, don't you, David?"

And of course I did, because of our prolonged summer journeys to England when my mother's sister, Cynthia, had died in Yorkshire of inoperable cancer. She too, like Peggy Ann, had been a feisty, independent lady and the last link with our family history—a history I thought I knew but that became colorfully "revisionist" in her torrid tales.

"Are you sure we're talking about the same people?!" I once asked her after a particularly ribald series of stories. She laughed and twinkled. (Tales of family derry-doings always seemed to make her twinkle.)

"Ah, well, you see, you were too young to know about all these things and"—she added mischievously—"maybe you still are!"

Cynthia's passing seemed to suck some of the fun and vitality out of my world. And, as with Peggy Ann, I felt annoyed with myself for not trying to learn more about a family history that was now all but closed to me. But such regrets were quickly submerged as I realized that Roddy

was about to run the same executor gauntlet as my sister and me and I wondered what I could do to help.

"Och, there's nothing, David," said Joan softly. "Just come round and sit with him from time to time . . . oh, and please come to the funeral. If y'wish, that is. He really enjoys your company."

"Ah—well, that feeling is mutual. Very mutual. But I've never met her, I don't know her . . . and I'm not part of the family."

"Oh yes, you are, David," Joan said quietly, with a warm smile. "Indeed you are."

"Well, then—yes. I'll definitely come. I'd be honored to. I feel I owe Peggy Ann at least that much . . . a first and a last visit all in one." I was sorry, though, that Anne was currently off-island for a while, visiting her parents in Yorkshire. She'd also looked forward to meeting Peggy Ann.

THE FUNERAL WAS SET FOR the following Tuesday at the Church of Scotland in Leverburgh. "*Not* the Free Church," Roddy emphasized. I didn't ask why. Religious convictions in the Hebrides are not matters for idle curiosity and outsiders best keep away from that subject if they wish to attain the goodwill of the stalwart islanders.

Although I promised the family I'd attend, there was a slight problem with my island clothes—mainly jeans, sweaters, and sneakers. Hardly appropriate funeral garb. Well, I thought, there's nothing I can do about the clothes. I've got a dark brown pair of slacks and my new blue-green Harris Tweed jacket, both of which I'd kept around for "special occasions." Of course I was thinking more of weddings, parties, and Saturday nights on the town. However, maybe I could just get away with them for a funeral. But definitely not the tie. The only tie in my tieless life was once bought as a gift by a friend who thought that a tie should express the essence of the inner man. In my case, I can only assume that the violent, clashing colors and discordantly aggressive geometric patterns meant that he saw me as some kind of schizoid roustabout on the verge of emotional self-destruction. Not exactly the everyday "me" I knew—and certainly not at all funereal.

So what I obviously needed was a black tie. A simple, plain, depress-

ingly dour and coal-black tie. Not much of a challenge, I thought. But of course I was on Harris, not on the mainland. Stores are in short supply in Tarbert, our only community of any size—if a population of five hundred or so could be classified as sizeable. We had the Tweed Shop (of course), two grocery stores, a couple of trinket shops, a post office, a pottery, a tiny fish 'n' chip shop, and Tarbert Stores, that bizarre mishmash of a place down by the ferry dock next to the delightful First Fruits tearoom, which sold everything for the do-it-yourself crofter-builder-fisherman-carpenter. Ah, but we also had the beloved Akram's, a general store run by a family from Pakistan, which has been a mainstay of island life here for over forty years.

It's an upmarket-ish offshoot of the old Pakistani-peddler days here, when, in the crofting era, mysterious gentlemen of exotic origin would wander the outer islands on bikes, horse-drawn carts, or in clapped-out vans, selling everything from ladies' undergarments and other lacy feminine accoutrements to hair lotions, health potions, cheap cutlery and crockery, combs, shoelaces, and "guaranteed" mousetraps.

Akram's is a modest peddler's or packman's pushcart transferred into an exotic Aladdin's cave of anything and everything that one might ever need in an average island household. Thousands of diverse items fill the shelves of this long, narrow bazaarlike store overlooking the dock from the steep bluff of the town. There's no food, of course. The two grocers defend their monopolies rigorously. But if you'd like a selection of half a dozen different types of can openers, a box of bonnie wee woolen bonnets for babies, a cornucopia of costume jewelry and toiletries, cheap and not quite so cheap watches, rolls upon rolls of rugs and wallpaper, footwear galore from delicate ladies' pumps to gargantuan hiking boots—even TVs and VCRs—then this is your place.

I'd met the lady behind the counter many times before as I scoured the shelves for Band-Aids, photo frames, cuddly toy gifts for children, hard-to-find batteries, and, on one occasion, a special kind of manual masher guaranteed to produce the creamiest of potato dishes. She was a plump, warm-faced woman with pronounced teeth, always pearly-white, and she had never yet failed to help me find what I needed. But she always seemed a little distracted by her voluminous stock lists, which

she constantly checked, the requests of other customers, and the frenetic activities of family members whose job it seemed was to scurry about cramming even more items of choice onto the already overpacked shelves.

This day was different. She was in despair. A black tie was not to be found anywhere. There were boxes of brightly colored striped, polka-dotted, and paisley-patterned ties, but not a single simple funereally black tie.

"I know we had . . . we definitely . . . I saw one only last . . . it was right . . . it must have . . . ," she mumbled, mainly to herself, in her increasingly enervating search. "I'm so sorry . . . I can't understand." Then she vanished, half whispering something about the stockroom. "Maybe it's under that pile of blankets and sheets . . ."

A few minutes later she returned, her face transformed into a smug smile, her eyes glowing with achievement and pride. "You see?! Here we are . . . I knew we had . . ." I thanked her sincerely and then she decided that, as I'd been so patient and understanding, she should finally, after all my previous visits, introduce herself.

"I am Bushra and my husband, who also works here with us and the family, is Ghaffar . . . he is really a doctor, you know. A PhD doctor. A biochemist. Very, very clever man. He worked in Japan for quite a long time. After the war, you know. And I was there too. We lived an hour or so outside Tokyo. Now, that was very interesting time, you see, because . . ."

And on she went with not a hint of her previous reticence. In ten minutes I'd received the full and fascinating story of her life, and then, to occupy another ten minutes, she launched into an eloquent and well-informed series of monologues on the old crofting life of Harris; the Scottish Parliament (whose new headquarters in Edinburgh had recently astounded the country by costing over $800 million when initial estimates had suggested a tenth of that price); the cruelty of the Taliban in Afghanistan; the difference between the Pakistani and Indian economies ("The Indians want economic success very badly—Pakistanis are Moslems and not so, well [big shrug here] . . .") and a potpourri of other worldly issues.

I looked at my watch. It was almost 2:00 P.M. and Peggy Ann's funeral

service, way down at the bottom end of the island, was set for 2:30 P.M. I apologized to Bushra for the urgency of my departure, grabbed my black tie, and tried to complete the forty-five-minute drive in half an hour. Unfortunately, the sheep did not cooperate. The tarmac road surface had been pleasantly warmed by the morning sun, and sheep love warm tarmac, happily plonking themselves down in the middle of the one-lane highway and refusing to budge until horns are blared vigorously and wheels are almost nudging their fleeces and ready to squash them into roadkill.

Thus, I was late. I could hear the slow, sad hymn singing already echoing out from the tiny church across from Leverburgh's An Clachan Co-operative store. So I feverishly pulled out the folded black tie from its packaging and proceeded to knot it around my neck. Unfortunately, as I am not normally a tie man, I'd failed to check if my shirt collar was of the "extra generous" circumference normally necessary to button for a tie. It wasn't. The button and the hole refused to meet. Okay, I thought, I'll do a fat Windsor knot and that'll cover the gap. Which it did quite effectively. I was about ready to leave the car when I noticed that my somber black tie possessed one particular element that set it apart from any other funeral tie I'd ever seen. There was a gray rabbit embroidered into the lower part of the tie that, in my haste, I—and Bushra—had failed to notice. I mean, one doesn't normally expect somber black ties to support embroidered representations of rabbits. And as I looked closer, I realized this was no ordinary rabbit. This was a rabbit with very large ears. And it was a rabbit holding an unusually large red carrot. It was the rabbit we all know and love. It was Bugs Bunny . . .

Epithets were definitely not deleted for the next minute or so and they covered quite a hit list, including me and my stupidity for not looking at the tie in the store, ditto Bushra, and certainly Bugs Bunny, who, up until now, had been one of my favorite cartoon characters.

Finally, I calmed down enough to realize that if I buttoned all three buttons on my Harris Tweed jacket, the offending image would be hidden. So I left the car and walked briskly to the church, trying to fasten the buttons. But something had happened to my midriff. Or to the size of the jacket. Bottom line: once again buttons and holes would not meet.

Oh, the hell with it, I thought. Just stand at the back somehow and hold the damn jacket closed. No one will notice. Then I'll be back in the car. Tie off.

Alas, 'twas not to be so.

I crept quietly into the church to find the place packed with more than two hundred mourners all singing this very, very depressssing dirge. Not only were all the pews full, but there seemed to be no standing room anywhere. Ah, well, I thought, at least I made the effort . . .

The singing stopped abruptly. Then a finger tapped my shoulder. I turned and a tall, stern-faced gentleman mumbled something incoherent, grabbed my elbow, and started half dragging me down the aisle. There was a somber, hushed silence in the church. Our feet were the only sounds to be heard. Heads turned at the disturbance. Scowls appeared on men's faces. Women's eyebrows were raised under a remarkable array of large black funeral hats. And on and on we went down the aisle. I couldn't see a seat anywhere. Finally we arrived directly below the pulpit, where the minister towered over us, regarding me with an odd mix of curiosity and distaste.

My guide—presumably an usher—waved to a cluster of elderly gentlemen sitting in a special raised pew that directly faced the congregation, indicating they should move up and make room for me. They did so with distinct ill grace. And I can't say I blamed them. I had been bodily transported to the most important place in the church—the Seats of the Elders—and here they were, all eight of them, all very elderly and very stern faced, having to shuffle and squeeze to let in this uninvited and rather overportly outsider. An outsider who was totally unfamiliar with the ways and rituals of the Church of Scotland, most inappropriately dressed in brown shoes, brown trousers, and blue jacket, hot and sweaty from the tortuous drive to the church, and, sacrilege of sacrilege, sporting on his tie an embroidered cartoon likeness of Bugs Bunny eating his trademark carrot, hidden under a jacket that was far too ill-fitting to fasten.

What followed after this can possibly be summed up in a single word: black.

Of course, one normally expects black to be the dominant color at

funerals, but, notwithstanding a couple of men's modestly colored shirts, I have never looked across so much blackness in a single place before. And the dark-toned service moved somberly along from slow, sad hymn to long—very long—prayers to Gaelic psalms chanted in melancholy minor keys. One writer suggested that the Harris islanders possessed "a deep, dark fear and fascination with death." Certainly, there seemed to be few references to poor Peggy Ann but abundant fire-and-brimstone content, along with threats of eternal damnation for the unrighteous and salvation only for those few chosen ones who managed to carefully preserve their own souls relatively unblemished and untainted by the nefarious ways of our wicked world. I remember one particularly morose line delivered by an equally morose-looking minister: "We are here on earth only to suffer and pray in fear and faith for eternal forgiveness . . ."

Now, I've been to dozens of funeral services encompassing widely contrasting cultures, religions, and societal mores. And while I'm certain I missed many of the subtleties and subtexts in the ceremonies, invariably I sensed that there was always a latent sense of celebrating the life, achievements, and contributions of the deceased. On some occasions these funerals resembled frenzied carnivals of joy, proclaiming the passing of an individual into a far better place. Others were more silent and mystical but rippled through with love and hope. A few were more structured by religious protocol but still left space for smiles and memories of "sweet sorrow."

In the case of my own late aunt, the priest's homily on Cynthia's life was full of warmth and love and deep affection. So were the stories that were shared by family members. Cynthia was almost reincarnated on that day, so mutual and so vibrant were the realities, joys, and memories of her life and her existence among us all.

But here, in this little Leverburgh church, as the minister read strange, dark passages from Revelation, unfamiliar at least to me, and ringing once again with those constant threats of punishment and the "great wrath and everlasting damnation to come," I wondered what had happened to poor Peggy Ann. Why was there no celebration of her life and so much focus on our own transgressions and the constant need to

"save ourselves"? Her death seemed to be used primarily as a reminder of the tenuousness of earthly mortality and a warning of the harsh judgments we will all, according to the Church of Scotland at least, ultimately face at the end.

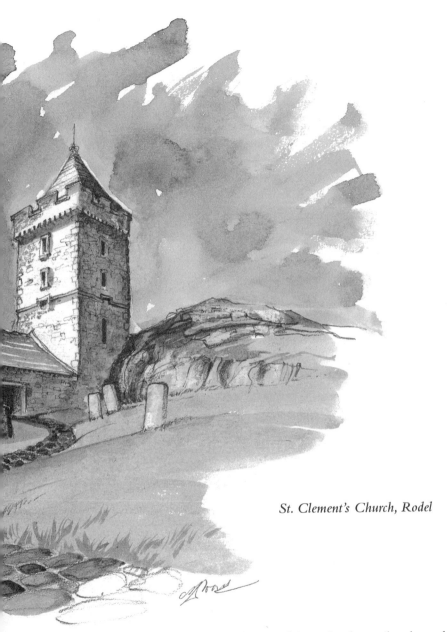

St. Clement's Church, Rodel

After the service the coffin was driven the few miles through wild heather and gorse-flecked hills to St. Clement's Church at Rodel, that proud stone edifice perched on a rocky puy at the southern tip of the island, with broad vistas of the surf-whipped coastline. And there was

Peggy Ann's resting place, neatly dug in the Stewart family plot and protected from the elements by a sturdy, dry stone wall.

As the mourners gathered around the grave and the minister began his final litany (yet another dour reminder of life's abruptness and the looming fires of hell that could await us all), two strange, omenlike events occurred.

I'd noticed on my drive to the cemetery the gathering clouds, darkly ogreish and moving rapidly in from the west. When I arrived it seemed as if the afternoon had turned suddenly to dusk. The clouds carried much weight in their massive gray bulks. They were angry, bloated, and ready to implode. But as the coffin was being prepared for lowering, one of those timely coincidences that primarily seem to occur in Romance and Gothic novels happened. A brilliant shaft of light lasered through the looming clouds and fell directly on Peggy Ann's coffin. The polished wood gleamed an amber glow and the brass handles and decorations sparkled like gold. It lasted no more than thirty seconds and then was gone. Some seemed to notice. Most didn't. But everyone noticed the next event as the coffin was being lowered into the ground. Barely had that shaft of light vanished than a violent wind came tearing across the Rodel hills. Hats were blown off, coats flapped like bats' wings, and the rain began. A sudden torrential downpour of storm-chilled water hit us all without warning.

It was then I finally spotted Roddy—one of the few men without a coat over his black suit—looking as if he'd been abruptly dipped in a sheep fank (pen). But, to give the mourners credit, no one left the grave site to seek shelter in the church. They all stood stoically, not only until the coffin was in the ground but until the two gravediggers had completely refilled the hole and even replaced the rain-sodden squares of turf on top of the grave. Normally, one sees a few shovels of earth scattered over the coffin and then it's off to the reception. But here these sturdy hell-and-damnation, get-thee-behind-me-Satan Calvinists of Harris stood through the storm until the job was properly done and Peggy Ann was safely and securely at rest.

Maybe the solemnity and sadness of the whole affair had gotten to Roddy too. He suddenly appeared at my side as the other mourners

were still gazing at the grave and whispered, "Have y'ever been inside the church here—our 'Cathedral of the Isle'?"

"Only briefly . . ."

"Well, c'mon, let me show you a few things . . ."

Considered by many architectural historians to be the ecclesiastical jewel of Scotland's west coast, this fortresslike structure was rebuilt in 1528 by Alasdair Crotach, the hunchbacked chief of the MacLeods of Harris and Dunvegan, on the site of a fifteen-hundred-year-old St. Columban–era *teampall*. It was then restored to its present splendor in 1873 by that matriarch of Harris fortunes, the much-beloved Dowager Countess of Dunmore.

Alasdair was renowned for his courage in battle and his ruthless manner of dealing with his adversaries. Possibly as penance for his overreactive spirit and sins, he invested a substantial sum in the creation of this monumental edifice but—with a pragmatic eye on posterity—he also gave himself pride of place inside the church.

"Just look at this tomb," whispered Roddy as we passed other ancient and intricately carved grave slabs lined up against the walls. "Na there's a man who was pretty proud of himself, wouldn't y'say?"

Recessed into the rugged stone wall by the altar was a magnificent arched tomb with an effigy of Alasdair lying in full armor, grasping his huge sword, and with his faithful hunting hound at his feet. The sculpture was worn by time and effacements, but I could still sense the power of this most feared of island chieftains as he lay, ever ready for battle, beneath a meticulously carved arch depicting a wealth of biblical scenes in nine medieval panels. On the recess wall was also a series of other equally elegant panels of St. Clement, third bishop of Rome after St. Peter, and other saints and apostles, animals, hunting scenes, a sailing galley, and a dedication tablet in elegantly carved Latin script.

Nearby was the far less ornate tomb of William, Alasdair's son, who died in 1551, and on the floor of the nave were other gravestones.

"These, so they say, were where the bearers of the MacLeod flag— 'the Fairy Flag,' they called it—were buried," said Roddy, still whispering. "And they say that each of the coffins here had a metal grid in the bottom so that as the next lot of flag bearers were buried, they'd push the

remains of the previous guys through the grid to make room for the new ones!"

"A sort of religious recycling . . ."

"Aye, sort of. Very thrifty policy, I'm thinkin'! Oh—and c'mon, there's somethin' else y'should see . . . might give ye' a wee smile . . ."

I was surprised by his suggestion. He was one of the key mourners and had certainly worn a stern, somber expression throughout. But now he was bounding up the steep grass slope of the cemetery to a weather-worn *caibeal*—a private walled burial plot on top of the hill by the church tower. "Now just read this inscription!" So I did and found it celebrated a Donald MacLeod of Berneray who, having fought with Bonnie Prince Charlie at the disastrous battle of Culloden in 1746, "returned home and, at the ripe old age of 75, married his third wife by whom he had nine children and died in his ninetieth year."

"Now, that's what y'call a man!" chuckled Roddy.

"Good to see you laughing again," I said. "That was a rather dour funeral."

"Och! Tha' was nothin'. Sometimes th' go on for hours."

"Oh," was all I could think to say (with a silent thanks in this instance for brevity).

"Aye, but y're right—it was a wee bit on the mournful side . . . more than usual," agreed Roddy. "That was a surprise—reading all that stuff from Revelation. Couldn't see how it related to Peggy Ann. She didn't get much mention at all now, did she? She was such a good . . . a vital . . . person. But it was all about saving *our* souls. No relation to the deceased. Jus' giving us warnings . . . I suppose that's the old form, though. It's all a bit confusing nowadays. What was the Free Church a while ago is now splitting up again into even smaller churches. It's all very difficult . . . strange . . ."

Finally came the reception at Donnie and Dena MacDonald's Rodel Hotel, set cozily nearby below a rocky cliff overlooking an attractive inlet-harbor. This was once the home of an eighteenth-century island benefactor, Captain Alexander MacLeod, renowned for his vision of Harris as a focus of the west coast fishing industry (alas, yet one more failed philanthropic initiative). And what a transformation in the day!

Suddenly gone was all the earlier dark gloom and doom. People were smiling, laughing, and sharing tales of Peggy Ann, sipping tea, and eagerly devouring dainty, crustless sandwiches. Some of the men, Roddy and myself included, sidled into the adjoining bar and enjoyed a couple of stronger libations before joining in the sandwich gorging. And I looked around and smiled, glad to be reminded once again that despite religions and other differences and all the will-I-be-saved? angst that permeates so many lives here on the island, people are still people, and laughter and smiles can still work their magic here, as they do everywhere else in the world.

But apparently I was not the only one dismayed by the mournfulness of the proceedings, and during my conversations with some of the men at the adjoining bar I was intrigued to note among the various comments the following: "Even wishin' is said to be sinful in these parts," murmured one elderly gentleman. "Acceptance, humility, passivity. These are the catchwords of our island religion. Keep y'mouth shut, y'heart pure, and pray for forgiveness and immortality!"

"How would ministers make a living," said another, "if it weren't for original sin, constant guilt, the eternal inadequacy of man, and the inevitability of dire retribution. No wonder we drink like we do!" He laughed. "First to drown our sorrows and second because, if we're all sinners, we might as well act like sinners and stir up some real justification for forgiveness!"

One very elderly gentleman who seemed to be a permanent appendage at the bar, according to Donnie, saw things in an even longer and more depressing perspective: "It's as it's always been: the clergy on the side of the kings and the lairds and all we others must pay for our sins, scratching a life from this barren place and saying thank you, thank you to the whole lot of them—the ministers, the factors, the lairds, the royals."

"But these lairds and factors and royals are not very significant today, surely," I said.

He gave a sneering laugh. "Och! Nothing much has changed. We even say thank you to the tourists now for bringin' in a little new money, and oh! thank you to the government of course for givin' us wee hand-

outs when the going gets too tough even for the strongest and most bloody-minded of us."

Well, I thought to myself on the drive home, I've really seen the underbelly today of the island's religious spirit. And much as I'm reluctant to dabble too deeply in such matters, I felt that I at least owed it to my own understanding to explore the eccentricities of the spiritual underpinnings of life here.

So, later in the week I went to meet Reverend Murdo Smith, the youthful, auburn-haired Church of Scotland minister who had led the service for Peggy Ann. He had one of those open, honest faces and a beguiling smile that seemed to contrast so markedly with the mood and tone of the funeral.

During a general chat in his Scarista home on "the state of the isles" (invariably a very popular subject of conversation here), he lamented the declining population and church congregations, the dying of the Gaelic language despite a host of projects to maintain it, the outmigration of island youths, the "fading of the tweed industry," the difficulty in attracting new ministers "to these isolated places," and the increasing fragmentation of the Scottish churches generally.

"It's really quite ironic," he said with a wry smile. "At a time when church members are dwindling across the board, the schisms between the churches keep growing and widening. In Stornoway today, for example, they have at least ten different churches. The Church of Scotland—my church—is still strong. Sometimes we have attendances of over fifteen hundred—actually one of the largest single church congregations in the whole of Scotland. But the Free Church is still the largest overall here, followed by the Free Presbyterian, then the APC—the Associated Presbyterian Church—and then the Free Church (Continuing) . . ."

"What's that last one—I keep hearing it mentioned . . ."

"Oh, it's another schism—they claim to be the *true* Free Church since the great split with the Church of Scotland in 1843. The doctrinal differences are very minor—but they seem to be extremely important to them."

"But all these churches are essentially Calvinistic, right?"

"To varying degrees of rigidity. We're perhaps the least doctrinaire . . ."

"Well—if I can be honest—at Peggy Ann's funeral the other day, you seemed . . . how can I say it? . . . rather stern and full of threatening references to 'the wrath of God' and suchlike."

I watched his face to see if I'd been a little too blunt, but to my relief he smiled and gave a chuckle: "Ah—well, what you must bear in mind is that on that particular occasion we actually had two additional ministers present from the Free Presbyterian Church."

"Were they the ones who gave those long mournful prayers?"

"Ah . . . yes, they were indeed. I felt duty-bound to let them lead the prayers. And in their church they do tend to keep funerals very . . . abstract. They don't even usually name the deceased or say anything specific about them."

"I noticed that."

"Y'see—the Church of Scotland is in a difficult situation. We obviously don't want to do anything to increase the rifts between all the various congregations so we occasionally accept . . . even adopt . . . some of their 'stricter' ways. For example, there's been talk in our church of allowing organ music for the hymns and psalms, but there's a great fear that would only create larger barriers between us and the rest. Many of the more Calvinistic churches even ban hymns altogether. So, as you can understand, all this tends to inhibit what we can do. We even had problems with our Gaelic services. When I first came they were almost all Gaelic, but Gaelic speaking has declined, so now we're down to only one in every four services. It created a lot of tension and, even when our elders approved the changes, they knew we might lose some of our members to a stricter church."

"Quite a dilemma." I'd done some reading at the Tarbert library and had tried to make some sense out of the labyrinthine tangle of Scottish church "schisms," but I found myself lost in a welter of secessionist names—Burghers, Auld Lichts, New Lichts, Lifters, Anti-Lifters, Evangelicals, Episcopalians, Original Secession Church, Presbyterian splinter sects, and numerous other groups all decrying one another with varying degrees of righteous indignation. It was all too much, and "dilemma" was the politest word I could think of to describe all the confusions of Calvinism.

"It is . . . and yet, you know, I wouldn't want to do anything else or be anywhere else. Our family has lived on Lewis since the early 1600s and I've been a minister here at Scarista for sixteen years. In my younger days, I ran a construction company with my brother, but when I was thirty-three my father died—I was very close to him—and I felt there had to be more to life than what I was doing. So I took theological training—four years in all—and joined the church. I was very moved by the great awareness of the spiritual life here on the islands. I suppose there are not so many diversions. You're in touch with nature all the time. Close up. In the crofting tradition—long generations of family living and working together—that creates a strong foundation for religious bonding. I mean, just last week I held a Communion here."

"Don't you do that every week?"

"Oh no, no. Our Communions are very different here—different from the Anglican Church. They're held twice a year in March and October and last for four or five days. Each day has a different focus—this time, for example, the sequence was Humility, Self-Examination, Preparation for Communion, Communion, and Thanksgiving. They're wonderful occasions—a little like those American 'revivals.' People come from all over the island. And then in the evenings we usually gather here at my home and sing hymns together. It's a real learning and bonding experience. Of course the Reformation started all that too, by giving more learning and freedom to the people."

"I've heard some claim that the Calvinism that grew out of the Reformation—the rejection of the Catholic Church and all its sumptuous monasteries—in fact became a new instrument of fundamentalism and rigid doctrine, not a freeing of the individual. Wasn't it Sir Walter Scott who claimed that the traditional Calvinist hellfire-and-brimstone sermon was 'the great suppressor of imagination and free thinking'? And many have real problems with 'the Elect'—the idea that a certain privileged few in the church have already been chosen by God almost from birth for places in heaven—apparently very few places! And the rest of us can just go and . . ."

The reverend laughed and nodded: "Oh—you make me feel I'm back in theological school again! And it's true. Many creative people see

the church—particularly the Scottish churches—as being very suppressive. I think it was that famous Gaelic poet, Sorley MacLean, who wrote something like, 'All is vanity, fear, and nothingness and the only valid "ism" is nihilism!' And—sadly—there are many who think like that. Many. And I empathize to some extent even though, obviously, I can't agree. I mean, some churches can get a little too carried away and doctrinaire and imply that life is all about collecting merit points for salvation and things like that."

"But you don't?"

"No. Indeed not! In simple terms I believe that the way you try to lead your life is best guided by attempting to do what you feel Christ would have done in whatever situation you are in. Becoming a little like an extension of his eyes, his head, and . . . and his love. I mean—we can argue forever about doctrinal issues and a whole host of theological and ontological mind games, but in the end it all basically comes down to trying to understand and help others."

"Just as I was told by many people that Peggy Ann used to do . . ."

"Oh yes. Definitely. Peggy Ann was a very fine example for us all . . . Listen, have you got time for a cup o' tea?"

"I don't see why not . . ."

It's not very often I get the chance to chat with a priest. Particularly a priest with such a friendly and apparently open-minded demeanor. So, as we enjoyed our tea and his wife's homemade shortcake, I thought I'd run a few questions past him—questions that have fluttered around the back of my head for years and for which I'm still trying to seek answers. Unfortunately, during his fascinating reply to my first question—"Are we still evolving as humans into an even higher species?"—he was called away by some domestic emergency in Leverburgh. We agreed to meet again, but so far that pleasure has not yet come to pass. However, I still have my questions, and one day I even hope to hear his opinion on the future of the poor, beleaguered tweed industry here on Harris. That's certainly something that would benefit from the benevolent intervention of a higher power . . .

11

The New Crofters

*I*T HAD TO HAPPEN.

With so many Hebridean crofts today, abandoned and over-grown, and the sad eroded turf-lumps of lazybed vegetable plots long since forgotten, it's hardly surprising that a few visionary incomers have seen opportunities here for renewal and restoration.

These once-beloved and vital smallholdings, rarely more than six acres of *inbye* grazing land close to the house and adjoining lazybeds, were for generation after generation crucial foundations for the existence of hundreds of thousands of crofters and cottars ("squatter" residents) all across Scotland. Then (that old familiar island story again) the terrible clearances from the mid-1800s led to their forced removal and relocation as far afield as Canada and Australia, and turned a large portion of these primitive homesteads into far more extensive and lucrative sheep farms or game-hunting preserves for the well-heeled lairds and the landed gentry of the south.

Fortunately, the 1883 Napier Report on the abominable conditions created by these clearances generated radical pro-crofting legislation and guaranteed at least the partial survival of this ancient subsistence way of life for almost another hundred years.

Until today—when the combination of a rapidly aging population, the wholesale outmigration of the young, declining crofting subsidies, and temptingly high land prices brought about by affluent incomers has led once again to a dramatic demise of this economy and the sad picture,

in Harris particularly, of once-fertile crofts left now weed-bound and worn out with no one to care for or about them. No one except individuals like Peter and Jane Harlington—prime examples of a "new crofting" trend. Not a particularly pronounced trend as yet and primarily evident only on Lewis—but certainly promising even in its current embryonic form.

Anne and I had read about the Harlingtons' endeavors in a brief *Stornoway Gazette* article, so we set out across the vast Barvas peat bogs and moors of central Lewis to find these hardy pioneers. Out of curiosity we decided to take the notorious Pentland Road, a recently surfaced, one-lane cart track that is, without doubt, one of Britain's loneliest and eeriest highways. Although less than fifteen miles long, it possesses an unnerving aura of bleak infinitude. As you drive across this barren, black peat plateau, you lose all sense of scale and time. Landmarks are nonexistent, beyond a few ragtag remnants of tar paper and clapboard shacks. In happier times, dairymaids from the coastal crofts would move with their cattle up to the high summer "shieling" pastures here and pass the warm months making butter and cheese and canoodling with their male admirers (if they managed to avoid the watchful eyes of protective "old maids"). For the rest of the journey our eyes scoured the flat wastes wondering if we'd ever reach the comfortable familiarity of houses, farms, and lines of wash wafting in balmy, sea-scented breezes.

Our mood, despite the fact that it was only early afternoon, became one of trepidation. We'd listened in the weeks gone by to all the tales of creatures that supposedly haunted these boggy expanses—the ghosts, the water horses, *glaistigs, gigelorums, sidheans,* and "the wee folk." And we'd smiled, admiring the vivid imagination of the storytellers, and relegated their warnings to the "quaint and folksy" files in our heads. But as we drove on, meeting no one and nothing at all on this endlessly bleak road, such tales seemed not quite so far-fetched after all.

"What are those . . . things . . . over there?" Anne pointed to the left, across the moor. "They seem to be moving . . ."

I slowed down and looked. At first I saw nothing and then, way in the distance, silhouetted against an ominously stormy sky, I did see some-

thing. Something like a line of strange figures, bowed and bent. And there was indeed a sense of slow, almost menacing, movement.

"Peat hags . . . I think," I said, trying to exhibit more assurance than I felt. "Just a line of peat hags . . . they seem to be moving because we're moving."

"Are you sure . . . ?" said Anne in an uncertain voice. "Because they—"

"No, darling—don't worry. The moors play tricks with your head. Look—you can hardly see them now."

"Okay," said Anne, but she still kept peering out across the bogs, obviously not entirely convinced by my forced nonchalance.

It was with some relief that we finally reached the village of Carloway on the west coast of Lewis.

"Wow—that's quite a drive!" I gushed to Peter Harlington when we arrived at his croft, "That Pentland Road."

Peter was a lean, sinewy young man with a great mop of ginger hair and a ragged beard. His light blue eyes sparkled with amusement and his laid-back, laconic way of speaking seemed to soften what I immediately sensed was a strong and determined nature. We also both warmed to his distinct Yorkshire accent.

"Oh, aye, 'tis. But y'shoulda traveled that before they put the new surface on. Felt much wilder then. And it had quite a reputation. People didn't like to use it except to get to the sheilings, 'specially not at night. It was definitely not a road for crossing at night . . ." Then Peter laughed at himself. "Well, that's what they say, anyway—you know how these superstitions used to spread around the peat fire *ceilidhs* in the old black houses on those long, dark winter nights!"

I laughed with him but Anne only grinned a little, apparently still uncertain about those strange peat hags—or whatever the eerie shapes had been.

"This looks fascinating," I said, pointing to his small house and fenced croft, where work was well under way restoring the ancient lazybeds and the small *inbye* flower garden and grazing pastures. "How did you start all this—or more importantly, why?!"

The Harlingtons' story was one of uncompromising vision and per-

severance. Peter explained that he'd been head gardener at Dunbeath Castle in Caithness for many years and that Jane was a talented artist currently giving courses in "enabling creativity" to local residents at a small gallery-classroom she rented nearby. In 2002 they were attracted by the initiatives of the Rural Stewardship Scheme, aimed at sustaining traditional lifestyles and protecting the natural environment. At first the locals were a little skeptical, but gradually, as the two of them have reformed the lazybeds, built vegetable and flower gardens, introduced such historically traditional livestock as Shetland cows and small, chocolate-brown fleeced Soay (St. Kildan) sheep, and rare island free-range chicken breeds, they have begun to bond with the community.

"I think it's because we really reach out to them. I run a few hands-on courses for livestock maintenance and 'green fingers' garden upkeep, which seem to be quite popular," Peter told us. "And we offer all our produce for sale—you know, flowers, especially for local weddings and family events, and fruits, vegetables—even Jane's famous baked goods, like her mince pies, Clootie dumpling, tea loaf, and her fantastic lemon cake. Oh—and our potluck suppers. For twenty-five dollars a head guests can join us around our dining table and enjoy a real traditional seasonal-food dinner with wines and sherry—everything! I usually cook these—it's a welcome break from all that digging and maintenance on the croft. And though I say it m'self, I make a great steak and kidney pudding using our own meats. Sometimes I'll try recipes from some of the locals—their old traditional dishes—flavors that many people have forgotten . . ."

"And is all this working?" asked Anne. "Can you both live in a sustainable, self-sufficient way—or do you find you're sneaking off every week to the co-op in Stornoway to stock up on exotic luxuries . . . ?!"

Peter grinned. "Well—we're gettin' there. It's only been two years and, if I'm honest, we're still a bit squeamish about eating and selling our own animals, especially when our two kids give them names and regard them as individual friends. Jane does that 'naming' thing too, so you can imagine the bother I get into when I have to let an Ernie or a Gertrude go out for processing."

As he was speaking I looked around at the broad vistas of the Car-

loway community—scores of small, whitewashed houses and crofts scattered across the green, rolling hills surrounding Loch Carloway. Just down the road, by the seashore, was the restored Gearrannan Blackhouse Village, one of the most characterful and authentic of Hebridean restorations, and to the south on a high bluff, the preserved remnants of a defensive Iron Age *broch*. Further to the northwest were ancient stone circles, a restored Viking mill, the Harris Tweed mill at Shawbost, the enormous whalebone jaw arch at Bragar, and scattered galleries and a pottery along the road to the northernmost cliffs of Ness and the Butt of Lewis. The whole coastline here contains a panoply of historic and traditional reminders of ancient island cultures dating back over five thousand years.

"You're really in the thick of it," I said, "surrounded by so many remnants of the lifeways you're trying to restore and maintain here. And in one of the most scenic parts of Lewis too. What else could a young family wish for?"

"Y'can't beat it, can ye?" agreed Peter. "Sometimes when I'm cursing at how stubborn and hard this land of ours can be, or when I'm getting real frustrated by all the jobs left to do to get this croft the way we want it—all I've got to do is straighten up, take a few deep breaths, look around me, and I know it's all worthwhile. Money just can't buy this kind of place. And our two boys—Oliver and Jason—they love it too, so it makes it all fun. And Jane—well, of course, she'll never leave . . . she's set for life here!"

And, right on cue, who should emerge from the house but Jane, Peter's grinning, red-cheeked, blond-haired mate, exuding all the rural charm of a happy farmer's wife. "Instead of just standing around in the mud, why don't you all come in for a cup o' tea?" she said, laughing.

Of course, a "cup o' tea" in a Hebridean home is never merely a cup of tea. It was, in Jane's case, a cornucopia of buns, fruit pies, slices of thick, moist "boiled fruitcake," and sandwiches layered with succulent roasted ham.

"This ham is gorgeous—where did you get it from?" asked Anne.

Jane smiled as she watched us devour her home-baked delights. "Oh. That's Bernie."

"Bernie?" asked Anne, wondering if it was the name of her local butcher.

"Bernie—one of our pigs."

"Oh," said Anne hesitantly.

Jane laughed. "No, no . . . eat him . . . it . . . the sandwich. He had a great life here. Spoilt rotten by the kids. I'm sure he'd be really pleased you're enjoying him . . . it . . . the sandwich!"

But despite her generosity as our hostess and her beguiling grin, something seemed to be bothering Jane. Finally, at the end of a meandering conversation, she suddenly let it all out. "Look, you know, I'm sorry. It's just that I'm feeling a bit bad right now for our two boys. We've all just come back from the Perth Mod."

"Ah, we saw bits of that on television last night," said Anne.

"Yes—it's been on a lot. And it really was a great event. A huge celebration of the Gaelic culture: music, songs, dancing, choirs, poetry, and stories—all that good stuff. But our poor lads. They had a bit of a rough time. Oliver—he's thirteen—plays guitar and he's got this little band and they wrote some lovely Gaelic songs—all their own. They won the local Mod here. People thought they were fantastic. Giving Gaelic a bit of a boost with guitars and drums and whatnot. But at Perth, oh no—not at all! 'Far too modern,' they said. 'Not traditional enough. Too loud' . . . and other stupid things. They got praised for the songs themselves but they didn't even get a look-in because of the way they played them . . . I mean, you've got to keep up with the times, haven't you, for goodness sake!"

Jane looked a bit more cheerful after her outburst. "Well—I've got that off my shoulders now. Sorry. But look—have some more tea."

I must admit, it did strike me as rather ironic that a family so determined to authentically revive and maintain the generations-old traditional crofting lifeways would be frustrated by a similar intent on the part of the Mod itself, but I didn't say that. Instead I asked about her own paintings, proudly displayed on the walls of her cozy dining room, where we all sat devouring the last of her culinary delights. They were bold works—mostly semiabstract renditions of fishing boats and harbor scenes in Stornoway.

Highland Cow

"I can't go totally abstract," she explained. "I'm not sure I want to. It can get far too personal—too self-focused. What I try to do is use my big black marker pens to sketch some of the basic composition lines—you know, how the massings of the boats echo the verticals of the quays, and the horizontals pick up the lines of lobster creels, the harbor wall, the decks of the trawlers. I try to find patterns—geometric forms—that work as partial abstracts of color and light but still keep the essence of the actual reality. You know, the things that made me want to sketch that particular subject in the first place . . . things that might make people see new beauty—awareness—in everyday scenes."

"There seem to be touches of Cézanne . . . and Georges Braques in them . . . ," I said hesitantly. I'm always a little nervous when discussing "influences" in art. Some artists can be rather sensitive about such things.

"Oh, really—you think so?" Jane said. She giggled too, so I think she was pleased to be included in such elite company. "Thank you."

At that point Peter interrupted our little art-soiree chat with an invitation to go see some of his projects, with a warning that "it might be a little muddy."

Muddy it indeed was, but we soon forgot the gooey going as Peter pointed out some of the nuances of his work on the twelve-acre croft. Much of it was over our heads—references to dual-purpose cows; "natural weaning" for the calves; "maintaining family groups"; reduced castration of male sheep to increase breeding rams and the rare Hebridean stock; strict rotation schedules for potatoes, hay, and other crops on the lazybeds and higher pastures; and even the creation of a small bird-conservation area for the protection of the increasingly elusive corncrake, already nesting on Peter's land.

It was a hard, gloppy slog up the steep slope of his croft, leaping across newly dug drainage ditches and avoiding pernicious patches of bog by hopping from tussock to tussock through the spindly marsh grass. At the high end of the croft above the Harlingtons' home, the rough-and-tumble land began to meld with the weed-smothered remnants of old black houses. Little was left other than stumpy humps of ancient and thick stone walls, but it was obvious that over the last few centuries, a thriving crofting community had existed here.

"Some of these ruins have pre–Bronze Age origins," said Peter. "There are burial cairns and standing stones all around here, many with cup-and-ring markings. This place has deep echoes."

We stopped to look more closely at the rubbled remnants. A chill wind skirmished through the marsh grass, making the brittle blades rattle like old bones. Peter watched us closely and then said quietly, "Presences . . . can you sense them?"

Anne nodded a little warily, remembering our strange drive across the moor. I too felt that beguiling aura of layered life and death. So many centuries, so many stories, so many existences scrabbled out of this primordial, peaty earth.

"I love it up here," Peter said quietly. "I feel we're part of something so enduring, solid, and honest."

Peter's enthusiasm was contagious—about the land, about his little croft slowly being revived from the decay of decades, and in particular about his carefully nurtured livestock. In fact, he identified so strongly with his animals that when he discussed castration, you almost sensed he was talking about himself.

"I don't believe in it at all," he said stridently. "The meat is much tastier if you leave them 'intact.' The fat can be a bit gamey but a shoulder or a leg from our own breed will be the best you've ever had. And these St. Kildan sheep—at the moment we've got ten ewes and one ram and fourteen lambs—they're smaller, hardier, and unlike most other breeds, they love these tussocky grasses here—which is good because we've got an awful lot of tussocks. Also, they're very selective about how they eat the heather compared to other breeds. They don't tear it out by the roots, so it keeps on growing."

"How have the other crofters reacted to what you're doing here?" asked Anne.

"You know, that's been one of the best things in these last two years. So many come by for a chat and we exchange ideas. And they'll tell me some of the things that their great-great-grandparents used to do to make the croft better. I feel quite privileged. And they seem to enjoy my classes too—particularly the women at the flower and garden classes. Things are changing quite a bit. Old gardens and *inbye* grazing land around here were previously unused but are now being turned over for new plantings. It's very encouraging."

"So—no *dis*couragements?" I asked.

"Well—I suppose, in any experiment like this, there are bound to be disappointments . . . frustrations. I mean y'wouldn't believe, for example, all the new European Union regulations about how we can—actually, can't—use our own milk. Can you believe this—even if I fully pasteurize our milk, I'm the only one in the family allowed to drink it! And I certainly can't sell it. And cheeses—forget about it! I looked into building our own small cheesery, but wow—when I saw the books and books of regulations, I realized that they weren't interested at all in supporting small farmers. It seems they just want to wipe us all out. I don't know how the small farmers in countries like France and Italy even manage. I

mean, there are so many of them over there and they're getting smoth-
ered in these mountains of regulations that none of them can afford to
implement—or even understand."

"So, what's the future for the small farmer—crofter—in places like
Harris and Lewis?" asked Anne.

"Well—we'll have to see how all this works out, won't we? I mean,
that's why we're here—why we came. To make it work. To show it can
be done. To prove you can live a reasonably self-sufficient life on a few
acres with very little money. Which is, of course, the essence of the old
crofting life. Simple, basic, wholesome, healthy—entirely the result of
your own hard work and the community spirit of the other local crofter
families. That's what it was all about then ... and if we're lucky here, that's
what our lives will be all about too ... now."

"It's very ... inspiring," said Anne quietly. "You're giving something
back to a way of life that's almost vanished."

"Well, we're not advocating a mass 'return to the land' movement.
That's far too visionary—and irrelevant—to what's going on today. No,
it's really all about choices, I suppose. We're trying to show that this way
of life is still viable as an option, not a necessity. And for me—for us," said
Peter, extending his arms to encompass the whole beautiful tableau of
this small corner of Lewis, "this is definitely *our* option. This is *our*
choice."

THE "HARLINGTON SPIRIT" REMAINED WITH us over the ensuing
weeks, and when Celia and Robby, a couple of close friends, decided
that it was time to leave the familiar comforts of their New York home
and visit us at our island cottage, we knew that Peter and Jane's croft
would be one of the first places we'd take them. And not just for a cur-
sory tour but for one of their gargantuan dinner feasts.

We, and they, were not disappointed. Jane had transformed the small
dining/living room into a scene fit for a regal banquet: brightly colored
place mats spread across their antique oak dining table; gleaming cordial
and wine glasses; freshly cut flowers from the garden; two enormous
home-baked loaves still warm and aromatic from the huge Aga oven at

the side of the room; candles glowing in the early-evening twilight; and bottles of wine and sherry ready for immediate imbibement.

It was a truly memorable gastronomic experience. First—after a platter of cheese and homemade pâté hors d'oeuvres—came a huge steaming tureen of sorrel and squash soup peaked with dashes of tarragon and nutmeg, which Jane ladled out into our brimming bowls. We floated chunks of her walnut and oatmeal bread across its thick, silken surface and let them suck up all the gentle flavors. Then (there should have been a trumpet fanfare at this point) Peter marched in with an enormous haunch of richly marinated, nut-crusted venison and proceeded to cut thick, juice-dripping slices. Rich, gamey aromas filled the cozy room and we salivated as plates of steamed home-grown vegetables, roast potatoes, deep chocolatey venison gravy, and a relish of pureed Carloway red currants floated their way around the table.

Silence reigned as we ate, interspersed with moans and gasps of overindulgent delight. Chairs creaked and bellies rumbled, but we steadfastly continued on into the dessert course—that great mounded Christmas pudding–like Hebridean delight known as steamed Clootie dumpling, served with whipped cream, slices of the Harlingtons' pungent homemade cheese (deliciously illegal, of course—according to those interminable EU regulations), and a marmalade-like side relish of fresh oranges, lemons, and sweet dark treacle (a very British oddity, similar to blackstrap molasses).

There was silence again as we enjoyed the thick, rich dumpling and then—applause! Sudden, spontaneous, and utterly deserved. Jane and Peter stood and bowed, and I'm sure we would have stood too if it weren't for a strange affliction of chair-bound lethargy.

How we got back home to Harris much later that night after such Lucullan indulgence I can't quite remember, but as the four of us stood together outside our cottage bathed in soft nocturnal fragrances and that strange half-light of those island summer nights, Robby added the final oratorical flourish to the evening's proceedings: "Now, if that's your typical Hebridean dinner," he said between gentle burps, "we're staying!"

Celia groaned—but it seemed to be a groan of happy satiation . . .

Luskentyre and Seilibost

AUTUMN

1 2

Time for a Change:
Life on the Sands

S<small>O MANY FINE WRITERS HAVE</small> been bewitched by the beauty and mysteries of the Harris seashore that I thought it only fitting, before describing our own "bewitched" state, to share some of their descriptions, perceptions, and enticing images that possess true "take-home" longevity.

I begin of course with Finlay J. Macdonald's immortal memoir of his Hebridean childhood, *Crowdie and Cream*. Perhaps more than any other book, including Compton Mackenzie's comedic *Whisky Galore*, the word pictures so carefully crafted by this raconteur extraordinaire and maestro of island memoirs have enticed outsiders for decades to this remote place and enabled them to sense the enduring traditions and bondings that existed here deep in the old crofting days. Of the vast west coast beaches he wrote: "The relentless rocky moorland gave way to flat green pastures fringed with golden beaches . . . As far as the eye could see there was nothing but beautiful emptiness—I was a miniature fluff of infancy on an infinity of sand . . ."

Bill Lawson, our genealogical-guru friend and one of the island's most respected historians, lives virtually on the sands and writes of their unique spirit in his enticing book *Harris in History and Legend*:

The views . . . must be among the most beautiful in the whole island—especially on a summer's evening, looking across the sea pools and the

sands against the light of a setting sun . . . Pure white stretches of shell-sand, with views across to the mountains of North Harris and to the island of Tarasaigh (Taransay) with the machair itself a carpet of wild-flowers . . .

Alison Johnson and her husband, Andrew, best known for the restoration of the old minister's "manse" overlooking the *machair* and beaches of Scarista and its transformation into Scarista House, one of the most celebrated small guesthouses in the Hebrides, seem to have an ongoing love affair with these great golden west coast beaches. In their early twenties they relinquished their mutual "degree collecting" at Oxford, combined their varied interests and life goals, and formulated a visionary plan of action: "We could buy a large and derelict old house (architecture) near the sea (sailing) and in the country (rural living), restore it (joinery), and run it as a hotel (cooking.)"

And this is precisely what they did, although their arduous, calamity-filled odyssey between dream and reality, so humorously described in Alison's evocative book, *A House by the Shore*, can only make one boggle at the boldness of their achievements. At one point Alison admits to utter "shell shock—a dreadful feeling that everything is completely out of control, and the recurring question 'What on earth are we doing here?' Andrew," she adds, "even favors a spell in prison to facilitate reflection!"

Fortunately, they found their reflective times in rare interludes of peace among the great sandy infinities immediately below their tiny jewel of a creation. Even on a chill winter's day, Alison manages to capture the enduring magic of this evocative shore:

> The vast expanse of Scarista Bay was in front of us. It was a blustery gray day in February but the sands glowed and sang in the wind, golden, pink and silver. Inexorable Atlantic swells bore slowly towards them. As each green mile-long ridge of water breasted the shoreline it reared and hung stationary for an instant, and crashed, growling in the foaming shallows. Long wisps of spray tore loose from the threatening crests and mingled with the sand-devils above the tideline. Blowing sand stung our faces. Tatters of dry black wrack and broken shells scuttered towards us, chit-

tering faintly against the massive roar of the water. Down the beach where the pale dry sand became wet and ochre were drifts of shells, a prodigal treasure of gleaming violet and yellow, pink, blue and silver. Some were as tiny as grains of sand, and the sand itself was made up of the shattered wrecks of these shells . . . You cannot walk on this beach without feeling cut down to size. So inhuman is this area of wind-sculpted dunes, bare sand and moving water that its very indifference eventually makes welcome a sense of kinship with the other short-lived things of flesh and blood that blow and scuttle across it. Our footmarks criss-cross with the round-toed prints of an otter, the long lope of a rabbit, a black-back's clumsy webs, the scurry of a rat. The impassivity of the mountains and the sands leads to speculation: what were they doing; what do they feel?

And while the mysteries of what such creatures were indeed doing remained, this young couple eventually disentangled their own "what are *we* doing?" dilemmas and sold their guesthouse, and have remained on-island ever since, with Andrew now offering sailing boat trips off the Sound of Harris islets.

After meeting the Johnsons in person at their home near Lever-burgh, Anne and I recognized the emergence of our own what-are-we-doing restlessness. The sands and the sea were calling us—so we decided to house-swap for a while. Our time at the MacAskills' Clisham Cottage at Ardhasaig, with its magnificent postcardlike living room vistas across Loch Bunavoneadar to the burly wall of the North Harris mountains, had given us daily nurture. No matter what the weather. And we were certainly presented with an overabundance of weather due in large part to the malicious microclimate created by these impressive bulwarks. The Atlantic air, often saturated after its three-thousand-mile journey across open ocean, suddenly stalls against these bare gneiss buttresses, struggles to rise over them, and in doing so invariably becomes cloud-bound, soggy, and desperate to relieve itself of its watery burden. Which it did with great and enthusiastic regularity. Right on top of Ardhasaig village and, of course, our little cottage in particular.

Now, such a predicament of localized climatic zeitgeist in itself can

create undue house-bound frustration. But when coupled with glimpses between our clouds and teeming rain shafts, of gloriously blue skies over the great west coast beaches only five or so seagull-soaring miles to the south—it encourages one to wonder.

So wonder we did and finally made our decision to move for a season to another small cottage we'd discovered at Seilibost—away from the road, nestled in dunes, perched idyllically on the very edge of the beach, with vistas across mile after mile of those creamy infinitudes of Lusken-

West Coast "Pancake" **Machair**

tyre Bay. The cozy little house said a distinct yes to us and we immediately said yes back.

"Perfect!" Anne smiled, eyes gleaming in anticipation.

"Unbelievable," I think I said, and meant it.

"Welcome!" said Catherine Morrison, the owner.

And so, a deal was done and the move was made after long farewells ("only for a wee while," we promised) with the MacAskills. For all the fuss and kindness they showed us, you'd think we were emigrating to the far side of the planet. Although, we admit that as we hoisted the last box into our car and hugged Dondy, Katie, Joan, and Roddy one by one, we experienced moments of hesitation and uncertainty. Little Clisham Cottage had been a much-loved haven for us, and with Roddy's store immediately across the road, Katie's guesthouse and restaurant just down the hill, and Joan's kitchen of delights right next door, we wondered for a fleeting moment why we'd ever thought of leaving.

The rich scarlet glory of that first Seilibost sunset, bathing our new home—and us—in an ethereal amber glow, quickly dispelled such trepidations and squirrelly anxieties. We stood together, then sat holding hands, on the cusp of the *machair*, where the wildflower-bedecked grasses ended abruptly in a swirl of striated rock strata. The faintest of perfumed breezes in that little tidal ripple of warm air preceding the setting sun ruffled our hair. Anne smiled but said nothing. I felt root-shoots emerging. We had barely arrived at this beach cottage on the lip of the bay and already I sensed its seductions. Then somewhere, way in the distance, deep in the *machair* on the fringe of the "blackland moors," came the strange, eerie rasp of the corncrake.

This increasingly rare species of bird, a migrant from African wintering grounds, seeks out the "ragged land" for its elusive nests—places lush with rushes, reeds, nettles, hogweed, and wild iris beds. It is an extraordinarily shy creature, often heard at dusk throughout the spring and summer but rarely seen. Except in one particularly amusing incident recounted by Finlay J. Macdonald. In this short anecdote from his book *The Corncrake and the Lysander*, he reveals the layered depths and complexities of Harris folklore:

I spent long hours of boyhood searching for her—stalking her croaks as she held rasping conversations with far away echoes, and once I found her lying dead on her back, as I thought, with her pale green belly matched to the iris and her striped legs pointing upwards, but when I bent down to pick her up she was away like a shuttle through thread and when she hawked a few moments later there was a laugh in her throat.

"You shouldn't have disturbed her," Old Aunt Rachael said when I told her. "Don't you know that it's millions of crakes lying on their backs with their feet up that keep the sky in place? And it's the strain of it that's made their singing hoarse over the thousands of years. Only fools hunt the corncrake," she went on. "And those with little to do. But the wise man listens to her and holds back the spring work till her first croak tells him that the frost is over for good; nor will he take his scythe from the rafters till her chorus is ended. It was the coming of the scythe that made her start taking to below the water for the winter, don't you know? And if you don't believe me, keep an eye on the moor lochs during the spring and you might catch her coming out from under the water after her winter sleep with a white patch on her forehead from the cold." She chortled, "In any case your chances of seeing her then are as good as your ever seeing another one; already you've seen as many in your short life as I've seen in my long one!"

Anne smiled when I reminded her of Finlay's tale. "It's like there's a meaning in every detail of island life," she half whispered, as if reluctant to disturb the silence of our golden dusk.

And there was nothing more to be said. We had come to our new home and we were very happy.

Dawdle Days in the Dunes

I MAKE NO APOLOGIES HERE FOR this diversion into impressionistic and semiabstract mood. What else can you expect from time spent a-dreamin' during our "dawdle days in the dunes," on this magnificent beach of Seilibost—although to call it a beach hardly does justice to our golden strand of infinitudes.

This is one of those faces of Harris that makes this island iconic. This is also one of the reasons outsiders undertake rather arduous—and expensive—pilgrimages here. Returnees are certainly aware of its validity. Yes, of course, there's the history and the tweed and the crofters, and the fishermen, and the Gaelic, and all those rich images of an ancient and resonant culture. But there's something more too. Something in the wild land, the ocean, and these great sand spaces that resonates deeply in the bass chords of human awareness and evolution. Touchstones of magic and mystery that ease off the clunky carapace of everyday mundanities and wait patiently here to be nurtured and absorbed.

AT LAST. AFTER DAYS OF early autumnal rain, the sun emerges from dark dawn clouds and, for once, appears resolute. Determined to endure and bring warmth. Determined to melt the early clouds into wispy submission and bathe the soggy, beaten land in a sheen of gold as it rises. Then, gathering strength, a strong and burnished silver turns the *machair* into fairy fields of brilliance, almost antipodean in mood and spirit.

It is definitely a day for the beach. We have waited a long time—far too long through these dreary, dripping days of Celtic melancholia—for a day like this. So—it's cancel all plans. Forget Stornoway and all our multitudinous must-dos and must-buys. They can wait. A day like this is not for shopping or a few hours in the library on Cromwell Street or a beer in the smoky Criterion or McNeill's or a platter of Cameron's battered fish (deliciously tempura-crisp when fresh-fried, ghastly if allowed to wilt under the heat lamps), or mooching along the harbor in the evening, waiting for the prawn boats to ease in and hoping to grab a bargain bag of little langoustines, too small to send off to Spain that night with the bigger ones, neatly slotted in their boxed crates.

All that can wait. It is time to sit, as we are sitting now, on the curved sandy crest of a blown dune, with the brittle marram grass chattering in breezes soft as sighs. It is time to listen and look and learn. It is time to watch the tide slowly recede and then return in frilled eddies across the long horizontal swaths of gilded, syllabub-smooth sand. The day is all ours and the spill of days beyond. We need to be nowhere. We need to be nothing at all. Except here. Letting the layers peel back; letting all the mental fripperies go; quieting the incessant yammer of overactive psyches; and arriving at . . . nothing, except that deep stillness of restful spirits and mellowed souls.

A friend of ours once remarked that "my problem with doing nothing is that I don't know when it's time to do something." But "doing nothing" is rarely what it seems to be. More often it's about rediscovering the obvious—those simple, uncomplicated feelings and perceptions all too easily overlooked in the search for the new and novel—and the constant grappling with impulses, choices, "must dos," and surfeits of sensory overload: The eternal juxtaposition and balancing of inner and outer journeys.

Alec Guinness once wrote: "Paying attention to anything is a window into the universe," and in our case we started off by paying attention just to the clouds. They alone are enough to occupy hours of observation as their profiles and moods change. Bold, bulging cumuli, massing across the horizon, tumescent, pearlescent, some cut by canyons, others puffy as soufflés or cuddly as plump cherubs under feathery

brushstrokes of cirrus; a thunderhead growing over a sun-shafted summit and purpling under a flattening head—glowing with power as if barely containing its furies within.

Gulls fly close (I'm always surprised by their impressive size) and glide to smooth landings alongside one last tidal stream meandering its diminishing way across the beach to where the surf breaks gently on a distant strand. Two hours ago the surf was clearly visible in white-maned lines of waves, but with the tide receding, they barely exist now. It looks as if you could set off and walk straight across the three miles of sand to Taransay Island. It's a tempting proposition, just to head off in a straight line across those infinitudes of soft shell dust and see how far you could get before the tide decides it's time to turn again.

So we walk together slowly out in a wide arc across the sand and a great calm settles over us.

"We are *so* lucky," Anne said softly as if to avoid disturbing the silence and the gentle rhythm of our steps.

I nod and smile and know exactly what she means. Back in our small beach cottage, perched on a rocky buckle of land, we have everything. We need for nothing at all. We have our favorite music on a handful of CDs, a dozen or so "important" books we've been meaning to read for eons, a well-stocked refrigerator, a change of clothes, a guitar, notebooks and journals, a comfortable double bed, a couple of elephantine armchairs, and a small but idyllic glass-enclosed sunroom overlooking the whole glorious vista of sand, dunes, mountains, and ocean. And then, of course, we have time itself—time for thinking, daydreaming, looking, focusing, and letting free-floating feelings roll—a month's sensation and thoughts in a single day. And we have as well a sense of that "wild, roving, vagabond life" so celebrated by Sir Richard Burton, the famous Victorian explorer.

And rhythms. We have the slow, regular rhythms of the day, each and every day. Sometimes placid and predictable as the tides. Sometimes typically Hebridean, when, in the course of a single hour, we might watch the following sequence: first, a furious little rainstorm whirling in off the Atlantic on air currents that have crossed over those three thousand miles of untrammeled ocean; then angry little black clouds appearing over

Taransay as if to express frustration at this unexpected island obstacle; and the rain coming at us across the sand, flailing like a horse's tail, hitting the large windows of our sunroom hard as hail. Taransay vanishes, lost in a sudden white mist-sheen. Then the whole bay vanishes and all we can see, through the rain-streaked glass, are small clusters of *machair* wildflowers a few feet away from the cottage, flailing about like placard-hoisting protesters at an anti-something-or-other rally.

I remember a comment Roddy had made a few days previous as one autumn storm too many had disturbed his normally calm demeanor: "Did y'know, David, that it's estimated there's more'n ninety billion gallons of rain falling on Scotland in an average year. An' I reckon most of it came down in the last two weeks ... directly on top of our wee island."

This time the petulant storm barely lasts three minutes. And then it's all over. The misty strands evaporate like wraiths suddenly exposed to daylight. And light comes. A watery sun at first, limpidly silver, then turning more and more sauterne-gold as the land appears once again. The long dune-strand of Corran Seilibost, the great concave profiles of the Luskentyre dunes, the languorous green profile of Taransay, and, still a little hazy, the bold bulk of the North Harris hills. They're all back in barely a minute with only our rain-dappled windows as evidence of that fickle storm fury.

And then comes the rainbow. Actually, this time it's one of those magnificent double rainbows—two perfect concentric arcs with each spectrum color distinct and separate. And it's now warm again, with the sun beaming in brazenly through the large sunroom windows. The sands gleam like burnished bronze, but down farther to the south, over the straggled croft community of Northton, another dark little storm suddenly appears atop Chaipaval and we watch the rain fall in silky white strands like long man-of-war tentacles.

As we turn eastward, looking through the living room windows, across the peaty wastes of the island's central spine, huge cumuli float like bulbous galleons toward the soaring cliffs of Skye. And to the north, over Clisham, shafts of sun burst through the mountains' semipermanent cloud cover and dapple the dun green-brown slopes with patches of emerald and polished copper hues. And finally, looking straight out at

Taransay again, the rainbow is fading and—would you believe—another little petulant flurry of gale and rain looks to be forming once more as the Atlantic air decries the arrogant intrusion of land . . .

And so it goes. A cycle of five or more entirely different but simultaneous bouts of weather, each one transforming into something else even as it is created. A ceaseless round of restless, almost playful, climatology that makes us happy just to sit, watch, and wonder how an impressionistic icon like Monet would have relished such a mélange of mood shifts.

Anne is right. We are very lucky. What more could we possibly need of our little beachside home? The place murmurs its enticements quietly, invites gentle introspection and natural meditation, and reflects the haunting mood of William Wordsworth's words:

> And I have felt
> A presence that disturbs me with the joy
> Of elevated thoughts; a sense sublime
> Of something far more deeply interfused . . .
> A motion and a spirit, that impel
> All thinking things, all objects of all thought,
> and scrolls through all things.

That same spirit that "scrolls through all things" was with us as we wandered slowly together once again across those golden sands. We'd been warned, of course, by at least one trepidatious local, of "quicksands" ("Y'll never spot 'em 'til y're in 'em!"), rapid tidal reversals ("Aye—it comes in faster'n y'can run in places"), and the perniciously strong currents of the "sand rivers." But by now we were used to occasional island doomsayers and walked on across the firm flats with not a care in the world.

First came the rock pools of Corran Seilibost. Dozens of them, nestled among brittle ledges of exposed gneiss. Some were still and empty. The larger ones teemed with small-scale life—minnow-sized fish, tiny hermit crabs, limpets, anemones, and purple-shelled whelks. And interlaced among the pools were rocks graced with thick, bright green, hairlike sea

moss twirled into curls and slack knots by the tide. The moss was soft to the touch, almost like the downy peach fuzz on a baby's head. And tiny interwoven fragments of sand and powdered seashells made the "hair" sparkle and flash as we moved slowly across this little world of pools.

Intrigued as we both were by these miniature worlds, we were all too aware of our limited observation and descriptive skills. This was relatively new territory for us. We were merely neophyte pool-ponderers compared to people like Alison Johnson and her beautiful and learned portraits of similar territory in her book *Islands in the Sound*. This was Alison's third book on Harris, and it is her combination of detailed knowledge and love of the seashore environment that makes her writing so intriguing—as in this description of rock pools on the islands in the Sound of Harris:

[It was] so hushed that the kelp fronds barely stirred in the water. Time moved gently to suit the slow questing feelers of the little winkles grazing the weed, soft green-gray bodies gloriously shelled in bright yellow, scarlet or humbug stripes. Some of them were so tiny as to be invisible at first; but all were poking out feelers, all brilliantly colored against the rich brown weed. There were some tops among them, far more pearled and striped in life than the dead shells suggest, and a sea urchin, delicately flushed with pink and lilac, and haloed by its waving semi-transparent tube-feet. The live animal shimmers with fluid movement and luminous tints, quite unlike the static, brittle empty test one finds wasted up on the beach . . . On the sandy bottom inside the edge of the tangle, shore and velvet crabs scuttle from one clump of weed to the next leaving clear "footprints" in the sand, which was strewn with razor shells . . . Clumps of bright green sea lettuce lolled on the still seabed like blown roses. From scattered pebbles on the bottom, bootlace weed and soarwrack trailed languidly upright, diffusing an oily haze from the swollen fruiting tips and flounced with fluffy yellow tufts . . . and the leaf-green blades of eel grass . . . crossed at a right diagonal by flickering broken lines of silver—a shoal of sand-eels, casting shifting flecks of viridian shadow on the bottom in a three dimensional checkwork of pure abstract beauty.

A few weeks back we'd spent a gloriously sunny afternoon with Alison and Andrew at their "always expanding" house at Leverburgh, and I asked them if they missed the old Scarista House days. Andrew smiled his pleasantly mellow, noncommittal smile, but Alison, rather more stern and direct, refused to be sentimental: "I'm just not that person anymore . . . I can't even read my own book nowadays. In fact, I don't think I have a single copy in the house. It all became a bit too much. Andrew's much better with people than I am—by the time I'd done the dinners there, I wasn't good company—for anybody! I'm pleased it's still going, though. The new owners, the Martins, are very good friends but . . . well, now we're happily and deeply into publishing academic and research materials. A new career. Environmental issues mainly. Only small runs. Looking back, I suppose I should have toned my book down a bit. I'm sure it caused mortal offense to some on the island. I was a little too blunt, I think. I still am!"

Andrew continued to smile and nodded vague agreement before wandering off "to feed the neighbor's hens."

"I don't know how he puts up with me sometimes." Alison laughed when he'd left and then launched into tirades over some of the latest "developmental" issues plaguing Harris, including the finally rejected Lingarabay Superquarry, those proposed four-hundred-foot-high wind turbines on Lewis, rumors of "toxic" salmon farms, "pseudo" summer festivals, the decline of the Gaelic language, and—of course—the future fortunes of poor old Harris Tweed.

This stridently assertive Alison seemed very different from the gentle, sensitive author of *Islands in the Sound*, but as we shared slices of her amazingly pungent fruitcake over tea, a softer side emerged and we left, hours later, glad that the island still had people like the Johnsons to protect and celebrate it.

ANNE AND I AMBLED ON, splashing through the sinuous, chuckling sand streams and leaving a looping trail of footprints in the sand (I looked back and was surprised to see that I apparently walk with my right foot slightly askew; I'd never been aware of that before). Then we

found the cockleshells. A vast graveyard of millions upon millions of them in linear tide-wrack formation strewn along the base of the rabbit burrow–pocked and marram grass–topped dunes of Corran. The broken habitats of so many succulent, brine-laced creatures that, when fresh-dug and after being steamed and doused in warm seasoned butter, offer the perfect opening act of a fine island dinner.

"Isn't that . . . somebody out there?" asked Anne, pointing into a soft sea haze across Taransay Sound.

"I guess . . . unless it's a piece of driftwood stuck in the sand."

"No, no . . . look! He's moving . . . very slowly."

And so he was. A little black, bent stick figure edging his way across the sand with a small spade or something. Looking rather forlorn and lonely.

"Must be a cockleman," I said. "Who else would be daft enough to go so far out? He'll have a long run back here when the tide turns."

"Shall we go over?"

"No. Leave him alone. We might catch him later when he's finished . . ."

And so we wandered on, discovering more details and delights. And I thought back to a beautifully crafted passage in Gavin Maxwell's *Ring of Bright Water*, which seemed to capture all the nuances of our dawdling day:

> There is a perpetual mystery and excitement in living on the seashore, which is in part a return to childhood and in part because for all of us the sea's edge remains the edge of the unknown; the child sees bright shells, and vivid weeds and red sea-anemones of the rock pools with wonder and with the child's eye for minutiae; the adult who retains wonder brings to his gaze some partial knowledge which can but increase it and he brings too, the eye of association and of symbolism, so that at the edges of the ocean he stands at the brink of his own unconsciousness.

We were both certainly recapturing the child in our explorations. That's what made the tiny rock pools so evocative and tantalizing. I used to dig around for hours in such places as a boy, gleefully celebrating yet another summer holiday at the seashore with my family. "Don't you want to go out and play football with those other children?" my mother would

ask in her constant concern for my somewhat atrophied socialization skills at that age. And sometimes I did. But mostly I didn't. The pools, with their myriad aquatic mysteries, were far more enticing. And still are.

I was reminded too of a passage from John Lister-Kaye's superb book *Song of the Rolling Earth: A Highland Odyssey*:

> Joy and delight are nature's gift to those who seek it and strive to reveal
> its truths. Nature comes free and in full Technicolor . . . It is utterly orig-
> inal, constantly recreating itself anew dazzling and inspirational . . . For
> those who are fortunate enough to be able to know it well, it reveals the
> triumph of creation.

And at least for Anne and me, dawdling our way across those sands under the great blue dome of sky, the "triumph of creation" indeed revealed itself as "nature's gift"—a gift we carried with us gently and gratefully as we made our way slowly homeward to the little cottage on the bluff above the beach.

But not alone.

"Hey!" came a voice a long way behind us. We turned and there was our cockleman, silhouetted against the green contours of Taransay. He carried—actually, dragged—two enormous sacks and seemed stooped and weary. We waited for his slow approach and his greeting of "Well, now, y'two look like you're enjoyin' y'selves."

"Actually, we are. It's a do-nothing day and we're doing nothing. But you look like you could do with some help!"

The man—actually more of a lean, gangly youth with an open face, blue eyes, the shadow of a mustache, and dimpled cheeks—laughed as we all introduced ourselves. "Alan MacLeod," he said, with a cheeky grin. "Cockleman supremo!" He hefted up his two sacks. "Not bad for an afternoon's work, eh?"

"Looks very impressive," I said, admiring the hundreds of white cockles peering through the tight orange mesh of his nylon sacks.

"'S'bout thirty kilos—at least," he said, "an' all caught wi' this wee thing." Alan indicated a two-foot-long rake stuck in his belt.

"That's all you need?" asked Anne.

"Aye, well, some have bigger rakes, but that means you're always bob-bin' up and down. I like to keep close to the sand. You can spot 'em an' hear 'em faster."

"Hear them? Cockles make noises?" That was news to me.

"Oh aye, indeed. They're usually only a coupla inches down and when y'walk in these waders y'll hear 'em swishin' and closin' up when you're nearby. Then you've got to move fast. They can shift through that wet sand faster'n clams. Clever little buggers, they are . . . but, as y'can see—once y'get the hang of it, y'get half a day's catch like this. An' at over a pound a kilo, it's not a bad life, really."

"I guess . . ." I said, only half convinced by the allure of being alone, permanently bent, and chasing after "clever buggers" with a kid's rake for hour after hour. "Maybe when the sun's out. But the weather across the sound here seems so . . ."

"Bloody awful!" Alan completed my sentence.

"Well—yes. It can be. Typical 'if y'don't like the weather, just wait five minutes' stuff. You never know what's coming next."

"Aye," said Alan, with a grin. "But I know what I'd like next!"

"What?" asked Anne, laughing.

"A big mug o' strong tea!"

"Done!" I said. "That's exactly what you'll have!"

"How's that?" asked Alan.

"Well—that's our cottage over there," I said. "At least for a while. So come on in and join us for tea and maybe a glass of something a bit stronger."

Alan hoisted up his sacks of cockles with fresh vigor. "You, sir, and you, madam—are both lifesavers!"

"C'mon," I said. "Let me carry one of those sacks."

Alan couldn't seem to take it all in. "Y'know, I've been doin' this on and off for five years in all kinds of weather and you're the first people ever to offer me . . . anything!"

And in the end it turned out well for all of us. Alan glugged his way through two large mugs of tea, three drams of malt, and a plateful of cook-ies, all the while regaling us with tales and local gossip. And then, just as he was about to leave, he said nonchalantly, "Y'got a bucket or something?"

"Sure," I said, wondering if he was about to start washing his cockles in the kitchen. And he did indeed fill our plastic bucket with cockles, but then he said, "And these are yours. Just let 'em rest for a day or so in cold water to get rid of t'sand. Then boil 'em up 'til they open and mix 'em with some hot butter and—well, y'got y'selves a real nice snack."

Alan left with a standing invitation to join us for refreshments any-time he was back on the sands. And he did on a couple of occasions, each time leaving us a bucketload of those delectable little delicacies.

All in all, a fine conclusion to yet one more of our dawdle days.

BUT OF COURSE, IN THE NATURE of things, there has to be a downside to all these enticing romps.

And there indeed was—a week or so later when Anne had gone into Tarbert to do the shopping and I told her I'd take another stroll across the sands on what looked like a perfect blue-sky day.

She thought it was a great idea.

Only it wasn't.

Oh—as these things go—everything started out just fine. I strolled across our cottage lawn, through the iron swing gate, down the ten-foot-high bluff of gneiss strata, across the dappled rock pools, and out onto those glorious shell sands once more.

A soft autumn breeze was still full of the scent of resilient *machair* flowers. Away across the bay rose the high, bold dunes of the Luskentyre Banks—the highest dunes in the Hebrides, and my destination for the day. It was a long but relatively easy walk requiring only a little bare-footed fording of sand rivers where the remnants of the last high tide still skittered and chittered across the dimpled shallows to join the ocean in the Sound of Taransay.

Once Taransay, that languorous isle of green hills and golden beaches visible each day from our cottage, was a flourishing crofting community of three villages and a wealth of ancient remnants, including a standing stone, *teampalls*, a prehistoric shell midden, and a sixteen-foot-high Iron Age dun-fort still largely intact in the late nineteenth century. Then gradually, like so many of the small islands around Harris and Lewis,

Taransay lost its population and slumbered on, relatively unmolested, until that odd fiasco in 2000 of *Castaway*—one of the first prototypes of the now ubiquitous TV reality *Survivor*-type programs that plague today's viewing options ad nauseam.

Viewers may have hoped for a real beachcombing, Robinson Crusoe kind of experience but ended up watching a watered-down, semistaged pseudodrama of thirty or so adults left "to fend for themselves on a deserted isle." Alas, for multitudinous reasons and mishaps, many of them spent more time living the highlife at the Harris Hotel in Tarbert than "surviving" on Taransay, and the whole fiasco ended up resembling, according to the gossipy headlines of national tabloid newspapers (and the comments of locals), a typical Brit-TV soap.

In my case I've often been fascinated by the idea of a beachcombing life. Once very early on in our "earth gypsy" ramblings, Anne and I tried a spot of living "off the beach." Actually, "try" is possibly a misleading verb. We had little option at the time—what with only a couple of hundred dollars to our names, a recalcitrant VW camper that exhibited a remarkable capacity for incapacity, and a couple of honor-bound fiscal debts to settle with kind friends whose initial generosity in the "travel for us" spirit had turned a little maudlin after months of silence on our part.

So—beach living seemed to be our only option for a while. But, looking back, I still think it was fun—gathering mussels and fishing for sunfish on hidden northern California beaches, devouring wild fruit, mushrooms, and "borrowed" corn (we decided that ripe but broken corncob-heavy stalks were free game)—all seemed to be part of the authentic essence of our "randoming" lives at that time.

However, when I read Alasdair Maclean's *Night Falls on Ardnamurchan*, I realized that our "fun" was often a serious beachcombing way of life in the islands here:

The use made by crofters of the gifts of the sea merits a book in itself: seaweed for fertilizer and if need be for food; sea birds for their flesh and their eggs; driftwood for fuel and for building; sand for fertilizer, for cement mixing and infilling, and to provide a layer of insulation under bedding in byres; and of course fish. There is always a chance, too, of

finding something really interesting or valuable. For instance, there is the semi-mythical ambergris [from a gland near a whale's brain] reportedly worth a king's ransom a lump, which all beachcombers hoped for but none ever seems to find. And there is the beauty, mystery and terror of the great ocean to love and to make a lifetime study of.

When I was a boy beachcombing-protocol was strict and competition fierce . . . Two or three days of northwest wind would bring the driftwood in and you would have to rise at the peep of day if you wanted to be first on the scene . . . As for the rules of the game, if you took your beachcombing finds well clear of the high water mark, so eliminating any possible ambiguity about their status, they were yours till you chose to fetch them . . . Generations might pass and no one would touch them . . . How changed things are now! You scarcely dare leave your shadow unattended for a moment . . . The more advanced the culture, the less civilized the people . . . But I still adore beachcombing and it still gives me joy to discover—for example—a really fine piece of timber . . .

Ironically, as I reached the far side of the bay, I found meager scatterings of beachcombing items above the tide line, but the "fine timber" described by Alasdair Maclean was more like fragmented bits of trees with jagged branch stumps and sea-eroded trunks devoid of bark and smoothed to a worn-silver texture by the churnings of the tides. Beautiful in a wild kind of way, but hardly true beachcombing bonanzas.

Just ahead the soaring Luskentyre dunes rose up like a golden fortress over two hundred feet high to tufted marram grass summits. They seemed unassailable. And they *were* unassailable, as five minutes of scrambling up their fragile flanks, followed by a roly-poly return to the base when the sand finally gave way, made very evident. But I was determined to find a way onto their tops and finally, after easing my way around the less eroded northern edge of the dunes, I found I could climb a semivertical slope well covered with marram. Ideal for handholds, I thought. Grab clumps of the deep-rooted stuff and haul myself up in no time. Only I'd forgotten one of the less appealing attributes of this spikey grass. The blades are like knives—sharp and slightly serrated—and when

Gray Seal

they didn't actually cut my hands, they left enough scratches so that when I finally reached the summit, puffing like one of those overweight gray seals that colonize these islands, my fingers looked as if they'd been caught in a remorseless shredding machine.

No matter, I consoled myself. I'd made it. Only I hadn't quite got the lay of the land up there and didn't realize that the slope I'd climbed was actually the leading edge of a sandy arête, and as soon as I stepped on the ridge, the sand gave way and I went tumbling down the backside of the dune, with no marram grass to slow my rapidly accelerating rate of descent.

I ended up in a hundred-foot-deep bowl of talcum-textured sand, almost as far down as I'd been when I started the climb from the other side. And it was a bowl with no discernible exit. All around me rose those soaring walls of wind-smooth sand offering no footholds and no chance of immediate escape.

"Crazy!" I mumbled—or maybe something a little bit more epithet-laced. "There must be a way out—try traversing, zigzagging back up to the top . . ."

But this was very pernicious material. It looked beautiful and golden in the afternoon light and it felt so benign—even warm. However, in terms of ascending footholds, it was utterly useless. Like trying to climb up through powder snow. Every few tentative steps up eventually led to a slide back down to the level at which I started. An interesting predicament.

And it was then I spotted the skeleton. At first it was just the hint of a rib cage a few feet to my right at the very bottom of the sand bowl. I edged over and nudged the sand away with my feet. More ribs and part of a backbone. Whatever it was, it had obviously been there a long time. The bones were ghost-white, picked clean of all skin, flesh, and tendons. I had a dramatic vision—courtesy of my inner demons, doubtless—of some poor lonely hiker who had made the same mistake as me and ended up his days trying to claw his way out of this malevolent bowl before finally dying of exhaustion, thirst, and a horrible slow starvation.

It, of course, turned out to be a sheep. When I kicked off enough sand, out came the skull with prominent curved horns and a menacing toothy grin. For a moment I was relieved. But then I realized that if a nimble-footed sheep couldn't escape from this place, what chance did I have?

That maudlin sense of hopelessness was eventually replaced by determination. No way was I going to let a few dunes—admittedly the largest dunes I'd ever seen outside the Sahara—do me in. I had things to accomplish and places to go. Most important, I had dinner to cook back at the cottage and I knew how disappointed Anne would be if I failed to turn up for cocktails at the allotted time on our lawn overlooking the sound.

So eventually I figured it out. As I watched how the wind would spiral into the bowl, whipping sand off the lee slopes and depositing it in great swirls on the opposite side, I realized that the lee must consist of harder, more compact sand. So that's where I started to climb and, despite occasional slip-backs, I finally traversed my way up to the grass-tufted ridge and edged very cautiously onto something resembling a flattish plateau.

I always feel humbled and intimidated by the almost-tangible energy and mystery of wild places. But, believing that true discoveries and rev-

elations only come through letting go of such emotions, I celebrated the sense that I was obviously safe now. All I had to do was find my way out through this dune labyrinth to the safety of the cemetery, which I knew from my map existed at the northern tip, and the narrow track that would eventually lead me back to Seilibost.

My pessimist-self, however, was not quite so complacent: "When things start to go well—watch out!" it muttered. My optimist-self responded on autopilot: "Any further problems are merely opportunities in disguise!" And there were indeed problems. Two of them. First, my plateau of safety was actually lower than the main dunes, so I couldn't see out for orientation. And second, the sun, which had been my comforting companion throughout the hike, had suddenly vanished in an ominous pall of clouds that were now rapidly descending as a thick and chilly mist, sullen, silent, and ominously still. A sudden sheen of silence.

Oh, great! I thought. I could be wandering around this wilderness for ages trying to find my way out. And of course that's what happened. For the next hour I flailed through this omnipresent fog, maybe walking in circles along the highest ridges, hoping for something to confirm my somewhat confused sense of direction. A friend of mine once advised me that "the key to a good walk is knowing when to sit." Obviously I forgot his advice that day.

Eventually I realized that I was actually going consistently downhill, either back to the beach or, hopefully, toward the cemetery. But this strange little corner of my island still had a few tricks up its topographical sleeve: nasty overhangs of soft sand that wanted to send me tumbling back into one of those treacherous bowls; little scooped-out "sand holes," many partially hidden in the marram tufts and carved out by vicious little mini-tornadoes or "sand devils"; and ankle-snapping rabbit burrows that pockmarked the surface of the sand like Gruyère cheese holes.

Finally I heard a car or a truck or something with linkages to a more familiar world. It came from quite a distance but at least it was straight ahead. And then—a path! Only a rough indentation in the sand, but at least something to suggest that other of my species had wandered, and presumably survived, here.

The velvety, sheep-cropped grass of the cemetery suddenly appeared out of the mist as I made a long descent down the last of the dunes. I sighed with relief and wandered past the scores of headstones for MacLeods, MacLeans, MacKayes, MacDonalds, Morrisons, and MacAskills. All lovely familiar names in this safe, quiet haven. Which it indeed once was, and still is. A haven, particularly for those who died on the eastern bay side of Harris, where the ground is so rock-bound that no space could be found for communal burial sites. So, along an ancient peaty track (now part of the Harris Walkway, which links over twenty miles of traditional hill tracks from the Lewis border to the Seilibost Sands), the coffins had to be carried the ten or so miles from Grosebay to the soft *machair* earth of Luskentyre for sanctified interment. It doesn't sound particularly far, but as later hikes across the "lunarland" of central Harris showed us, it can be an extremely arduous experience.

Then came the track. A narrow, sinuous creature that I knew would take me safely back home. Maybe I'd even get a lift. Otherwise I knew I'd be in for a long walk.

It was not only a long walk. It was also cold, wet, and utterly spirit-crushing. Not a single vehicle passed me along those three miles back to the main road. And the cloud-fog, which I hoped would eventually lift as quickly as it had come, decided instead that it was time to release its pent-up burden of Atlantic rain, with drops big as pinto beans, and dump a good part of it right on top of me as I sloshed along, soaked and shivering in this ridiculously unseasonable autumnal storm.

I tried to restore my subdued spirits by remembering one of my favorite mantralike travel aphorisms—another beauty attributed to Sir Richard Burton: "Of the gladdests moments methinks in human life is the departing upon a distant journey into lands unknown."

But the only really good thing about the remainder of that eminently forgettable day was the fact that when I finally gained the sanctuary of our little cottage, Anne cosseted me like a newborn baby, supplied me with mug after mug of strong hot tea, and, God bless her, had even prepared a delicious and truly Yorkshire dinner of steak and kidney pie with minted peas and roasted potatoes.

"I almost cooked some lamb," she told me. I was glad she hadn't. The

memory of that poor creature—and doubtless many others—trapped and terminated in the sand bowl had spoiled that particular aspect of my appetite for quite a while.

But as the days passed and the weather became pleasant and predictable (a rather rare occurrence on this climatically fickle island), we continued to explore the sands together and our discoveries of new mini-earthscapes, strange aquatic creatures in the rock pools, and other multifaceted peculiarities of local flora and fauna, were endless and always enticing.

Now, MUCH AS I HATE TO spoil this picture of our deliciously carefree ramblings, I feel I should mention one particular drawback at this and other seasons: the pernicious midge.

You'll never forget that first bite of the *meanbh chuileag*—the little fly—a ridiculously polite euphemism for one of the most detested plagues of the warm months here. And one reason you won't forget the bite of this virtually invisible attacker, with a wingspan of barely a millimeter, is because it rarely attacks on its own. Rather like Canada geese, midges are social creatures, enjoying the perpetual company and attack formations of cloudlike collections of clones that breed in their billions among the bogs, lochans, and wet grasslands of the islands. Piranhas, of course, act within similar cohesion and, having once experienced nips from these devil-teethed barbarians of the Orinoco River in deepest Venezuela, I will

The Pernicious Midge

congratulate the tiny midge on coming in a close second on the pain scale.

"Ach, it's only the pregnant female that bites. The males are harmless," I'd been told at the beginning of the midge season in late May by a strappingly bold ex-crofter in the Tarbert Stores, that lopsided wonderworld of do-it-yourself miscellanea next door to the Clisham Keel.

"Well," I said a little grumpily, having just beaten off an attacking army with huge clouds of my cigar smoke (and a quick dash for the store too), "when there's a million buzzing around your head, I don't think it makes any damn difference if only half of them are biting!"

"Well, what y'might wanna do," replied my stoic informant, "is use a little squirt of oil of citronella or pennyroyal, or a sprig of bog myrtle pinned to your clothes . . . or . . ."

"Aw, no, no," chipped in one of the young men behind the counter, "my granny always says one part of lavender oil to twenty parts of elderflower water."

"Nah—that'll not do it. Just try lemon juice . . ."

And even a fourth joined in: "Listen—the best cure of all is a mix of lanolin, camphor, and cassia . . . I forget how many parts . . ."

The owner of the store was dismissive of such folk remedies: "Na' listen—all those things are useless—just tasty salad dressings for those hungry creatures—but we've got this new machine comin' in next week . . . The Midge Master. Y'put it outside where y'sit, turn on the special fuel, and the midges think it's you an' they get sucked in by the thousands. Works wonders!"

Roddy laughed when I told him of all these remedies. "Well, now, there's always someone comin' up wi' a new remedy, but the only real way to beat 'em is t'keep the breeze about ye, particularly in the evening, or puff like crazy on a big cigar, or . . . well, y'could do what I do and jus' stay inside and enjoy a nice glass o' malt."

That and a noxious cigar sounded by far the best solution. But that first sudden ambush had left me fired up both physically (I had dozens of little red welts all over my face and arms) and mentally. The Hebrideans are a little canny about their summer plague ("Don' wanna put the poor

tourists off, now, d'we?"), so I decided to undertake a little research into the matter.

I began with George Hendry's *Midges in Scotland*, in which he explains in cool, nonemotive, scientific prose (obviously he'd never experienced a full-blown armada attack) that:

> The critical step for the female of the culicoides impunctatus species is to secure a supply of fresh blood . . . without it egg development is arrested and, given the short life span of twenty, perhaps thirty, days for the adult, this is the point on which all future generations depend absolutely . . . but blood meals are none too common in the Highlands.

Which of course would explain their vampirish voraciousness when they finally do find a gullible victim. Like me.

However, being usually of a generous and benevolent nature, I would hate to see any species threatened through lack of basic nutrition, despite the fact that it seems the midge's only purpose, other than self-perpetuation, is to satisfy the gustatory requirements of reed warblers. So feed away, little fly, on whatever sheep, cows, horses, rats you find (although it does distress me to see sheep particularly driven to suicidal distraction by these avaricious hordes)—but leave us *Homo erectus* alone!

But of course they never do. Even cigar puffing, lanolin and lemon juice–drenched, pennyroyal-protected members of our species seem to suffer as much as everything else. Some claim that concentrated elixirs of Deet can do the trick, but my feeling is why kill yourself just to avoid a few nibbles. After all, others have suffered and survived, including this anonymous island visitor in 1850 who later wrote (thus confirming his survival):

> Talk of solitude on the Moors! Why, every square yard contains a population of millions of these little black harpies, that pump blood out of you with amazing savageness and insatiability. While you are in motion, not one is visible, but when you stop a mist seems to curl around your feet and legs, rising, and at the same time expanding, until you become painfully sensible that the appearance is due to a cloud of midges . . . which in one instance sent me reeling down the craggy steep, half mad . . .

Even the most distinguished of travelers here have had to suffer the same torture. For example, according to John O'Sullivan, a fugitive from Culloden along with Bonnie Prince Charlie:

> The Prince was in a terrible condition, his legs and thy's cut all over from the bryers; the mitches or flys wch are terrible in yt contry, devored him, and made him scratch those scars, wch made him appear as if he was cover'd with ulsers . . . so we wrapt his head and feet in his plaid and cover'd him in long heather. After leaving him in that posture, he uttered several heavy sighs and groans . . .

Even Queen Victoria noted in her *Leaves from Our Life in the Highlands* that on an 1872 visit "we stopped to take our tea and coffee but were half devoured by midges." Apparently, she even borrowed a cigarette from one of her courtiers to keep them at bay notwithstanding the fact that she avidly discouraged smoking. Ironically, the two greatest moaners and groaners about Highland conditions, Boswell and Johnson, never mentioned midges. Neither did many of the celebrated artists and writers who ventured into these wildernesses, including the renowned William Wordsworth, who apparently wrote his mellifluous, rosy-hued lines here in perfect peace.

But when I read of today's scourge in the guest book of our little cottage—*"You swat and flail, clawing at your scalp, cursing. But a cloud of them hangs about your head, your nostrils, your hairline, your brows—it is hell on earth!"*—I decided that Roddy's advice is perhaps the best. Light up the most noxious cigar you can find (or a pipe of strong Navy Cut tobacco—I'm told that's pretty effective too) and valiantly sally forth into the summer skirmishes. Or, better still, close all doors and windows, open up a bottle of fine malt, and watch these clouds of egg-anxious females have their wayward way outside. With someone else—preferably one of those stoic, dismissive *Hearaich* characters who claims that we "outsiders" just don't have what it takes to resist these summer onslaughts. And may he be wearing a very loose kilt when they swoop in for the kill.

1 4

The Sheep Farmer, The Fank— and The Finnock

W ELL, AS WITH MOST ENJOYABLE things in life, the sheep's year begins with a real good tuppin'!" said Ian Mac-Sween, one of the island's leading sheep farmers, with a broad grin.

"Tupping?" I asked.

"You know—mating."

"Ah—right."

"That's usually next month—in November. After the October dipping in the fank . . ."

"The fank being all those pens outside your croft?"

"Tha's right."

"And that's what I'm coming to see next week—the dipping?"

"Well, you'll be doing more than seeing. You'll be part of the gathering . . . won't you?"

"Bringing the sheep down from the hills?"

"Tha's right. Tha's where all the fun is. Bring your wife too, if you like."

"Well—I'll certainly ask her."

"Aye—you do that!" He laughed and his massive frame, sprawled Nero-like across the large armchair by the fire, rocked violently. He knew as well as I did that such gatherings held no great appeal to the

females of most families. From what Ian had told me so far, it was a
tough biannual exercise trying to entice hundreds of sheep—in Ian's
case around six hundred—down from the high boggy hills of North
Harris to the rich grassy *inbye* land beside the cottage and the dipping
fank.

I liked this gentle giant as soon as I met him. The first greeting, how-
ever, came from a great brown slavering dog of obscure origin that
rushed me as soon as I opened my car door.

"Down, Lassie, down!" boomed a voice in the doorway of a modest-
sized croft cottage set on a steep slope overlooking the broad, twilight-
glimmering expanse of Loch Seaforth, just over the mountains of
North Harris at Scaladale. Lassie paid no attention whatsoever and
seemed determined to plant a sticky wet kiss, first on my face and then,
as I resisted, on my crotch.

"Lassie! Down!" the voice called again to no effect.

So this large figure, silhouetted against the house lights, rolled toward

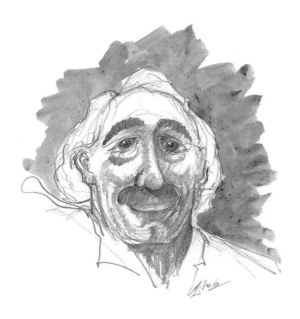

Ian MacSween—Sheep Farmer

me, arms outstretched, seized the recalcitrant dog by the scruff of its neck, and shouted into its face: "Inside! Now!"

Finally the dog obeyed and my hand was grasped by a man whose billowing white hair, huge walrus mustache, and twinkling eyes, full of humor, immediately conjured up images of Albert Einstein. A somewhat larger and more rotund version of the original, it's true, but a definite clonish resemblance. And I told him so.

"Now that's most ironic y'think that." Ian laughed as he led me inside to a cozy sitting room with a glowing peat fire (and Lassie, still awaiting her kiss), "because as well as being a sheep crofter, I run the maths department at the Nicolson in Stornoway."

"How d'you find time to do both?" I asked, surprised because Roddy MacAskill had told me Ian was one of the last few major sheep farmers on the island. "An' that takes an awful lot of time and hard work!"

"Well, things have really changed, y'know, for this generation. There are so few people involved now compared to what it used to be in my late father, Hughie's, time, and my grandfather's. Can't really see it going on too much longer. We're all getting older. The young ones won't stay and the landlords don't like us grazing sheep on their deer-hunting estates. So—there's only a handful of bigger crofts left now. There used to be gatherings galore when we brought the flocks to the fanks all down the valley here. Our sheep aren't 'hefted,' y'see—that's when they instinctively stay on the part of the hills they were born in. Ours roam all over the place on the 'common grazing,' so it's quite a job finding 'em all and gettin' 'em down here. But we all used to work together—helping each other. Only now there are so few of us. You really need at least ten people and the same number of dogs for a good gathering. These sheep can be spread out over miles up there—and it's hard going. Even the small crofts are dwindling—just a few trying to stay on, but they won't last for long."

"I keep hearing that same story about so many things that used to make the islands special . . . unique."

Ian nodded. "Aye. And I've only got two dogs now. I love 'em both, but they're not as good as the ones I used to have. With those, I could go up there gathering a few strays all by m'self—didn't need anyone else to

help out—but now, with these two, I'd likely come back empty-handed. Good trained dogs nowadays cost upwards of a thousand pounds—far too much for most of us around here . . ."

"So why continue?"

"Because that's what we've always done. And I love working with sheep. Have done ever since I was a child. It's a family thing. You get to know them almost as individuals—the strong ones, the weak ones, the stubborn ones. You can tell, almost as soon as a lamb pops out, what kind of sheep it'll be. It's an instinct that builds up over the generations. My great-grandfather came here to Scaladale in 1885. He came from Scalpay, that wee island just off Tarbert. Used to be a real big fishing island. Almost every family around here came from Scalpay. They were given crofts—it wasn't what you'd call a real 'clearance'—more 'an incentive-motivated inevitability'! They built black houses down by the shore—y'can still see the ruins. My dad—Hughie—was one of thirteen children. This house we're in now they built in 1912 and another one close by. But there were just too many people—up to fifteen in a house sometimes. My mother was English—from Birmingham. She married my father after the war in 1946 and moved here. She often said if she'd known where and how she was going to live, she'd never have come. I mean, there was no electricity, no inside water—not much of anything really. True culture shock it was for her. But she stuck it out . . . adapted quite well in the end, bless her."

"How did you manage to build up such a large sheep farm?"

"Well—it used to be even bigger. We ran sheep over all the hills around here and we even once held the grazing rights to the Shiants."

"Adam Nicolson's islands?" Anne and I had become ardent admirers of Adam's recent book, *Sea Room*—an exquisitely crafted, multilayered portrait of the tiny Shiant Isles, way out in The Minch, east of Harris.

"Aye—well, they belonged to his father, Nigel, then. Y'know, the son of Harold Nicolson and Vita Sackville-West. Part of the infamous Bloomsbury group—Virginia Woolf and all that. He wrote that great book on Lord Leverhulme, *Lord of the Isles*. Anyway, he passed them on to Adam when he was twenty-one. I coulda kept the grazing . . . my father said I should . . . but I didn't . . ."

"Why?"

Ian's huge face crumpled a little. He looked embarrassed and replied hesitantly, as if reluctant to explain. "Well . . . it was like this . . . I'm not, ah, much of a man f'boats . . . for the water . . . I only went to the Shiants once as a youngster. I never wanted to go again. My father looked after that grazing. When he retired, I let it go."

It seemed oddly touching—this large, powerful man, devoted to his dogs and sheep, willing to climb and search the most arduous of terrain, bog-laden and littered with pernicious, leg-breaking hollows—looking for strays or lost lambs. And yet, bound to the land by a deep-seated fear of the water.

"Must be all those tales of the Blue Men in The Minch!" I said, hoping to lighten our conversation.

Ian laughed. "Aye—must be something like that . . ."

"Are you superstitious?"

"I didn't think I was, but I must admit my great-grandmother seemed to have . . . the powers . . ."

"Y'mean like 'second sight'?" I was becoming increasingly fascinated by this subject.

"Aye. I guess you can call it that, although I'm not really a great believer in it m'self. Still, it makes you wonder. I remember there was this one time when my great-grandfather had found a long, curved strip of metal—the kind they line the keel of a boat with. So he decided to keep it. Up on the rafters of the cow byre in case it came in handy. Then one day my great-grandmother came rushing in from the milking in the byre, shouting that the keel strip was jumping about like something alive on the rafters and that she wanted it out—right now! So he took it out and threw it into our drainage ditch. On the edge of the *inbye* land. And then one day a friend came along and asked if he could have it for his own boat and my great-grandfather said he could. And so he took it and fixed it on his boat and . . ."

"Yes . . . ," I said, already suspecting the outcome.

"Well, not long after, he and some others were out in the boat. It was quite calm out there on the loch. No storms or anything. But someone on the shore saw the boat jumping about like it was being tossed by

storms and waves. Only there weren't any waves. And then the boat suddenly capsized and they were all drowned . . ."

Silence. The usual reaction to such second-sight tales.

"Well—I guess that's a good enough reason to get boat phobia!"

"Maybe, maybe," chuckled Ian. "These stories can sneak inside your head . . . like this other time my great-grandmother rushed back from milking, saying she'd seen two strange men all dressed in black, walking down the track past our house. She couldn't recognize who they were, so we all ran out but there was nobody around. Then a week later, the man who lived in the only other house down the track got into a bar scuffle in Stornoway, hit his head on a concrete floor, and died. And late that night, two men all dressed in black walked down the same street to tell his wife of his death . . . and my great-grandmother had seen it all . . . a week before it happened."

It was time to change the subject. Second-sight tales here, while intriguing, always make me a little uncomfortable. And the ones gifted with the ability seem the most uncomfortable of all and certainly the most reluctant to discuss the subject. "It's not a thing to be proud of," one elderly woman in the Bays once told me. "It's like a curse . . ."

"So tell me more about the life of a sheep farmer. What happens when and why and where?"

"It's all pretty simple . . . at least, after a lifetime doing it, it seems that way."

And that's when we started with the "real good tupping" in November and moved on into the winter.

"That's the worst time, really," said Ian. "Our climate seems to be getting wetter and colder every winter. The young hoggs [the current year's lambs], the ewe hoggs, and the wedders [castrated hoggs] I usually send by cattle float across to the Black Isle for wintering. It's warmer there and the grass is good in the fields. The older sheep—the ewes and tupps [noncastrated rams] and gimmers [older females], I let out again in the hills and I feed them regularly. Mostly flaked barley. I leave it near the roadside. Drivers get annoyed by all the sheep on the roads but they go there anyway to lick up the gritting salt when it's snowing. Some farm-

ers say feeding them is bad because it makes the sheep dependent and they lose their foraging ability. But, well—I'm a bit of a softie . . . and I love my sheep . . ."

"Do you eat lamb?"

"I never butcher a young lamb for myself personally. It's not a sentimental thing. Truly. It's from the meat point of view. My choice is a two-year-old wedder—much, much tastier. It's not really lamb—it's mutton. But many call it lamb because there's no real market for mutton. It conjures up images of wartime rations and tough boiled gamey meat."

The house was suddenly hit by an abrupt thwack—almost like a landslide. I jumped. Lassie, who had been quiescent for the last half hour or so, leapt up barking. "Jeez! What the heck was that?!"

"Ah, nothin' much, David . . . just the wind. We're a wee bit exposed here."

"But you're in the bottom of a beautiful glaciated bowl with hills all around . . . I thought it would be sheltered here."

Ian had an attack of the giggles. Once again his large sprawled body rocked in his armchair. "Sheltered? Never! You should be here when the real gales come . . . in both directions, depending on the mood of the weather. Sometimes screaming like a horde of witches up the loch. Other times roaring down from Clisham and the high glens. Sheltered! The only thing we're sheltered from is the sun. Most of winter when the sun hardly gets over the horizon we're in shadow here—and a very cold shadow it can be too."

"So much for global warming, then."

"Warming for some maybe. Here it feels like the beginning of a new Ice Age at times!"

"Anyway," I said, trying to ignore the ominous groaning of the rafters as the winds continued to batter the little house, "we've had the tupping and the long winter, so then comes . . . ?"

"Oh, then comes the best time of all—the lambing—in April and May. Smaller farmers bring the sheep down to the croft, but there's not enough grass yet here, so we let them lamb up on the moor. We lose some that way, but in a good year it's really an amazing sight. Each ewe—

and we have around five hundred or so up there—can average around two lambs, so the hills are full of 'em!"

"Yes—Anne and I saw that in the spring. Beautiful. Hundreds of little bouncy balls of fleece. Tails wagging as they suckled greedily. She wanted to write poetry about it all . . . but took photographs instead!"

"Aye, it's my favorite time."

"And then?"

"Well—then we have the sales. Some of the lambs, but mainly the older males. And then in June and July we have the first gathering for the fank—marking and shearing. Not much of a market for the wool, though, nowadays. They use mainland wool for the Harris Tweed here. Our Blackface wool is too hard. Used to be popular for carpets and the like—but not so much now. And then in August we have the big lamb sales—we had over six hundred from Harris this year . . . a pretty good year, despite everything."

"And then we're back to now."

"Right. Another gathering at the fank."

"For which you'd like my help."

"Aye—that would be very nice indeed."

"For you . . . I'm sure."

Ian gave a great snort. "And for you too! It's an experience not many outsiders enjoy."

UNFORTUNATELY, THIS OUTSIDER DIDN'T ENJOY it either.

And it wasn't through reluctance or laziness. It was simply because I was caught unwittingly in a difficult dilemma that can be traced back a couple of months or more when I'd been cajoled by the charming—and always helpful—librarian at our little library into buying a handful of lottery tickets for some school improvement project in Tarbert.

"You've won second prize!" I remember an excited Dondy telling me. "A day of fly fishing with your own personal ghillie on the Amhuinnsuidhe Castle estate! Isn't that fantastic?!"

"Well, I suppose it is," I said, being rather cool about the whole thing because I'd never done a minute's fly fishing in my life. But also inwardly

delighted because this was the first prize of any significance I'd ever won anywhere.

And then I promptly forgot all about it until early October when Dondy asked me how I'd enjoyed the experience. I goofily admitted that my memory, not being what it once was, had failed me. Again.

"Well—you'd better get moving. Fishing season ends on October fifteenth—in less than a week!"

So I got moving, called the castle, and asked when it might be convenient to come and enjoy my prize. I was informed that, because of a series of important fee-booked events (doubtless attended by the cream of British aristocracy or a bevy of megamillionaires), the coming Friday was the only possible day available. Virtually the last day of the season.

And Friday, of course, was Ian's sheep-gathering day on the high hills of North Harris.

Convincing myself that the gathering might slide over into Saturday—after all, sheep are not known for precise schedule-keeping—I called Ian to explain.

He seemed disappointed but agreed that there might, in fact, be a little final rounding-up to do early Saturday morning.

Thus, I was so to speak, and no pun intended, off the hook and free to go happily hooking other things up among the high lochans of the castle estate.

"So—y'no done s'much in the way o' fishin,' then?" asked ghillie David Brown, a lean, wiry man, possibly in his late forties. He was dressed in traditional ghillie garb of moorland-hued tweed suit, green rubber wading boots, thick woolen pullover, and a perky little deerstalker hat set, with Sherlock Holmes panache, firmly upright on his narrow, weather-etched head. He looked distinctly disappointed.

"Well—I thought I should level with you," I said, wondering if it would have been better if I'd donated my day of fishing to someone who would have better appreciated the honor of being hosted around this revered estate with his own personal ghillie.

"An' fly fishin'—have y'never tried that either a' suppose?"

"Uh . . . no. Never."

"Ah," said David, looking even more forlorn.

"Well—they say there's always that chance of beginner's luck . . ."

"Aye, aye, they do say that . . . indeed they do," mumbled David, looking extremely unconvinced by such inane platitudes.

"To be honest, the thing that really made me want to have a go when I won the prize was that book by Norman Maclean—y'know the one—*A River Runs Through It.* I've always remembered that wonderful line: 'The one great thing about fly fishing is that after a while nothing exists of the world but thoughts about fly fishing.' He makes it all sound so meditational and Zenlike."

David's eyes brightened and a smile appeared. "Aye—so y'know that book, d'ye?"

"Indeed I do—y'remember, he says: 'In our family there was no clear line between religion and fly fishing.'"

"Right. And then he says: 'Fishing is a world created apart from all others, and inside are special worlds of their own . . .'"

"Yes. Great. Well—at least we both enjoy the same book!"

"'S'one of my favorites. I'm a real one for reading. Gi'me a book and a warm fire and I'm set for the night. Y'can forget yer TV and videos and all that stuff. Books a' much better, don't ye think?"

"Absolutely!" I gushed, realizing that all was not yet lost. The day might well turn out to be worthwhile after all, despite my distinctly neophyte status. Certainly in terms of the weather, things already looked promising. After three miserable October days of "mizzle" and murk, the sun had finally broken through that ponderous clutter of gray clouds and I could feel autumnal warmth on my shoulders as the two of us stood together outside the castle looking out across Soay Sound.

Ian Scarr-Hall, the new owner of Amhuinnsuidhe Castle, was now only into his second season of hosting gatherings of avid deer hunters and salmon fishers here, and he had given me a quick tour of his elegant hostelry before my ghillie turned up.

"Madonna almost bought this place, y'know . . . ," Ian told me, with a sly smile, almost as soon as we met. He was a tall, thin, energetic-looking man, a wealthy owner of a large property management company, and exuding that proud air of someone who, in the riper years of life, was finally living his life's dream. "But she didn't like the fact that the main

road to Hushinish went right past her front door!" (This sixteen-mile cul-de-sac, barely wider than a cart track, is actually little used, except by seclusion seekers enjoying the sublime charms of Hushinish Bay beach and the more hidden sunbathing enclaves overlooking tiny Scarp Island.)

"No chance of a bypass 'specially for her, then?"

Ian gave a hearty guffaw and just pointed at the rocky terrain that rose up immediately behind the castle and continued on, pretty much semivertically, for another mile or so onto the vast open moors of North Harris.

"So—I was lucky," he continued in his broad, mid-England accent. "It needed quite a bit of restoration so that put off a lot of other potential buyers. But I just had to have the place. I've been coming to Harris for decades—almost since I was a lad. I love the island—everything about it."

Ian extended his arms in an eloquent theatrical gesture to encompass the sweeping vistas across to Taransay, the elegant arched gateway to the estate, and the soaring mountains behind him. And my favorite feature— the magnificently layered series of waterfalls that tumbled off the moor and cascaded into the small bay and harbor across the far side of the castle's sheep-cropped lawns.

He noticed me focusing on the frothy spate of peat-colored waters. "Oh, boy, yes—that's so beautiful in the summer. Boiling with salmon as they come in by the hundreds from the ocean—thousands of miles they've traveled—all the way back to the stream of their birth. And then they leap—huge, powerful leaps, almost like flying—up and up the ledges of the falls and then way up the stream. It's an incredible sight! I never get tired of watching them."

I could tell this man was entirely in his element despite the deluge of details he'd had to face during a long and arduous restoration of the castle.

"But it's been worth it, don't y'think?" he asked rhetorically, after our tour of the grand highlights—the elegantly paneled and painting-adorned dining room and lounges, the enormous baronial fireplaces, a beautifully furbished library, and an eclectic selection of a dozen or so luxurious bedrooms.

"Amazing," I think I said after this glimpse into his hedonistic haven-supreme.

"What's amazing is the range of people who've owned the castle since it was built for the Earl of Dunmore in 1867."

"Wasn't he the man who went bankrupt trying to make the place big enough to satisfy his son's fiancée?"

"That's the poor fellow, yes. And so many others bit off a bit more than they expected. It can be a bit of a money pit . . . but I think we're getting it right now."

On our way out to join my ghillie, Ian introduced me to a young man with enthusiasm written all over his cheerful face. "Ah, meet David Taylor—our fine chef. He joined us after Rosemary Shragar left—y'know, she had a TV series here called *Castle Cook*. I'm never sure, though, if our guests come here for David's cooking or the hunting!"

David grinned. "Oh—bit o' both. I mean y'can find just about any kind of fish and game y'want on the estate—venison, grouse, pheasant, wood pigeon, seafood galore, wild salmon—our own smoked salmon—and we've even started to bottle our own water now with our own filtration plant. Best water y'll find anywhere in Scotland!"

David gave me a tour of his well-equipped kitchen and then the "wellie room," where guests dressed for their hunting and fishing adventures, way back in the wild glens. Replicas of enormous salmon caught on the estate were mounted on the walls, with pride of place being given to the castle's "record catch." He pointed to its elegant plaque. "See if you can understand any of that!":

18¾ lbs, slightly colored but well-shaped cock fish. September 1987. Using a 10' carbon fibre rod and 50 yards of line and backing a 10 lb cast with a muddler on the bob and a size 6 Alexandria on the tail. 1 hour and 2 minutes after catching the fly. Caught by Hugh Carmichael, retired nuclear physicist. 80 years old. Congratulated by everyone on the estate.

"Well—bully for the eighty-year-old Mr. Carmichael," I said. "But the rest of it's a bit gobbledegooky!"

David laughed. "Ah, well—maybe a day out fishin' on the loch will educate you a wee bit more!"

"I certainly hope so . . . ," I said, quietly wondering how I'd got myself into this mysterious world with no clue at all about its niceties and nuances.

Anyway, I was finally, if hesitantly, ready for my first day of fly fishing. The huge monoliths of North Harris were bathed in early-morning sunshine as ghillie David Brown and I drove for miles in the estate jeep on a rock-pocked track, deeper and deeper up Glen Meavaig until suddenly, on the brow of the hillock, a broad loch appeared.

"That's the first loch," said David. "The salmon and sea trout come up here from Sea Loch Meavaig. It's a good stream. Famous for freshwater mussels . . . very rare. Protected."

"Seems like an awful long journey for them."

"More'n two miles, but that's nothin'. There's places where they have to travel twice that distance and more to reach the headwaters where they were first spawned. They keep that memory. It's like a compass— they know exactly where to return f' the female to lay her eggs among the stones and the male to 'milk' them."

"Y'mean after all that unbelievable effort to get here there's no actual mating—no little pleasure-bonus!?"

"Oh, sadly, no—the males do their thing over the eggs up a wee burn from the loch and then they all come back here for a while before returnin'—those that have survived—back downstream to the ocean."

"The whole process is so amazing—the distances they travel, the strength they need . . ."

"Aye," said David, chuckling. "Takes almost as much effort as marriage itself!"

"But at least the mating side of marriage is a lot more enjoyable for us humans."

"Aye, true. Maybe too rewarding. I've had two wives and three children—and another wee bairn on the way."

"Congratulations," was all I could think to say.

David gave me a sidelong, somewhat foxy glance and laughed. "Right! Thanks!"

Ahead rose the almost vertical crags of Sron Scourst, hundreds of feet of dark, glacier-gouged gneiss, cracked and striated. Then came a second loch, and broad vistas to the north of the gentler Lewis hills.

"This is our spot—Loch Voshimid. We're over the watershed of the glen here so the fish come up from the Loch Resort on Lewis, another long climb for 'em."

We parked the jeep by a flimsy-looking, metal-paneled hut. "This is where we have lunch if the weather's bad," David told me.

"It's not exactly one of your elaborate hunting lodges for the landed gentry, is it?"

"No, indeed it's not, but when the gales are blowin' and the rain is tearin' into ye like steel blades, you'd find it awful warm and cozy. Don't think we'll need it today, though, by the look o' things."

A boat awaited us by the loch shore. David loaded the fishing gear and together we pushed it out into the water, leapt aboard, and began our journey in search of "the big ones." Ian had insisted that despite the lateness of the season, it should still be possible to hook a ten- or fifteen-pound salmon. "Don't get too greedy, though," he'd warned me. "You only get to keep one salmon and two sea trout per rod per day. The rest you catch and release. Estate policy."

"Fine," I told him. "One'll do just fine."

David was less optimistic. Possibly in an effort to assuage my expectations, he suggested that the season was "pretty well gone by now," that the lack of a breeze would prejudice good casting, and that, if the catch were too large, I might well "lose a fly"!

But, to give him his due, he seemed determined to give me a sporting chance by carefully instructing me in the graceful art of fly casting.

"Jus' get a nice, steady rhythm . . . start at nine o'clock and don't go back beyond one o'clock. Keep plenty of slack on the line . . . lean forward a little as y'cast . . . pull in the line gently by hand . . . then repeat the process. Remember that technique from *A River Runs Through It*— the four-beat rhythm. Right? An' if this blue fly doesn't work, I've got some others you can use," he said, pointing to a little menagerie of flies hooked around the brim of his deerstalker hat.

David patiently nurtured me through the learning curve. "Gi'y'sel' a

wee bit more line . . . keep castin' . . . the breeze at y'back . . ." (Finally we had a slight breeze that rippled the water hypnotically.) "Pull it in gently—don't jerk it . . . watch y'backcast, y'r letting it stroke the water behind ye . . . Then David chuckled, "Unless a'course you're trying to fish both sides of the boat . . . in which case, y'doin' jus' fine . . ."

Slowly, painfully slowly, a rhythm began to emerge from what had been a mess of jerky, uncoordinated reflexes and matured gradually into a smoother sequence—an almost graceful flow of movements. Simple yet infinitely subtle, although apparently, after half an hour of careful casting, not quite subtle enough to tempt the elusive salmon and sea trout.

And what made it particularly frustrating was the fact that every few minutes we'd see one of these splendid creatures leap vertically out of the water nearby, do a little aerial pirouette, and then crash back down into the loch as if to say, "Hey, dummy! I'm over here!"

After another utterly uneventful half hour, I sat down in the boat feeling a little dejected. David was encouraging, though. "You're the man behind the rod . . . y'gettin' it now. That's pretty neat castin' y'doin' here. Y'gettin' the hang of it right enough."

"Yes, but not even a nibble yet. They seem to be everywhere we're not!"

David laughed. "Y'got to be patient . . . a' mean, just sit and look at all this. Enjoy it. All these mountains, the reflections in the water, those golden eagles up there—y'see 'em? Up in that corrie near those crags on Sron . . . just floatin'."

"Yes—right. I've got them now."

"Y'see," said David, "it's not all about catchin' things like some people think. It's about being here . . . a' mean, people pay a small fortune just to get a few days o' this. Some of 'em start out wantin' to shoot or hook anything that moves and then gradually the peace o' the place comes in and th' start to settle down . . . shows y'what a wonky world some of us live in when you've got to pay so much—did y'know, in addition to all the cost of the castle lodgings and the meals and whatnot, it then costs a guest an extra three hundred pounds more each time he bags a stag—an' go to such effort just to find a bit o' quiet and contentment."

David Brown—Ghillie Supreme

"Yeah—it's strange, isn't it? We seem to have lost the ability to give peace to ourselves—wherever we are."

"Well, there are some who can't get their minds off killin' things—particularly when it comes to the stags. And there's plenty of those all around us in these hills here . . ." (I didn't see a single one that day.) "But y'know, quite a while back I lost the taste fer it m'self. Not for ghillieing—I love that—but for the shootin'. And it's a long season to get through—July first to October twenty-sixth for stags and October twenty-first to February fifteenth for the hinds, the females. That last is really a cull for the locals to keep the numbers down for grazin'—not many visitors want hinds. Anyway, it was one day we went up to that high glen. Y'can just see it there beyond Sron Scourst. And this big German guy was with me. Real desperate to get a kill. Like his whole life depended on it. And we heard the sound of stags head buckin' . . . y'know, that wild crack of those huge ten-point clashing antlers. Echoin' all around the glen. So we crawled up to the top of that ridge and there

they were, just a wee bit below us—m'be a hundred yards away. Two beauties. Really going at it . . ."

David's voice tailed off as he remembered the incident. "A' mean, a' could have just laid there watchin' them all day. It was a beautiful sight. But this guy was itchin' to start shootin' and he said, 'I want both of them,' and so he sights his gun, pulls the trigger, and wham! down goes the first . . . and then he pulls again and wham! there goes the other. Both of them . . . in a couple of seconds. Gone."

Another long pause. And then David continued, "A'll admit, he was an excellent shot. Both clean kills—no wounding. But when I got down to them and kneeled to start to *gralloch* [gut and trim] 'em so we could carry 'em out, I couldn't help thinking that, a few minutes ago, these were two magnificent animals—combating one another—full of life and strength and pride. And now here they were, nothin' left at all of that power and that beauty . . . and it may seem strange for a hunter to say this, but I've had no desire to go shootin' again since that day. I can understand why others do it, and I'll always do a good job helpin' 'em, but I have no interest in doin' it m'self. Ever again."

We sat quietly together in the boat. The breeze-buffeted ripples on the lake were lapping gently against its wooden sides. Eventually I reached into my bag and pulled out a pack of sandwiches I'd brought with me and offered one to David. "Ham and cheese," I said.

"Great—I'll take one o' your pieces if you'll eat half my pork pie."

It looked delicious—one of those baked, golden-brown, cold-crust pastry creations with a spicy pork filling, which he held out on a small plate. So I accepted. I was beginning to really enjoy the company of this man—an avid reader of books, a true nature lover (even the author of his own book on bird-watching), and full of quiet sensitivity and wisdom.

"D'you know," he told me, "I've ghillied everyone from dukes to dustmen for over fifteen years. And when y'get down to it, t'me it seems we're all equal when we've got a gun or a rod in hand. The character of a man soon comes out and it's got nothin' to do with money or class or breedin'. Y'can tell the true mettle of a man after a day's fishin' or huntin'. Stands out a mile—clear as a bell . . . and what you learn is not always so pleasant. Sometimes I'm beginning to think that we're becom-

ing a rogue species—us humans—for all our so-called superior evolu-
tion. A real *Homo tyrannicus* messin' up the whole world, destroyin' a
whole evolutionary process that's been goin' for millions of years . . ."

Our conversation rambled on as we slowly ate our lunch in the gent-
ly rocking boat.

I'd always been curious about the eternal battle in the Highlands
between the landowner lairds and the poachers. In the case of
Amhuinnsuidhe Castle, the matter seems to have been resolved in a
unique relationship between Ian and the North Harris Trust, which
recently purchased the 55,000-acre estate, as part of a recent trend in
"people ownership," and then leased back the hunting rights to Ian. But
even here, apparently, David had to supervise a group of young game
wardens to ensure the fish stocks were not plundered by poachers.

Red Stag

"In some ways, though," I said hesitantly, "it does seem a little odd to claim that these wild creatures—both the deer and the fish—'belong' to the landowner . . ."

David dealt with my comment benignly: "Aye—it's an old problem. 'S'caused a lot of tension for generations and still does. There's talk of new laws—the new Land Reform Bill—that gives crofters the right to purchase land and game rights, even if the owner is unwilling. I think that could be a disaster—a real free-for-all. Most people don't realize how expensive estate management and husbandry can be to sustain the fish stocks and animals. I know the poachers don't agree, but just wait 'til they find there's no fish and no game left . . ."

In order to ensure an amicable outing, I decided not to push the discussion and, as I remembered Ian MacSween's tales about his grandmother, we went on to talk about "second-sighters." "Och—everybody's granny's got second sight, if you believe all the rumors," was David's comment as he laconically rolled his own cigarette in a small square tin filled with cut tobacco (a familiar sight in Harris). But he was adamant in his belief on the existence of waterhorses, one of that multitude of mythical Highland creatures. "Now *that* I do credit—I've seen one—a real *each-uisge*. Bigger than the biggest black bull . . . just stepped down into the top end of the loch here and kept walking in 'til it completely disappeared—and never came back up! Terrible creatures." He grinned with ghoulish glee. "Shape-shifters. They can become a gorgeous lady or anything to tempt a victim. Some keep the shape of a fine-bred horse and as soon as someone tries to mount it, they leap into the water, drag 'em under, drown 'em, and eat 'em!"

And then, somehow, as I guess it does when you're bobbing about in a boat not doing very much of anything, the subject moved on to food and David described the annual Robbie Burns dinner he'd attended the previous January at Leverburgh, a riotous occasion Anne and I had missed due to an off-island journey.

"Och, that was a fine do indeed," he enthused. "David Taylor from the castle did the cooking—y'know, the traditional cock a' leekie soup and then 'Addressing the Haggis'—carrying it in all flaming with whisky and the bagpipes playing and served up with 'taties and neeps.' Then

there was a real fine *ceilidh* with singing and dancing and Robbie Burns's poems—a really good Gaelic affair . . . all very traditional."

I mentioned the fact that I'd served haggis to some guests at the cottage recently. "Bought it from MacLeod's in Stornoway—along with some of his black pudding, by far the best I've ever tried."

"Oh, it is indeed, it is. Nobody makes it like him. I think it's the nutmeg, y'know."

"Yeah, maybe, but there's something else in it too, and he wouldn't tell me what it was. You can buy it at Munro's in Tarbert."

"Oh, yes—a good place, that."

"Along with salted herring, salt lamb, white pudding with currants, real finnan haddie (smoked haddock) . . ."

"Och, stop it now, man—otherwise I'll have to finish all your pieces f'ye . . ."

We continued on after lunch as the sun eased up the sky. David rowed gently the mile or so to the end of the loch and then back past a particularly prominent rock—actually, a small islet—rising abruptly out of the water and covered in a rich intensity of vegetation.

"That," said David sadly, "is what these moors and these hills would look like if they weren't so overgrazed by sheep. Oh, and by the way, this is the rock that they say inspired J. M. Barrie to write his play *Marie Rose*, when he was livin' at the castle. He called it 'the little island that likes to be visited.' "

"I know his *Peter Pan*, but not *Marie Rose* . . ."

"Oh, it's a fine story. Very magical."

And then came something truly magical. No sooner had David used that word than my rod—which, having become a little weary of casting to no effect, I'd rested on the back of the boat with the line trailing in the water—suddenly went taut. Fortunately, I managed to grab it before it was pulled overboard and I felt the power of something tugging and wriggling maniacally on the hook.

"Dammit, David, I think I've got something!"

"Okay—now just take it easy. Let it run a little bit, then start to reel it in. Tha's right . . . run, then reel . . ."

I couldn't believe that, at a time when I'd actually stopped casting, I'd

possibly caught a fish. Or, rather, the fish had caught itself. Slowly I reeled it in. It seemed a rambunctious and voracious creature, obviously extremely annoyed by its predicament, but I was winning and about to become the owner of a fine . . . tiddler!

Well—a bit more than a tiddler, I suppose. It was eight inches long, twisting and sparkling-silver as I lifted it out of the water.

"Ah," David was chuckling. "You've just caught a fine . . . *finnock!*"

"And what the hell is a *finnock?*"

"Well," he said, trying to be tactful, "it's a wee sea trout . . . but they grow sometimes up to fifteen pounds."

"Well, this one hasn't!"

"No, this is, unfortunately, less than a pound . . . a lot less."

"Aw, I'll let it go," I said, disappointed by its size and embarrassed by the fact that I couldn't even claim I'd caught it.

"Aye—that's the right thing to do," agreed David, as he deftly removed the tiny blue fly and hook and lowered the fish gently back into the loch.

I tried to keep up my enthusiasm but, though I was casting far better now than my earlier attempts, by three o'clock in the afternoon I felt I'd had enough.

"You're the boss," said David, and added by way of consolation, "It's not really the best of days anyway for fishing . . . and the breeze is way down now and . . ." He was trolling around for a final encouragement. I knew what was coming and we ended up saying it together. "And it's almost the end of the season."

They say laughter cures almost everything, and in this instance they were right.

As promised, I returned to Ian MacSween's croft and fank the day after my well-intentioned but pathetic performance on the loch with David Brown. I was looking forward to meeting this corpulent, cheerful, and chuckling sheep farmer again.

From high up on the pass over the North Harris hills, I could see Ian's house overlooking Loch Seaforth and, just a little to the left, a great

white mass of woolly bodies crammed together and slowly churning in the fank pens.

Ian beckoned me over when I arrived and introduced me to three friends who had come to help with the dipping.

"An' so now, David, was y'fishin' expedition worth it?"

I was honest and told him the melancholy tale of the leaping salmon and my miserable little catch of a single sea trout *finnock*, not even big enough to keep.

"Well," he said consolingly, "it's a wee bit late in the season now for a good catch anyway."

"I reckon it was," I mumbled, wondering if this "late in the season" remark was some kind of island mantra for ineffective fly casters.

"But y'missed a fine old gatherin' time with us yesterday up on the hills there. Ten of us and all the dogs. And look what we brought home with us. Now, there's a fine catch, don't y'think!"

It was an amazing sight. The fank pens were teeming with almost six hundred sheep, all remarkably quiet and docile and awaiting their biannual dipping. I looked up at Ian's so-called hills, now oddly denuded of sheep, and marveled at the kind of terrain they'd had to clamber over to get all the animals penned up. Huge crags and precipices, hundreds of feet high, scarred the ancient gneiss monoliths. Full, frothy waterfalls sliced and tumbled down their near-vertical flanks. Huge, dark swathes of lose-your-boots bogs and thick, chocolatey peat ridges bound by treacherous tussocks of marsh grass and ankle-tangling heather characterized most of the rest of the terrain. The worst kind of walking country with no handy footpaths or trails to follow. Manageable by fleet-footed sheep, reluctant to be rounded up and determined to dodge the dogs, but much more difficult and exhausting for humans, no matter how agile their bog-trotting abilities.

"Must have been quite a day for you," I said admiringly, but thankful that I'd been elsewhere, despite the disappointments.

Ian and the three other men laughed in agreement.

"So today should be a doddle in comparison," I said. "Only six hundred or so sheep to dip now ..."

"Maybe you'd like to try," said Ian with a mischievous glint. "Just one ..."

"Maybe I will, but I'll watch you first, if you don't mind, just to get the hang of it."

"Well, stand far back from the dip—they splash around a lot . . ."

And splash they indeed did. And buck and fight and do just about anything to resist the inevitable. Some tried to climb the metal railings of the fank fences; others formed tight circles and performed a kind of communal whirling-dervish dance to prevent Ian from grabbing their horns and dragging them—sometimes half carrying them—toward the dip.

But somehow, despite all the confusion and panic and the endless choruses of bleating cries, Ian and his companions managed to perform the ritual tasks methodically and efficiently. First came the horn trimming (only necessary if horns are growing too close to the sheep's eyes), then the administering of a dose of antigastrointestinal worm and fluke solution through the use of a squirt gun slid gently to the back of their throats, followed by an agile lift-twist-and-upside-down immersion in the narrow trough of sheep dip solution. And finally, another twist-and-push to force the sheep, now head up, along the eight-foot-long dip channel to the safety of the walled pen at the other end. Here the terrified, and outraged, animals—exhibiting a melancholy mix of quivering vanity and morose dignity—would emerge, wobbly and shaking their fleeces violently, to join their confused companions, all doubtless hoping that would be the end of the indignities for the day.

"There's the very devil in these Blackface sheep," Ian called out as he was trying to twist the next violently struggling animal onto its back in the dip. "Compton Mackenzie said that—one of his few true utterances!"

I watched this process for quite a while, particularly admiring the ingenuity of some of the animals trying to escape the dipping fank. One actually clambered onto the backs of two of its companions and was about to leap over the fence when they abruptly pulled away and let the poor creature fall flat on its belly in the mud. Another managed to get its head and one leg between the bars of the fank gate. Then, having realized the unlikelihood of success, it tried to extract itself. Somehow the leg, the horns, and the gate bar became so entangled it took all three of the men to free the rebellious creature.

In one of the higher fanks I saw some odd behavior going on. So I strolled up for a closer look and what I thought was a rather touching display of male bonding turned out to be young tupps trying out their first head-butting contests. It seemed to be an instinctive ritual that even they didn't understand, beginning with a long period of mutual cheek-to-cheek nuzzling, then a back-off of a couple of feet or so, a bit of staring down, and finally a sudden leap forward at each other, followed by a sickening crash of skulls. Then they'd stand looking at each other as if asking, "Why are we doing this? Why on Earth are we performing this ridiculous and painful ritual?" This would then be followed by another one of those rather touching nuzzling exchanges—and then it was back off, stare, and crash again!

Eventually, after about half a dozen of these genetically driven behavioral quirks, they'd walk away from each other shaking their bruised heads and doubtless wondering what other bizarre tricks-of-instinct nature had in store for them in the future.

After a hundred or so sheep were dipped, Ian and his mates were beginning to take on the same dazed "why on earth are we doing this?" look as the head butters. So without thinking and in a surge of empathy engendered by their dip-dripping clothes and mud-caked faces, I asked if there was anything I could do to relieve the monotony of the process and their obviously exhausted state.

This is not an offer I shall make lightly again. Maybe I just assumed they would smile nicely and mutter something like, "No thanks, Dave, but we really appreciate your offer . . ." Unfortunately, they didn't. They thought it would be a splendid idea if yours truly stopped aimlessly wandering around the fank and got down and dirty and into the thick of things. So after that, my luxurious role as objective observer was relegated to something far more messy, and laborious, and smelly. And I decided, after it was all over, that despite moments of manly comradeship and a whisky-laced interlude or two, I'd had enough of fanks and sheep and dips for quite a while. Oh—and fishing too. I'd had my fill of that too, although I must admit I've always been moved by the last line of *A River Runs Through It:* "Eventually all things merge into one, and a river runs through it . . . I am haunted by waters . . ."

Sammy and the Salmon

—————————

H AVE Y'NOT MET SAMMY YET?" asked Roddy over Friday evening whiskies, now a regular bonding ritual of our friendship.

"Sammy who?" Anne asked.

"Sammy MacLeod—the great poacher man of Harris. Well . . . ex-poacher. He's very reformed now . . . reformed from a lot of things. He lives just down the road. He's one of our island's best storytellers—a real *ceilidh* man. Once he gets going, y'll have quite a job stoppin' him . . ."

So down the road Anne and I walked together one afternoon to meet the famous storyteller. He lived by himself in a neat, whitewashed cottage overlooking Loch Bunavoneadar and greeted us both like long-lost family. Cups of tea, cookies, and even a plate of beef-filled sandwich "pieces" appeared as if by magic on a low table in his small, furniture-filled living room. The peat fire glowed white-hot. We were soon down to shirtsleeves and Sammy laughed. "Oh—I always keep it too hot—look, move over there away from the peats. Y'all right now? Not too warm? Have another piece . . ."

Sammy was a fine host. His lean, lined face constantly broke into smiles as we devoured his offerings. Anne pointed over to a set of drums by the window. "Are you a musician?"

His laugh had a whisky-and-cigarette burr to it, but apparently, in those respects at least, he had amended his errant ways. "Oh, yes indeed—I'm a drummer in our band, The Sound o' Harris Ceilidh

Band. Here, I'll put on a wee bit of our music while we chat. There's three of us now—accordion, pipes, and drums. For a while, though, there almost wasn't. We were all drinkin' ourselves to death. Our level of excess was what y'might call 'dependent upon the dimensions of the drams'! I was the worst. I went through three wives—and a new one coming! I've just proposed. Before that a' was drinkin' two bottles of whisky a day, smoking sixty cigarettes. Doctor told me, 'Y'shudda been in y'grave years ago.' So I says, 'Doctor, I've had three wives. It takes a lotta whisky to help me forget 'em!' An' the last one—she really took me to town. She was what you might call 'a stranger to personal happiness'! I lost a lot o' money over that one. She was a clever little . . . but I was a step or two ahead of her. One day she said, 'Sammy, I've had enough. I'm leaving. I'm going back to my mother's.' So I said to her, 'If y'hold on a minute, I'll get m'jacket and walk y' and make sure ye get there . . . and *stay* there!' "

Sammy had a way of talking that made us both laugh even when we sensed the subject was deadly serious.

"But a' knew she was right. A' was jus' no good to live with. No good at all. We were all terrible for the drink in those days. Och aye—terrible. I don't drink or smoke at all now. But then, all of us in the band—we were heavy, heavy drinkers. We was washed up. Because we all had troubles, y'see. We had to finish. Or it was to be finishin' us. So—it's been twelve years now with hardly a taste. Not even a wee 'shandy' [a mix of lemonade and beer]. But it wasn't easy . . . the demon drink is always there."

It seemed odd listening to such personal tales barely ten minutes after our arrival, but Sammy was one of those characters who just didn't hold back. He paused briefly in his raconteur flow, possibly still coming to terms with his demons. "Anyway—I put m'self into a clinic. I paid twelve hundred pounds for the two weeks. I couldn't get it for free. I was earning too much money. So—when I came out I went up the road to Roddy's shop. And Roddy said, 'Well, how're y'feeling now, Sammy?' and I said, 'Aw, I'm feeling fine,' an' he says, 'D'y'think y'll have a drink again?' "Well,' I said, 'I don't know. But I'll show y'this.' So I took out m'wallet and showed him the bill for the twelve hundred pounds and I says, 'All I've got to do every morning when I wake up is to look at this bloody thing and that would stop anyone from drinkin' ever again.'

"So—six months down the line, I was feeling glorious, but then, wouldn't y'know it, I found a wee bottle in the cupboard and it was gone so fast. So I went back up to Roddy's store and I obviously had a stagger on going up the road and they watched me comin' and Roddy said, 'I thought y'was off the bottle,' and Joan—she said, 'Aye, well I'm thinking he must have gone an' lost that wee bill of his!' but, God bless 'er, she reminded me of what I'd said, and she never sold me another bottle . . ."

It was hard to stop Sammy once the storytelling started. And the stories were so rich, and raucous, and full of island nuances, that we didn't even try. We just settled back, sipped our cups of tea, nibbled his cookies and pieces, and let him tell us about his early life as a lobsterman.

"On and off I was for more'n twenty years. Best months were June to October. Around Taransay Island. Good rocky beds there. Lobsters love the rocks for all the hiding places. Prawns prefer it smooth—mud and sand—they're better on The Minch side of the island. Y'can make a good living at both at twelve pounds a pound for lobsters."

"Twelve pounds—that's almost twenty-five dollars!" I said. "Sammy, that's extortion! Back in the States you can buy them alive from supermarket tanks for around seven dollars a pound. Sometimes less . . . that's less than four pounds a pound."

"Oh—but these beauties here . . . they're different . . . much sweeter . . . very tender . . ."

Sammy was one of those quick-minded raconteurs, always ready with repartee responses, so I decided (after a gentle nudge from Anne) not to interrupt him as he launched into more tales of his checkered, but never dull, career.

He began by describing home life when he was young: "Where y'sittin' just now, this used to be the loom shed and m'mother—y've prob'ly heard about the old looms, before the Hattersleys—the big wooden ones. Well, my mother worked with that type and my father worked a Hattersley over there. And I used to come wi' m'sister and before we had anything to eat—before we did our homework, even—we had to fill the bobbins. There was no stuff provided by the factory in those days—you know, the big rollers with all the warp set ready for the hand loom. You

had to do everything from start to finish—spinnin', dyein'—I even used to scrape the *crotal* (lichen) from the rocks with a spoon. It was cut to have a sharp edge on one side like a knife. And there were pails everywhere of brown and green *crotal*. Oh, and look at this photograph—that's my mother there—y'can just see her through the loom. Everyone worked very hard . . . very, very hard. No television, no electricity. Just the loom an' prayer an' homework an' the occasional *ceilidh*."

"The *ceilidhs* are pretty well gone now, right?" asked Anne. "The ones in the home?"

"Och aye—true *ceilidhs* are rare nowadays. They've almost died out—at least in the *ceilidh* houses. We used to play at one every Friday. But the Gaelic's going. The youngsters are taught it in school, but they don't use it. It's not important to them. If they stayed on the island, they might. But they're always off. Fast. So things are fadin' away. Y'see, in the past, it was all up to you. All your food, your income, your entertainment, your cookin', bakin'—everything was up to you and the family. I remember round about October, November, we always brought in five or six of our sheep and slaughtered 'em and m'mother dressed 'em and they were left to hang for five or six days to tender 'em a bit until when my father used to cut 'em up. We had these half-barrels—you don't see 'em much now—they used to be used for salt herring but they were well scrubbed inside—so we salted the mutton pieces and they'd last us for all the winter. Nothing like salted mutton with taties. You soak the pieces a bit when you pull 'em out of the barrel to get rid of some o' the salt, and then bake 'em and—well—you'll never eat normal mutton or lamb again. Now it's all TVs, frozen foods, supermarkets, cheap vegetables, the kids moving away, families moving away, cars so you can move around everywhere, central heating—not so much sittin' around the fire together anymore—it's all changed. Most of all a' think it was those *ceilidhs* in the homes that made it so good. Anyone could come, people just popping in and stayin' a while to chat and maybe telling a few tales and singing a wee ballad or two." Sammy paused and asked if we needed more "pieces."

Anne laughed. "Oh, no thanks. Just more stories!"

"Well," Sammy continued, "sometimes the *ceilidh* stories were so

scary—tales of ghosts on the moors and all that—that you'd come back from the *ceilidh* house late on and you'd be scared stiff wondering when some creature was going to spring up out of the darkness or from behind some rock. *Ceilidhs* were all kinds of things—songs, stories, poems, gossip, legends of the great clans—all that. Anyone could get up and play— fiddles, pipes, mouth organs, Jew's harps—whatever. Fairies was a very popular subject. They were always on about fairies and all that. And they believed in the fairies—oh yes, b'God, they did! They believed in all that. But it was easy to get fooled too. Once you believed, you'd start to see 'em everywhere!"

Sammy chuckled to himself, obviously preparing to tell another of his colorful tales. "Och, I remember when I was a boy I believed in 'em too. Real bad. I read too much of our Robbie Burns's poetry—do you know this one?

> *"Let warlocks grim, an wither'd hags,*
> *Tell, how wi you [the devil], on ragweed nags,*
> *They skim the moors and dizzy crags*
> *Wi' wicked speed;*
> *And in kirkyards renew their leagues,*
> *Wi owre 'n howkit dead*

"Anyway, one night I was playing accordion down at Mackennar's— they had *ceilidhs* most Saturday nights in their house. It was always a good time but, you know, being Saturday, we all had to be back home before midnight. For the Sabbath, d'y'ken. It di'na matter where you were, you had to be right by the rules or you'd really be gettin' it from the parents. Oh yes you would! So—it was around eleven-thirty and I was leavin' and goin' up home and passin' by the old bridge at the bottom there— y'know it? Very old bridge on the road t'whaling station. And there were lots of tales about that bridge. Things—creatures—living under it. And there was I passing nearby and I saw these lights. Bright lights. Under the bridge. So I stopped suddenlike and ran back fast as a' could to the house. And I told the old man in there—I said, 'I'm not walkin' past that bridge,' and he said, 'So go by the shore. Past the old whaling station.' But

that was a pretty strange place too, and by now it was gettin' on fast to midnight. So I thought, I'll not be a coward. I'll just run like the clappers over that bridge. And I was coming up to it and I saw the lights again and I was gonna really race for it, but then I looked closer and—wha'd'ya think it was—the light? It was the damn moon, wasn't it—the stupid moon—round as a wheel, bright as silver, reflectin' in the water . . .

"But y'know, if I'd done what I said to m'self and run like the clappers and told me parents about the light and all that—they'd have believed it! And they'd have told others. And it would have spread around like wildfire. And everyone would end up believing there were lights and fairies under that bridge . . . and that's the way these things start, y'know. A wee mistake. A cockeyed illusion—but because you believed in all these stories, it became something real. A little local legend."

"What about all those stories of waterhorses and other creatures up there in the high lochs," I asked. "Are they just based on bits of local hysteria too?"

"Och, right enough they are. M'be an attempt to keep the poachers away. These are always nighttime creatures and that's when the poachers are out on the moors . . ."

"And of course you're speaking from experience!" Anne laughed, familiar with Roddy's tales of Sammy's famous poaching prowess.

Sammy's face lit up and you could tell we had touched upon one of his favorite subjects. "Och, yes—plenty of experience there! I've poached salmon all my life. Everyone knew that and th'all tried to catch me. But no one ever did. I was known for it. But I wasn't a rogue, y'ken. I was doing it the proper way. I always gave the water bailiffs all the respect in the world. But they never seen me do anything. I was into poaching since I was very, very small. I was going to write a book because I've had so many experiences. I was gonna call it *One for the Pot*. I remember one particular night when my friend was with me. He was with me practically everywhere a' went. And we never talked 'on the job'—we used signals and that kind of stuff. And we went into the pub in Tarbert and there was this English guy. Bit of a show-off guy. Flashy dressed. And we got to talkin' 'bout fishing and stuff and he buys us drams . . . and more drams . . . and then he whispers that he'd like to do

a wee bit of poachin', just for the experience. So we wink at one another and he buys us more drams and I say to him, 'Would you like a wee bit of the fishing tonight?' 'Oh yes,' he says. 'I'd like that.' So I said, 'Well, y'd best bring a couple o' bottles o' whisky 'cause it gets awful cold,' and he says, 'Oh, that'll be no problem.' So I says, 'Fine. We'll pick you up by the pier at eleven o'clock tonight.' We were going to poach the Harris Hotel lochs."

Sammy paused to scan the table. "Sure you've both had enough t'eat . . . I can get more . . ."

"No, no, we're fine," said Anne. "Go on with your story."

"All right, fine—so, we all set off and went up to the lochs and fixed up one of our nets. And it was a real good night. We got four good ones. But then I could see someone coming on the far side. He was carrying only a wee torch, but I could see it. The local gamekeeper didn't have much sense when it came to catching poachers. But I knew who it was and he was a mean fellow—bald as a neep [turnip] and tough as one of our wee Scottish terriers—so I whispered to this English guy, 'We best be off. There's trouble coming.' So I scooped up the net and the salmon and off we ran. And this guy, he was fallin' and trippin' all over the place. And he had a hold of m'jacket and he was holdin' me back and he was trippin' and tumblin'. He didn't have a clue what he was doin'. I had to take care of him because he was useless. And then he panics and says, 'What's gonna happen if we're caught?!' and I says, 'It's jail. Guaranteed.' And he goes a wee bit crazy. 'Oh my God!' he says. 'Oh my God! I'll lose my job . . . I'll lose everything!' Which seemed a bit overdramatic to me, 'specially as he would only get a warning. I told him jail just to get him movin' faster. I'd mor'n likely get some jail—but not him. And there he was, running like the clappers and oh-my-Godding . . . and I said to him, 'How will you lose everything?' and he says, 'You don't understand. I'm a lawyer!' 'Oh,' I said. 'That could be a problem . . .' 'And I'm a judge!' he says."

"So, did you get caught?" asked Anne.

"Och, no, no. The gamekeeper couldn't keep up. I told you—I never got caught. Ever. Not like poachers today. Let's just say . . . they give poachin' a bad name. They're just young hooligans. We respected the law

and we respected the people who owned the place. We only took what we ate. But I stopped it ages ago . . . in an interestin' kind of way. Would y'like to hear 'bout that?"

"Of course!" we said, almost in unison.

Sammy paused to refill our cups with the last of the now lukewarm tea. And then he was off again, smiling and chuckling as we settled down for a long, laughter-filled evening . . .

The Lure of St. Kilda

I AM A GREAT ADMIRER OF John Fowles's book *Islands*—and this collage of quotes in particular:

> Islands strip and dissolve the crud of our pretensions and cultural accretions ... One returns to the roots of something beyond one's personal descent ... In terms of consciousness, and self-consciousness, every individual human is an island in spite of John Donne's famous preaching to the contrary ... Since the proximity of the sea melts so much in us, an island is doubly liberating ... it is also a secret place where possibilities mushroom, where imagination never rests.

Islands do indeed possess strange and intriguing qualities. They lure you in with their uniqueness, captivating you with their history, people, and folklore. And while lulling you with the pleasures of enticing isolation, they also spur the very spirit that brought you to them in the first place. They succor the lust for more searchings—more explorations—of island places even farther out. Far, far beyond the sea-hazy horizons ...

Which is exactly what happened to Anne and me on Harris. Hardly a month or so after we'd happily settled into our dune cottage, we heard a series of folk songs one evening at the Clisham Keel. They were different from the usual minor-keyed Scottish ballads and they told of an island, far to the west of Harris, way out in the Atlantic, where a small

community had once lived lives of great peace and harmony, well removed from the evils and secular temptations of the mainland. This island, so the singer explained, was St. Kilda, one of the world's loneliest outposts, home to vast flocks of seabirds but now abandoned by its people, leaving only the echoes of their lives and the ghostly remnants of their little civilization.

After the concert we talked to the singer and he told us he had been there only once but had found the place to be "one of the most beautiful parts of the world I've ever seen. Imagine soaring, green-sheened precipices exploding out of the Atlantic, wrapped in ghostly hazes, the air full of wheeling birds, with crashing waves fifty feet high, carving the cliffs, gouging out the sea caves, and great ocean winds howling around the peaks and cutting away at the stony remnants of the old community . . . set in a huge grassy bowl with all the ancient crofting walls still intact. Like they were waiting for the people to return" (very poetic, these island folk singers).

We drove home that night with one thought in our minds. We had to know more about—and see—this island. This St. Kilda.

FROM ANCIENT PLACE NAMES—Rueval, Oiseval, Boreray, and Soay—one can assume this remote cluster of islands was well known to early Norse sailors, although no records of actual habitation here exist until the sixteenth century. However, a famously colorful legend of early conflicts over land ownership describes a boat race between the MacDonalds of Uist and the MacLeods of Harris to claim the island. Realizing that his crew was losing, the crafty (or suicidal) Colla MacLeod proceeded to lop off his left hand with his claymore sword in the final moments of the race and hurl it ashore ahead of the MacDonalds' boat and thus win the place "by a fist" for his clan.

After that, it all gets a little vague and folklorish until a few visitors braved the journey here in the seventeenth century and waxed lyrical over the utopian qualities they perceived in the two hundred or so residents on the island. Most notable among these explorers was of course the irrepressible Martin Martin, one of the first traveler-writers to jour-

ney extensively through the Western Isles and record his experiences in his famous work, *A Description of the Western Isles of Scotland Circa 1695 and a Voyage to St. Kilda.*

Martin Martin seemed to have only words of glowing praise for the St. Kildans on his first visit here in 1695. He saw in their "simplicity, purity, mutual love and cordial friendship . . . a new Golden Age" of societal mores and traditions. He notes that they appeared to be "free of care and covetousness, envy and dissimulation, ambition and pride and . . . altogether ignorant of the vices of foreigners, and governed by the dictates of reason and Christianity." Martin was also impressed by their physical prowess: "Anyone inhabiting St. Kilda, is always reputed stronger than two of the inhabitants belonging to the isle of Harries." His only criticism—in actuality, a high compliment—was that "they themselves do not know how happy they are, and how much they are above the avarice and slavery of the rest of mankind."

Other traveler-writers followed, equally convinced of the paradise-on-earth qualities of the tiny St. Kildan society, at that time fewer than a hundred and eighty inhabitants. The Reverend Kenneth MacAulay claimed in 1764 that "the St. Kildans possess as great a share of true substantial happiness as any equal number of men elsewhere." And fifty years later Duncan MacCulloch waxed even more fervently:

> If this island is not the Eutopia long sought, where will it be found? Where is the land which has neither arms, money, law, physics, politics, nor taxes? That land is St. Kilda . . . Here no tax-gatherers' bill threatens [not quite true, but why spoil the picture], the game laws reach not their gannets . . . It heeds not the storms which shake the foundations of Europe and acknowledges the dominion of MacLeod [the leading clan at the time in the Western Isles] and King George . . . The St. Kildan's slumbers are late, his labors are light, and his occupation is his amusement, since his sea-fowl constitute at once his food, his luxury, his game, his wealth, and his bed of down . . . He has the liberty of his thoughts, his actions and his kingdom, and all his world are his equals. His climate is mild [again—a little poetic license] and his island is green. If happiness is not a dweller in St. Kilda, where shall it be sought?

And then came the eighteenth- and nineteenth-century poets with their glowing epiphanies. First, David Mallet:

Thrice happy land! Blameless still of arts
That polish to deprave each softer clime
With simple nature, simple virtue blessed!
This little world, to all its sons secure,

St. Kilda—Village Bay

Man's happiest life; the soul serene and sound
From passion's rage, the body from disease . . .
True liberty is theirs, the heaven-sent guest,
In youth, in age, their sun that never sets.

And later came William Collins, who was particularly impressed by the St. Kildan ability to live almost solely on the flesh and eggs of gan-

nets lifted, at great danger to themselves, from the towering vertical cliffs of Hirta (aka St. Kilda).

> *Forget not Kilda's race,*
> *On whose bleak rocks, which brave the wasting tides,*
> *Fair nature's daughter, virtue, yet abides . . .*
> *Thus blessed in primal innocence they live,*
> *Sufficed and happy with their frugal fare,*
> *Which tasteful toil and hourly danger give.*

One of the most intriguing episodes in St. Kilda's history—an ironic blending of utopian elements with testosterone traumas of decadence and debauchery—was the reign of Roderick the Imposter, a young, charismatic island-born preacher who claimed to be in constant contact with John the Baptist. In most communities, particularly on the mainland—where religious and political scams, peddler-thieves, spell-weaving gypsies, and counterfeit "gentlemen of position" were commonplace and more easily spotted—Roderick would not have survived his first blasphemic utterances. But in that small, intimately homogenous, and isolated community of St. Kilda, which according to one visitor had experienced a somewhat "checkered kind of religion—a mixture of Druidism and popery," a little wile and guile coupled with a generous dose of "the gift of the gab" could go a long way to achieving prominence. And dominance.

Which is precisely what young Roderick set out to do. And what a splendidly bawdy and ribald film or musical his story would make. For Roderick was barely eighteen when he claimed that he was meeting John the Baptist face-to-face on a regular basis and being given personal instructions for major religious reform among the islanders. Now, it's quite possible that the islanders were ready for a bit of a shake-up, and embryonic leaders and "reformers" often quickly spot a need of this kind and proceed to satisfy it. Or maybe they were just bored to distraction with their "utopian life" of egg gathering, bird catching, potato planting, halfhearted fishing, and endless knitting—and turned to this young, red-haired, and immensely strong young man for new order and direction.

Whatever the circumstances, it appears the eloquent and statuesque Roderick, whose bravery and prowess as a wildfowler on the island's soaring cliffs was renowned, found a most receptive audience and discovered, much to his delight, that his pronouncements and edicts were carried out to the letter. These included a substantial rewriting of the Ten Commandments, the banning of the Lord's Prayer and the Creed, strange new interpretations of the Gospels that gave special privileges and power of authority to "direct descendants of the holy ones" (which Roderick, of course, claimed to be), and the authority to proclaim new religious edicts and initiate bizarre rites at will.

According to records of the time, these included the imposition of "fasting Fridays," when nothing, "neither meat, nor grain, nor flesh of fowl, nor drink of any kind," could be partaken from Thursday evening to early Saturday morning. Other requirements included obligatory and regular "confessions" by all islanders to Roderick, which gave him immense power and influence over his unsuspecting congregation. Then came a number of other more pernicious requirements especially created for "the edification of island women." These included, most notably, the teaching of special hymns to protect the young wives from death during childbirth. But these were not the usual communal hymns. Each woman had to learn her own special hymn and it was often a rather long and complex litany that, of course, required "individual tuition in isolation" by the saintly Roderick himself. Who, it turns out, practiced far less saintly activities with each lady once they were left alone in a special "teaching cell" built by the island men for his "tuitions."

To gauge from accounts of the time, Roderick created for himself a virtual harem in his cozy cell. The men of the island at first were pleasantly surprised by the remarkable increase in fertility of their wives until it slowly became evident to them that many island offspring bore remarkable resemblances to the potent Roderick himself. The rumblings of dissent began to arise.

Roderick was ready for such backlash and met each accusation with tirades of rhetoric and new, ever-stricter behavioral edicts that he claimed to still be receiving on a regular basis, following his ongoing conversations with St. John the Baptist.

And so it went on for several years, with Roderick gaining even more control of his flock and condemning, as ordered by the Baptist, any contravening behavior or even scintilla of skepticism and "traitorous thought" on the part of the confused islanders. Not only condemning but threatening that such activities "would incur eternal damnation in a future world, and be overtaken by some signal judgement!"

Thus Roderick continued to conjure up terrible tribulations for any who disobeyed his increasingly strict and self-serving laws and regulations. The women suffered most of all. Not only were they ordered "to conceal everything that happened to them at their 'tuitions' under the pain of hellfire" but if any one of them "rejected his addresses and debauches," he immediately commenced a criminal prosecution against her. The Baptist had, it seems, told him that one particularly rebellious woman had committed some flagitious action . . . and was made to walk over a beach made up of loose round stones. Kenneth MacAulay, in his fascinating 1764 *History of St. Kilda*, describes this inquisition-like ritual:

> If a single stone was removed out of place or rattled against another, the accused person was declared guilty by his inquisitor. The punishment inflicted was a complication of infamy, pain and danger; she was to stand naked under a high cataract, and a mighty torrent of water which had been dammed up for some time, for that very purpose, was upon a given signal let loose upon her with great violence . . . The unhappy women of St. Kilda have not the smallest chance of escaping.

Nor, apparently, had the men. If any one of them became outspoken or in any way displeased Roderick:

> The holy villain declared to them that The Baptist had consecrated a spot of ground, which his chosen servant called John's Hillock. If any beast, sheep or cow, was sacrilegious enough to touch that hallowed ground, though very ill-fenced [on purpose, no doubt, so Roderick could select his victims at will] it was immediately killed, and by much the greatest part of the victim belonged to the priest. In this way, did an

impure, avaricious, insolvent man continue to debauch the obsequious part of the women—and punish those who were virtuous—and to lord it over the men in their consciences, rights and liberties for six whole years.

Fortunately, Martin Martin and his traveling companions finally managed to put a stop to Roderick's dictatorial reign:

> We reproved the credulous people for complying implicitly with such follies and delusions as were delivered to them by the Imposter; and all of them with one voice answered that what they did was unaccountable ...that they were induced to believe his mission from heaven, and therefore complied with his commands without dispute.

But it also appeared the islanders were ready to remove him anyway, especially as recent threats of retribution on his congregation by this young roustabout had failed to materialize. However, there was still fear of his inordinate strength and power. So Martin flattered and praised Roderick, and told him how much the great clan chief of the mainland, MacLeod of Dunvegan, was desirous of meeting him and hearing his eloquence, insights, and John the Baptist–inspired wisdoms.

So, off Roderick sailed with Martin, who had been earnestly warned by islanders that he might create "mighty storms" on the way to Skye. Apparently, though, his powers must have failed him and he was taken to Dunvegan Castle, made to confess his crimes, and then ordered to walk on foot throughout the Isle of Skye from parish to parish, issuing public confessions of his sins, "declaring everywhere before the several congregations that he had acted the part of a consummate villain."

Some claim he managed to return to St. Kilda with the intent of rekindling his little empire and his harem, but most agree that he spent the rest of his life ignominiously on the mainland and that eventually (it took ten years!) the first official missionary was sent to St. Kilda. Nevertheless, Roderick's power and sway over the populace were such that one of his many female grandchildren promulgated his legacy here, and according to MacAulay, "A very scandalous and wicked person, was the

last pretender here to the faculty of being second-sighted. This unworthy woman inherits her grandfather's [Roderick's] cunning, ambition, avarice and lewdness in a very high degree."

Eventually, however, a kind of ministerial orthodoxy was gradually established on St. Kilda, although, according to one skeptical visitor, "It did not gain a stranglehold on the life of the community until the Nineteenth Century."

And quite a stranglehold that indeed became to the point where some islanders claimed they had enjoyed "far more liberty and happiness from the Imposter than these joyless despotic ministers."

Whatever their opinions, the mythic utopian or "savage" world of St. Kilda eventually ended abruptly on August 29, 1930, when the whole population (actually only thirty-six people were left—a rather sad remnant of the original two hundred or so) were moved lock, stock, bed and barrel, sheep and sheepdog, to new homes on the mainland. Unlike other similar events in the Highlands and islands, this was a benign "clearance" agreed upon—indeed requested by proclamation—by the islanders. And as they left for the last time, on the HMS *Harebell*, watching the early sunrise over their home isle of Hirta, all that remained in each of the homes was a Bible and a plate of oats.

That purple-prose proponent, Alasdair Alpin MacGregor, who witnessed this sad departure, penned the following tribute: "The loneliest of Britain's island-dwellers have resigned their heritage to the ghosts and seabirds, and the curtain is run down on haunted homes and the sagas of the centuries."

But a Bible still remains open in one of those deserted homes here today. And how do we know this? Well, because the more Anne and I read about this strange, evocative place—which is in fact an official outpost of Harris—and watched the eyes of islanders who described its mysteries to us, the more we decided that this was obviously somewhere we had to explore.

And so we did . . .

A Journey to St. Kilda

———————◆———————

*I*N THE PAST, GETTING TO ST. KILDA was a long and often haz-
ardous venture. On one of the Hebridean fishing boats—if you
could persuade the oft reluctant skippers to add you to their
crew—the journey could take up to nine hours, with no clear itinerary
for a return. A couple of other companies offer more traveler-oriented
camping voyages, but these can last for up to a week. This seems like a
long time to be stuck on a virtually deserted island, unless your bird-
watching enthusiasm is such that creature comfort requirements are neg-
ligible and you possess a stoic attitude toward solitude and the furious
tirades of fickle Atlantic storms.

But then, along came the farsighted Angus Campbell, the fisherman
who had tolerated my neophyte presence on his boat, *Harmony*, in the
spring when we'd spent a day prawning together in The Minch. For
years, Angus had nurtured a dream. Surely, he thought, if you could build
a boat strong enough and fast enough, you could offer one-day round
trips to the scores of adventurous travelers and bird-watchers who came
to Harris not only enticed by the powerful beauty of the little island but
also entranced by the mystery and myths enveloping the St. Kilda archi-
pelago, now celebrated as a UNESCO World Heritage Site.

Others had considered the idea but balked at the huge investment
required and the high prices that would have to be charged (up to $150
per passenger) to make the project viable. But Angus held fast to his
dream. He designed what he considered to be the perfect motor cruiser

for the projected two-hour, twenty-five-knot journey, and a passenger contingent of around twelve. He also managed to obtain "enterprise" funds from the Western Isles Council, supervised the boat's construction in Ireland, and finally launched his *Interceptor 42* (the 42 denotes the length of the boat) in spring 2005 to enthusiastic press accolades—even including a special feature in the *London Times*.

Some of the local skeptics, however, despite a series of highly successful "tryout" runs, predicted catastrophe for Angus's project. Their scowling, pessimistic mutterings ran the gamut from excessive start-up costs and fares, huge insurance liabilities, and the calamitous Hebridean weather to spiraling fuel costs, the short tourist season, and, worst of all, "What'll happen when they lose a dinghy-load of passengers tryin' to land in one of those St. Kilda swells?"

Angus's response was invariably a sly smile and a just-you-wait-and-see shrug. And his smile turned into ribald chortles over dinner one evening at his home down by Tarbert harbor. Anne and I had been invited over to celebrate the recent arrival of his family's second child, and as Christina served up a superb prawn salad of just-caught langoustines and one of the most succulent pot roasts we'd ever eaten in Britain (with apologies to my late mother), Angus almost fell off his chair laughing at one particular local's doom-and-gloom comments.

"This fella—can y'imagine—predicted that we'll all end up massacred by the million or so birds out there for invading their territory!"

"Just like the Hitchcock movie!" said Anne.

"Well, since the islanders left in 1930 and stopped eating thousands of those birds every year, they should be very grateful!" chuckled Christina. "And now they've got World Heritage and National Nature Reserve status, they couldn't be any safer."

"Of course, they might be a little overenthusiastic in their displays of gratitude," I suggested.

Angus almost toppled from his chair a second time. "Ah well, now, that's true! 'S'best to have a hat on or somethin' when they start to circle round the boat . . . their little droppings of thanks can be a wee bit on the overgenerous side!"

The image of a dozen bird-loving passengers being deluged by

guano-gifts from appreciative gannets, fulmars, kestrels, puffins, and kittiwakes was enough to bring our pot-roast gorging to an impromptu halt.

"But it's amazin'," said Angus when the laughter finally subsided. "I mean, these little islands are Europe's most important seabird colonies. The numbers are fantastic: sixty thousand pairs of gannets, the largest anywhere in the world; sixty-two thousand pairs of fulmars; a hundred and forty pairs of puffins—half of all Britain's puffin population—fifteen thousand pairs of guillemots, and thousands more of Leach's petrels, razorbills, kittiwakes, and skuas. Plus all the big migrations in the spring and autumn—graylag geese, whooper swans, pink-footed geese, snow buntings, redwings—well over a hundred different species during the year. It's a fantastic place!"

"So—I assume just the bird-watchers alone are going to be enough to fill your boat," said Anne.

"Y'know, you wouldn't believe the response," said Angus. "A'mean, even I was a bit nervous about all this . . . I wondered if all the doomsayers would turn out to be right what with our crazy weather and the cost of the trip and all their other jibes and whatnot . . . but so far it looks like we're providing something that people really want. A chance to visit a place that's almost mythical . . . to see the way that tiny strange community once lived . . . and then to sail around all those huge rock columns—the stacs—and watch the birds on those fourteen-hundred-foot-high sea cliffs—every ledge and nook and cranny crammed with them. Och, the sky's almost black with wings."

Angus seemed to run out of words in capturing the experience that Anne and I had been waiting for ever since we'd heard of his proposed venture months ago.

"So—when can we go!?" I said.

"Well, the trip this comin' Wednesday is full . . . but there's a couple of places on Friday. In fact, if the weather holds we might even stay over and camp on-island if you have the time."

Anne grinned. "Oh yes. We definitely have the time!"

And so, on Friday at 8:00 A.M. prompt, Anne and I joined a small group of ten St. Kilda enthusiasts and left Leverburgh harbor in a great

swirl of spray and the snarl of the *Interceptor's* enormous diesel engine, off into the wide Atlantic.

It was a perfect Hebridean morning. Beyond the almost inevitable haze over the North Harris hills, the sky was cloudless and the sun warm. Angus's young assistant, Duncan, handed out cups of fresh-brewed coffee and fat, succulent slices of Christina's homemade banana and currant cake. A few of the passengers sat at the tables in the galley but most of us preferred to sprawl on the open deck, breathing in the cool salt air and feeling the frothy spume settling on our cheeks and foreheads like thistledown.

Behind us, Harris and the long swathes of the Uist beaches and hills faded and we peered westward way out into the Atlantic, waiting for our first glimpse of lonely St. Kilda and its cluster of islets and stacs.

For a long while there was nothing to see across the calm, almost silk-surfaced ocean.

"Keep y'eyes open," Angus called from the galley. "It's a wee bit early in the season but y'might see a few dolphins—mainly bottlenose—they like riding the bow waves . . . and maybe basking sharks and whales—y'get to see them too from time to time."

An elderly gentleman was sitting beside us on the deck. He wore a brown felt trilby hat and nursed an elegant ebony walking stick with a ram's horn handle between his thighs. We'd exchanged the usual pleasantries about the weather, the sturdiness and elegant design of Angus's cruiser, and the excellence of Christina's cake. But then he seemed to doze off until, as Anne and I continued to scan the horizon, he suddenly turned to us and half whispered, "This has been a dream of mine, y'know . . . ever since I was a young boy."

"To come to St. Kilda?" asked Anne.

"My family called it Hirta—the old Gaelic name for St. Kilda. My grandfather had his own name for it, though. He called it Providence Isle."

"Interesting name," said Anne. "Did he come from here?"

"No—but he almost died here," said the elderly man quietly.

"Really? What happened?"

The man sighed and then smiled. He seemed happy to be telling a tale that was obviously an important part of his family heritage.

"Well, he was a sailing man. Very adventurous. Did a lot of solo sailing back in the late 1800s. And one of his journeys was a long meander up the west coast of Scotland. He was hoping to reach the Faeroe Islands—y'know, way up there toward Iceland—owned by Denmark. He said they were very wild and beautiful— 'like huge green pyramids rising out of some of the wildest seas in the world,' was how he described them. Anyway, he decided he'd take a detour from his route and visit Hirta. He'd read a book that described the island as 'an earthly paradise inhabited by people of unusual grace and integrity.' Anyway, things went a little awry. A storm came up very quickly out of the southwest and when he entered the bay of Hirta—Village Bay, they call it—he lost control of his boat in a tidal surge—they're deadly in that bay, so they say—and was beached very violently on the rocks below the village. He was almost drowned but the villagers rushed down and managed to get a line out to him and rescued him. The boat got a bit of a battering but they managed to save that too. My grandfather's ankle was broken and he couldn't walk, so he stayed with the islanders for more than three weeks until he was just about well enough to sail back to the mainland. And he said he'd never been treated with more kindness and respect and vowed that one day he'd return. Unfortunately, he never did . . ."

We waited for the old man to continue. It was obvious he was moved by the retelling of an important family tale. Way ahead, the Atlantic was millpond-mellow, barely a ripple on its purple-turquoise surface. A drowsy downland of barely moving wavelets. On a sailboat we would have been doldrumized by the lack of a breeze, but Angus's engine growled with powerful pleasure as we cut through the ocean at a twenty-five-knot clip.

"No, he never did," the old man began again. "He never returned to his *Saoghal air leth*."

"His what?" asked Anne.

"Ah, that's the old Gaelic again. It means—as far as you can translate Gaelic into a language like English—something like 'a land apart,' a special unique place, as he always told us it was. And he really had planned to return. He wanted to give something to their church. I don't know what it was. Something he said they would understand . . . but he never

said what . . . I wish I'd known. I could have carried it for him. Even though there are no people left now, they say the church is still there."

Another long pause. The old man seemed lost in his own thoughts again until, in a stronger voice, he finally said: "So—I'm coming here . . . for him."

St. Kilda

Anne smiled and touched his arm.

"Would you like another cup of coffee?"

"Oh . . . ah . . . thank you. Most kind. Thank you."

Anne took his cup and vanished into the cabin.

When she returned, there was excitement on deck.

"There she is!" shouted a young boy. "I can see St. Kilda!"

Everyone on deck rushed to the rail, peering through the spray and spume, and, yes indeed, there the islands were—jagged cones of rock, silhouetted pale blue in the heat haze, rising like some Tolkienesque fantasy from the smooth ocean. Some journalist, in a rather dismissive mood, had described them as "like a mistake in the middle of nowhere." But that certainly didn't reflect the mood on the boat. I could hear the chatter and cheers from the half dozen or so passengers in the cabin. Even Angus, steady and stern at his wheel and focused on his welter of dials, switches, levers, and buttons, grinned as the excitement buzzed around him.

"'Bout another hour or so," he said. "Time to read up on the islands if you need to."

Duncan handed out colorful Scottish Natural Heritage brochures that gave, in English and Gaelic, a succinct introduction to St. Kildan geology, history, ecology, and anthropology.

There were a few surprises in the text too. Apparently these were not just islands in the traditional sense but the dramatic, fragmented remnants of a blown volcano active around 60 million years ago. Aerial photos showed the perfect caldera arc of Village Bay on the main island of Hirta, echoed in the curve of the original settlement set back a couple of hundred yards from the rocky beach.

Human occupation here on these "islands at the edge of the world" has been traced back over two thousand years, although unlike other island settlements off Scotland's west coast, there were no saintly links with early Christian hermits. The name of St. Kilda is thought to be a corruption of the ancient Norse word *skildir* (shields). Certainly the island profiles, with their jagged ramparts and soaring, spearlike towers of rock, suggested a powerful defensive bastion.

Despite the abundance of a unique species of small, brown-fleeced Soay sheep here and a rich variety of fish in the bay and among the spectacular undersea caves and grottoes, the small community preferred to dine—and dine well—primarily on seabirds. The sheep were valuable for their milk and for cheese making, but gannets and fulmars were the meat of choice. They were caught annually in their thousands, lifted by

hand or noosed off the ledges of the towering cliffs by intrepid male islanders belayed, often barefooted, on horsehair ropes. The birds were then stripped of their feathers, which were stored as trading barter, and then dried throughout the summer for winter use in scores of primitive oval stone-built and turf-topped *cleits* scattered across the steep slopes of the caldera, around and high above the village.

Nothing was wasted here.

Seabird eggs—preserved in the *cleits* under peat ash for up to eight months to heighten their flavor—formed a major component of the local diet. Lamp oil was extracted from the birds, their bones were carved into useful tools and implements, and their skins—particularly the throat skins—were made into shoes.

"It really was what my great-grandfather said—'a land apart,'" our old man in the trilby hat told us as we sprawled once again on the deck. "Bit like the Galapagos, I suppose, a Darwinian place with its own type of sheep, its own type of wren—bigger than those on the mainland—even its own type of mice."

"And the people too—the *Hiortaich*—they were almost like a separate species," I suggested. "They created their own form of traditional dress—crude tweeds made from the brown wool of the Soay sheep. And they had no priests or ministers in the formal sense, so they even invented their own spiritual culture." I told him the tale of Roderick the Imposter, who had imposed his unique form of "religion" on the islanders.

"That's fascinating," he responded. "Bit like Golding's *Lord of the Flies*."

"And also like that film—*The Wicker Man*. You remember that?" said Anne. "Christopher Lee and Britt Ekland. Some kind of thriller about human sacrifices on a remote 'pagan' island way out off the Scottish coast . . . an island like St. Kilda!"

"I remember the title—but I don't think I've ever seen it . . ."

"Wasn't there another film loosely based on St. Kilda?" I asked Anne, whose memory of films made during Hollywood's Golden Age is bizarrely extensive. "Something like *The Land at the Edge of the World*?"

"Actually it was *The Edge of the World*—made in the thirties I think, with John Laurie. Very powerful film. Beautiful black-and-white images of a 'lost world.' Based on St. Kilda but they had to use some other island

up in the Shetlands. Foula, I think. Apparently even then, after the people left in 1930, the laird owner wanted it preserved as a bird sanctuary."

"And just look at the place," I said, pointing at the islands, now much closer and even more dramatically distinct in character. "This is pure 'edge of the world' territory! I bet in a dark winter storm, this would seem like the end of all things—a black, lost world of loneliness and desolation . . ."

"Oh—very cheerful!" was Anne's dismissive response.

Ahead of us, at the end of a mile-long, dragon's back–profiled peninsula of bare black rock peaks and arêtes—a series of mini Matterhorns along the ridge of the ancient caldera wall—rose the formidable bulk of An Dun. One writer described it as "the least plausible place on Earth"—an otherworldly tower of striated, storm-gashed volcanic basalt. And it stands—or, rather, leans in a wearied way—as the guardian of the bay. A breakwater supreme. Yet it's strangely, almost sadly, so gouged and holed and hollowed and pocked that you wonder how much longer this immense creaturelike pinnacle, hundreds of fragmented feet high, can withstand the ferociously destructive power of those Atlantic storms for which St. Kilda is renowned. In fact, folklore has it that the islanders suffered regular bouts of collective deafness due to the incredible sound and fury of the gales here and the chaotic smashing and crashing of the man-sized boulders that constitute the Village Bay "beach."

Fortunately, on the day of our arrival, all was calm and benign as a duck pond. But those of us who had done a little reading about the island knew that such a deceiving tranquility could be eradicated in minutes by sudden force-12 hurricanes seemingly conjured up by their own sneaky malicious volition. Angus was fully aware of the fickleness of climatic quirks here and had already suggested to the group that weather conditions had changed dramatically to the south and a storm was forming and heading straight for the island. Not a concern at the moment, he emphasized. It was slow-moving and likely would not arrive until early morning, but he suggested, to our mutual disappointment, that an overnight camp would be "tempting fate a wee bit too much, I'm thinking."

So we had no choice but to accept his decision, focus on our slow

entry into Village Bay, and make the most of the few hours we could spend here exploring the mysteries and moods of the island.

First impressions are magnificent. A great arc of grass-sheened hills—part of the ancient caldera wall—rose up from the curved beach. Their slopes were dotted with those strange stone-built remnants of traditional *cleit* drying structures. Then came the long semicircular enclosure wall, or "head dyke," that once defined the village pasture "boundary," and below that were more *cleits*, larger and more substantial, with many still supporting thick, turf-topped roofs. Here the pasture grasses became greener—ideal grazing land for the Soay sheep still running semiwild on the island. And then came the remains of the village itself, its arc of dwellings echoing both the arc of the bay and the boundary wall. Radiating "wheel-spoke" fragments of walls linking the beach with the dyke indicated an almost medieval pattern of "long fields"—one for each croft. The old windowless, chimneyless, and round-cornered black houses, many built in the early 1800s and shared by the resident family's livestock, had lost their ponderous, knobbled permanence and were now rubbled skeletons of huge rocks with foundation walls over four feet thick. Between these stood the roofless shells of the more recent stone "white houses" funded in the 1860s largely by the Royal Highland Agricultural Society of Scotland, which insisted that islanders deserved "more decent and civilized dwellings."

Unfortunately, the use of windows, square-cornered and thinner walls, and less sturdy roofing materials meant that these well-intentioned structures often failed to offer the same solid protection as the black houses against those furious island storms. We could see that five of the newer dwellings had been reroofed. One of them, so Angus told us as we edged our way toward the shore, was now a small museum. The remainder provided accommodation for the National Trust warden and itinerant researchers who had spent years visiting here and studying the breeding patterns, survival abilities, and other quirks of the unique Soay sheep.

At the western end of the old village is the more substantial Factor's House, once home to the laird's tax collector when he came over on his annual summer trip to collect the rent from the crofters. As money was

virtually unknown on the island, this was usually paid in the form of bird feathers (for bedding and ladies' hat decorations), bird oil, and bolts of homemade brown "murrit" tweed that were kept in the store, still standing today at the top of the landing jetty. Close by we could see the small austere stone church built in the late 1820s, the adjoining school room and minister's manse, and something else that caused a sudden gasp of surprise among the passengers.

"I thought this was supposed to be a peaceful little community," one young man called out to Angus. "What the heck is that great cannon doing here over by the store? It's enormous!"

It did look rather idiosyncratic—a huge, twenty-foot-long, black artillery gun pointing directly toward our gently wallowing boat that Angus was in the process of anchoring prior to our disembarking by inflatable dinghy.

Angus laughed. "That's no old cannon. It was put there in 1918 after a German submarine had shelled the village to destroy a radio mast used to guide our Atlantic ships."

"The Germans came all this way just to attack little St. Kilda!?" asked the young man.

"Aye—but they were lousy shots. Used up seventy-two shells trying to hit it and damaged the church and the manse—but they were very polite about it all. They explained to the villagers why they'd come and suggested they find shelter well away from where they were going to shoot! And look—we're safe now too! We've got the army here," said Angus, pointing to an aesthetically discordant huddle of gray-painted Portakabin-type structures by the jetty.

"Those buildings really spoil the place," said another passenger. "What are they here for?"

"Ah well, they're a bit secretive about it all," said Angus, "but it's got to do with tracking missiles from the rocket range on South Uist. Oh—and maintaining that early warning station or something like that way up there on top of the ridge."

We all looked, and there indeed, hundreds of feet above the arc of the desolate village, was a cluster of aerials and radar devices perched all too obviously on Hirta's highest point. Despite its splendid isolation, the

island is now irrevocably a part of Britain's ultra-sophisticated national defense network.

"Why would they come and spoil such a beautiful place like this," asked one young girl sadly.

"Well"—Angus was obviously going to have to answer this question on each one of his *Interceptor* voyages, and he seemed to be trying to find a reply that would restore a little levity to his obviously disappointed audience—"at least they've got a pub here!"

"A pub!" Eyes widened, smiles appeared, and salty lips were licked.

"Yeah, tha's right. A nice little pub—the Puff-Inn, where drinks cost half price and they've got darts and billiards and—"

"What time's it open?" asked another young man, obviously delighted by the prospect of a long liquid interlude.

Angus decided honesty was the only policy.

"Well, now, if we'd been camping here, which we can't do now because of that storm that's coming up, we'd have been havin' a fine old time there . . . this evening."

"Evening?! What about now! It's getting on for eleven. Almost opening time . . ."

"Aye well, y'right. On Harris they'd be openin' up but here they don't start 'til five o'clock . . . long after we'll be gone."

Murmurs of dissent and disappointment rumbled through the huddled passengers preparing to disembark.

"But," continued Angus, "y'can still go in and see the place. It's a cozy little pub. It's just that you won't be gettin' any cheap beers today!"

Despite the disappointment, as soon as we'd made the brief crossing in the dinghy to the jetty, almost everyone in the group headed straight for the Puff-Inn, which was indeed quite cozy—almost clubby in its colorful informality. It possessed a distinct atmosphere of "eclectic mélange": large, humorous murals of puffins; a couple of battered guitars and a tiny ukulele leaning by a massive speaker amp; two large TVs; memorabilia-strewn walls; a message board full of cryptically worded flyers and in-joke cards; photos of the spectacularly labyrinthine underwater tunnels and caves found all around the island; a large sign celebrating the fact that St. Kilda was now "twinned" with Australia's Great

Barrier Reef; a huge stuffed teddy bear sitting atop a miniature upright coffin labeled with some cryptic reference to island shenanigans; a hand-written menu for the evening dinner delights—steak Diane, honey-roasted ham, and pork stir-fry (not bad for a handful of residents here that barely exceeded twenty at any one time)—and, of course, the bar itself, grills down and locked, with its long, tantalizing list of alcoholic delights at 1960s prices.

Finally, Anne and I were on our own. Following a brief welcoming introduction by the National Trust warden, the group quickly dispersed to explore the strange skeletal remnants of this once almost utopian (according to some commentators) community. We watched as our elderly gentleman-friend, with his brown trilby hat and elegant cane, made straight for the stern little church and vanished inside to do whatever he had to do in memory of his great-grandfather's rescue and recuperation here.

We walked slowly together along the long grassy arc of the village "main street," edged by the dual remnants of black and "white" houses. A dozen or so diminutive Soay sheep grazed on the long, narrow strips of arable land and pasture. Despite the generous land allocation for each croft, crop cultivation had invariably been meager here—oats, barley, hay, potatoes, and cabbages—with the gastronomic emphasis always on gannet and fulmar meat, lamb, and occasional fish.

Everywhere we looked were dozens of those sturdy stone drying-house *cleits*, once filled with dead birds morphing into wizened, jerkylike strips. Many of the thick turf roofs were occupied by nesting fulmars—noisily arrogant in their territorial declarations. If we came a little too close they would leap off their turf-perches, skim our heads with their broad white wings, drop gooey white discharges, and—so Angus had warned us—even spit at us if they felt threatened.

"Now tha's not a thing you'll enjoy ver' much," he'd said. "An' you'd definitely not be welcomed back on this boat if you've been hit with a blast of fulmar vomit. It's terribly oily stuff, stinkin' of rotten fish and God knows what else, and if it hits y'clothes y'might as well burn 'em. You'll never get rid of the smell!"

So we heeded his advice, steered clear of the nesting fulmar families, and explored the ancient graveyard set in a circular enclosure behind the

houses. It was full of small, simple, and usually unmarked headstones. Apparently, the love and devotion of the last St. Kildans who left here in 1930 was such that many asked to be returned and buried in this quiet place, protected from the flurries of island storms by its sturdy stone walls.

Just above the graveyard we found the remnants of an underground house—the House of the Fairies—thought to date from around 500 BC. This is just one of the many ancient remnants of subterranean (souterrain) dwellings, domed "beehive" houses, fanks, folds, and Iron Age circles scattered around the village and up the long slopes of the caldera.

A second ruined remnant nearby is claimed to be the site of "Lady Grange's House." She was the wife of a prominent Scottish gentleman who exiled her here for eight years because of her suspected involvement in Jacobite plots at the time of Culloden, and other "activities of questionable propriety." Her reputation prompted a famous remark from the ever-quotable Dr. Johnson that "if MacLeod would let it be known that he had such a place for naughty ladies, he might make his island a very profitable venue."

We peered into the walled remnants of the white houses and the far more primitive, round-cornered black houses. There was no one else around. The others from the boat seemed to have vanished mysteriously into the echoing emptiness of the place. And yet, in a strange way, despite all the ruins and wrecked structures, the old village still possessed an aura of occupancy, an edgy immediacy of presences.

Maybe it was the memory of old sepia photographs we'd seen in the little one-room museum of the village men, thick bearded, pipe smoking, and tough, grouped together around the low walls built in front of the houses to break the fury of southern winds blasting in from the bay. There they stood, gathered in their daily "parliament," to discuss affairs of the village and decide upon their shared activities. According to some visitors, these parliaments could be lengthy, loquacious affairs, lasting in some cases so long into the afternoon that work was often postponed until the following day in pragmatic island *mañana* fashion (once labeled "licentious lethargy" by an outsider ignorant of the subtleties of the St. Kildan democracy).

Or maybe it was the photographs of the women in "traditional" dress, described by one nineteenth-century visitor as follows:

> They all wore dresses of dark blue serge with a very tight bodice and full skirt, sometimes with an apron. The skirts were trimmed at the foot with a little strip of black velvet and they wore a little tartan kerchief or shawl over their heads. They had boxes of knitted socks and gloves to sell to us, blown seabird eggs, and rolls of St. Kilda "murrit" tweed made from the wool of the brown or murrit sheep on the neighboring isle of Soay . . .

Whatever the link to the island's past, it had permeated our mood, and as we sat together on one of those low, wind-blocking stone walls, looking down along the long, slow arc of the street and its thirty or so skeletal homes, the place seemed to possess a quiet spirit of animation. In that still, late-morning silence, something was there. Some faint echo of life, of activity, of community, of that quiet, intense certitude that invariably infuses small, isolated settlements. Flotillas of benevolent ghosts, wafting by in the warm sunshine.

Then it came to me, as I looked again at the structure of the village, its radiating fields, and its aura of self-contained totality. This was a true physical expression of harmony. It reflected order, social equality, resilient simplicity, a sustained and regular rhythm of life, mutual cooperation and respect, a satisfaction of basic needs—and a certainty of spirit. And not an imposed certainty (with the possible exception of the Roderick era) but a jointly agreed certainty shared and participated in by each and every member of this small, homogeneous society.

Possibly too utopian an interpretation? I wondered. Maybe you should just sit quietly or lie on this low turf-topped wall and enjoy the sun, my more mellow self suggested.

So that's what we did until a little later, when, much as we were seduced and intrigued by the tight, presence-rich intensity of the skeletal village itself, we suddenly felt a need to wander higher up this hill-girt world. We wanted to see its structure and layered origins from a higher—a more all-encompassing—perspective.

I was intrigued by the green valley to our right—the Gap—which, we'd been told by Angus, led to a spectacular six-hundred-foot-high cliff-climax between the great soaring ramparts of Conachair and Oiseval. "You're truly in the kingdom of the fulmars up there," he'd told us. "Sometimes y'can see whales hunting the Atlantic gray seals right off the rocks."

But just as we were about to embark on our mini adventure, we heard someone calling to us from a jeep on the track leading way up the mountainside of Gleann Mor to the radar station and the Cambir, the northernmost tip of the island, overlooking the smaller islet of Soay.

"You two want a ride?" the voice shouted.

"Where are you going?" I shouted back.

"To the top . . . some great views from up there . . ."

A quick decision. Walk or ride.

"Walk," said Anne.

"Ride," I said. "And then a walk back down."

"Okay," said Anne.

So we joined one of the young Soay sheep researchers in an ancient clapped-out Land Rover that somehow managed to grunt and growl its way along the rough track up the smooth grass slopes of Gleann Mor to the wind-buffeted summit. He was a shy fellow but offered one rather intriguing piece of recent research that suggested the more dominant Soay rams here often mate up to thirteen times in a single day!

We thanked him for sharing that impressive tidbit with us, tried to ignore the oppressive cluster of war-related structures and aerials and radar dishes up there, and wandered off together to see how our little isolated wonderworld looked from this dramatic vantage point.

We huddled, out of the wind, in a grassy dell. Tiny wild orchids frilled in errant breezes. Way, way below lay the three great arcs—the beach, the village, and the head dyke boundary wall. Then we looked at the land more closely, especially the greener, moist land along the tiny tumbling falls and sinuous curves of the stream known as *Abhainn a Ghlinne*. And it slowly became obvious that the subtly shadowed humps and bumps on the long slope down to the bay were not geological features but rather the ancient—very ancient—remnants of houses, sheil-

ings, and fanks. And once again that sense of latent but intriguingly invisible occupancy and ephemeral presences whispered around us in a way that was both comforting and reaffirming.

Something about the tenacity and enduring spirit of man—able to survive and create communities in the wildest and most remote places surrounded by the scoop and soar of limitless spaces—filled me with a kind of pride in my own species. It's not a feeling I've had too often, especially in today's world, where our abilities to nurture harmony, cooperation, and certainty of purpose seem at best fragmented and illusionary, and at worst absent to the point of mutual self-destruction.

Of course, it's not that simple. Examples of excellence and mutual generosity of spirit abound in our world. But here on this tiny island, as we strolled together back down the long slope of Gleann Mor, admiring the vast and massive power of the soaring cliffs, the peaked drama of the dun, the rock-bound bays thwacked by lines of surf hundreds of feet below us, and the nestled intensity of the ancient village circled around its beach—it all did seem so simple. And, without overromanticizing what must have been an extremely arduous existence here, as indeed it was throughout much of Scotland, I sensed something of the unique essence of place that had lured and nurtured people here century after century. And I envied them their certitude and their mutual harmony.

AROUND THREE O'CLOCK IN THE afternoon, we heard Angus ring his boat bell, signaling our time for reloading and the start of our second adventure of the day.

It was the silence I remember most about this next part of our journey. Although not in terms of the birds. They were a constant, full-throated cacophony of whirling, spiraling gannets dive-bombing the ocean or, in the case of the puffins, skimming the waves in hyperflighted flocks with their small, stubby, penguinlike wings barely keeping them airborne.

Rather, it was the silence of us all on the boat. Initially, leaving Village Bay after another frisky little dinghy ride through the wave-chop and a somewhat precarious clamber back up into *Interceptor 42*, there had been

excited chatter and sharing of experiences and discoveries among the passengers. It was fascinating to listen to these exchanges, which suggested that while we'd all been exploring the same small place, each one of us had returned with a different take—a personal perspective—on the island's significance and meaning.

But as we edged northward out of the bay and rounded the soaring 970-foot-high cliffs of Oiseval and the point of Rubha an Uisge, that strange, almost eerie silence fell upon our boat and all its passengers. Without exception. We just stood together on the deck by the rail and gazed at the unfolding drama of guano-coated cliffs rising precipitously from a choppy ocean, and the cloudlike circlings of tens of thousands of gannets, guillemots, fulmars, petrels, kittiwakes, and gulls. We wondered at first if our intrusive presence had stirred up all these frantic patterns of flight, with shadows like circling vultures scampering over the boat. But as we sailed slowly on along the base of the cliffs, the patterns and the amazing volume of sound continued unabated and we realized we were mere observers to their timeless rituals.

Anne was standing at my side by the rail. At first, because of the strange silence of awe and admiration that seemed to have descended upon our little group, I was reluctant to talk. Eventually I pulled her closer and whispered, "We're in another world here . . . this is no longer our planet . . . it's another place altogether . . . we're guests of the birds."

She smiled and whispered, "I don't feel unwelcome . . . but what do you think all the noise is about?"

"I don't know, but watching how they fly and circle and float on the air currents, barely moving their wings . . . I'd like to think it was all for pure, wonderful delight . . . maybe they fly and cry out like that simply because they can."

Angus guided the boat closer and closer to the towering cliffs until soon we were all looking up at the highest precipice of all—the gigantic rampart of fourteen-hundred-foot-high Conachair, the tallest sea cliff in the British Isles. This essay in pure raw, bold beauty is one of the primary bastions of the island fulmars. Countless thousands were nesting on its immensity. Every inch of ledge and rock-buckle was occupied by screeching white bodies, often lined up like uniformed militia on

parade. Guano mounds, dribbles, splatters, and splodges gave the soaring rock face the exuberant aura of an action painting thrown against the rock face by some Pollock-inspired, drug-laced expressionist exhibitionist. And it was down into these tumultuous cliff-worlds of screech and flight that the intrepid *Hiortaich* cragsmen once lowered themselves, snatching up the young fulmars and gugas (young gannets)—unable to fly from the ledges—collecting eggs, and noosing the larger birds with simple rope lassos attached to fishing rod–like poles.

A visitor here in 1908 was overawed by their skill and courage:

> The natives were the finest climbers I have ever known; they were absolutely fearless on the steepest cliffs. I have seen them perform feats which would make our hair stand on end in fright. They worked in pairs, one man attached to a rope, and the other in charge at the top of the cliff. I watched one man take a run at a cliff, eight hundred feet high, with a sheer drop to the sea, fall face downwards when he reached the edge and, while his brother at the top allowed the rope to run through his hands, the climber actually ran down the cliff side, then, when the rope had almost run its full length, the one above put on the brake, and the one below gave a twist, turned on his back so that he could see us above, and waved.

We learned later to our surprise that such activities still continue today on the island of Lewis. Against increasingly strident objections from naturalists and "Greens," a small group of tradition-honoring climbers set out annually in a small boat in late August for the rugged, deserted islet of Sulasgeir, thirty-five miles north of the Butt of Lewis, on a "*guga* hunt." While such activities are still very much a valued part of local life in Iceland and the Faeroe Islands, this particular two-week event on dangerous four-hundred-foot-high cliffs is the last remaining vestige of true fowling in Britain today. The fowlers claim that their catch is strictly limited to two thousand birds (less than twenty percent of the colony) and is justified as a "sustainability harvest" to prevent devastating "overnesting." However, when the bird lovers heard that the hunt was to be celebrated that autumn by a formal "international conference and

Boreray and The Stacs

dinner" with boiled *guga* as the prime delicacy on the menu, their out-cry against "this barbaric ancient ritual" reached crescendo pitch. Nevertheless, the event, organized by the Islands Book Trust in Ness (a fascinating repository of books and research materials on the Western Isles near Point of Ness), went off as planned.

One participant likened the *guga* flavor to "a very pleasant roast pork"; another described it as "rather overgamey venison with fishy undertones." Others adamantly declined to comment.

The precarious activities of fowlers on St. Kilda constituted a major part of their lives, their livelihood, and their proof of manhood. To fail as a fowler "at the crags" relegated you to a kind of social purgatory here. You were not a true *Hiortach*, and in an island community so small and interwoven with generations of inbreeding, that must have been as close to a living death as any man could experience.

Back at the village we'd explored a touching remnant to this form of social ostracization—the remains of a house set high above the village by the head dyke wall. It was built single-handedly in a day, according to local legend, by a man named Calum Mor to prove his strength and

manliness after the village fowlers had insultingly left him behind on one of their cliff-scaling forays.

Seasickness has also been described by sufferers in similar "living death" terms. And as Angus turned the boat northward for the four-mile ocean crossing to the most outlying of the archipelago islands, Boreray, the floppy chop at the base of the cliffs now became a wallowy, stomach-churning maelstrom.

"Nothin' to worry 'bout," Angus called out from his seat at the wheel. "Tide's turnin' a bit but it'll soon calm itself. It's often like this in the early evening."

Unfortunately, his reassuring words obviously failed to bolster two of our passengers, who sat, or rather half lay, on the deck by the cabin door, greened and cold-sweaty, and made abundant use of the little white paper bags handed to them by Duncan.

The rest of us huddled on the deck, keeping our eyes firmly locked on the horizon and sucking in great gobbets of sea air, as the boat floundered, lurched, and rolled toward the impressive hulk of Boreray. And toward something else. Something black and onerous that seemed to be shooting high out of the water like an emerging antiballistic warhead.

"Stac Lee," shouted Angus. "My favorite rock!"

And now it's ours too.

Stac Lee is a magnificent monolith—a creature that changes shape and mood as you circle it. From one angle it offers that ballistic warhead profile. From another, the rock striations tilt upward, giving it the thrust and menace of a huge attacking shark, jaws open and life-threatening, exploding out of the ocean. From a third angle it possesses the rather benign profile of an arrowhead chiseled into a series of flat facets. And as we edged around it, the gannets teemed above us in an almost impenetrable mass of wings and lean, javelin-tapered bodies. Once again came the strange feeling that we were truly in a different world, an unfamiliar place where birds were the dominant species and we were merely insignificant observers being treated with utter indifference and disdain.

And then, as we altered course around Stac Lee, a second, even more immense rock monolith—Stac an Armin—arose beyond the cliffs of Boreray, a favorite bird-hunting site, and the torn, hacked 1,270-foot

summit of Mullach an Eilean. From the south, Armin resembles an immense war galleon in full sail, its bulk leaning backward to emphasize its aura of sheer majesty and power. But as we moved in closer to gaze at its western profile, it suddenly became—just like Stac Lee—a jagged-pointed pyramid whose serrated pinnacle was echoed by a series of similar dagger-shaped peaks and fanged ridges on Boreray itself—a key, and very appropriate, location used for scenes in *Harry Potter and the Sorcerer's Stone.*

These sentrylike guardians of the huge Boreray cliffs could, with a few swirls of crevice-stuck clouds and a sheen of ethereal sea mists (neither, alas, present that day), quickly transform this already malevolently powerful place into something truly supernatural, laced with fantasy and fear. But then a squadron of Chaplinesque black puffins with their rainbowed bills suddenly skittered comically across the wave crests beyond our bow, their silly little wings beating frantically to keep them aloft—and the Tolkienesque/Potter mirage faded as we all giggled like a cluster of schoolkids.

Slowly the stacs and the islands began to fade into the evening haze as Angus set *Interceptor 42* at full-knot speed and we sped eastward across a calming sea back toward Harris. An aura of melancholy suddenly settled over our little group. It was obvious that none of us—with the possible exception of the two seasick ladies—wanted to leave. Something of the sheer beauty, power, and wonder of the place had touched our spirits. We had all been guests in a complex kingdom of birds of which we understood so little and yet had been deeply moved. Collectively. You could sense our sharing of the experience in the way we all seemed to stand closer together, exchanging murmured insights and mutual sighs of awe and admiration . . .

"St. Kilda is one of those places you won't ever forget," said Anne softly.

I nodded and then smiled at our elderly friend with the trilby hat and the ram's-horn walking stick. He was standing a little apart from the others, watching the islands slip away into the setting sun—a fiery miasma of gilded luminosity. He smiled back—a large and generous smile. Whatever he had done on the island in memory of his great-grandfather seemed to have made him very happy . . .

Artists and Creators

S OMETHING IN THE STARK, BROODING boldness of Harris, the gauzy infinitudes of the golden beaches, and the ever-present, ever-changing personality of the light and the weather, lures artists here like angels to the Holy Grail.

These are not landscapes for simpering watercolors, or ultra-high-definition digital photographs, although I've seen many of those. There are far too many powerful nuances here. Too many mysteries and moods for delicate aquatic or overdetailed renderings. Just the rocks alone—from the glacier-smooth strata ribs bursting through the dark peat beds to the ominous gneiss bulks of Clisham and its huddled compatriots, resonating with their 3.5-billion-year-old heritage—demand bold and muscular treatment.

From the depths and fires of time, the rocks arose and still remain as mute reminders of the tenuousness of human existence. Simon Rivett, a Lewis artist admired for his powerful moorland oils, claims, "The coloration and starkness of the wide-open spaces provide me a real challenge."

James Hawkins, creator of tumultuously churning canvases of rocks, lochs, and mountains, loves living in this remote country "with its constantly changing scenery, bathed in calm beauty or wild with furiously wrathful storms." In his works you can almost hear the power of moorland streams in full torrent and feel the scratched and broken profiles of the ancient hills in virtual tactile reality.

A similarly evocative but more stylized reality permeates the boldly composed watercolors of Anthony Barber, which are sold in the form of greeting cards and prints throughout the islands. More moody and visually dramatic are the heavy impasto canvases of Jolomo (John Lowrie Morrison), who draws inspiration "tied to memories of childhood . . . the dark, brooding mountains and dazzling moorlands . . . reflected in vivid layers of pure color." A similar spirit permeates the impressionistic works of Vega, which capture the vibrant tones of weather, light, water, and wild landscape here.

Marian MacPhee, on the other hand, celebrates some of the more legendary underpinnings of the islands, particularly in her furiously dynamic depiction of *The Blue Men of the Minch*, those demon creatures of the deep off the Shiant Islands who rise up during raging storms to challenge terrified boat crews to knowledge contests of Gaelic songs and verse, and then, if the men prove inadequate (which, I assume, it's hard not to be in a roaring gale), drag then and their boat down into the dark waters for eternity.

One of our favorite Harris artists, Willie Fulton, seems to be able to capture all these nuances and more in his ethereal canvases, often featuring mists, mountains, moonlight, and moods so intense that you can do little else but stand and stare, and, in my case at least, admit to a combined admiration and envy for his evocative techniques.

Willie laughed when I tried to say something like that as we stood with Anne inside his own tiny Ardbuidhe Cottage Gallery at Drinishader, deep in the jumbled moonscape of the east coast Bays. His smiling, open face, neatly trimmed white beard, and dismissive attitude toward overpurpled praise, suggested a man at peace with himself and in love with his own life.

A graduate of the Edinburgh College of Art and an art teacher, mostly in Tarbert, for "precisely twenty-nine years and one hundred and sixty-nine days," he has a philosophy and a wisdom (neither are words he would choose himself) that are disarmingly simple. "It's all about looking, really. If you look, you'll see and if you see, you'll discover. Every single day can be a voyage of visual discovery—exploring and experiencing the wonderful qualities of light here, the ever-changing moods, and that incredible sense of space."

And as he talked, Anne and I were looking out from the studio across to his house lower down the slope and the rocky arc of his Bays croft. The key elements of his art lay right there in front of us. All he had to do when seeking inspiration was look out of his window—and paint.

Willie seemed to sense what we were thinking: "Yes—it's great, isn't it. I'm always swimming in ideas here—they're all around—coquettish, dancing, laughing, fighting, having the time of their lives with my head. But once I'm latched onto an idea, I try to whittle it down. Find the essence. Simplify it. I try to keep the focus. I honestly feel it's through simplicity that we can perceive beauty and through beauty that we're drawn into those fleeting moments in nature—they can come and go so fast—they're all too easily missed. Sometimes I find achieving this kind of 'simplicity' is the most difficult thing to do. But then again, a constant challenge like that is what keeps me painting."

Willie talks and gestures with a spirit of suppressed energy. I had a feeling that if he really let go, his little studio would literally explode. Even in his paintings, despite their beguiling "simplicity," you sense the existence of other forces, other dynamics within the canvas. There's a sense of something about to happen, even though the mood in many of them is mistily ethereal, bathed in calm—and yet not so . . .

I tried to explain these reactions to him and told him that I was reminded of something Rodin said: "That which is more beautiful than a beautiful thing is the fading of a beautiful thing."

He gave a sort of beard-and-twinkle laugh. "Ah, that's me summed up to a T. I always was a bit mysterious, I suppose—even to myself. Fading in and out—changing directions. It's like I heard a writer on the radio last week describe how he wrote. Forgotten his name . . . anyway, he said something along the lines of: 'My books coagulate very slowly in a gloppy, primordial idea-soup.' I liked that. Same as me, really. I never seemed to do what everyone thought I should be doing. Self-destructive, maybe. Bit of a family black sheep, I suppose. I had no silver spoon—very working-class background, so I had to make my own life. Always drawing, never exhibiting. I was a healthily antiestablishment kind of guy. Never really liked the academic side of things. Didn't like the art world's

snobbism and game playing. But somehow we—my wife, Moira, and I—found ourselves here and I really enjoyed teaching in the school at Tarbert. But the bureaucracy eventually got me down. So I'd had this dream for years—I guess since I was a kid in love with art—that maybe I should one day pull away from the system and really do my own thing. Sounds a bit corny when I say it now but it seemed like the right moment—it was the right moment! So I concentrated on my own work. I decided it was my time now. Moira joined me too with her work. She's a fine painter. Better than me in many ways."

Anne and I paused to look at one of his latest works. "I like the way you've captured the illusion of a whale in this one in that mysterious cloud over the hills. Is that supposed to be symbolic of the island heritage as a whaling center?" asked Anne.

"Y'know, others have asked me the same thing. And it's nice you've spotted the link, but actually it's just supposed to be a cloud—I keep saying I'm gonna paint that bloody mouth out . . . and that stupid tail. I keep looking at it and thinking, My God! It does look like a whale!"

"You used whales—or at least very large fish—in some of your huge *Spirit of Harris* paintings at the Rodel Hotel," I said.

"Yeah, right," said Willie. "I spent the best part of a year creating that whole series. They're not pretty-pretty landscapes. They're how I felt about the island—its heritage and power—its uniqueness. Man's existence in this place and the huge passage of time here. I was kind of declaring myself. And when I'd done it, I decided maybe it was time to exhibit. So off I went with my portfolio to the big galleries in Edinburgh and I kept thinking, What the bloody hell am I doing here?! I feel like a commercial traveler lugging a box of samples around. So by the time I'd arrived at the first gallery, I hadn't even gone in through the door, and I was ready to say, 'Look! Stuff your stupid gallery, I'm off back home!' I was so full of self-doubt. I was thinking to myself, I'm hopeless, I'm no artist, certainly not with a capital A. To paraphrase T. S. Eliot, 'I can understand someone wanting to paint but I'm not sure I understand them wanting to be an artist.' So I thought, What the hell am I doing here? And I expected to be patronized and told, 'Oh, yes—quite nice, but it's just not our kind of thing.' But it didn't happen that way.

Not at all. She loved 'em. And she asked me what my expectations were for prices and I honestly hadn't a clue—I mean, what is art worth anyhow? How do you set a price on something so personal? So she suggested some prices—based, I think, on the size of the canvases. There were a lot more zeroes than I'd ever conceived, so I guess I sat there trying to be cool—which she took, I guess, for obstinacy—so she doubled the prices and I said, 'Well, I guess we could try them at that.' And she sold six of them almost immediately! And then she said, 'Would you be interested in doing a personal show at the gallery?' And—well, what else could I do? So I said, 'That's fine with me.'"

Willie paused, smiling to himelf, still apparently bemused by the quirkiness of his first gallery experience.

"Anyway . . . so I came back to my rock here and really got going with the paintings. And the place is so hidden with no distractions except all the things in my paintings—the shifting light, the earth colors, the changing patterns and shades of the ocean, the great ancient rocks . . . and when I opened my own small gallery last year here, I was honestly bowled over! People kept coming and buying whatever I produced. I worried I might become a sausage factory—producing the same paintings over and over. But I knew I couldn't—wouldn't—do that. I'd be bored so fast I'd probably jump off the cliff here."

"Ah, right," I said, "just like Samuel Beckett's wife said to him, 'No meaning in life again today, dear?'"

Willie laughed. "Right! Spot on! So, anyway, in order to maintain meaning, I kept changing—focusing more on the things that really draw me: light, wind, space, the moon, reflections, and moments in time—even those incredible aurora borealis light shows we get in the winter. Unbelievable colors and mysteries in their movement. It's all a bit like Monet with his haystacks. Every one the same basic subject, yet every one entirely different. Some of mine are more popular than others. People seem to love my moon works—that *Moon over Scalpay* sold for a heck of a lot. And suddenly I realized—this is my new life now! And I got full of excitement. And everything felt right—so long as I could keep reinventing and improving what I do. That's what I admired about artists like Picasso—always discovering, experimenting, reinventing."

"Right," I said. "I love that aphorism of his: 'A true artist must reinvent himself every single day.'"

"Yeah," said Willie. "Perfect! Says it all."

"And you've done so well," said Anne, "and nothing seems to have spoiled you—yet!"

"No—you're right," said Willie, his bearded face beaming. "If you'd have told me eight years ago that I'd be an independent artist making a pretty good living with shows in the big Scottish galleries and that I'd be deeply involved in island politics—and that I'd be playing golf, which I always thought was a stupid game, and now I'm captain of our little nine-hole golf course down on the Scarista dunes, I'd a'thought you were talking through your . . . lower orifice. But of course, I'd be far too polite to actually say that . . . even this reprobate black sheep knows how to behave. Sometimes."

"Except when you start telling your jokes?" said Anne, laughing.

"What can you possibly know about my jokes? I haven't told you any yet!" Willie chuckled.

"Ah . . . we have our ways . . . our island informants . . ."

"Okay, you want a joke. I've got one. Very Scottish religious joke but you've both been on-island long enough now to understand it. There're these two ministers, y'see, walkin' down the street, and they stop to talk to one another. So this Reverend MacKaye—he's the Presbyterian—says to Reverend MacLeod—he's Church of Scotland—'Good mornin', Reverend MacLeod. I hear you have an organ now in your church.' And the Church of Scotland minister replies, 'Och, well, y'know, it's far better singin' and praisin' the Lord with music. It gives us a great feeling of joy and uplift . . .' The Presbyterian minister frowns and then says, 'Ah, well, the next thing y'll be wantin' then is a monkey in the pulpit to give everyone a real laugh!' And then the Church of Scotland minister says, 'Aye, and if you're not careful, the next thing you'll be wanting, Reverend MacKaye, is an organ!' "

Willie was laughing at his own joke long before he'd finished, and we joined in after a hasty glance around to ensure the absence of any ardently religious eavesdroppers in the gallery.

"Not bad, not bad," Anne chuckled.

Steve Dilworth—Sculptor

"Oh, there's plenty more like that! But I'm not much of a joke teller. Y'should go and visit Steve Dilworth just up the road—they say he's pretty sharp when it comes to 'island colors'!"

"Steve Dilworth—who's he?" I asked.

"Oh, Lord—now I've gone and done it," said Willie. "Well—y'think I'm an artist. Y'should go and see his work. Sculpture. Amazing pieces. Top rank. Institutional awards and all that kind of thing. Makes me feel like a real doodler. And his daughter. Beka—a dynamite photographer. She's doing a book on Harris. Big black-and-white photographs. All exhibition stuff. Oh, yes—a very talented family, those Dilworths . . ."

"Just up the road?" Anne asked.

"Yeah. Two, three miles. Little white cottage smothered in ivy on a bend."

"We should go there," I said to Anne.

"Absolutely."

Willie tried to shift his jokester grin to a forlorn grimace. "Ah, tha's right. Jus' leave me here with m'bloody moons an' m'whales an' gallivant off to see the real stars."

"Well," said Anne slyly, "y'could tempt us to stay with a cup of tea and introduce us to your wife . . ."

"Ah, yes, Moira. Another fine island artist too. Lord, why am I sensing chronic inadequacy here?!"

"Baloney!" I said. "You're as proud as a peacock about your work."

"Right—a peacock being stripped of his bloody tail feathers!"

Anne laughed. "Ah—but a peacock who also doubles as captain of the local golf course! Which, by the way, we both think is one of the most beautiful nine-hole golf courses we've ever seen. Even compared to Barra."

Willie smiled. "It is indeed. It's been around since the twenties and keeps getting listed as one of the 'ten best hidden courses' and things like that . . . in many magazines. St. Andrews is one of the first official Scottish links. Dates from the mid-1800s. Home of the British Open and a real tough course. Over two hundred bunkers! Ours is only nine holes and its official length is four thousand eight hundred and sixty-four yards. The largest fairway is over four hundred and eighty yards. But can y'imagine any better place to play—in natural sand dunes and traps, right by the white sand beach and the ocean with all those sea breezes. Actually it's the breezes—gales occasionally—that make it challenging. Real golfers love them. It's a far more subtle course than it looks and the greens are tiny so y'need a good eye and an accurate swing."

"I like the idea of the 'honesty box' by your little clubhouse. Just pop in your twelve pounds and play," I said.

"Yeah, tha's worked well—in fact, one of our 'legends' is the money left with a personal note from Nick Faldo when he once played here. We even have an annual competition now for 'the Faldo Fiver.' And the clubhouse was opened by Ronan Rafferty in 2001. So all we need now is a visit from Tiger Woods and our life memberships will rocket! It's a hundred and fifty pounds for as much golf as you want. Forever! We've got over six hundred members and at least one billionaire who once dropped in by helicopter with some mates for a couple of rounds!"

"Well—y'should be able to do that yourself soon," said Anne, with a wide grin.

"What?"

"Drop in by helicopter . . . y' know, when you've sold a few more of your paintings!"

Willie's epithetic response, alas, is not suitable for publication in such a modestly toned book as this.

IT WAS QUITE A WHILE LATER, after a delightfully impromptu *strupach* afternoon tea with Willie and Moira, along with her delicious home-made Scottish pancakes and cookies, that we finally headed back to the narrow Bays road in search of the Dilworths.

And of course that meant more tea and cookies and cake, with the family greeting us as if we'd been expected all day. And Willie's recommendation was well justified. Steve and Beka sat together along one side of a huge pine table and regaled us with tales of their artistic ideas and projects. The walls of the cozy kitchen/living room were filled with collected objects from around the world and an eclectic array of artworks by the family, including Beka's superb black-and-white photographs and Steve's sculpture maquettes.

"I feel as if I've stepped right into the middle of a creative whirl-wind!" said Anne as Steve showed us photographs of some of his best-known works and then led us on a tour of one of the most jumbled and clay dust–smothered studio workshops it has ever been our pleasure to enter.

"Yeah—one day I'm gonna sort all this out," mumbled Steve, with a grin. He was a tall man, lean and strong as a tree, with de Kooning–like blond straggled hair, bright eyes, and an intriguing aura of energy, purpose, and beguiling humor about him. On a side table lay a catalog of his projects, barely visible among a welter of tools and more swirls of clay dust.

"Okay if I look at this?" I asked.

"Help yourself—it'll save me trying to explain what I do, although the language gets a little . . . well, y'know . . . arty."

"Who wrote it? One of those critics who believe that the more con-

voluted the explanation of an artist's work, the more 'important' it must be? Y'know—Tom Wolfe's comment in that book of his, *The Painted Word*, that art's in a weird state when you have to rely upon rhetorical mumbo-jumbo to establish its meaning and significance!"

Steve laughed. "Ah—truth is so refreshing at times!" he half shouted, and banged his hand on the workbench, sending clouds of dust spiraling up along a wall full of wood saws (at least a dozen), axes, hacksaws, drills, mallets, hammers, chisels, and random hangings of old and very large fishbones, fishnets, coiled ropes, animal skulls, and other skeletal remnants from creatures whose identity was ambiguous. And somewhat alarming.

Apparently, one of the main themes running through many of his works is "dead things encased"—in clay, wood, metal, coiled rope, or any combination of the above. His catalog was prefaced by a brief parable: "On being asked for proof that one of his objects did, indeed, contain a bird, Dilworth replied, 'Destroy it and see.' "

The catalog continued in user-friendly prose:

When living in Wales, my wife and I kept a few pigs and we made our own bacon. Lumps of meat would hang drying in the kitchen. So it was no great step to use meat as a material for sculpture. The earliest figures were very simple affairs, salted pigskins stretched over chicken wire frames. Then a firm was located which specialized in human skeletons for anatomical purposes. I already owned a fully-articulated skeleton which hung around the studio. Also, I acquired a dead calf from a knacker's yard and attempted to unravel it, muscle by muscle with tendons attached . . . using these materials—human bones and meat—I began to wonder if I was getting into something dangerous. Almost as if I was making some kind of bomb and beginning to realize the importance of the act of making it and its responsibility. Also the tapping of some kind of energy. Becoming a channel, however imperfect.

Birds are used in many works as a starting point. Some feel the work is all to do with death, but this is not correct. I do not deny anything as a possible material simply because it was once alive. Displacing it from its cycle of Life/Death/Decay, there is a point where a tree can become

timber, or a sand eel become a thread in a weaving, or a bird loses its identity and becomes material. These transitional points fascinate. I do not believe an artist's job is to state the answers but to find the questions. These objects are drawn from an internal world and exist with all their inadequacies in front of us. Perhaps they are metaphors of life—the more that is learned, the greater the depth of ignorance.

And that, in terms of text, was essentially all there was in the catalog. The remainder consisted of a series of finely modulated black-and-white photographs of Steve's studio, his wide range of once-animate remains, and finally a series of his "small objects"—tight, dramatically articulated mini sarcophagi, each reflecting aspects of the form and spirit of the mummified creature within.

"These are amazingly . . . powerful," I said. "You're using what?— shaped and polished wood, iron, brass, whalebone, silver, steel, dolphin teeth, fishing line, soapstone, all essentially inanimate substances—and yet the end form is so tactile . . . you want to reach out and move it around in your hands."

"Like this?" Steve grinned as he lifted one of his objects from beneath a dust cloth on the bench and passed it to me. "It's a maquette for a much larger work. This one will eventually be twenty feet or more across."

It was egg shaped, about a foot long, and consisted of two smooth, finely polished wood shapes—a carapace—bound together by steel "laces" except for a narrow separation of the two halves, which suggested a mysteriously dark interior and something lurking within.

I looked at Steve quizzically.

He laughed. "Oh, yes—there's a skeletal bird in there. Have faith! Unless, of course, you insist on breaking it open to see . . ."

"Ah, but . . . well, then I'd have the answer, wouldn't I? And it wouldn't be half so powerful as keeping the mystery . . . finding the question."

Steve laughed. "Now you're getting it!"

"And these superb photographs. Who took these?"

"Beka—of course. Who else?"

And right on cue, Beka joined us in the studio and came over to

stand with her father. She possessed the same tall, wiry frame, muscular arms, light blond hair and eyebrows—a sort of wispy Wyeth portrait of strength and determination coupled with a slight aura of vulnerability. That look of the always-questing artist. Or a young girl moving into mature womanhood. Vulnerability coupled with a vivacious smile—and, once she launched into describing her own photographic work, a vigorous sense of purpose almost bordering on a mission.

"I've always been drawn back to Harris—this incredible landscape. And the people . . . ," she told us as we returned to the house and climbed the steep stairs to a small (and exactingly neat) studio filled with computer electronics, camera equipment, and carefully filed project photographs and negatives.

"Bit of a contrast to your dad's workshop," I suggested.

Beka giggled, childlike for a moment. "Ah, well—our work is rather different. He needs the stimulus of things just lying around—'accidental aesthetics.' I'm a neat-freak. The mess is usually up here!" she said, pointing to her head.

"I don't see any 'mess' in these images," I said truthfully as she showed us some of the photographs for her *Harris Portraits* book. "You seem to know exactly what you want to say about the people you're photographing. Your sense of their character—their 'presence'—it just leaps right off the page! No gooey fog of pretension like you see in so many coffee-table books."

"Well—thank you," she responded somewhat bashfully. "Y'see, this is something I began a long while back—it's part of a college project. Mum and Dad had bought this place . . . over twenty years ago, I guess. And I would come here often in between doing all kinds of location photographs for the Scottish Film Commission. I even worked for a few weeks on the first Harry Potter movie—as a Steadicam assistant in London. My main project was that fabulous scene in the bank with all those gnomes. D'you remember? No blue-screen stuff—it was all on site—a real set—four teams of operators and cameras and all working simultaneously. Very choreographed. Absolutely fascinating. I learned so much."

"So why the switch to Harris photographs?" Anne asked.

"Well, I was—I am—in love with this island. I went to school here

and I've known most of the people I photographed for years. I some-
times spent days talking to them, letting them tell me about their lives
and their work here. And the photographs seemed to kind of take them-
selves. When the moment—the mood—was right. 'Happy accidents,'
many of them. So much of photography is pure luck no matter what the
professionals say. Y'can set things up right—but in the end there has to
be that special moment—that magic split second—when the thought,
the knowledge, the background, the scene, the individual—when they
all just coalesce—and you've got something usually even better than
what you'd intended . . . it's hard to explain. You just know it when it
happens."

"Like love!" said Anne.

"Yeah, right. A little bit. The 'creative moment' when it all comes
together . . . and that little bit of luck—and love—too."

"You're being very modest," I suggested.

Beka gave another one of her schoolgirl giggles. "Oh, maybe. But it
makes you feel quite humble, because it's more than just you taking the
photograph. It's . . . everything. Something greater than you and the
subject."

"Are you going to add descriptive captions in the book?" I asked.

"No. No, I don't think so. A good photograph should speak for itself.
If it's done right it contains its own story and words can get in the way
. . . not in your kind of book, obviously. But in a photographic book."

The three of us sat together quietly (maybe words were indeed get-
ting in the way) and just absorbed the power and intensity of Beka's
images. She had captured the hard, bold spirit of the island and its inhab-
itants perfectly. And she was right—the photographs did speak volumes.
Captions would be superfluous.

"Well—maybe at least someone with credibility should write a brief
foreword . . . y'know, provide a context for people not so familiar with
Harris," I suggested.

"Oh, absolutely. Definitely," Beka agreed. "And guess who's agreed to
write one . . ."

I could think of half a dozen island people who would do a fine job

in that area. Beka was watching me closely. "Well—there's one person in particular who I'm sure would be delighted to participate."

"Who?" she asked, grinning.

"Bill Lawson, our island history and genealogical guru. He's a fine writer with an amazing awareness of the significance of Harris."

There was a short silence and then Beka laughed aloud and clapped. "You got it!" she gushed. "How did you know?!"

"Because he's just right," I said, not quite telling her the whole truth, which was the fact that I'd already planned to get Bill involved with *my* book. But I guess I'd maybe left it a little too late now. "Congratulations!" I said.

"Oh, thank you. I think he'll be great!"

"Oh, he will, he will," I mumbled (maybe through a slightly clenched jaw—but I'm sure I hid my frustration well. And later on I decided to approach Bill anyway—which explains his eloquent Afterword at the end of this book!).

"And here's another guesstion for you," Beka chuckled.

"Yes . . . ," I said warily.

"Bet you can't guess what's under this bed in my studio . . ."

Anne and I looked at the bed. It seemed very neat and ordinary. "I'm not even going to try to guess—you and your family are far too full of surprises!"

Beka rose and fumbled under the bed. "Are you ready . . . ?"

Anne and I sat in rapt anticipation.

"Hope you're not queasy types." She laughed as she slowly pulled out what at first looked like a large, long bundle of weatherworn plaited ropes intricately bound around . . . a real human skeleton!

"Oh, my God!" whispered Anne, retreating to the far corner of the room.

"Jeez!" I think I said, or something equally inane.

"One of Dad's early masterpieces!" Beka giggled.

And I must admit that once the first shock had passed, I became intrigued with the incredibly complex binding patterns and tendonlike rope trusses of Steve's creation. The skulls, the hands, the legs and feet,

the carapace of dried and sewn animal skin, the locks of horsetail hair—all cocooned in endless but meticulously crafted tangles of twine and braided rope. Words again proved redundant. We all just sat looking at the . . . creature.

Frightening, proud, bizarre—like a huge African tribal idol. And I remembered something Steve had said quietly in his dust-shrouded studio: "My creations are kind of arks that sail through time . . ." And his other written comment: "I began to wonder if I was getting into something dangerous . . ."

I wasn't too sure about the "danger," but we all certainly sensed a dark, timeless totemic presence and power in that figure. Something that even another pot of tea downstairs with Beka and her parents couldn't quite dispel.

It's amazing what keeps popping up on the backroads of this strange little island. We'd suspected that, in a small-pond-big-fish kind of way, we'd discover excessive narcissisms here, twittish and tweedy one-upmanships, gonzo literati, and aesthete-harridans from Hades. And admittedly we did find a few "little emperors in grass castles" preening themselves with clip-job lives, and the intellectual quackery of artificially constructed egos barricading their carefully constructed—but usually utterly undeserved—reputations. But, in this curiously unpeopled island, we left them to float on in their fragile ego-crafts down into the drowsy half-dark. We enjoyed instead the company of those who seemed to have true vision and the willingness to undertake the hard work that shapes their arduously crafted meditations and creations.

Islands can offer moods of sweet, benign latency—an immense dreamscape of possibilities—a constant search for "there must be more" insights. And this we found on Harris. In abundance.

Visiting the Bard

N ARTIST, A SCULPTOR, A photographer—but, so far,
no writer. Then, as soon as I read that first paragraph of
Alasdair Campbell's book *Visiting the Bard*, I knew I'd
found a true island voice—a Hebridean James Joyce with all the lilt,
insight, crackle, and bite of a visionary poet:

> Back on the island, on a loose scree clifftop at the back of Aird, flat gray
> skelfs of Lewisian gneiss shift, clattering, under your feet, as your rig
> boots seek then secure a purchase, the district of Ness extends to your
> right in a blue haze, a darker blue stripe of road running through it, and
> under a high flaring sky, the Atlantic, streaked with tidal rips and cur-
> rents, stretches beyond the faint curving rim of the world, impossibly
> huge in the glistening space of afternoon light. Over the limitless waters,
> a deep-ocean wind sweeps cloudshadows, snaps the trousers against your
> braced legs, brings tears to your eyes. Confronted with this immensity, a
> primeval fear bates your breath, turns your stomach to ice—where is
> your defiance now? where is all your arrogance?

The Outer Hebrides have lured and nurtured more than their fair
share of celebrated writers—Martin Martin, Johnson and Boswell, J. M.
Barrie, Compton Mackenzie, Finlay J. Macdonald, and more recently, of
course, John MacLeod, Alison Johnson, Derrick Cooper, John Murray,

Norman MacDonald, Angus Peter Campbell, and the Nicolson family—Nigel and his son, Adam.

But many of these individuals were outsiders. What the islands invariably lacked, certainly in recent times, was their own true born-and-bred bard with a cadenced voice as strong and resolute as the ancient rocks here, and a vision that mingles detail, tone, emotion, and Gaelic-tinged humor into a magic mix resonating with truth and power.

Alasdair Campbell is that bard and I wanted to find him. Badly.

"Och, he's a hard man to pin down . . . always moving about . . . ," I'd been warned by one of my local informants.

"Well, dear me, now, I'm thinking he's way up in Ness—way, way up," another one told me, making that little outpost at the northern tip of Lewis sound as if it were lost somewhere in the deepest Arctic.

"He's not a very patient man," said a third, implying that I would likely not receive a warm welcome even if I went "way, way up." "Oh—an' he's got a great love o' the Gaelic . . . an' the bottle . . . so they say." Doubtless a suggestion that even if I made the journey, I'd be unable to decipher even a word of what he said, either due to great gushes of the native tongue or the confusions of a whisky-laced brain.

I thought a judicious phone call might indicate the appropriateness of an impromptu visit.

"Who d'y'say y'are again?" a deep voice with a distinct burr asked.

I explained for a second time.

"And y'want to do *what*?"

"I'm reading *Visiting the Bard* for the third time and I'd like to meet its creator."

There was one of those distinctly pregnant pauses.

"Third time, eh?"

"Yes. And who knows, maybe even a fourth. It gets better each time . . ."

The voice warmed and laughed. A genuine, hearty laugh. "So, when are y'comin' up?" Alasdair asked.

"Tomorrow. Day after. Whenever."

"You've got that much free time, eh?"

"For you—yes."

More laughter. "Nice jammy life y've got there!"

"I guess you could describe it that way."

Warm chuckles and silence. Then, "Ah, well. How 'bout tomorrow. Around one o'clock."

"Great!" I gushed. "And thanks."

"Well, we'll see about the thanks later . . ."

I detected a slight menace in the chuckling voice.

My informant was right about Ness being "way, way up." But it was a fine, clear day over the North Harris ranges, across the vast bronze-olive wastes

Alasdair Campbell—Writer

of Barvas Moor and up the arrow-straight road toward the cliff-bound tip of Port of Ness and the Butt of Lewis. I passed surprisingly hay-rich, Irish-green croft fields sprinkled with sheep and the occasional Shetland cow. Compared to the croft houses of Harris, their Lewis counterparts seemed larger, whiter, and altogether more prosperous. My landmark was "a wee kirk" on the left side of the road at Dell and then a rough track to "the largest house around." "Y'can't miss it," Alasdair had told me ". . . an' it's not mine. Writin' books doesn'a buy a place this size!"

Actually, there was no need for such modesty, as it wasn't that much bigger than many of the "improved" crofts I'd seen on my journey. But I quickly realized that despite his celebrity as the "Lewis Bard" and a host of BBC playwriting and teaching credentials, the man had a genuinely modest outlook about himself and his reputation.

He stood waiting at the door. Tall, distinguished—almost professorial—and smiling.

"So—you made it all the way from the sweet sands of Seilibost?"

"A superb drive. For a change. After two weeks of gray glop."

"Ah, yes, the joys of our Hebridean climate . . . come on in. Park y'self by the fire."

Yet another fine peat fire—glowing amber with a faint traditional earthy "reek"—in a cozy room filled with worn leather armchairs.

"So—tell me again. Who are you and whad'y'want of me?"

The first part was easy. I gave him a minibio. But the second was not.

What did I really want of this man whose two books—*Visiting the Bard* and *The Nessman*—had given me more insights into island life and ways than almost anything else I'd read? And I'd read a lot. Our little cottage was awash with books on the Hebrides. I'd relished them all, but something in the verbal power, pungent Proustian imagery, and almost tactile characters of Alasdair's work, possessed deeper and far more poetic resonances. How to tell him all this without sounding unduly sycophantic? In the end I just told him the truth: "The first pages of my copy of *Visit-*

Iron Age Carloway Dun

ing the Bard are an utter mess of underlining and scribbles—in fact, I should really buy another. I can hardly read the text with all my comparative notes about James Joyce, Dylan Thomas, Brendan Behan—I think there's even a mention of Henry James alongside some of your longer sentences—oh, and sometimes flashes of Jack Kerouac and William Burroughs . . ."

Alasdair looked a little embarrassed. Maybe, despite my honesty, such comparisons with other oracles of fine oratory were a little overwhelming. "Well, anyhow," I said, moving away from all the name dropping, "you write as if you're on a real high—and it makes me high just reading it . . ."

He roared with laughter. "It's a good job there's no bottle around or we'd be toastin' that remark!"

"Okay," I said, finally adopting my role as interviewer as our laughter subsided. "Let's go back. How did your writing begin?"

"All right. Well I wrote m'first . . . novel, if y'can call it that . . . when I was in university. I had a tutor—friend of Dylan Thomas. Good critic, though he couldn't write himself. Encouraged me a lot but, thank Christ, I lost that book. But I banged out another one . . . possibly the worst thing I've ever written. Got rid of that one too. But he wanted it published—his critical faculties were definitely suspect at that time—but I think he enjoyed being my Svengali. He said it had 'real truth' in it . . ."

"Why—are most of your books autobiographical?"

"Not autobiographical, but it has to be pretty close to your own experience if you're writing fiction. It's based on characters I know—but a character goes its own way once you start writing. People point out 'that's so-and-so and that's so-and-so and that's you' and I tell them it isn't because, well, for a start these people are Gaelic speakers and I'm writing in English. Some could barely speak English. Bits of it I did in Gaelic and I've written quite a few Gaelic books—but *Nessman* and *Bard* reflected the fact I was doing plays in English for BBC Radio Four—the afternoon plays, y'know. Then I stopped doing them and I'm pretty sorry now that I did. I lost touch because I was doing a Gaelic radio drama for three years . . . something like *The Archers*, that English radio

series that's been running forever. I set mine in Harris because I lived there—in the Bays, Drinishader—four years, when I was married. My wife was a teacher. And I was staying in the schoolhouse there, but we were a bit low on production budgets. I even had to kill off one actor because we couldn't afford to fly her home from Stornoway every week! And I found out you can't live by plays alone—or by novels for that matter! Currently I've got a grant from the Scottish Arts Council to do six one-act plays in Gaelic and we're thinking of starting a drama group in Ness."

"Is *The Nessman* a popular book? Did it sell well?"

"It certainly sold well regionally . . . but I don't really pay much attention once a book is finished. It'd be nice to get rich on royalties, but that's not the way it usually happens. You've got to keep on working—get out, round and about. I was just down at a book festival in Wigtown recently—y'know, reading and signing. First time I've done it. Terrible panic at the beginning but after that I found the audience was very friendly—they weren't throwing cabbages and the like. I was in there a couple of hours and most of the time I was okay. But it's a wee bit nerve-racking. It's the way of the world now. You have to be a performer. Seems to be that way. TV talk shows. Bookstores. You get to feel like a traveling salesman. Performing and writing don't really go along together. The performer takes over. Dickens killed himself doing that—especially on that American tour. Dylan Thomas too . . . and James Joyce."

"I told you I could sense flickers of all those and other writers in your books."

"Well, I don't imitate them. But inevitably your style is formed by what you read and admire . . . it's probably what Robert Louis Stevenson called 'the imitating ape' in me. I have to be very, very wary when I'm writing. Whoever I happen to be meeting at the time is goin' to come into it . . . and then I have to make sure I don't let style—the influences of other writers—mold the actual words and experiences. Y'have to clear your mind of such influences as much as y'can—but they're still there. I certainly admit that Joyce is an influence on my writing, but there again, almost every writer who came after him has been affected by him to

some extent. He liberated the language . . . the thoughts . . . the whole approach to what writing really is. I mean, he truly is the giant of the twentieth century."

"Do you use a word processor? My editor believes the computer has done enormous damage to writing in general."

Alasdair threw his hands in the air and shouted, "Oh, yes! True, true, true! Ah . . . the ubiquitous computer . . . it's very dangerous . . . all too easy . . . looks too neat . . . you can't see the bad stuff at all. The problem with many writers is there's a helluva lot of superfluous stuff you have to wade through . . . the computer has made that much worse. Too fast—too finished. With prose writing, y'have t'keep revising it . . . y'have t'keep going back to it . . . removing the superfluous, the weak parts, the stuff in it that maybe makes you laugh but doesn't get the story out . . . and in a lot of prose writing, exorcism is vital!"

"Yes, right, 'kill your darlings' and all that—but of course you Gaels are not known for minimalistic prose."

"Absolutely! The Gael is very fond of not using one word when ten will do . . . the winter nights were very long here and very much in that tradition of the *ceilidh*. It's just about dead now, of course, 'cause of that bloody TV box. It was all so wonderful . . . in this part of the island in particular there were drinking places, y'know, the bothies in the village—a lot of *Visiting the Bard* took place in those bothies. Not secretive, every village had one or two and that's where the men went—no women—and you went every night and . . . it was pretty good, to put it mildly. The stories, well, they could stretch out sometimes over a whole week. Those long stories. They were the real *ceilidh* spirit! Sammy MacLeod can tell great stories in Gaelic and in English—well, y'know that because he told me you've met him. But the stories you get that someone might translate for you—they lose just about everything . . . it really depresses me. The new people who come here, they don't make any effort to learn the language or, if they do, they start writing spurious nonsense—some on Skye do it all the time. They'll never be 'of the place'—never will be . . . just can't do it. My characters are all Gaels . . . I just can't get into the head of an Englishman. I wouldn't presume to do such a thing."

Alasdair paused. The Gaelic language was obviously a key touchstone of his life and his art—but frowns kept forming on his forehead. "Y'see—this is one of the last places in the world where the language is used on a daily basis. Maybe a little in Wales too, with the Welsh language. But we're not going to be able to fully revive the Gaelic because we're being taken over and more and more outsider people are settling here who just won't learn it. So Gaelic is dying. It's moribund, despite the efforts to legally revive it. People who sold a leaky garage in London can move into a full croft up here and there's nothing you can do about it. There's no way of stopping it. This is the way of the world and that's it. I mean, y're not gonna put a house on the market and stipulate that only Gaelic speakers can bid! Very worthy idea—but no. Och, the remnants of us will be ready for the grave soon, wasted hopes and tattered dreams—jibbering to one another in Gaelic—and no one knowing what we say."

"There's a great Gaelic spirit in the way you describe the land, the island topography, the moors . . ."

"Ah, the moors. I know these moors. I've lived on these moors and among all the remnants of ancient cultures around here. You don't have to be very long on the moors before you realize . . . y'become very quiet in y'self . . . what Yeats called 'peace dropping slow.' The proud Gaelic melancholy of all that wild blackland . . . and all that silence. It gets into you. It was wonderful on the sheilings up there in the summers—with the cattle. My mother taught me so much . . . the lowing of the cattle, the birds, y'see the weather comin' for miles . . . and all that silence. The silence of the moor. The silence is what the old people always talk about and they all say the same thing about the moor—you didn't want to come off it, you only wanted to stay. Y'know what it does t'you? When you come off the moor? If y'been in a shieling or suchlike for a month . . . it's all so bloody noisy when you come off . . . why's everybody so churlish and talking so loudly! All that shouting!

"I know people from Ness—they'd wait for April and then they'd be up there and that's where they'd all stay until October. Maybe walk back once a fortnight or so for eggs and suchlike. I would love—before I die—to spend a lot more time up there, but the paths we took are now

heathered up because there are no sheep left—I'll need to take a young folk or two to clear the way and someone with second sight to warn us of all the dangers!"

"Second-sighters keep creeping into your books . . . and ghosts too."

"Ah, yes—they're good, good stories. This is what the *ceilidh* was great for. I mention the ghost stories in my books just as it was in our house. I know Lewis people with second sight. Many people. They didn't think it was anything special. But today—they've really gone and mucked up our ghosts. Electricity, cars, TV, telephones, and all those things—a decent ghost wouldn't hang around here with all this palaver. How can a ghost survive? What would be the point?!"

Our meandering conversation moved on to other things—stories of Alasdair's life on the oil rigs in the North Sea, his two failed marriages, and his still optimistic activities to recharge the Gaelic spirit and language against all the rampant odds of a faster, more fluid, open-to-change world.

Then he paused for a moment. "But y'know, I'm just thinking about those ghosts and things . . . I reckon I'm so tied into this place that even when I'm gone . . . there'll still be a part of me floating around here, haunting these moors . . ."

WINTER

Bays Scene

2 0

Hogmanay Interludes

———

*E*VERYONE HERE KNOWS THAT CHRISTMAS is not a particularly
popular celebration on Harris due to staunchly Presbyterian
ethics that virtually dismiss the season as a paganized irrele-
vancy—or, as one friend put it, "a peculiar period of wavering agnosti-
cism"!

Everyone knows this. Everyone, apparently, except me.

On a recent trip to Stornoway, I'd seen plenty of Christmas decora-
tions in the stores, spontaneous demonstrations of affection for the Yule-
tide in the pubs, and people dragging enormous bags of brightly
wrapped gifts up and down Cromwell Street.

On Harris, however, things were far more subdued. True, there was a
single modest line of colored lights strung out by the stores overlooking
the harbor and a few hesitant attempts at holly wreaths and the like on
the doors and porches of some of the homes. But you could tell the
hearts of the *Hearaich* were not particularly galvanized by this particular
season.

Talking with the old salts down at the Clisham Keel (where else?), I
got a hearty dousing of Calvinistic diatribes about the "Catholic frivoli-
ties of Christmas" and the fact that most islanders regarded Christmas as
merely a kind of lukewarm interlude prior to the year's major celebra-
tion of the Scottish New Year, better known as Hogmanay.

As soon as the magic "H" word was mentioned they were off, filling
my uninitiated Yorkshire head with tales of ribald indulgences and unfet-

tered frolicking among the homes of Tarbert and in the isolated croft cottages along The Bays and on the road to Hushinish in North Harris.

"Ne'er stops f'a week or more," claimed one elderly man who invariably sat at the bar wearing what he proudly called "m'Aussie desert hat." This was an ancient, sweat-dissolved remnant that admittedly had some tattered bits of netting dangling from the brim, so I guess it might once have been the traditional Australian outback "fly screen" headgear.

"Usta be a lot more fun than 'tis today," murmured another, and told me tales of the "real traditional rituals of *Challuinn*," originally held on the twelfth of January—the "*old* New Year's Day." Apparently, in many communities, the young boys would form into bands and select a leader who was made to wear a sheepskin or cowhide on his back. Others carried sacks and off they'd meander from home to home, reciting Gaelic rhymes that began:

This is the night of gifts
Good wife rise up and bring down the Hogmanay bannock
We take the bread without butter
We take the butter without bread
And we bless this house
And all who are in it.

All being well, the festive group would then be invited in and the leader would walk clockwise around the fire (my informant was referring to the old black-house days when central peat fires were commonplace), his followers striking his sheepskin with sticks. Then they'd all be given their bannock cakes or whatever else the "good wife" could muster up, bless the house, and move on into the night, filling their sacks at house after house until they finally sat and gorged on their collected goodies at the end of their meanderings.

"Aye, that was fun enough," agreed another elderly gentleman at the bar, "but when y'got to be an adult, the real games started!" And he gave me a rather racy tale of the men setting out with whisky bottles and oatcakes to "first-foot" as many houses as they could through the long, fes-

tive, and raucous night. Whisky was given and received in abundance; food was offered everywhere as a symbol of expected plenty for the coming year. But there were cautions too: "Y' never brought in a red-haired man—ver' bad luck that could bring [maybe, due to what remains of my Irish-red hair, that's why my invitations to "first footings" were a little sparse], and a woman! Och, that's much worse—'specially if she's a blonde!"

The old salts were right. Christmas indeed was a rather limp and languid affair, although I did enjoy a splendid dinner at Katie's hotel with the MacAskill family, buoyed by seasonal blessings and awash in fine whiskies, as Roddy insisted on giving me yet one more lesson in the "magic of the malt."

"An' if y'just wait a few more days," he said, "we'll do it all over again for Hogmanay!"

THE NEXT DAY, THIS LONG, DARK season of almost-perpetual night became distinctly white.

These first bouts of winter during the New Year Hogmanay period came at a most inconvenient time. First, Anne was away. Her mother had taken ill in Yorkshire and she'd headed south again to be with the family. Second, although we'd finally returned to our Ardhasaig cottage after that idyllic interlude on the Seilibost sands, we'd had to move out for a few days due to a prior booking by some Londoners who wanted to experience a riotous Hogmanay in Harris. (They should have gone to Edinburgh instead. The whole thing there is a true tourist happening.)

So, I was stuck in an unfamiliar rented house with no wife and no heat and trying to engender emergency warmth through the magic of strong Yorkshire tea. But then I looked out of the window, and all pending *duldachd*—a sort of melancholy Hebridean winter depression—floated away. It was a glorious early morning—a low, horizon-bound sun, bronze-burnished clouds, the North Harris peaks salted with snow and their lower slopes still in their traditional tweedy colors of ochre and moss green. And I was suddenly happy. If this is winter, I thought, I'll survive it quite comfortably.

Then things changed. Dramatically. Admittedly a Hebridean norm, but it certainly took me by surprise as I turned to look again at the gentle morning scene half an hour later to be met with . . . white.

Obviously steam on the window, I thought. I'd made a real fog in the kitchen as I boiled water for the tea, so I carefully cleared the glass surface of condensation . . . and noticed not a scintilla of change. If anything the white was even more pronounced. Except there was movement in this white. Furious horizontal flurries in the form of snow, the hiss and crackle of hailstones like small golf balls, and a rapidly rising scream of gale-force winds.

It was a true, authentic whiteout. I could see nothing of the mountains now, the sea lochs, the small boats, the salmon farm, or the crofter's cottage just down the grassy slope. I couldn't even see the grass outside the window, and my tiny car parked below had vanished into this eerily blank, bleach-white world.

I turned back to make more tea, amazed both by the ferocity of the snowstorm and the rapidity of its arrival. I couldn't have been more than five minutes or so in the kitchen preparing the brew, and selecting a couple of very English-style cookies for my breakfast. And then I thought I'd check on the storm's wild progress.

Only now there was no storm.

And nothing to reflect its prior demonic presence except a luscious, velvety coating of sun-sheened snow across the whole glorious vista from the tops of Clisham to the slate windowsill outside, a few inches from my bemused face.

I don't think I've ever seen such rapid shifts in weather anywhere. And it continued on through this strange day—one idiosyncratic montage of brilliant sun-bathed interlude in which the snow sparkled like gold-dusted ermine, then another whiteout, followed by a glorious winter sunset at three o'clock in the afternoon that created a world so golden, silent, and mystical I felt I'd slipped into a soft dream.

My dreamlike mood is matched in the fine book *The Islanders: A Hebridean Experience,* by Rosemary Millington, who expresses the mystery of the Hebridean weather in a paean of prose poetry:

The climate of these hills was mysterious. Seemingly out of nothing, invisible winds, intangible humidities and tentative currents of warmth were drawn out of the air; the weather was engendered. Here the winds lived and the heavens came nearest to the earth—the clouds drifted about the high castles of rocks and left shining rain running down their ramparts. It rained or deluged on twenty days in every month, and more . . . Sometimes rain and hail jetted out of a naked sky and there were fleetings of strange unaccountable shadows over the hills and magic luminosities smiled when the shadows went away.

I suddenly realized, after the sun had vanished, that the house was becoming distinctly chilly. When I'd first moved in a couple of days previously, the rather stern lady proprietor had pointed to an enormous square cast-iron contraption full of little doors and vents and pock-marked with knobs. It crouched ominously in the corner of the kitchen. I thought it looked distinctly unfriendly. A Stephen King type of thing. She smiled a sort of wan half-smile and almost dismissively told me, "Oh, and that's your central heating stove."

"Stove? You heat the water for the radiators in this?"

"Yes. It was once an oven, too, and other things, but we only use it now for the central."

"It's what? Oil, propane . . ."

"No." She gave a patronizing smile. "Of course not. It's coal."

"Ah. Coal . . ."

"And dross."

"Ah, dross . . ."

"The instructions are around somewhere. It's quite straightforward. Just read them. Carefully."

When she left I searched for the instructions and finally found them under a pile of "how not to make a mess of things" manuals for all the other bits of equipment around the cottage. Unfortunately, I couldn't seem to master the subtleties of this strange and complex item and so I left it alone, silent and glowering in its corner.

And the same went for the peat fire in the living room. How delightful, I thought, when she showed me the tiny fireplace all ready with kin-

dling and paper and two fat slabs of peat waiting to be lit and burned merrily in traditional Highland fashion, bestowing a pleasant peat-reek aroma to the room. I'll luxuriate tonight . . .

Before lighting, I paused to admire the peat squares. I lifted one and it was almost as light as polystyrene. The sodden, wet moussey stuff they cut from the peat banks in May, then dry on the moors during the summer, then carry back to the house and pile up in great herringbone-patterned stacks (*cruachs*) for winter, seemed so dainty and crumbly now. Little roots of ancient growth stuck out and I thought, this could be hundreds, maybe thousands, of years of rotted, compacted moorland vegetation here. A beautiful organic, environmentally correct, and sustainable slab of nature's bounty.

Only it wouldn't burn.

The paper did. Beautifully. And the kindling. And the flames licked the peats, and licked and licked and then finally gave up. Ten minutes later the big fire pile was reduced to an ashy residue in the grate, with the two pristine peats apparently untouched. And try as I might over subsequent days, I never learned the art of getting these things to do any more than give off a lot of smoke and smolder—but no flame. And no heat. And certainly no peat-reek.

And—at the very beginning of the Hogmanay week—there was no power either. A furious Atlantic gale had apparently felled a number of electricity poles high up in the North Harris hills and it took two long and chilly days before power was restored. Not a pleasant predicament, and despite the glimmering light of the candles, the room in my temporary new home seemed ominously dark and full of looming shadows. If Anne had been around, we'd not have even noticed and doubtless would have been drinking hot mugs of Christmas cheer and reminiscing about other Christmases we'd spent in exotically odd places around the world.

But Anne was not here and, despite the kindness of a few newfound friends around Tarbert who'd plied me with invitations to join them for seasonal celebrations, tonight I was alone. And a little lonely too.

Normally I have no problems being alone. Which is perhaps a good thing, because so much of the traveling life consists of inner journeying with only yourself for company. But on that particular night, my alone-

ness in that dark room—in a dark and strange house, in a dark town, with not a glimmer of light to be seen anywhere because of the power cut—felt distinctly maudlin and oppressive.

Wham!

The front door suddenly started to rattle and shake, and if this had been a Disneyesque cartoon, I think my body would have shot vertically out of the armchair, ramming my head straight through the plaster ceiling (with those little cheeping birds and stars flying around my head to emphasize my dazed predicament).

As it was, I remained firmly seated but my eyes were focused on the door. What the hell was that!? Was it some errant blast of a winter williwaw? Was the handle moving? And was that a scratching sound, like long nails being drawn slowly down the worn wood outside . . . ?

Stupid! I thought. Forget it.

But I couldn't. I was, as they say in Yorkshire, becoming "half a bubble off plumb," and for some dumb reason I rose slowly from the chair and tiptoed across the floor to the now silent door. I waited. The handle was not moving.

"Hello," I said in a voice so low and hoarse I hardly recognized myself.

Silence.

"Anyone there?"

More silence.

So—nothing to do but open the thing and take a quick, nervous peep outside.

Which I did. And there was . . . nothing.

Nothing, that is, except a small plate wrapped in cheesecloth sitting off in the shadows by the winter skeleton of a small bush.

I leaned down and picked it up. It felt warm. Which was more than I was, so I carried it inside, closed the door hurriedly, placed it on the table by my chair. And opened it.

I think it was the closest I got during that strange Christmas to a tear or two. Maybe it was Anne's absence that added a touch of drippy sentimentality to this little miracle—a plate of four warm mince pies, redolent in Christmas aromas, and a tiny miniature bottle of Chivas Regal.

But no note. No indication of who was responsible for this little gift of generous spontaneity.

But it changed everything. Someone had remembered I was here in this unfamiliar house and not at Clisham Cottage. And someone had cared enough to bring the spirit of the season to me on this cold black night, and in the middle of a power cut too.

God, it's a strange place, this Harris, I thought, but then suddenly felt a rush of love for the island—and all the people on it.

"God bless us, every one!" I said aloud, quoting that beloved last line of Dickens's *A Christmas Carol*.

WITH THE RESTORATION OF LIGHT and a modicum of warmth after those two frigid days (I finally managed to master "the creature-in-the-kitchen"), my lonely mood lifted and, in full-color hindsight, I guess Hogmanay turned out to be a time of fine fun and frivolity, couched in luxuriant waves of indolent lethargy. In fact, ironically, we possibly had more fun here in Harris than the tens of thousands of frustrated revelers in Edinburgh who had gathered for the annual megacelebration of music, dancing, fireworks, and feasting. Because it never happened. A sudden storm of epic violence tore into that poor city, ripping up show tents, felling trees and miles of seasonal decorations, and scattering the drenched and freezing crowds who never got to dance to the big-name rock bands or applaud the "massed pipers," or even sing that epic Robbie Burns ballad of "Auld Lang Syne" on the midnight cusp of the New Year.

There was plenty of singing, dancing, and kissing, though, and antics of a slightly more exotic nature, at our local community center dance in Tarbert. I enjoyed prancing around the floor with some of the lovely ladies here, with Sammy MacLeod's band playing reels so fast and furious that you felt you were going to spin yourself and your partner right out the snow-laced windows. And I took a few toasts with my friends down at the Clisham Keel, a dram or two with Roddy, a delightful evening listening to the tales of John Murdo Morrison (an invaluable island informant for us) and Catherine Morrison (owner of our Seilibost cottage). And I also remember a dozen other memorable Hogmanay

interludes that, despite Anne's absence and the ghostly creaks and groans of beams and rafters at night in my temporary home, I recollect enjoying immensely here, on my little island, celebrating the immortal words and sentiments of Robert Louis Stevenson: "So long as we are loved by others I should say that we are almost indispensable; and no man is useless while he has a friend." And despite the fact that my wife and best friend was off-island, I certainly don't remember ever feeling "useless" during that delightful season.

The Arts Meeting

H ARRIS THRIVES ON ITS MEETINGS and public discussions. These constitute the pumping blood—the adrenaline—of democratic island life here. They are boring, fascinating, tedious, inspired, dogmatic, perceptive, tautologically excessive, sonorously self-important—and long. Invariably they are all far too long, unless Morag Munro is the chairperson, in which case the often rambunctious, outspoken, opinionated participants will invariably become subdued by her strict, no-nonsense, headmistress-like demeanor.

Morag is only a small lady and, in a one-on-one chat, a delightfully modest and impeccably polite individual. But put her and her tightly bunned hair and her stern bespectacled face in front of a restless *Hearaich* crowd in the local community center and the meeting will quickly come to order and usually stay ordered—and even brief—if she has her way. Which she usually does. And such a skill is vital here on an island awash with issues of dire consequence, from the (still) ongoing debates about the Lingarabay rock quarry, the allocation of bus contracts (lifeblood of island mobility), and the future of fish farming, to the purpose of the as-yet-unbuilt Harris Tweed Center site (a real boondoggle project), the proposals for those vast wind farm developments, the ever-increasing demand of incomers for new housing permits, and that constantly divisive issue of Sabbath ferry sailings (so far, still strictly forbidden).

If Morag is in charge, such critical issues will be dealt with efficiently (if not finally—nothing seems to be final here) and fairly. But if Morag is

not around, as at one particular meeting Anne and I attended, things can become a little more unfocused, almost to the point of blindness—or certainly severe blandness.

It seemed a simple enough agenda according to the handwritten signs on the local shop windows: "How we should organize the arts—and the artists—on the island into a coordinated, new fund-supported program for progress and enhanced expression." A straightforward, even inspiring initiative, one would have thought, particularly in the light of these new funds apparently being offered by external grant sources.

However, that was not to be the case, and we, as relatively impartial observers, only wished Morag had been with us.

Maybe someone had closed the doors to the small meeting room at the Harris Hotel a little too early on in the proceedings. Maybe the resultant fog and misty condensation on the large windows overlooking the harbor and the shaggy-grass hills across the road introduced a som-nolent note into the presentations and discussions. Or maybe the free coffee and shortcake biscuits did not inject enough caffeine and sugar-laced energy and enthusiasm into the two-hour-long gathering.

Certainly, that flyer had been enticing, suggesting new strategies for stimulating the arts on the island. Well, Anne and I thought, there are certainly enough artists and craftspeople working in homes and studios all around Harris to warrant a lively evening's debate on future possibil-ities and potentials.

But it soon became clear that the dozen or so artists and craftspeople who attended quickly became a little blurry-eyed and fuzzy-headed, as the charming young lady who had recently been appointed to spearhead these "new initiatives" here seemed determined to emphasize the intan-gibles rather than the pragmatics of her project.

She first tried to explain about the "cultural rights and entitlements" for artists: the need to "level the playing field" for artistic opportunities; the amalgamation of notoriously territorial arts councils and cultural institutions; the need for radical redefinition and "infrastructural enhancements"; and the challenging role the arts had to play on Harris in education, health, cultural development, and macro/microeconomics; and so forth. It all began to sound a bit like a university tutorial with an

avid student trying to impress her peers with sweeping generalizations punctuated by key buzzwords of the month.

Eventually she realized that her hesitant delivery and academic phraseology were not exactly sparking the ardor and involvement of the participants who had gathered so expectantly in that little room, now distinctly overheated and moist with trapped air.

"Best o' luck," mumbled a young man, who I later learned had once played a similar kind of coordinator role to the newly appointed presenter. He told me that despite fine aspirations and intents, he had actually spent most of his time ensuring that funds were available to cover his own salary for the next fiscal year. "It really takes it out o' ye," he half whispered. "There was so much crap flyin' around . . . no one seemed to know what I was doing . . . and no one wanted to know . . ."

Finally, there was an outburst of frustration: "C'mon now—let's get down to nuts and bolts," said Willie Fulton, one of our favorite island artists, and obviously in a puckish mood that night. "What exactly d'y'think you'll be able to do to help us all?"

The young lady seemed a little disconcerted by such a direct line of questioning and turned to a second presenter from the "High Arts" element of the Scottish Executive at the national level (or something like that). "Well—maybe you could follow up on that, Robert . . . ," she said pleadingly, and then escaped to get herself a cup of urgently needed coffee.

And, bless him, Robert certainly tried. He had a pleasant, laid-back manner, but he still seemed to

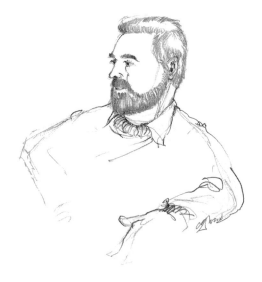

Willie Fulton—Artist

feel that a description of the "larger picture of opportunities" was essential "to establish a content and context for localized initiatives." And so he told us that the arts included *all* the arts—music, drama, dance, visual arts, crafts, and so on; that meetings and "dialogues" would be set up at all levels to develop "integrative analyses and responses" and "route maps" that reflected a "redefined infrastructure" that in turn would "permeate in a most dynamic fashion down to the local and individual levels."

We all soon realized that this was actually a meeting to discuss the mechanism for creating more meetings and reports and studies, while the local artists, craftspeople, and other embryonic cultural entities waited to see what could and would be done. If anything.

Willie was on his feet again, a little more dark-browed and impatient this time with all this limousine-liberal vacuousness: "So I ask again— what d'ye think are the local benefits—the real nuts and bolts that could help us out here? In Harris."

Robert still didn't get it. He launched on again with his clammy fog of rhetorical references to "coordinated funding" (not *new* funding, he emphasized—a bit of a letdown there—but primarily a more effective use of existing funds), his role as a "catalyst for change and cooperation," the potentials for "far more integrated action here in Harris," and the creation of workshops for policy formulation, blah-blah-blah . . .

"Och! Forget it! We'll do it ourselves!" mumbled Willie. And that finally hit the right note with the small audience. They started to talk among themselves, leaving the two presenters to leaf furiously through papers and booklets and notes to see if they could find anything a little more tangible and pragmatic to suggest in a frantic effort to regain their stature as truly useful "catalysts."

But it was too late. With mumbles about "buckets of hogwash," "gushy gobbledegook," and the "bland leading the bland," the locals were off discussing their own priorities and concerns in a spirit of collegiate conspiracy, and the ideas poured out—subsidized local visits by theater, dance, operatic, and other national institutions; subsidies for creating more artists' studios; help to promote artists' works in the major cities and "getting the goods to market"; and the need for a local com-

munity arts cooperative center and gallery to display the remarkable range of on-island talent.

"Maybe that's what we should build on all the land they've spent millions on filling down by the harbor for the Harris Tweed Center," mumbled Willie again. He was certainly enjoying his own role as "catalyst." Other ideas included the distribution of "art and craft trail maps" for visitors, indicating the location of island studios and workshops; funds to support evening classes in the arts for everyone; funds to create new annual local arts events; new types of employment in arts-related activities for the young to stem the tide of their out-migration; more use of Web sites and online gallery guides; the creation of interactive arts journals; and on and on.

In the end, life, energy, and ideas filled the tiny room. The doors were opened to remove the fog and condensation, discussions eased out into the hotel bar, and the island artists in their little groups were fast becoming a splendid example of do-it-yourself local initiatives and innovations.

Even the two presenters looked pleased—and relieved. They climbed off their high horses of hyperbole and joined in the fray of discussion and debate. I heard Robert at one point waxing eloquent about the island being "one of the richest cultural hot spots in Britain," and Willie responding with an uncharacteristically enthusiastic "Aye, y'damn right there—we jus' need to use it more!" Nods of agreement all around.

Well, Anne and I thought as we left the hotel in a rather bubbly mood, it's definitely a start. So many plans and projects for Harris and the other outer islands have vanished into the great maw of bureaucratic territorialism, half-baked concepts, outrageously inept implementations, and even occasional gaudy scandals of greed, graft, and corruption. But this time, if the artists themselves keep priming the fires of initiative and action, who knows—things might actually begin to change . . .

But we couldn't forget the skeptical words of the ex–arts director: "Best o' luck!"

A COUPLE OF NIGHTS LATER I was discussing this meeting with two old fishermen in the Clisham Keel. They shook their heads and chuckled

and said they'd heard so much about these kinds of "improvements" over the years that they couldn't be bothered to listen anymore. A third man overheard our conversation and muttered something in Gaelic. The two fishermen laughed and one told me, "Och—it's an old proverb: '*Cha thainig gaoth riamh nach robh an seol feareigin*'—'Whatever wind is blowing will fill someone's sail.'"

2 2

Seals, Silkies, Shape-Shifters, and Other eMysteries

O UR FLIRTATION WITH ISLAND FOLKLORE and other strange-
nesses was revived at the tail end of another rather limp *ceilidh*
at the Clisham Keel. Apparently we'd missed one of the star
attractions of the evening, a young man once connected with the famous
New Age folk-rock group Runrig. After he left, the solo accordionist in
the corner of the room dabbled with a reel or two, but without the crisp
clip of a snare drum, a prancing fiddle, and a set of pipes, his rendition
was irregularly rhythmed and lacked the normal toe-tapping bounce
and briskness.

Then a young girl with a plain, rather sad face, long brown hair
unstyled and badly cut, and a distinctly hunched way of moving stood up
and mooched over to the microphone. No one seemed to pay much
attention. The accordionist started packing up his instrument and we
assumed it was all pretty much over. Until she began to sing. A cappella.

Her voice was electric. Galvanizing. Even the beer swillers at the bar
quieted and turned to listen. The room was silent in seconds as her song
flowed out among the surprised onlookers. Anne nudged me. We both
recognized the words and the tune immediately. In an instant I was back
to my late teenage years when I'd fancied myself as something of a folk
singer–guitarist, until I realized that it was actually my sister, Lynne, that
pub audiences in Yorkshire came to see and hear. And one of the songs

they requested, more than any other, was a strange, magically melancholy series of minor-chord verses. Lynne would explain to the audience that it was an ancient Gaelic ballad describing the strange transformation of a seal (*silkie*) into a man who falls in love with a beautiful island girl who bears his child. Eventually the man returns to his seal life, singing his strange lament:

> *I am a man upon the land*
> *I am a silkie in the sea*
> *And when I'm far from land*
> *My home it is in Sule Skerrie.*

Later he returns briefly to be with his earthbound love and tells her that eventually their son will join him in his aquatic home. And here's the stanza that's guaranteed to silence sensitive audiences—as he predicts:

> *And thou shalt marry a proud gunner*
> *And a fine proud gunner he shall be*
> *But the very first shot that e'er he shoots*
> *Will shoot both my young son and me.*

If it's done right, this odd little fragment of a folk ditty will water the eyes of the most ardent resister of sentimental songs. As this young girl did that night. There were definitely tears in beers around the bar and the scattered tables. And what was as transforming as the song itself was the beguiling way that that hunched, plain-faced, skinny shard of womanhood stood straighter and taller as her song progressed, threw back her head, and let her voice—pure tonal silver—flow out into that silent room and mesmerize everyone in it.

And, as seems to happen so often in our lives, synchronicity slipped in a few days after our evening at the Keel when we met a man who not only knew about silkies and the like, but had spent years researching the strange legends surrounding these shape-shifting sealmen. He'd even written a book on the subject: *Seal-Folk and Ocean Paddlers.*

His name was John MacAulay, famous as one of the last island boat builders and the man who had custom-built Adam Nicolson's boat, *The Freyja,* in 1999. Adam's intention was to use the craft primarily for journeys across the treacherous waters of The Minch to the Shiants—his cluster of high, seabird-encrusted islets rising dramatically from the ocean about eighteen miles due east of Tarbert. They were first purchased by Adam's father, Nigel, in the 1940s and had passed down to Adam himself and recently to his own son. The outcome of all these sea crossings in John's sturdy creation emerged finally in Adam's finely crafted masterwork, *Sea Room,* a book much respected by islanders for its scope, accuracy, and enticing "sense of place."

"I learned an awful lot from that book," Roddy MacAskill had told me. "M'family's been on Harris for generations . . . so I should have known much more than I did. Adam's book opened a lot of eyes and hearts here. It made you realize just how rich everything is on our islands."

That was a lesson I also learned prior to our meeting with John when we were trying to understand more about Harris folklore. I mean, I'd heard brief references to *silkies, kelpies, glaistigs, gigelorums, sidheans,* and mercurial "wee folk," but the *Hearaich* are a canny Calvinistic lot, reluctant to admit any real knowledge of such "sillinesses." Even discussions of "wise women" and those with "second sight" tend to be cursory and dismissive, although there are many tales floating about of individuals with strange powers and seers with prophetic insights.

Some of the legends stretch credulity to the snapping point, especially stories of Loch Lann's *Flath Innis* (Rich Pastures of Lost Heroes), the Celtic paradise of *Tir-nan-og,* or Atlantis-like lands sunken beneath the ocean waves. There's even one tale that tells of people "from under the waves" emerging to teach the *Hearaich* how to dye and weave their world-famous tweed and to sing the weaving songs that reflected the pattern thread sequences of the warp and weft:

Ten of blue to two of red
That's the way to lay the thread

Ten of green to two of white
Thus we have the pattern right

Another bizarre folktale claims that Noah's Ark came to rest in the hills of North Harris as the Great Flood receded, leaving "a goodly supply of small birds and animals" before being refloated and sailing on to Mount Ararat in Turkey. The fact that an ancient carved stone on Canna contains a depiction of something closely resembling a camel is considered evidence that species far more exotic than small birds may also have been left behind here!

After such hyperbole, it's almost a relief to listen to lesser tales of the pernicious *fridach*—"small, minute, miserable creatures, full of spite, venom, and hostility" that brought disease and distress to the crofters—along with the *gigelorum*, equally evil, and "an animal so small that it makes its nest in a mite's ear." There were wormy creatures too—*fiollan*—that could cause great pain and swelling. They became useful threats to lazy children who were warned that "idle worms" would plague their fingers if not occupied in useful labor. *Fuath*, or evil spirits that popped up in a number of guises, were also a particular threat to poachers, particularly fishermen. Poltergeists too were a real nuisance around the croft, uprooting fence poles, pushing over *cruach* peat piles, and stealing hens' eggs.

Ghosts, as might be expected, came in various forms and contexts. There were your everyday wraiths floating around cemeteries, abandoned crofts, and the dark corners of black houses. But others were involved in more complex things like "teleportations"—a spiriting away and return (sometimes) of the living on long, mysterious journeys known as *falbh air an t-Sluagh*. There were also tales of phantom sailing ships, and even on occasion kind spirits and creatures that helped sailors in perilous seas find safe harbors. Wizards, or *fiosache*, were also said to use ghosts and other supernatural creatures in their spells. Seers, however, did not. They relied primarily on "second sight" and other prophetic abilities to warn of coming events and catastrophes.

And then, of course, come all the odd superstitions, such as sailors

welcoming the sight of teal ducks or swans flying over their boats as a blessing and guarantee of good fortune on the voyage. However, the presence of a raven or a cormorant nearby was always considered an ill omen:

> *When she sailed out to the deep*
> *Never a teal-duck greeted her*
> *But a raven on her track*
> *Oh, pity those at sea tonight!*

The snipe was also considered an eerie bird, particularly at night, and even the mention of its name was thought to engender misfortune. The same went for the cuckoo. So numerous synonyms had to be invented to avoid saying their dread names.

Windows on the west side of houses (actually, many houses tend to avoid windows on that side to reduce the impact of furious Atlantic storms and gales) should always be closed at dusk to deter those ghostly *Sluagh* teleportations.

One of the most interesting superstitions is related to salt, once an extremely valuable commodity despite the abundance of seawater everywhere. It was the expensive option and preferred to the ash of kelp, the traditional ingredient for meat preservation. Stealing someone's salt was tantamount to stealing a wife and equally fraught with terrible consequences. However, because salt was considered "blessed," giving some to a neighbor was "most meritous" so long as its repayment was never expected or accepted ("The eye shall not follow it").

And thus Anne and I did our homework, piecing together the complex jigsaw of island superstitions and supernaturals, prior to our meeting with John MacAulay. Which finally came one "mizzley" late afternoon as we wriggled our way along the narrow Bays road, always wary of reckless sheep or cocky drivers assuming the road was all theirs, and down into the rocky hollow of Flodabay.

The Bays landscape was at its lunar best—or worst, depending on your climatic preferences. Under sodden gray skies, ponderously thick and spitting irritating drizzle that required a constant, slow sweep of

windshield wipers, the broken rocks reared up like primordial life-forms emerging from the boggy soup of creation. Their ragged profiles and lumpen tumbles were glossed with rain. Black lochans lay still and peat-black between the mires of marsh grass and mounded tussocks.

"Miserable," muttered Anne.

"But beautiful . . . in a dramatic kind of way," I suggested.

Silence. A familiar stalemate of perceptions.

"It's scary . . . the whole moor seems alive with . . . ," said Anne, leaving me to fill in the blanks.

"Creatures! Monsters! Things emerging—ancient things—from all this black gloop . . ."

More silence, broken by the intermittent whine of the wipers.

And then, around a tight bend and down a steep incline, came life in a more recognizable form. A man. White-haired and ramrod-erect in the wet, moving among a huddle of boats in various stages of disrepair. Behind him a corrugated metal hut was set in a hollow overlooking a tight, rock-bound inlet—a fjord in miniature—with more boats floating against rough-hewn piers. Compared to the empty desolation of the Bays coastline, this place reeked of activity, purpose, and passion. We had found our boatman-author surrounded by his creations. He watched as I pulled the car off the narrow road. I recognized him immediately from Adam's description in *Sea Room*: "He stood four-square, legs apart and shoulders back, resting a hand on the gunwale. His long gray hair was brushed back from his temples. He wore a small gray moustache and looked me straight in the eye: a straight, calm, evaluating look . . ."

But with a welcoming smile too.

"Ah—you must be David . . . and Anne."

"Yes, indeed we are. Hope we're not interrupting your day . . ."

John chuckled. "On this kind of day, interruptions are most welcome!"

The rain, of course, intensified as soon as we stepped out of the car. We all moved to the cozy, dry shelter of his hut. A boat in the process of construction filled much of the cramped space.

"Looks a bit like the boat Adam described. The one you built for him."

"Ah, yes—the *birlinn* type. A good boat, that one. Not your ordinary kind of tub like this one. I'm working on it for a friend. Not much of a craft, but by the time I'm finished with it . . ." John laughed and left the sentence dangling. I explained that ever since I'd read Adam's description of John's work on his own sixteen-foot-long boat, I'd wanted to meet its creator.

John smiled. "Well, now you have . . ." And then added quietly, "That book of his has led to quite a few . . . occurrences."

"What—like a host of wannabe sailors demanding replicas?!"

"Aye, well, a bit o' that too." John grinned. "But no—much stranger . . . let's go in the house for tea and I'll tell you quite a story."

I liked this man already and so did Anne. She was smiling that special kind of smile she saves for individuals in whom she senses straightforward honesty, integrity—and humor.

"You keep a very neat workshop here," Anne said. "Everything organized and close at hand."

John grinned sheepishly. "I can't work any other way."

Anne was right. The hut, despite its sparse architectural charms, was meticulously organized with all the various boat-building tools arrayed by type and size along the walls above the workbenches. Mallets, saws, chisels, drills, grinders, hammers, and countless other collections of woodworking and metal-working devices were displayed with exhibition-level meticulousness. A dust-coated radio crackled erratically in the corner by the rain-etched window at the rear of the hut.

John noticed my glance and apologized for the noise. "Yeah, I know. 'S'time I got a new one. Aerial's gone . . . or something."

I smiled. At least there was one imperfection in this tiny haven of organized creativity. Something he had not yet mastered. Unlike the rest of his life, which, according to others on the island, reflected his Renaissance-man capacities for historical research into the island's Viking heritage ("I've got Norse blood in me, I guess," he told us later; "MacAulay is the Gaelic equivalent of that very common Scandinavian surname, Olafson"), fishing and sailing, writing, bagpipe and violin playing, poetry, boat building and restoration, and—as we were soon to learn—a new and unfamiliar role, as a father!

"Yes, it was Adam's book that altered my whole life. Not just because of its popularity but . . . well, let me see to y'tea first . . ."

We had moved from the hut (a sudden cacophonous downpour on the metal roof made conversation virtually impossible) into the warm intimacy of his home across the road.

The place had all the thick, stone-built durability of a typical Hebridean black house, and the neatness of the living room, with its cozy fire, reflected John's meticulous, everything-in-its-correct-place sense of order.

"Can y'manage a wee bit of cake too?" he asked.

"Absolutely!" said Anne as we settled into the armchairs by the glowing peats.

He was back in no time with a full tray, teapot steaming and plates with sliced cake and cookies. One never said no to such hospitality and, as was the custom, one always tried to empty the plates in gratitude for the host or hostess's generosity. The only challenge was, as we had learned much earlier on, to pace ourselves.

John didn't seem ready to tell his tale yet, so the conversation rambled and we let him do most of the talking.

First it was about boats. "I work maybe on six or so a year, on average. The *birlinn* is one of my favorites. Not much bigger than a large rowboat but, at sixteen, eighteen feet, she's more like a small, sturdy ship—integral keel from bow to stern giving you stability, yet it's still a light craft for its size. Nice narrow bow, good for rowing and direction—she slides through the water—but a wider middle to reduce roll and pitch."

Looking outside the rain-streaked window, I pointed to one of his boats set proudly on blocks outside his workshop. "That's far bigger than Adam's boat."

John laughed. "Ah, yes, well, that's my private project. Three years in the making. Thirty-eight feet and solid oak. It's a replica of Joshua Slocum's *Sea Spray*. It's for myself—a sort of retirement fantasy. I've no plans of following Joshua's explorations but . . . well, some nice extended cruising would be a great pleasure to me in my dotage. 'Course that's assumin' I ever get any dotage. I've just started a boat-building class at the

school in Tarbert. Always wanted to try that. I've got half a dozen really keen students at the moment and it's hard work—but a lot of fun. My feelin' is if I can help even just one of these lads stay on-island and build boats rather than movin' off, it'll all be worthwhile."

Then the conversation switched to fishing boats and the depleted fishing industry in general. "If I had my way," said John with almost religious fervor (we learned later that he was a highly respected elder at his Leverburgh church), "I think the whole of the west coast of Scotland should be closed off and kept as a fish-nursery area for at least ten years. The Minch particularly. It's getting completely fished out. We should just allow creels and long lines—no more major commercial fishing until the stocks revive."

"And scallops. Would you include those?" I asked.

"Of course. Cut out the dredging. It wrecks the breeding grounds at the bottom and you end up with piles of broken scallops—no good for eating. Dive scallops are the best. The ones who're doing it on-island make a good living at it, but they have to be careful and not too greedy. It's not just the depth you dive, it's also the amount of time you're underwater. Regardless of depth. I know about that firsthand. I used to do it—along with many other crazy things: crofting, working in the Glasgow shipyards, boat chartering. A lot of lives in a single life!"

"And talking about single . . . are you?" I asked, wondering when we'd hear the story of his unexpected fatherhood.

"Oh, right! Yes—I was goin' to tell you . . . right. Well, as I said, it's all Adam's fault. Here was I, living a pleasant sort of bachelor-type existence, minding my own business, building my boats and whatnot. And then, talk about coincidences. Someone—a young lady—very recently was reading through Adam's *Sea Room* on the ferry from Tarbert to Uig and suddenly realized that this boat builder described in his book might just be her own father. I wasn't even aware of her existence, of course. I didn't even know she was on this Earth. Her mother had never told her—or me—who the father was. She only said sometime last year that I was a boat builder from Lewis. Now her mother lives there and my new thirty-five-year-old daughter lives there too, with her own family in Point of Lewis. It also turns out I've got three grandchildren!"

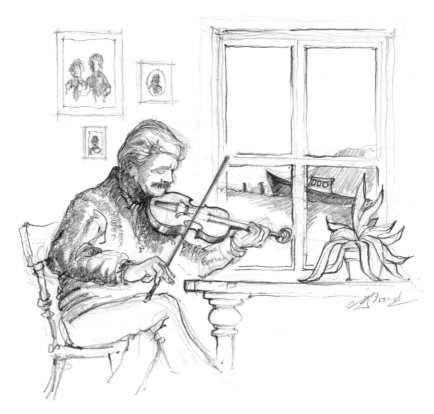

John MacAulay—Boat Builder

John paused, obviously still beguiled by his new discoveries. "Ah—but look now, I'm getting ahead of m'self! So—she was reading Adam's book and she knew there weren't too many boat builders left on the island today and realized that it may be me that's her father. So when she was back on-island she decided she'd come down by herself, not knowing, of course, what to expect or what kind of welcome she was going to get or anything. And she arrived out of the blue and well . . . it was just great! Love at first sight! Straightaway I could see myself and my family in her. Very much so. Now that's about three months ago and we all spent this Christmas together and we're the best of friends now. But I did call Adam to tell him the story—and I also told him not to write any more books! It's sad, of course, that I missed out on all the younger years of the grandkids—but well, at least we've found each other now and we

speak several times a week. And I'm even friends again with her mother. So that was a really nice coincidence . . . it's all been quite hectic. Wonderfully hectic. Not just with my newfound family but everyone they're connected with too."

Anne loved the story. "You're so . . . lucky!" she said, laughing.

"Yes, yes, I am. Still can't quite believe it."

"Of course that's what some say about your seal-folk book . . . ," I said, a rather tactless segue of mine back to the primary reason for our visit.

"What?" asked John, a little surprised.

"Well—that they seem to have problems believing some of your stories . . ."

John laughed and nodded. "Oh aye, that's understandable, I suppose. We're a hard-nosed Presbyterian bunch on this island. Some people get a little nervous . . . well . . . y'know . . . about the more mythical, mysterious aspects of our culture. To them it can seem like a return to . . . I don't know . . . pagan elements, fairies . . . waterhorses . . . the Blue Men of The Minch . . . the *Sruth na Fir Ghorm* . . . all that stuff the church doesn't like. 'Long nights in the black house' legends and the fishermen's tales. But y'know, when you've spent your life in boats out on the water, there are always things happening. Strange things. I've got a lot of respect for The Minch and its stories. When I was young I spent deep time out in the fishing boats around the islands and boy!—could those old salties come out with their 'trawler tales.' Sitting together around the cooking stove when it's black and stormy, you'd hear things that you remember forever. Mysteries that last. Of course, they were very superstitious, these fishermen. The tales were taboo except when they were all together . . . and from what they told me, they hauled up some pretty strange . . . creatures . . . in their nets."

"Creatures!? What kind of creatures?" I asked, trying to put flesh on the skeletal bones of John's mysteries.

"Did you ever see any of these 'creatures' . . . did anything in particular happen to you that made these mysteries real?" Anne asked.

John chuckled. "Och, no, not really . . . I'd love to give you a true 'I was there' tale, but honestly, I don't think I can. My book was not so

much about making the myths even more mysterious, but rather trying to research them and explain how the seal-folk legends could actually be based on historical fact."

"But one of the blurb quotes on the back of your book says that you 'reopen one of the most fascinating puzzles of Scottish maritime history and leave us with as many questions as answers and the mystery surrounding the seal-folk of legend remains . . .'"

"Well, that's as may be. What I tried to do was to remove at least some of the nonsense. I tried to show that the *silkie* legend of seals assuming human form and being unable to return to their seal homes without their mysterious sealskin belts was, in actuality, based on sightings of Norse kayak-men often seen around these islands in the seventeenth century and long before. They traveled independently over huge distances, wrapped in sealskin clothing and kept watertight in their sealskin kayaks by a tight belt around their waists. They couldn't set out on their journeys without such a belt. They'd sink in no time. And so the legend of the magic belt and the shape-shifting transformation from men on land to sealskin-encased individuals on the sea began—and endured. There are even traces of very early Norse encampments in the bay north of Ness. They were small people—possibly linked to the Sami Laplanders—the Finn folk. There's even an island near Ness—Pygmy Island—that's possibly linked to a resting place for these 'little folk.' The funny thing is that the Gaelic for the island is *Luchruban* . . . which sounds a lot like the Irish term 'leprechaun' . . ."

"So myths and realities slide easily back and forth into one another," I suggested.

"Too easily. The Grimm brothers were masters of the art . . ." He reached out for a copy of his book. "Listen to how Jakob Ludwig Grimm described these Finn folk:

"They were like the swan-maidens and mer-wives of Scandinavian and German tradition. They are denizens of a region below the depths of the ocean, and are able to ascend to the land above by donning a sealskin. If this garment be taken from them, they cannot pass through the sea again and return to their proper abode."

"So already—reality is merging into myth . . ."

"Oh, yes—and isn't that how most myths emerge?"

"Through myth-takes!" I suggested.

John laughed. "Or a mixupery—or a mixery, as opposed to a true 'mystery.' And also, out of all this mixery came tales of 'second-sight' abilities. One of our most notable lives here on the island, as I'm sure you've both found out by now. Let me just read you a bit more:

> "These seal-folk, already endowed with extraordinary maritime skills were nearly always attributed with supernatural powers—able to predict and control weather; practicing magic; soothsaying and sorcery. They also had, too, the power of healing man and beast and an uncanny ability to communicate readily over long distances—through the medium of telepathy . . ."

Anne laughed. "A very talented species."

"No, but listen—it's fascinating what published twentieth-century researchers have come up with," said John on an enthusiastic roll. "Robert Crottet wrote in a 1947 article entitled 'Children of the Wild' about a special subrace known as the Scolt (Scott?) Lapps: 'Nature has preserved in them the powers we generally call "second-sight." Telepathy among them is a commonplace . . . we need to know that on the confines of Europe there are some people who preserve these special powers we have had to lose in our constant endeavor to master nature, and sometimes even its creator.'"

"And have you had any personal experience with 'second-sighters'?" I asked.

John chuckled again. "Ah—you're trying to get me tangled up with 'the mysteries' again! I'm the one who's trying to sort them out by showing the links between historical fact and maritime folklore—all inexorably intertwined."

"Yes, I know. And you've done a great job with your book. It's just that I wondered . . . I made a note of something in Fiona MacDonald's book *Island Voices* [frantic search through my notebook]. Ah, here it is. This is an elderly woman describing her second-sight premonitions:

"It's often about death but there's nothing to be frightened of. It's something like an inward eye. One thing that's a mystery—two things—first, sometimes you can pass your vision to someone else if you're touching them. Also, when I was very young, I could sense death when I walked through the door of a house. And also whatever you see you go on seeing it until you actually understand what it's about and who it concerns. It keeps repeating until you get the full picture. And once you recognize the person concerned you never see it again ..."

I closed the notebook. "So—does that sound familiar?"

John smiled. "Familiar, yes. But it's still a big mystery to me—although the best mystery I've ever experienced is finding my new family!"

"Yes, I bet it is," said Anne.

"Y'know," I said, shifting the focus a little, "if only you could direct some of your expertise to resolving the mystery of poor old Harris Tweed and its constant misfortunes ..."

"Ah, yes," said John with a slight sigh of relief, possibly glad of a change of subject. "Now, here's a real dilemma where some second sight could be most useful. Problem is, weaving's been up and down for decades. Every few years it goes up. Then down again. Harris was never the main weaving area anyhow, despite its name. It was up in Lewis around Stornoway and Carloway. Most children were once taught to weave as a matter of course. My mother and father, like most folk, weren't full-time weavers. They did it when they could or when the demand was up. It's strenuous work, particularly on the old Hattersley looms—you need strong thigh muscles for the foot pedals, and a good eye for the weft, for broken threads and the like. But I'm sure it'll come back. With some changes. M'be a wider range of colors and a lighter fabric for the ladies."

"So long as it doesn't lose its water-resistant qualities. That's a great bonus of the old tweed in a climate like this," I said, pointing through the window at the teeming rain outside.

IT TURNED OUT TO BE a long, tale-filled afternoon and as a parting gift, John asked if he could play us a tune on his violin. "There's no words to

it . . . yet. It's just something I made up for my newly discovered grand-children . . . a little jig for them to dance to."

And so there he sat by the window, with the rain-sheened view of his boats-in-progress across the road, playing away happily.

When we were about to leave I had one more question to ask him:

"John," I said as innocently as I could, "do you ever take a sail across to Adam's islands . . . to the Shiants?"

He smiled—a slightly sly smile. John is a "canny man" and just as he spotted my attempts to extract a tale or two of his own personal experiences with the supernatural, he also sensed a possible not-so-hidden agenda in this query. But he was graceful in his response.

"Oh aye, once in a wee while. When I'm testing out a boat . . . and when the Blue Men are quiet . . . why? Would you like to join me?"

"Well, actually . . . yes, I—we—would. Adam's book has made me extremely curious about the place."

"'S'not surprising—those islands have a real 'presence.' They look so close but when you get there and start walking on those five-hundred-feet-high cliffs with all those thousands on thousands of birds, you're in a different world altogether."

"Right—that's what I got from Adam's descriptions . . . y'remember that line at the end of his first chapter—I know it by heart: 'I have never known a place where life is so thick, experience so immediate or the barriers between self and the world so tissue-thin.'"

"Oh, yes," said John with a broad grin. "I remember that"—he reached for a copy of *Sea Room* on his bookshelf—"but I think my favorite bit is on the last page: 'The islands embraced and enveloped me.' That's what it feels like when you're out there."

"Sounds like the kind of place that one of my favorite travel writers, Paul Theroux, would enjoy. He once wrote something like: 'The greatest travel always contains within it the seeds of a spiritual quest, or what's the point?'"

John chuckled. "Oh yes. Indeed."

There was silence in the cozy room again, until he continued. "Listen, I'd have been more than happy to take y'both out to the Shiants but I don't have a boat that would do the trip at the moment. Why don't you

ask Adam if he's planning to be up here anytime soon. He could show you much more than I could. He knows those islands probably better than anyone."

"Of course!" I said. "Why didn't I think of that? But he lives way down in the south of England."

"Yes, that's true. In fact, I've heard he was moving back into the family estate—y'know, Sissinghurst Castle in Kent—since his father, Nigel, died just recently."

"Oh, really," I mused, wondering how I could lure a self-declared "English toff" from the leisured luxury of one of England's most famous stately homes to the barren bastion of his Scottish isles and the sparse facilities of his rat-inhabited shack there by the shore.

"Why don't y'just call him and see what his plans are?" suggested John. "You'll never know if y'don't ask."

A pause. Followed by a decision.

"Right. I'll do just that."

23

A Journey to the Shiants

\mathcal{J}OHN MACAULAY'S IDEA WAS BLISSFULLY simple. Give Adam
Nicolson a call, explain what Anne and I are doing on Harris, tell
him how much we truly admire his book, and ask if he'd like to
take us out to the Shiants sometime for a couple of days to share
his islands and his island insights with us.

The actuality, however, was far more convoluted.

Adam was the perfect host when we e-mailed him at his beautiful
Sissinghurst Castle home in Kent. He expressed his willingness—indeed
his enthusiasm—for the prospect of such an adventure but emphasized
that first he had a book to complete with very tight deadlines, and sec-
ond, that his boat, *Freyja*, was docked way down on the Isle of Mull and
out of action for the foreseeable future.

"If you can organize a boat for us I could join you in a couple of
months," he e-mailed.

"No problem. Leave all the details to me," I confidently e-mailed
back, assuming that finding a boat on our island of sailors and fishermen
would be as simple as raking up cockles on the Luskentyre sands.

However, looking back through my files and copies of endless e-mails,
I found this cryptic communication a while later:

Greetings Adam,
You remember what I was saying in my last e-mail about the accumu-
lating minutiae of our small odyssey?

Well, how's this for a hopeless lot of non-sailing sailors on Harris—
an island once renowned for its stalwart skippers?

In order of frustration:

John MacAulay ... with apologies, no boat available (and he being such
a famed builder and restorer of boats!)

David "Woody" Wood ... Unbelievable rates for two return twelve
mile crossings but no boat available anyway until June "at the earliest ...
it's in the shop."

Alison and Andrew Johnson ... "Would love to help out but the Shi-
ants are a bit too far for our little craft!"

Shiants Trips Company ... company defunct and boat sold.

Hamish Taylor ... "A wee bit much for my 6 meter boat and it's also
a very unforgiving place."

Neil Cunningham ... Lost a finger. No sailing for a while ...

Donald MacSween ... the clam fisherman—no reply after 6 answer-
phone messages.

I'm almost at the point of giving up and making the story a kind of
hapless Brit-com about never getting there at all ... !

All the best, A weary and worried David

Nevertheless, I didn't give up. It was a long shot but I called good
old Angus Campbell, my fisherman friend and skipper of his *Intercep-
tor 42* who had taken us out to St. Kilda a while back. The only prob-
lem was that his cruiser was docked in West Loch Tarbert and the
Shiants are off the east coast of Harris, requiring a departure from the
Tarbert ferry dock. If Lord Leverhulme had ever managed to complete
his proposed two-hundred-yard-long "canal" linking the two docks
(and thus formally making South Harris an island in its own right),
there would have been no problem. Angus could have motored
through in a couple of minutes. But, as it was, he would now have to
sail all the way around the bottom of South Harris, a journey of over
thirty miles. And then back again. Twice. I felt guilty even suggesting
the venture to him.

"Okay. Fine," he said.

"What?!"

"Fine. Sounds like fun."

"Angus, it's a heck of a long way for you . . ."

"If you pick up just for the fuel, I'll promise to bring some of Christina's banana cake . . ."

I couldn't believe our luck and his generosity and heard myself starting to gush thanks.

"Okay. Deal done, David. Give me the dates when you've talked to Adam. Bye."

Angus is not a man to waste words. But he is definitely a man *of* his word and it was he who turned what was beginning to look like a farcical impossibility into a splendid actuality.

It may seem a little odd, going to all this trouble just to spend a couple of days and nights on two deserted islets, fully visible from the shore, and with few if any diversions beyond the bizarre antics of a small flock of sheep. Indeed, the world-famous author of *Whisky Galore* and dozens of other books, Compton Mackenzie, who first purchased the islands in 1925 and rebuilt the one shack here, described them as merely "three specks of black pepper in the middle of that uncomfortable stretch of sea called The Minch."

But I found the multilayered portrait painted by Adam of his little fiefdom too vivid and enticing to ignore. And in fact, on his Web site (www.shiantisles.net) he offers an open invitation to anyone to visit: "You are extremely welcome to stay on . . . this wild, beautiful and demanding place . . . one of the great bird-stations of the northern hemisphere, with some 250,000 seabirds, including puffins, guillemots, razorbills, shags and great skuas, arriving there in the summer to breed." He even goes on to suggest a shopping list of basic supplies for those adventurous enough to accept his invitation.

The birds are obviously the galvanizing attraction on the Shiants. But, as Adam revealed in his *Sea Room*, the islands resonate too with geological wonders, dramatically untrammeled beauty, and deep echoes of ancient cultures and occupancies.

Adam even turns such "presences" into evocative and slightly eerie prose:

Islands, because of their isolation, are revelatory places where the boundaries are wafer-thin. My sons tell me that night after night, asleep in their tent on the island, they have heard footsteps beside them in the grass. Not the pattering of rats, nor the sheep but something else. And although I have never heard anything like that, I am inclined to believe them. These remote islands are "places of inherent sanctity" and these footsteps are perhaps some of the last modern echoes of an ancient presence.

Later on, during our stay together on the islands, he told me a second short tale that has now become part of the folklore of the two-room cottage. Some visitor here had slept in a bed by the far wall of the second room and had been awoken by persistent knocking on the door. He got out of bed, opened the door, peered outside, and to his great relief saw no one. However, he had been suddenly chilled by a blast of ice-cold air and quickly returned to his bed, only to be awoken later in the night by the sight of a very old and wizened man standing over him. The old man stared at him for a long time, shaking with anger, and then finally said, "You are sleeping on my grave . . . and that is where you shall remain." Obviously, the visitor somehow survived in order to tell his alarming tale, but since that time beds have never been placed in that corner again.

Much later, when we were finally together on the Shiants, along with a celebrated photographer-friend of Adam's, Harry Cory Wright, who had joined us at the last minute, I was intrigued by Adam's references to the "presences" haunting his own life back in England.

Despite his own remarkable achievements and awards in publishing, his life had been immersed in the Nicolson literary pantheon of his father, Nigel, his grandfather Harold, his grandmother Victoria ("Vita") Sackville-West, and the whole Bloomsbury cult, revolving largely around Virginia Woolf: "It all became a bit too much—too much history, too many myths and ghosts. I mean tradition has it that the Nicolsons—my lot—are Viking descendants who once owned castles in Stornoway and Sutherland and pretty well ran things up here long before the MacLeods muscled in. And then, much more recently came the whole Bloomsbury-groupie era. My grandmother was invariably cast in the role of Virginia Woolf's lover but she was a kind of fictional figure to

me—I never really knew her. She died when I was four. And even if I had remembered her it's been so overlain with all the family history and papers and letters and photos and hundreds of books and magazine articles—many misleading, some utterly bizarre—that it feels almost like pure fantasy at times. When I was in my late teens I honestly couldn't bear anything to do with all the family stories, so I just pursued my own track without any reference to . . . well, I just couldn't take any more of the 'Adam Nicolson, grandson of Vita Sackville-West' stuff . . . you've just got to have some pride in yourself and who you are personally."

Adam paused. The onus of the "celebrity-offspring" state had obviously been difficult for him. I wanted to tell him of my fascination with the Bloomsburys, particularly when, as a young urban planner working in London, I'd lived for two years right in Bloomsbury Square, once the social hot spot of the avant-garde literary set. But I didn't like to disturb his story.

"Anyway," he continued, "now it's different. I've actually become really quite interested in it all. I don't feel in the shadows anymore. I've had wonderful arguments with my father—Nigel—about writing. We invariably disagreed about style. He said what mattered most was 'clarity' and you shouldn't write anything you couldn't explain in the same way at a table. My feeling is that writing is much more complicated: it should have its own internal landscape—rich, convoluted . . . I mean *Sea Room* is a curious combination of things I know very well layered over with a million things that I didn't know anything about . . . and it's odd. When I read it now I feel it's drenched in terrible sadness—everything passing—layers of things long gone . . ."

"Ah—those 'presences' again . . ."

"Yes—those—and other 'presences' too. My own family particularly! I felt I had to be honest and get rid of those, otherwise they'd be lurking behind the whole book . . ."

"Hence your exquisitely memorable, almost throwaway line—'Most of my family was gay' . . ."

"Oh God, yes. Got a few reprimands for that . . . and I had to kind of make fun of myself too by using that cartoon of me in the *West Highland Free Press*—a very antilairdish paper—showing me sitting like a London

toff—more British than croquet hoops—in a bowler hat on a rock ledge being shat upon by guillemots and snarled at by sea monsters!"

"Those presences again. The guilt of the aristocratic landowner—*snoblesse oblige!*"

"Absolutely!" Adam laughed. "Definitely a problem. When my father bought the islands over sixty years ago for fourteen hundred pounds, he said, 'To me, buying them was the most exciting thing in the world,' but the only real interest it generated was the fact he was taking over Compton Mackenzie's little fiefdom and his cottage, previously owned by Lord Leverhulme until 1925. Nowadays, as I wrote in the book: 'My presence on the Shiants is about as easy or convincing as a basking shark ordering Sole Veronique in the dining room at the Ritz! Up here the English landowner is an alien, part joke, part irritant. As one angry local once said to me here—"You can no more say that these islands belong to you than I can say that I'm landlord of the moon." '

"And he was right—although they're no longer 'mine.' I passed them on recently to my son Tom when we was twenty-one, just as my father did to me. They're the center of their own universe. They can't be 'owned.' When you think that prior ownerships might have been historically dependent on a succession of acts of violence, quite literally of murder, rape, and expulsion. Y'know—Viking-inspired 'rites of inheritance' and not something I want to be part of!"

"But of course," I said (with a chuckle, not wanting to offend this likeable "toff"), "didn't you claim in that TV series you did for your book *Seamanship*—great stuff, by the way, I really enjoyed it—that you have no problems with your magnificent fifteenth-century Sissinghurst Castle with one of the finest formal gardens in England created by Vita and Harold in the 1930s, and your beautiful Perch Hill farm too, which your TV-star wife, Sarah, has made into a masterpiece of rural organic husbandry and commercial acumen."

"Too true!" Adam chuckled back. "I'm quite content with my farm and my castle, thank you very much! But actually, the National Trust owns a lot of the castle and the farm is a serious and difficult business. We work hard, y'know. We don't spend our days chasing foxes with hounds and indulging ourselves in decadent country-house parties!"

"No—that definitely seems to be true if the number of books you've written is anything to go by. I'm even amazed you had time to join me here!"

"Ah well—your idea was just too enticing to pass on. Plus the fact I love being on the Shiants. Any excuse will do! If you want to get fit—or die—this is the place! I never cease to be amazed by how beautiful and halcyon it all is. So—thanks for organizing everything so well."

THE "ORGANIZING" HAD BEEN A little more trepidatious than Adam knew. I had become too familiar with the fickle vicissitudes of arranging anything on Harris. Invariably some glitch or unexpected catastrophe would botch my carefully made plans and schemes. The weather was often a prime causal factor of glitchiness, but it could just as easily be the kind of blocks and barriers that initially made finding a boat to the Shiants nigh on impossible. But then, fortunately, along came Angus with his generous offer and everything began to tick and tock along like finely tuned clockwork.

Shiantscape

And there he was. His boat was on time, ready and waiting, my carefully purchased boxes of supplies were lined up neatly on the dock along with four heavy bags of coal ("You'd be amazed how much coal gets used up in that chilly little shack," Adam had told me), and I was standing there expectantly clutching a rather sad little farewell card from Anne. There had been another family emergency and she'd returned once again to Yorkshire. "Take care, and make sure you have a life jacket . . . and don't do anything daft!" she'd written, fully aware of one of those minor glitches that had almost led to the cancellation of the entire venture. It could have been worse, but on one of my rambles across the pernicious, heather-clad slopes of the moor above our cottage, I'd managed to lock my ankle in a tight cleft between two invisible rocks and, if the pain was anything to go by, almost tore it off.

"Nothing torn," the doctor in Tarbert had assured me, "however try not to walk around on it too much for a while . . ."

"But I'm off to the Shiants for a couple of days with some friends," I said. "And there'll be quite a bit of walking and climbing involved."

"Ah, the Shiants—I've always wanted to go out there," he'd mused. "Well—who's doing the cooking?"

"I've no idea," I said.

"So—why don't you let your friends do the walking and whatnot and you stay and look after the meals?"

"That's not quite what I had in mind."

"No, I'm sure it's not, but I'm assuming you'd actually like the use of your ankle back sometime in the foreseeable future."

"That bad, eh?"

"It will be if you don't watch it!"

So watch it I did, wrapping the poor bruised and swollen appendage in an elastic bandage and cramming it into a near-bursting boot. And there I stood on the dock as Angus made his final preparations for the voyage, suddenly realizing that time was slipping by and there was still only me at the appointed meeting place.

Surely not another glitch, I thought. The worse one of all. Angus ready, boat ready, supplies ready—but no Adam!

Suddenly a cheerful shout echoed along the harbor—"There you

are, you old . . ."—and I turned to see this tall, long-faced, aristocratic-looking individual, dressed in a navy pea jacket and laughing gleefully between huge teeth, giant-striding along the dock, arms outstretched, face aglow with good fellowship.

And despite the fact that we were only e-mail colleagues, we greeted each other like long-lost friends. Angus laughed as he started to load the supplies onto the boat. And then laughed even louder at the sight of Harry, Adam's longtime photographer-friend, lugging his enormous, antique-looking square box camera and tripod toward us. Harry's relatively modest height made it appear he was being attacked by his massive contraption. But he seemed happy enough and reminded me immediately of Kenneth Branagh in his *Henry V* role, with his wild red hair, a face full of mischief and mirth, and a voice with that distinct Branagh burr.

"So you're not into digital, then, Harry?" was, I think, my first comment.

Harry gave a rich, throaty laugh. "Oh no, this creature does just fine f'me—I like 'em big an' a real handful!"

"Don't we all!" muttered Adam suggestively.

"Okay, gentlemen," shouted Angus. "Boarding time!"

Within minutes *Interceptor 42* gave its familiar throaty roar and Tarbert vanished in a frothy rainbowed spume.

"Angus doesn't mess around, does he?" grinned Harry, his Irish-red hair flailing. Definitely Henry V.

We were soon out of the narrow channel between Harris and Scalpay and roaring across the open Minch. Watch out, Blue Men, I thought, you'll not catch us today in this boat. And there, ten or so miles to our east, lay the bulky, whale-backed profiles of the Shiants bathed in warm morning sunshine. I'd hoped for fine weather but this was way beyond expectations. Not a single cloud broke the purity of the great blue dome above us.

"Great stuff!" shouted Adam as spray rolled down his long nose. "Angus, could you do a circuit of the islands, I want David and Harry to see the cliffs on the east side."

"Already planned on that," Angus shouted back from the wheel. "It's been a long while since I've seen 'em too."

And what a sight they were. We made the crossing in less than half an hour. I'd never seen The Minch as calm and benevolent as this before. And as we slowed to edge our way along a dragon's-back series of sharp-profile islets, the *Galtachan*, a bizarre prelude to the Shiants (Adam describes them as "the knobbled spine of a half-submerged creature"), the soaring basalt cliffs of the first of the two main islands, Garbh Eilean, came into view. Almost a match for the Giant's Causeway in Northern Ireland or Fingal's Cave on Staffa, thousands of hexagonal basalt columns rose together like organ pipes more than five hundred feet into the crystal-clear air. Adam refers to this half-mile-long "curtain of columns" as "the heroic heart of the Shiants," and it is virtually continuous along the northern shore except for the enticing natural arch punched through by the ceaseless pounding of the waves at the northeastern corner of the island.

Despite the appearance of great age and endurance, this almost perfect example of intrusive magma forcing its way to the surface from deep in the Earth's core is less than 60 million years old. Compared to the staggering age of Harris's 3.5-billion-year-old bedrock, this event occurred a few nanoseconds ago in geological time. But it was nevertheless an event of cataclysmic proportions—a vast upwelling of 1,200°C magma along a tectonic plate rift that stretched from Greenland through Iceland, the Faeroes, and the Scottish isles to the tortured black granite of Lundy Island in England's Bristol Channel, encompassing in its explosive outpourings Staffa and Antrim's Giant's Causeway.

And, just as on St. Kilda, a panoply of seabirds here of a dozen or more different species whirled and dived and spun slowly on the thermals and perched on ledges like little platoons of black-and-white-clad soldiers on parade. And once again there seemed to be no panic, no protest over our presence in their self-contained world of flight—just a kind of blithe acceptance with maybe a touch of curiosity, particularly on the part of the shags and puffins.

I had the impression that this may have been a first-time experience for Harry as he stood at the rail, mesmerized. Adam smiled and eased up beside us.

"Fantastic, isn't it," he murmured.

"Utterly unbelievable," said Harry.

"I had no idea . . . ," I said, mouth open in awe.

"Ah, but I should bring you here in the height of summer when the flocks are at their fullest. You can barely see the sky for wings . . ."

Harry nodded and smiled, more than content with today's aerial wonderworld. But as he was such an avid photographer, I was surprised he wasn't using a smaller camera to capture the scene. There was obviously no chance, with the wallowing of Angus's boat, of dragging out his mammoth box. However, he seemed happy just to stand, watch, and grin his endearing grin at whatever this season offered to show him.

I always remember Adam's emotive—but perceptive—description of his seasonal experiences here. It was one of those passages that first drew me to his book:

> Spring here is always beautiful . . . for its hesitations and incongruities laid alongside each other without comment or contest . . . The new lambs all have the same little bony body, the same strange combination of fragility and resilience, the same jumpy immediacy . . . It is the season of discontinuity. The other three have a sort of wholeness to them . . . Think of the summer and what drifts into your mind—or mine anyway—is languor, the breath of the grass banks on Eilean Mhuire where the thick summer growth stretches unbroken from cliff to cliff, the length of the days, the sheer extent of summer; autumn hangs on like an old tapestry, brown and mottled, a slow, long slide into winter, unhurried in its seamless descent into death; and winter itself, of course, has persistence at its heart, a long, dogged grimness which gives nothing and allows nothing . . . one long, wet, dark, hard day after another.

We eased on southward down the cliffs of Garbh Eilean, then passed the narrow, boulder-strewn spit of land across to the second island of Eilean an Tighe with its own magnificent contingent of soaring basalt column cliff and bird colonies. We got a brief glimpse of Adam's cottage, nestled above the beach and the landing spot on the west side. To the east rose the bold profile of a third island—Eilean Mhuire—which Adam described

Puffin

to us as "a vast guillemot colony in the summer and amazingly rich in remnants of settlements, but we're not sure of their age because they were built mainly of turf. There's not much available stone over there. And it must have been a hard place to live—there's no real protection against the Minch winter gales. Definitely brass monkey territory out there!"

Despite his age and sophistication, Adam seemed to possess an endearingly boyish nature—rich in giggles and guffaws and always ready to spot Monty Pythonesque situations zinging with zany ironic humor.

We rounded the southern tip of the Eilean an Tighe—appropriately named House Island—and headed north toward the cottage. But suddenly, as we stood by the rail, looking for an anchoring spot to launch the dinghy for the transfer to our new home, Adam's face lost its youthful appearance.

"Something's wrong," he gasped. "Very wrong."

Harry and I looked at him and then at the shore. Everything appeared fine to us. The little whitewashed cottage sat prim and perky above the rock-strewn beach, its bright scarlet roof gleaming in the noon sun. The two chimneys were intact and the grasses around the cottage had been cropped to a velvety fuzz by the ever-avaricious sheep.

"It's incredible!" Adam half-shouted. "The land's been ripped away . . . at least forty feet in front of the house has gone. And what the heck are those bloody great boulders doing around the door . . . and what's the door doing open?!"

Angus came out from the galley and stared along with him.

"Ah, right—looks like y'got the storm, Adam . . . terrible four days . . . near hurricane conditions a while back. Huge tidal surges—almost tsunamis! Made a real mess of things . . . the trees at Lews Castle were decimated . . . power was out for ages, roofs ripped open . . . even some people killed down in the Uists."

Adam didn't—couldn't—respond. He just kept staring at the unfamiliar landscape of the new beach with swathes of strata and rocks freshly exposed to the elements. He remained silent as we loaded the supplies on the dinghy and motored across to the shore. Then he scampered ahead and rushed into the cottage. We could hear his cry of outrage: "Good God—what a bloody mess!"

And it was indeed a bloody mess. We could now clearly see the tide-wrack line marking the high point of the surge. It had reached at least halfway up the cottage walls, smashing in the door, churning bunk beds, tables, chairs, lamps, pots, pans, and anything else moveable and leaving them in chaotic piles against the far walls of the two tiny rooms.

"No problem . . . ," said the gallant Harry, with a half-convincing smile. "We'll have it all back together in no time."

Adam nodded, but his eyes were blank as if in a stupor. However, Harry was right. After Angus had helped us unload the supplies and set off back to Harris, we got to work, sweeping, cleaning, replacing the furniture, and lighting a roaring fire to try to dispel the damp, musty, rotten-seaweed smell that permeated the place.

"Cup a tea?" asked the ever-cheerful Harry.

"The heck with tea. Get the Scotch out," said Adam.

We compromised and enjoyed both. And in less than an hour we had not only transformed the place into a reasonably comfortable living space but also rebuilt the wrecked iron-railing sheep fank at the side of the cottage.

"What about these boulders?" I asked Adam, pointing to four enormous basalt monoliths that the tsunami-like tidal surge had dumped haphazardly around the front of the cottage.

"Leave 'em. They're our souvenirs . . . can you imagine the strength of that storm to move things as big as this so easily—and so far!"

"They deserve a photograph." Harry laughed as he set about preparing his monstrous contraption.

"Doesn't it come with one of those shelves for a magnesium flash?" I asked facetiously.

Harry ignored me, as indeed he should have.

Adam laughed. "And surely you're going to vanish under a black shroud or something . . ."

Harry ignored him too and labored on, trying to ensure his tripod, almost as large as himself, was suitably level.

The tea, the Scotch, the revived humor, and the warm sun eventually restored our collective mood. We'd done a good job of making the place habitable, although Adam decided he'd erect his own pup tent well away from the battered cottage.

"It's best I do . . . for all our sakes," he explained. "I'm the world's loudest snorer."

"Ah—a true flubberblaster!" I said as he began to unravel the blue nylon. "That looks brand-new."

"It *is* brand-new!" he grunted. "Can you believe it . . . they lost all my luggage somewhere on the flight up from London via Glasgow to Stornoway! I had to buy everything new in town . . ."

"Do I sense more jinxes on this little adventure: your lost luggage, my lousy ankle, a drowned cottage, a decimated beach . . . and Harry . . . you had any jinxes so far?!"

Harry chuckled. "Not yet, but I'm sure I'll think of something, especially if you ask me to cook."

Actually, Harry was a fine cook, as we found out much later that day. But first there was some serious exploring to be done.

"Dave, y'sure you'll be okay with that ankle?" asked Adam.

"I didn't come all this way just to houseclean," I said, and hoped my wonky appendage would survive cliff clambering and the like. Shades of Yeats floating about: "Things fall apart: the center does not hold . . ."

But, all in all, things went pretty well. Adam was a remarkable guide to his own island and its boundless layered complexities of botany, history, ornithology, etymology, and archaeology all wrapped eloquently in his own very personal insights and interpretations.

I was hoping, initially at least, for a pleasant stroll up what Adam called the "Central Valley" of the island, teeming with lumpy remnants of ancient occupancies—possibly encompassing Neolithic, Bronze Age, and Iron Age people; the Vikings; the Clan crofters; and nowadays only the occasional visiting shepherd—a span of almost five thousand years from 3000 BC to the mid-eighteenth century. "There are," he told us, "armies of ghosts here."

But my newfound friend had other plans and set off instead up the near-vertical rock face behind the cottage. "You get more of a general view of things up here," he said, back to his cheerfully energetic self. "Oh—and be careful of loose rocks and whatnot. A young boy was killed just about here a few years back when he dislodged a huge boulder near the top. He was crushed in the fall. Horrible . . ."

Great! I thought. What's he trying to do? Tempt even more jinxes upon us?

But we clambered up anyway, without dislodging anything, onto the breezy top and edged our way across the thick grasses to the precipitous fringe of sea cliffs, more than four hundred feet high and teeming with birds. Chaplinesque puffins were the star comedic attractions at first, flapping their odd little stunted wings frantically but somehow maintaining an ordered formation of flight over the frisky wave tops.

"The Lewismen used to sail over and catch puffins here by the

score," said Adam. "They were a popular delicacy, boiled up into a lovely rich stew. Or roasted. That's the way I like them best . . ."

"You've eaten puffin here?!" Harry gasped.

"Of course. From time to time. Boiled, roasted, smoked, salted, and stuffed!"

"And are you planning to add these to our menu tonight?" he asked anxiously.

"No, no—worry not, Harry. It's illegal now."

"I'm glad to hear that. I think our frozen supermarket lamb will do just fine."

"Chicken," grunted Adam.

"No, lamb," said Harry.

"I was referring to your mental attitude!"

"Well—puffins to you too!"

Strolling slowly southward along the cliff edge, we spotted just about all of the primary species of seabirds on the Shiants—razorbills and guillemots (close cousins of the puffin), skinny, black shags (small versions of cormorants), fulmars (we watched them nervously, all too aware of their notorious habit of spitting out vile, reeking vomit at unwanted intruders), gannets, kittiwakes, and various other species of gulls. We'd heard from Angus that sea eagles, with their condorlike, eight-foot wingspans, had also been seen here recently, but we were never lucky enough to spot one.

"My favorites are still the geese," said Adam. "The only occupants really during the colder months. The barnacles, sort of a more delicate version of the Canada goose—and the graylags. I call them my winter spirits. Very sociable in nature. They seem to hate being separate from each other and the flock. Sometimes there are hundreds all collected together in one place—white chests and heads, black neck and back, and beautifully subtle tones of gray and white in the wing feathers. And they're always eating, tugging at the grass, and leaving extremely generous deposits behind them. 'Loose as a goose' is a very appropriate expression! And a little ungainly too—wobbly—on the ground. But when they take off en masse—now, that's a truly wondrous sight—so effortlessly, so easily forming into those V shapes, as cohesive as . . . as a single wing . . .

There's a real emptiness here when they leave and before the other birds start to float in . . . a spooky silence . . . otherworldly—which ironically is one of the various translations of the word '*shiant*.' "

Adam's deep knowledge of and love for these islands allowed him to free-associate gleefully in his commentaries. A brief summation of Viking history here in the ninth century and the observation that these islands possess a microcosm of the whole flow and horror of Highland history would lead to a discussion of the Neolithic world, and a description of the discovery here of a golden Bronze Age necklace, or *torc*, possibly dating from around 1200 BC. Then would follow a digression about a week spent in the cottage as a schoolboy with his father, Nigel, a few tongue-very-much-in-cheek warnings about island ghosts and *sithean*, and an outspoken diatribe against the "lordism" and "lairdic antics" of some of the "new money" landowners who had recently purchased clan estates on Harris and Lewis.

He seemed particularly intrigued with Compton Mackenzie's occupation of the islands after 1925, and it was indeed fascinating to realize we were staying in the house he had drastically renovated himself and which was featured, stylistically at least, in his two-volume novel *The North Wind of Love*.

"Not one of his best works by a long way," said Adam. "But his affection for what he calls the 'Shiel Islands' comes through so strongly through his main character—a playwright—modeled on himself, of course! As with the primary theme of the book—the creation of an independent Scotland—which was behind much of Mackenzie's political activities."

"Wasn't he also very involved in protecting the fishing grounds for Scottish trawlers?" I asked.

"Definitely. Very aggressively. He seemed to thrive on the allure of islands and their spirit of strong independence. And he lived on so many—Barra, Skye, Herm, and Jethou in the Channel Islands, Capri, and others. But D. H. Lawrence, for some reason, took offense at all this—what he calls 'I-island' self-importance. In fact he even wrote a parody of Mackenzie, *The Man Who Loved Islands*, showing how the neurotic need to 'make a world of his own' ultimately ends up with 'a beautiful private landscape dead and sterile under drifts of egotistical snow'!"

"So—no love lost between those two famous writers."

"No—Mackenzie never forgave him . . . although ironically, he did a similar thing to Alasdair Alpin MacGregor."

"Yeah, I remember that story. A cruel obliteration of that master of the purple prose! But maybe living on islands can do that to you. You get back to basics—no hyperbole, no pseudo anything . . . you see things more clearly . . . all the pretenses and all our petty self-glorifying arrogances . . ."

"Interesting idea," mumbled Adam. "Maybe that's why I was so nervous writing *Sea Room* . . . everyone seemed to feel they knew the place better than me—despite the fact I've been coming here for decades and my Viking family ancestors possibly once owned the whole region . . . I'm still seen as an outsider by many . . . and maybe I am . . ."

But as we talked, I remembered something toward the end of his book, when the writing was complete, that seemed to suggest a reconciliation with his apparent modesty. Later that evening I found the passage:

> I know the islands now more than I have ever known them, more in a way than anyone has ever known them, and as I sit here in the house I have a feeling, for a moment, of completeness and gratitude. My love affair with these islands is reaching full term . . . I went up to the far north cliff of Garbh Eilean and lay down there on the cold turf . . . I put my head over the edge of the cliff and watch the sea pulling at the black seal reef five hundred feet below me . . . I start to fall asleep then to the long, asthmatic rhythm of the surf . . . and the islands embraced and enveloped me.

Slowly we made our way along the cliff tops for an hour or two and then began to curl down off the high ground and into the long indentation of the "Central Valley."

"This is really a strange place," said Adam as we negotiated our way between nefarious marshy bits by attempting to leap, gazellelike, from tussock to tussock (my ankle required wet elephantine ploddishness instead). "There's something definitely uneasy about it—it's not a confident occupation of place."

"Well, it certainly looks as though it's been fully occupied for a long

time," I said. There were grassy humps galore, remnants of black-house walls and sheep enclosures, ancient shell middens, and abundant evidence of archaeological excavations, something that Adam has been encouraging and participating in for years.

"The problem with archaeology is that you discover the story back to front . . . upside down. We know there was a huge house here, almost forty feet long and ten feet wide with double-skinned stone walls three feet thick. And there were storage buildings nearby and a stockyard. Much of these seem to be postmedieval structures. But there's a way to go yet before we trace it all back to prehistory . . . so in the meantime I decided to add my own little twenty-first-century addition."

Adam pointed to a rather dilapidated little rectangle of land nearby surrounded by a sheep-resistant wire fence.

"My garden," he said in a wary tone, casting sidelong glances to gauge my and Harry's reactions.

"Ah," I think I said. "And you're growing what precisely?"

"Er . . . precisely nothing at the moment. I tried potatoes, neeps, and cabbages last year but they were . . . a bit of a flop."

"A little small, were they?" asked Harry sympathetically.

"Small to the point of nonexistence!"

"Ah," said Harry.

"Tough luck," I said.

"Bollocks!" said Adam, with a hearty guffaw and one of his disarmingly cheerful toothy grins.

The sun was beginning its slow, bronzing fade behind Clisham when we finally returned to the tiny cottage. Harry immediately set about preparing dinner. We carried in a couple of buckets of clear, cold water from the spring behind the cottage to help him in his labors. And then, as there seemed little else to do, Adam and I sprawled outside together on the warm turf and sipped the velvety Glenfiddich malt to toast the easing down of the first day.

Conversation roamed widely as we lay back on the grass and ruminated about the future of Harris, his upcoming book, *Seize the Fire*, on Lord Nelson to mark the two hundredth anniversary of the battle of Trafalgar, my search for an ideal Greek island of *Seasons in* . . . authentic-

ity and charm, the recent death of his father ("I still haven't gone through all his things yet—it's harder than I thought it would be"), his occasional frustrations with the rat-infested cottage here and the absence of electricity, a toilet, or running water, and my increasing irritation with an ankle that was complaining loudly about its overuse on the tussocks of the Central Valley.

"Easy solution for that," said Adam.

"Really—what is it?"

"Fill your glass again!"

"Best idea of the day," I said.

Harry's dinner was a masterful blending of barbecued leg of lamb, crackle-crisp on the outside and delicately pink at its center, a mix of fire-roasted potatoes and carrots, and a large green salad. It was dark outside by this time. Stars sparkled like diamond dust on black ebony. We dined in a medieval setting of roaring fire and flickering candles and Harry decided that, as no one else had claimed it, he'd gorge himself on the meat shreds hanging off the lamb bone. So, leg bone in hand and chin dripping with juices, he played his Henry V role to the hilt and, as our conversation meandered on into the night, his demeanor became so distinctly regal and animated that I expected him to launch into his St. Crispin's Day speech at any moment.

And he may well have done so for all I remember. But, alas, due to a surfeit of fine food, wine, and laughter, I don't remember much at all really. I don't even remember the scrabbling of rats among the roof rafters that poor Harry claimed kept him awake for much of the night. His frustration with their antics was not eased by Adam's insistence that these creatures were a very rare species of "black" rat, considered by many environmentalists to be "more important than the puffin colonies here!"

The following morning I realized that my walking and climbing capacities had now become severely limited by a distinctly errant ankle. So, as my two friends planned a rigorous clamber over Garbh Eilean island to parade along the bird-encrusted cliff tops and visit the site of an Iron Age house and other prehistoric site discoveries on the central, wind-torn heights of the island, I decided to limit my explorations to the Central Valley.

Gannet

"I'll do dinner," I said by way of apology. They were both appropriately empathetic and then left.

Silence descended like a shroud. But more silky gossamer than funereal. It was that scintillating silence of benevolent solitude—what Adam calls "the sheer, solid stillness of the islands." I finally had the place all to myself. I was free to let Adam's "ecstasy of being alone" work its magic.

As indeed it did.

My long, slow, and meandering stroll up the valley led eventually to the cliffs at the southern tip of the island. They were not as high as the towering ramparts on the eastern flank, and the basalt column structure was far less articulately formed. Maybe the magma had emerged more

slowly here from the great subaquatic rift. Apparently the cooling rate of magma greatly affects its molecular and columnar structure. But the soaring vertical shafts were precipitously powerful nevertheless and crammed with birds—mainly gannets as far as I could tell—resting on every minuscule black basalt ledge and turf-topped cranny they could find. How could they possibly breed, sleep, feed, and nurture their chicks on such tiny appendages of rock, I wondered?

They seemed equally curious at first about my presence too on the grassy edge of the cliffs. Despite my attempts to sit quietly without moving, they would take turns skimming my head and performing aerial acrobatics immediately in front of me, using the rush of air up the cliff face to help them whirl and spin with barely any movement of their wings. Just the slightest adjustment in feather-tip profile was enough to send them forty feet into the air above my head and then down in a return plunge, swoop, and hover in front of me, as if to say, conceitedly and complacently, "Bet you can't do that."

And the odd thing was that, watching them and the apparent simplicity of their aeronautical agility, I began to think "I wish I could . . . I bet I could . . ." It was a dangerously seductive sensation.

But eventually they seemed to accept my intrusive presence and floated off to perform more productive activities, such as dive-bombing the ocean for fish or alighting gently as thistledown on their family ledges to nestle with their mates and then stand rigidly like sentries, proud guardians of their tiny slivers of rock.

I have no idea how long I sat there. A seductive sense of Shiantism timelessness crept in. A stilling of things. I had nothing in particular to do and nowhere special to go. The day was all mine and I realized that, while being with Adam and Harry was a delight, the island now had me all to itself and was quietly offering glimpses of its own special moods and magic. And all it asked in return was that I watch, see, and remember.

I think, in addition to the pleasures I gained from being with the birds and admiring the strength, wildness, and durability of this small island, it was the sounds that I remember most of all: the thick, lush sounds of ocean breezes captured and channeled upward by the cliffs; the skittering swish of wavelets on the small pebbled beach far below; the deep thump

of larger waves on the vertical cliff face that vibrated through the rock; the serpentlike hiss of the explosive surf sprays; the guttural growling of larger rocks and boulders deep under the sea-savaging tidal flows as they moved together, rounding down each other; the silky, wind-skim sounds from birds' wings as they passed close over my head; the chitter and chuckle of small streams as they trickled, almost invisibly, through the marshy tussocks on the cliff tops; the sudden cessation of those sounds when the streams plunged over the cliff edge and released their waters to the air, spuming, like a confetti of rainbow-sparkling diamonds, down into the ocean hundreds of feet below.

Much later on in the afternoon, I wandered again, wrapped in a sumptuous silence, among the ancient stumps of dwellings, sheepfolds, and shell middens in the lower part of the valley. And here I sat for a while, ensnared by emotions, and scribbled fragments, observations and "rememberings," hoping to carry them home, hoping to retain "fragments of Shiants" to refresh, restore, and revitalize my spirit when I returned to familiar surroundings and the daily round of more mundane activities.

"So—how was your day?" asked Harry cheerfully when I had finally dragged myself away from all these musings and returned to the cottage.

All I could do, I think, was to give him a goofy grin and mumble something about the validity of Adam's phrase "the ecstasy of being alone."

"So you didn't miss us at all?!" said Adam.

More goofy grins on my part.

"Well," he continued, with his big smile, "we're whacked out and starving. Any chance of your dinner being ready in the next day or so d'y'think?!"

That got me refocused. I forgot I'd offered to cook our evening meal and here I was, still afloat in my "rememberings" with one major "remember" already forgotten.

"Grub's up in no time," I said, wondering what the heck I'd planned to prepare.

In fact, although I say it myself, the meal did come together remarkably quickly. And, if our collective grunts and sighs were any indication, we all ate long and well in our cozy kitchen with its flickering candles,

dancing shadows, flaming coal fire, and the rich aromas of crisped-top roast beef mingled with glasses of fine burgundy.

Conversations rambled on deep into the night with a generous mix of confessions, life-illuminating perceptions, and ribald humor when we started to take ourselves a little too seriously. We knew we'd be leaving the following afternoon, and although our time together had been brief, we all felt reluctant to face that prospect. The islands had indeed worked their magic on the three of us, despite the fact that I knew I'd barely tickled the surface of their secrets and deep seductiveness.

SOME OF THE LAST THOUGHTS of our brief odyssey are left to John Murdo Matheson, the burly, red-cheeked sheep farmer whose sheep roam the wild cliff tops and hidden dells of these islands.

Angus had brought John and a few other friends over with him when he returned to pick us up for the return journey to Tarbert. Among the group were his sister, Katherine, who along with his mother, Katie, is one of Harris's most noted tweed weavers, and the famous "Charlie Barley" of MacLeod's butcher shop in Stornoway, whose father created the still-secret recipe for the finest black pudding in the Western Isles.

It was a lively return trip. Angus took another long detour around the islands and the nesting birds greeted us once again with spectacular aerial displays, curling, wheeling, and diving in their thousands, with puffins performing more of their massed, wave top–skimming antics on cue.

One young man decided to sing a raunchy limerick of celebration that he claimed to have copied out of the visitors' book at the cottage:

There was a young man on the Shiants
Who leapt in a most furious dance
When one day at Bog rock [the traditional outdoor toilet here behind
* the cottage!]*
He got bites on his cock
When the midges got trapped in his pants!

Not exactly the most subtle of verses, but it certainly amused most of the passengers. With the possible exception of John, the shepherd, who had spent an hour or so roaming the cliffs to check on his sheep, and was now explaining to me the enticements he often experienced here. His deep awareness of the myriad nooks and crannies, hollows and crags, ancient dwellings and sheep enclosures was a match even for Adam's encyclopedic knowledge and appreciation. For such a large and obviously strong man, he spoke with remarkable quietude about the carpet-like richness and variety of the flora here, the remarkable deep-diving, fish-catching abilities of the shags that constitute the second-largest "shaggery" in the British Isles, the great stillness that I too had sensed here as the wind dropped and the seas calmed at sunset, and his deep love of being here alone "in a place that wraps itself around you and doesn't want to let you leave."

I'd sensed that too despite the fact I'd only been here a couple of days and much of that time in the company of two extremely sensitive, loquacious, and perceptive men. Our conversations had been loud, long, laughter-rich, and tinged with that beguiling intimacy of a shared, and deeply moving, experience. We had cooked with pleasure and care for one another, supped generously together, meticulously cleaned up the cottage and the adjoining fank, and sloshed through the marshy fringes and among the strange humpy remnants of ancient occupancies of the Central Valley. We'd explored the newly exposed mysteries of the "new" beach ripped open by that furious January storm, and shared comfortable silences outside on the velvety sheep-cropped grass, bathed in the bright, warm afternoon sun or glazed in silver moonlight under star-filled night skies.

There were so many small delights and experiences during that short period. The absence of normal diversions and distractions seemed to have expanded our time together to something beyond time. A still timelessness unrelated to clocks and calendars; a period of "powerful absences" that enabled the island spirit to ease itself into our own spirits and expand them—pushing out the boundaries of our oft blinkered perceptions and nudging them into new patterns of awareness and appreciation.

As reflected in the visitors' book, others had obviously sensed similar

emotions here. One wrote: "Time does not exist here on the Shiants." Another described how "our little-huge world here could not be simpler—eating (anything!), drinking, sleeping, bog-hopping, driftwood-collecting, seabird and seal-watching, fresh unspoilt air, clear spring water to drink and sun, rain, drizzle, and gales all in the same hour." Someone else had written, "I am afraid as I sit here alone in the warm sun that I will never experience this again" and another, "Magic lurks here on this Prospero's isle." I could sense the happiness that these islands and this little cottage have brought to so many. It's in the air, it's in the walls.

Maybe the last lines should be Adam's, expressing the depth that the Shiants offer in each single moment—in each precious perception:

> A gannet is sailing above the storm, in close beside the beach so that I can watch it above the stained green-and-white surface of the sea. The day is dark and the gannet is lit like a crucifixion against it. I could never tire of this, never think of anything I would rather watch, or of any place I would rather be than here, in front of the endless renewing of the sea bird's genius, again and again carving its path inside the wind, holding and playing with all the mobility that surrounds it like a magician with his silks, before the moment comes, it pauses and plunges for the kill, the sudden folded, twisted purpose, the immersion, disappearance and the detonation of the surf. The wind bellows in my ears as if in a shell. No one can own this, no individual, no community. This is beyond all owning . . . this wonderful sea room, the surge of freedom which a moated island provides.

That was the one key thought that welled up inside as I remembered Adam's words—we all "own" nothing except the freedom, intensity, depth, and beauty of each moment and each memory. And, for me, as well as for my new friends, the Shiants provided these in abundance . . .

24

Leaving the Island:
A Tweed Revival?

ELL—YOU'LL BE GLAD TO KNOW—it's finally happenin,' David! At long last!"

"Sorry? Who is this?"

"Have y'heard already? Ah . . . maybe y'have . . ."

"Heard what . . . who is this?"

"The tweed!"

"What tweed?!"

"It's back . . ."

"What do you mean . . . hold on . . . who is this and what are you talking about?"

There was a pause at the other end. I could hear heavy breathing.

"David, this is Roddy. Roddy MacAskill."

I was suspicious. It didn't sound like Roddy. The voice was too high and he was talking too quickly.

"Where are you calling from, Roddy?" I asked, I guess as a kind of test. We weren't used to crank calls in the Hebrides. Especially about tweed.

"From the office . . . up from the shop . . . right across from you!"

"Oh . . . okay . . . sorry, it just didn't sound like you."

"Aye, well, maybe I'm just a wee bit excited."

"About tweed?"

"Yes, about tweed. And about Donald John and Maureen . . . the MacKays . . . the weavers down at Luskentyre . . ."

"Yes, we know them well. Lovely people."

"Well . . . looks like they've gone and got things going again."

"With the tweed?"

"Yes, David." Roddy's voice seemed a little exasperated with my slow grasp of what sounded like very important—and good—news . . . about the tweed. "They've gone and got us a huge order from Nike—y'know, the people who make all those trainers . . . or what d'y'call 'em in America . . ."

"Sneakers."

"Aye . . . those things."

"And what is Nike going to do with the tweed and its sneakers?"

"Och, I don't know all the details yet. Why don' y'jus' call Donald John. He sounds like he needs a nice calm voice like yours to soothe him down a wee bit."

"Is he okay?"

"Sounds like he was having a heart attack t'me. Y'know how fast he talks. Well he was going a mile a minute . . . like he was running a race in a pair o' those Nikes!" Roddy chuckled at his own impromptu humor.

"Okay, I'll give him a call and get the details. Sounds interesting . . ."

"It'll be more than interestin' if it all works out. It'll give our weavers some real work for a change!"

"And your tweed factory at Shawbost too? Are you still involved in that?"

"Oh aye, sort of . . . on and off, y'know . . ." Roddy was always a little cautious in revealing too many details of his considerable mélange of business activities on the island.

"Well, that could be a bit of a lift for you, then?"

"Ay, well, maybe . . . but it's the weavers I'm thinkin' about. This could be what they've all been waitin' for—for far too long now. Far too long . . ."

"Okay, Roddy, thanks for the tip. I'll call the MacKays right now. See what the story is."

"Aye—why don' you do that . . . and then pop round later . . . around dinnertime. We'll have a wee dram or two to celebrate."

"Sounds like a grand idea!"

"Let's call the MacKays and get the real story," I said to Anne, who was standing beside me, intrigued by all the possibilities of a sudden tweed revival on the island. "Although from what Roddy just told me that might not be so easy."

It wasn't. Donald John picked up the phone and Roddy was right. His voice was half an octave higher, and his Hebridean accent even more pronounced than ever, with words tumbling out chaotically. "Ah yes, wonderful news, isn't it, David . . . hold on . . . Maureen, it's David from Ardhasaig and—hold on again—there's someone at the door . . . oh, okay . . . David, sorry, it's all a bit of a madhouse at the moment . . . no, no, you don't need to call back . . . it's jus' that . . . Granada TV is coming this afternoon . . . they want something for the evening news . . . and then the BBC . . . Maureen, when's the BBC comin' . . . Friday? Yeah, tha's right. Friday. They're talkin' about a half hour special—a TV documentary about it all! Can y'believe it . . . everything's going so fast . . . hold on— he wants me now, Maureen? Okay . . . tell him I'll be out . . . can you speak with David and Anne . . . David, I've got a newspaper reporter here. Maureen . . . you speak to them . . . David, Maureen's comin' . . . I'll catch up w'you later."

Maureen's slow, measured way of talking and her clear English Midlands accent eventually allowed us to extract the essence of the story, which went something like this:

"Well, y'know how Donald John is always looking out for new clients and designers—y'know, people who'll bring in new fashions and new ways of using tweed. He's met so many people—I think he's told you—Vivienne Westwood's designers, Selina Blow, Timothy Everest, Miuccia Prada . . . a lot of clothes people from Japan, they love his new patterns he designed just for them, also quite a few Germans and Americans. The orders are not always large, but they've been consistent. And we've managed to farm out some of the work—to help other weavers. And Donald John has always been true to the tweed. You know that."

HAND WOVEN

Harris Tweed

HAND WOVEN IN THE OUTER HEBRIDES
FROM SCOTTISH GROWN WOOL
100% WOOL

The Pride of the Tweed

"Yes, we do," I said. "He's a stickler for tradition."

Maureen laughed, "Oh, that he is. And he's been asked to do all kinds of things—y'know, weave in fluorescent colors, mix the wool with cashmere and suchlike, make an ultra-light fabric for young buyers . . . but he won't do it. He says there are a lot of tweeds—so called—around the world, done in all kinds of ways—mainly made in factories—and with all kinds of weird stuff mixed in the weave. But he says he'll only make his tweed the way that Harris Tweed is supposed to be made. Otherwise what's the point!? And there are three weights nowadays anyway—standard, light, and bantam-feather—so there's plenty of versatility already. And, as you know, he even makes his own bobbins of yarn and sets up his own warp—doesn't use any factory-delivered warp 'hanks.' Anyway, word must have got around and a few months ago we got this call from the Nike company, asking if they could send someone over to look at samples and see how the tweed is made on the island—to check its authenticity, I suppose. So we said yes, of course, fine, c'mon and visit,

and so they came and then they went and nothing happened, so we forgot all about it.

"Anyway, when was it? Last week, last Wednesday, I think, we suddenly got this e-mail"—[Maureen had long ago discovered the value to her wide-ranging customers of having a computer with e-mail access]—"bet most people don't know we have an 'electronic cottage' here now! Donald John wasn't too keen at first but I told him, if we're going to keep this business going and you want my help we need a computer. It's either that, I said, or I'm going to carry you off back down with me to my part of England to try another line of work! So—he agreed and now I've got my little work station where this e-mail arrived last week—from Nike—asking for nine hundred and fifty meters of our special tweed pattern—Donald John designed it himself—a lovely sort of sage green with touches of blue and red in it, the kind of amber-red y'used to get from the old crotal dyes. And we thought—well, that's nice. That'll keep us busy for a while. Donald John turns out thirty yards a day on a good day on his single-wide Hattersley in the weavin' shed out there. So we said yes and told them the price. And they didn't quibble or anything—they just said fine and when could they expect the rolls. And we told them. And everything was peachy until we got this second e-mail the next day . . ."

"Oh, no," said Anne. "Bad news?"

"No, no. Just the opposite! They said they'd made a mistake in the first e-mail. They'd missed a zero, and they actually needed ninety-five hundred meters—that's nine thousand five hundred meters—can you believe it?!"

"Fantastic!" I said. "A very healthy order!"

"Yes, it is. And, from what they told us, there'll likely be more orders . . . a lot more . . ."

"Congratulations to you both . . . you deserve it," we said, almost in unison.

"Thanks . . . now how about comin' down for a cup of tea to celebrate?"

So we did, and despite numerous phone calls and Donald John dodging in and out of the house like an excited rabbit, Maureen managed to prepare a brimming tray of tea, cookies, and homemade cake.

We felt guilty taking up their time in the midst of all this entrepreneurial uproar. But somehow Maureen found the tranquility to sit calmly with us by the fire.

"It's been a hard few years—for all the island weavers, really. You know this well by now—you've talked with them. There used to be over four hundred, y'know, in Lewis and Harris—it was a useful income for the crofters. Something they could do in the evenings after dinner for a few hours. Then everything slowed down. The worst was when the American market collapsed. That was the daftest thing, but somehow they'd got stuck with a huge overstock of tweeds in the Stornoway mill and someone had the bright idea of selling it cheaply in bulk to clear warehouse space. And somehow it ended up as jackets selling in places like Wal-Mart in the USA! Can y'believe it?! Top o' the line Harris Tweed in Wal-Mart! Well—y'can understand what it did for the high-end trade . . . y'know, in the posh clothing stores. It killed it stone dead. People wouldn't pay five hundred dollars for a Harris Tweed jacket on Fifth Avenue in New York when you could buy virtually the same thing—admittedly tailored in Asia somewhere—but the same cloth, for less than a hundred dollars in a Wal-Mart!"

Maureen paused and gave a sigh of exasperation.

"Anyway . . . it took a long while to recover from that . . . but if this Nike thing works out we'll be well and truly on the map again, I hope. 'Course we can't do it all ourselves so we're going to partner up with Derick Murray at his Stornoway factory and let him find the other weavers we'll need to complete the order—then who knows what it could lead to? We've already had one other sneaker company calling us and asking for samples . . . and Nike says this might be just the start . . . there's some other new ideas they're working on and they asked just this morning if we thought we could manage to produce another five thousand or so meters of the same pattern. So . . . it's a little bit exciting at the moment as y'can imagine. I mean, this could be a whole new beginning for us all here—if we can interest the younger generation and get rid of the fuddy-duddy image of tweed a bit. Trainers might just be the answer, eh!?"

"Oh, and there's also the knitting too, y'know. That's really coming up nowadays! The small factory up at Carloway is starting to produce as

much tweed wool for knitting now as it does for weaving. S'quite amaz-ing. Apparently it's all the rage, not only in Britain but in Europe too. Knitting classes and clubs sprouting up fast as barley stalks. Ruth Mor-ris—that island girl who created the famous Roobedo store in Edin-burgh—has bought plenty of tweed from us and sells a lot of the new knitwear. And there are knitters sprouting up again all over the island—Mairi Fraser and Katherine Llips's Isle of Harris Knitwear store in Grosebay sells a lot of their creations now. An' there's Heather Butter-worth and her Kells Tweed Company—oh, and Tweeds and Knitwear in Plocrapool too. And of course there's Margaret MacKay at Soay Studio in Tarbert—I think y'know her—she's done wonders for keeping and teaching the old traditional dyeing techniques from local plants and sell-ing her knitting wool. Beautiful, subtle colors she produces—quite dif-ferent from the chemical dyes. 'Course there was a time when every weaver would dye his own yarn but that's long gone now. I think, before Margaret came, the last weaver who was still doing it was dear old Mar-ion Campbell."

"Oh, Marion—yes—we met her years ago. She let us spend a whole afternoon with her. Couldn't get her peat-soot dye off my hands for days. Lovely, gracious lady . . ."

"Yes, she was. It was a sad day for us all when she passed . . . but any-way enough of all this—c'mon, have some more tea, and eat up the cake if y'will. I hate putting cut slices back in a tin . . . they say it's bad luck to do that. And right at the moment, we prefer whole dollops of good luck for once!"

As our time drew to a close on Harris, we visited Donald John and Maureen one last time to say our farewells and to find out how the whole Nike episode was working out.

This time there was an aura of calm confidence in their little house. Even Donald John seemed to be talking at a slower pace, smiling brightly, and full of new hope for the future of his own tweed making and for the island industry as a whole.

"Did y'two see the local paper yesterday? What our Derick Murray

just said? He's like a new man now. He's given up all his ideas of sellin' up his two factories. Here"—he reached for the paper—"this is what he told the *Gazette*:'I'm far more confident than I was for a long time. And I'm sure this will be a great success and bring the industry back. Harris Tweed means everything to me. I've been at it all my life. If you are committed to an industry like this you are committed to the whole island.'"

"Great!"Anne said."We were worried about him—in fact about the whole tweed industry—when we met him last spring."

Donald John laughed."Well he's a different man altogether today an' did y'hear he's got ads out now for new weavers—not just the older ones. They're already back at their looms now, but for new trainee weavers, mind you! Can y'believe that? I can't remember when new people were comin' in to start weavin' in the traditional way. Young ones too. Now that's a real eye-opener, and a good way to get some of our youngsters to stay on-island for a change. D'you remember that lovely old Gaelic saying: *Sann o'n duthaich a thig an clò*—'From our land comes our cloth.' Would be nice to hear more of that and a little less of 'to get on you've got to get out' attitude. The island needs its young people. I know it's against all the trends—all the tourists, self-catering cottages, incomers buying up everything, and all that. But it's good to know that there might be a better balance—y'know, of people comin' and goin'. Wouldn't it be a shame for Harris to wake up one morning and realize that there were hardly any real *Hearaich* left! What kind of island would that be now!? God help us and help our tweed is what I say! And it looks like he might—there are bigger orders on the way—so keep all your fingers crossed!"

All great news, but I was struck by his previous comment. What kind of island indeed? Certainly not the kind of island that we were seduced by all those years ago and finally returned to—as enthusiastically as the first time—to celebrate its people, its spirit, and its deep, rich heritage. In a book. In *this* book of tales, adventures, traumas, and island people. A book that has allowed us to discover, explore, and learn the island and its ways far more extensively and enthusiastically than we ever thought possible. And maybe this is an appropriate moment to pay my respects to one of my favorite "travel" books—Henry Miller's *The Colossus of*

Maroussi—by quoting his summation of his own explorations and writings: "I give this record of my journey not as a contribution to human knowledge, because my knowledge is small and of little account, but as a contribution to human experience."

Then Miller adds this final line, which we echo here on behalf of all the inhabitants of these small, wild islands: "Peace to all men, I say, and life more abundant."

Black House on The Bays

Postscript:
Toward a New Abundance?

———

*A*s we slowly prepared to leave, making farewell visits to all our friends, we decided to invite a few of them to offer some final thoughts and perceptions on what Harris still means to them in their lives—and their hopes, along with a few fears, for their mutual future and a possible "new abundance" here.

Roddy MacAskill—of course—was one of the first. During our stay in Harris we'd spent countless hours discussing just about every aspect of island affairs with him, and I knew from past experience he'd present his opinions clearly and without wile, guile, or gush. Which is precisely what he did.

"You've got to remember who we are—we're still the descendants of crofter-weavers. They're our family—our heritage. That's what almost all of us were—and in our hearts, that's what we still are today despite all the many changes."

"So—you're still 'the little island that could . . .'"

"Weel—if we're not, it's not for want a' tryin'. A' mean, you can't fight everything. . . . And some of the changes are good. People are livin' a lot better nowadays, gen'rally speaking. And the tourists have helped with that. They bring in a bit o' fresh air y'know . . . and fresh cash! Nothin' wrong wi' that. . . ."

"So long as Harris doesn't start going Disney!"

Roddy laughed, "Ah, a' don' think there'll be much chance of that on our wee place! We're too stubborn! I jus' wish we could find more for

our youngsters . . . things to keep them on island doin' worthwhile work an' such."

"I heard—after Donald John's big Nike contract that really got the weavers back at their looms—there was talk of setting up a training workshop for young weavers. . . ."

"Aye—well, they did—they have. And a few got involved but you never know how long it'll last y'know...although I have to tell you—tweed's really rolling at the moment. Big new orders comin' in—so I heard. Derick Murray seems to be awful busy and Donald John MacKay is quite a local hero. . . . But, listen—don't just take my word. Go and talk with others—you know just about everybody on island by now. . . . I think y'might be pleasantly surprised. . . ."

And indeed I was.

Willie Fulton, as I expected, turned my questions about all the new "trends" here—the proposed wind turbine farms, new salmon farms, the Harris Tweed Center in Tarbert, and others—into one of his jokes. "There was this councilman y'see an' he was asked by an impatient incomer why ideas took so long to become realities here—why there seemed to be so much mañana-lethargy around. The councilman thought for a minute and then slowly replied: 'Mañana, y'say . . . och, well, I dunna think we have a Gaelic word here as immediate as that. . . .'"

It was typical Willie humor. Apt but good-natured too.

"I do sense a change though, y'know. The rebounding of the tweed—while no one knows how long it will last—it's given us all a little bit of a boost. Wee David's facing up to Goliath at last—So . . . y'canna write this fine place off yet by a long way!"

Another boost came when I called Robert Fernandino at Celtic Clothing in Stornoway—the man who had sold me my first tweed jacket. He was away on vacation but his spritely assistant, Lorraine, gushed about "all these big new orders comin' in it's back in fashion now, y'see. I heard it on Radio One—that famous Irish DJ—he said it's okay to wear the tweed again! It's not considered old-fashioned anymore!"

Derek McKim's reaction as Head of Strategy at the Western Isles Council was a little more studied—but still upbeat. "I don't think we'll

ever get back to the good old 7-million-yards-a-year days—but so long as the 'niche markets' and fashion houses keep using our tweed, I think we might be all right. Oh, an' don't forget—we've just reopened two small plants, one making parts of wave power devices for Portugal—and a fish oil biotech factory. Quite a few new jobs there—all 'fine green shoots of recovery.'"

Similar conversations with Margaret MacKay, Morag Munro, Ian MacKenzie at the Harris Tweed Association, Angus Campbell and his weaver-mother, Katie, Catherine Morrison, Bill Lawson, John Murdo Morrison, Alison Johnson and others reaffirmed something of a "renaissance spirit" wafting through the islands.

Iain MacSween at the *Stornoway Gazette* was my key informant as usual and he was even more upbeat than ever. "Listen—I'll read you a bit of what we wrote in a piece a week or so ago," he said with a grin:

> "Harris Tweed orders from America and Germany have given a tremendous boost to the industry. Managing Director of the KM Harris Tweed Group Derick Murray said more workers would be taken on and if this continues in the months ahead it will make it a spectacular year for Harris Tweed and the local island economy.

There's lots more but—what d'y' think o' that then?!
"Sounds just like 'the little island that could' to me."
"Absolutely!"
And to hear that the normally modest Derick Murray, owner of the two largest mills on the islands, was finally sounding optimistic, verging on triumphant, was a most unusual—and positive—landmark event.

And, of course, who best to offer the last word and speak for everyone on the island than our "local hero"—he of "Nike" notoriety—the irrepressible Donald John MacKay:

"Och, David—y'wouldna believe how things are going here! It's buzzin'—really buzzin' what with all these new orders. . . . California too—she's comin' in strong. Now they're worried about not havin' enough weavers! Can y' believe? We get great news like this and new worries start up! Anyway Derick Murray's gettin' some kind of appren-

tice scheme for new younger weavers so that should help. And last time a' saw him—a week or so ago—he was actually laughin'! Derick laughin'—high as a kite he was! Haven't seen that for a long time. Anyway, to sum it all up—it looks like we're off the cusp for now and rollin' along the right track—at last—at long last! Och, yes, it's wonderful—our tweed is finally coming back!"

And so it goes—a little island, now our little island too—floating on into what could be a future of true "sustainable" balance, pride in its enduring traditions, and buoyant optimism.

And I can hear Roddy's toast: "Na' that's certainly something to drink to! Top 'em up David . . . *Slainte! and Ceud mile failte!*"

Yes indeed. "Good health" to our island—and a "hundred thousand welcomes" to what could be a fine "future of abundance" here.

Afterword

by Bill Lawson,
author of *Harris in History and Legend*

*T*HE ISLE OF HARRIS, IN the Western Isles of Scotland, is an island of paradoxes.

It is an island, yet it is not an island, being joined by land to the larger Isle of Lewis—though separated by mountains.

It is an island whose east coast is an incredible terrain of rock-strewn wastes—and whose west coast boasts some of the finest sandy beaches in the world.

It is an island on the same latitude as Estonia or Churchill on Hudson's Bay in Canada, yet we rarely see snow, except on the mountain tops.

It is an island of incredible bleakness in a winter storm, yet the spring and summer coverage of flowers on its *machair*—the Atlantic shorelands—is a riot of color, and of perfume.

It is an island whose economy is probably at its lowest ebb, yet where there are expensive new houses being built all the time—though mainly by newcomers, for holiday and retirement homes.

It is an island where the young people have to leave, through lack of economic opportunity, to be replaced by people from all over the world, looking for peace and tranquillity.

It is an island whose culture is being eroded at a frightening pace by

the onslaught of modern communications technology and by the replacement of the indigenous people by newcomers, yet it is also a place where visitors come in numbers from all over the world to experience what is left of an older way of life.

It is an island world-famous for the Harris Tweed, yet there are dwindling numbers of weavers left here, and the tweed industry ricochets from crisis to crisis.

It is an island which by all economic measurements ought to be sunk in despondency and depression, and yet has a cheerfulness and ebullience which is a source of wonder to the visitor.

But it is also an island which, if it once gets a hold of you, will stay in your mind—an island which you will wish to visit again and again, to which you will return as to home.

What is the visitor to make of all these facets of the same island? Some come only in the summer, and see the island thronged with tourists, and enjoy summer weather on the beaches and coasts. Others come in the winter, and see an almost-empty island, buffeted by gales and drenched in rain. Some come to see the after-glow of a Celtic twilight, others to hear the Gaelic language in one of its last strongholds. Some come to see a land where virtually nothing has changed for centuries, others to witness the death-throes of a culture under the onslaught of modernity.

Only a few see the island in all its moods, all its weathers, the community in all its strengths and weaknesses. But it is those few who are truly in a position to write about the island as a whole.

David and Anne Yeadon have lived in Harris at all different times of year, in all seasons and in all weathers. They have lived under the shadow of the mountains of North Harris, and beside the sun-white beaches of the Atlantic coast of South Harris, and where they have not lived, they have visited. They have frequented pubs and hotels, they have made the tour of visitor places with the tourists, they have found quiet private places of their own, and above all, they have talked to people—in shops, at the road-side, as guests in their own home, where David is an excellent host, and an excellent chef!

David's understanding of the world and its remote places has been honed by years of writing travel books and articles for *National Geographic* and many other magazines, and he has already published a book on the different aspects of a year spent in Basilicata in Southern Italy. It is of great interest to see what he makes of Harris and its paradoxes—and what Harris made of him!

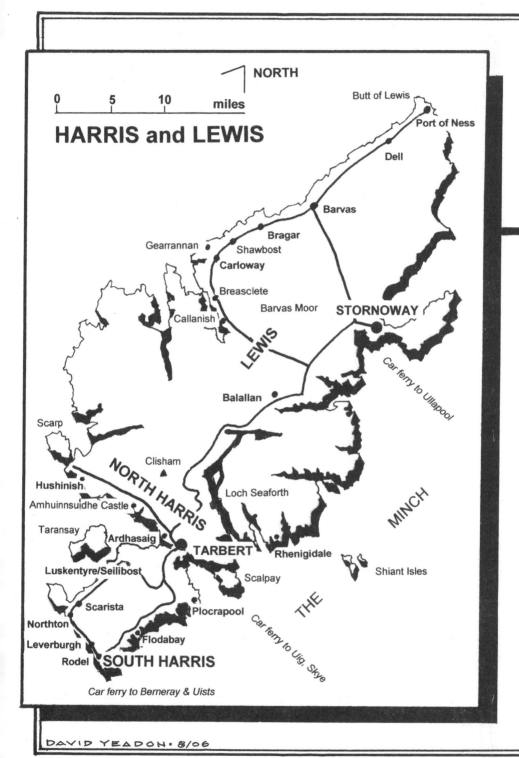